ATLANTIS
Mother
Of Empires

The Atlantis Reprint Series:
- THE HISTORY OF ATLANTIS by Lewis Spence (1926)
- ATLANTIS IN SPAIN by Elena Whishaw (1929)
- RIDDLE OF THE PACIFIC by John MacMillan Brown (1924)
- THE SHADOW OF ATLANTIS by Col. A. Braghine (1940)
- SECRET CITIES OF OLD SOUTH AMERICA by H. Wilkins (1952)
- ATLANTIS: MOTHER OF EMPIRES by Robert Stacy-Judd (1939)

The Mystic Traveller Series:
- IN SECRET TIBET by Theodore Illion (1937)
- DARKNESS OVER TIBET by Theodore Illion (1938)
- IN SECRET MONGOLIA by Henning Haslund (1934)
- MEN AND GODS IN MONGOLIA by Henning Haslund (1935)
- MYSTERY CITIES OF THE MAYA by Thomas Gann (1925)
- THE MYSTERY OF EASTER ISLAND by Katherine Routledge (1919)
- IN QUEST OF LOST WORLDS by Byron de Prorok (1937)

The Lost Cities Series:
- LOST CITIES OF ATLANTIS, ANCIENT EUROPE
 & THE MEDITERRANEAN
- LOST CITIES OF NORTH & CENTRAL AMERICA
- LOST CITIES & ANCIENT MYSTERIES OF SOUTH AMERICA
- LOST CITIES OF ANCIENT LEMURIA & THE PACIFIC
- LOST CITIES & ANCIENT MYSTERIES OF AFRICA & ARABIA
- LOST CITIES OF CHINA, CENTRAL ASIA & INDIA

The New Science Series:
- THE FREE ENERGY DEVICE HANDBOOK
- THE FANTASTIC INVENTIONS OF NIKOLA TESLA
- THE ANTI-GRAVITY HANDBOOK
- ANTI-GRAVITY & THE WORLD GRID
- ANTI-GRAVITY & THE UNIFIED FIELD
- VIMANA AIRCRAFT OF ANCIENT INDIA & ATLANTIS

Write for our free catalog of hundreds of books and videos

ATLANTIS
Mother
Of Empires

by
Robert Stacy-Judd

Atlantis: Mother of Empires

© 1939 by Robert B. Stacy-Judd

This Edition published March 1999
by Adventures Unlimited Press

First Printing

ISBN 0-932813-69-0

Printed in the United States of America

Published by
Adventures Unlimited Press
One Adventure Place
Kempton, Illinois 60946 USA
auphq@frontiernet.net

Acknowledgement

In a work of this nature it is obviously impossible to acknowledge my obligations to the numerous authorities whose information and opinions I have so freely taken the liberty of quoting. Collectively, therefore, I tender my sincere thanks and deep appreciation to all those authorities whose aid I have sought. My gratitude is extended individually to T. A. Willard, for his many efforts in my behalf; to Manly P. Hall, for his sound advice and the use of his extensive library; to Gerry Fitzgerald for his assistance in checking the preliminary manuscript; to Homer P. Earle and Edgar Lloyd Hampton for their scholarly editorial work and criticisms, and for putting the book through the presses and the bindery, and to the publishers, for their encouragement and unceasing efforts to make this work worthy of public presentation.

THE AUTHOR

Contents

CHAPTER ONE

THE MAYAS AND THE LOST ATLANTIS

Confusion

CHAPTER TWO

CONJECTURES AND OPINIONS

Speculation

CHAPTER SIX

AND WEST IS EAST

CHAPTER SEVEN

THE MORMONS AND THE MAYAS

CHAPTER EIGHT

ASTROLOGY IN TWO HEMISPHERES

CHAPTER NINE

THE LANGUAGE OF ARCHITECTURE

CHAPTER TEN

THE AMERICAN INDIAN

Earth-mound builders

CHAPTER ELEVEN

PRE-PANAMANIANS AND PRE-INCAS

American cultures

CHAPTER TWELVE

COLUMNS AND CITY PLANNING

*Christ's
last
words*

CHAPTER SIXTEEN

QUETZALCOATL

*A conferred
title*

CHAPTER SEVENTEEN

SUMMING UP THE EVIDENCE

Illustrations

IN THE ORDER OF THEIR APPEARANCE

NOTE: The frontispiece, all illustrations marked with an asterisk (*), and all illuminated letters, symbols, et cetera, were made by the author.

FACING PAGE

Foreword

 IN this work, opinions have been quoted freely from recognized authorities, and my disagreement with certain of their conclusions has been as freely expressed, without prejudice.

The method here used in assigning the approximate arrival dates of the principal ancient peoples of the Americas is analogous to the method devised by Doctor Andrew Elliott Douglass, of the University of Arizona, to decide the age of early American pueblos.

The tree-ring method

In recent years we have learned that trees are remarkably accurate recorders of both time and weather. Annual rings that follow one another in close formation chronicle a succession of dry seasons; spaced wide apart, they indicate wet seasons. According to the width of the space separating the rings, the rainfall, or lack of it, is indicated.

A boring taken from the outer ring to the heart of a living tree in a given wooded area will correspond exactly with borings from other living trees of the same kind in the same area.

Charting tree-rings

To find the age of an early Indian structure in which large timbers were used, the first step is to seek growing trees near the structure, of an age likely to antedate it.

Suppose that archeological findings suggest, though vaguely, that the age of the structure does not exceed six hundred years. Within a reasonable distance — that is, within an area

where climatic changes have been reasonably uniform — we discover trees and take borings that show a range of ages in excess of seven hundred years. We select suitable borings or cores and of the best one we make an exact chart of the annual rings it discloses.

An analogous chart system

Next, we extract cores from two or three of the largest timbers found still in place in the Indian structure, timbers originally used in the building, and having at least a part of the outer ring of the tree when it was cut down. After making charts of their rings, we select the best one and slide this chart up and down beside the chart of the living tree.

If the building were erected at any time within the last seven hundred years, the timber chart will find its exact counterpart somewhere on the chart of the living tree, the outer ring of the timber chart—indicating the very year the building was erected.

Of course the timber may have been put in place at a later date than the date of the original walls, or it may have been taken from a structure greatly antedating the walls on which it is found. These possibilities have to be eliminated, and usually offer no insurmountable difficulty. When they have been cleared away, the chart of an undoubtedly original timber is a reliable aid in arriving at the age of the structure.

The now famous technique of Doctor Douglass illustrates the analogous method I have used in formulating my theory of the origin of the principal cultures of the Americas. My key chart is like the living tree chart. It consists of events, cults, customs, and remains associated, in chronological order, with important ancient peoples of Europe and Asia Minor. These phenomena are analogous to the rings of the tree. Similarly, a culture chart of the ancient peoples of the Americas is like the timber chart. And by sliding it up and down the Old World chart I have found, in many cases, parallels as convincing as those of the tree rings. The sum of such parallels is the basis of my argument for a common source of the cultures of the Old World and the New.

Liberties taken

I have taken certain liberties with such words as theory, hypothesis, race, tribe, people, data, evidence, testimony, and information. I have not always used them in their strict sense but in a more commonly accepted meaning. Indeed, the strict sense of some of them, as that of race, is elusive, and no writer appears to have used all such terms with unvarying precision. Also, it will be noticed, in numer-

ous instances, when quoting excerpts from the works of others, I have called for certain passages to be in Italics. This is for the purpose of emphasis only.

My wish throughout is to discuss with the reader certain conjectures and opinions, certain hypotheses and theories, in terms easily understandable, and in a spirit free from dogmatism and intolerance. As Edmund Burke said: "Toleration is good for all or it is good for none."

Tolerance
an
essential

ROBERT B. STACY-JUDD

Los Angeles, California,

ATLANTIS--MOTHER OF EMPIRES

Chapter One

The Mayas and the Lost Atlantis

UCATAN . . . Land of pitiless jungle life . . . Land of mystery and death . . . Land where lies waiting, perhaps, the key to the world's greatest secret. Yucatan . . . Great black vultures hover at the scent of new death—the jaguar's night kill. And as the jungle monarch lingers over the body of a doe, even though Kin, god of the sun, rides high, the vultures wing lower, their ghastly heads swinging as they peer earthward. Their raucous cries pierce the sullen, over-heated air and set the jaguar's flattened ears a-twitching, but the scent of the living beast holds them aloft and beating upward.

Beneath their baleful eyes stretches a sea of tangled growth, green on green to the horizon. Everywhere the jungle like a vast octopus, breeds and slays.

The Yucatan jungle today is the home of savage animals, deadly snakes and maddening insects. For nine months in the year it is a waterless hell — sweltering, fever-stricken — a paradox of beauty and stark, staring ugliness. Yet within its green tentacles lie smothered the stupendous works of a civilization which may prove to be the greatest and most important in the history of man.

Throughout this land where now the jaguar and the vulture enact their grim roles lie scattered pages of stone from the history-book of a vanished civilization. Some remain intact. Many have been torn from their places by jungle growth, or the ignorant, destructive hand of man. Yet each building remains a page, each city a chapter in the history of a wonderful race—buildings and cities unbelievably vast and beautiful.

History book in stone

They are cities of silence now, their builders lost, forgotten. Where once an advanced civilization reared its dignity in stone, now parrots chatter and death slinks on soft, jungle feet. Where once walked youth and wisdom, now stand closely packed boles in deadly competition, struggling in vain against the strangle-hold of an army of parasites. The once pastel shaded or white stone facades of architectural masterpieces no longer gleam joyously in the bright sun. Yet there are walls which stand defiant, guarding another world of thought, a realm of unrevealed knowledge and a treasure house of intrinsic and esoteric wealth.

The discovery of these ancient cities is more than just another prehistoric find. It is pregnant with startling possibilities. When the stone pages are at last rebound, they will reveal one of the greatest stories in the world, a story so rich, not only in human interest but in scientific knowledge, that our present-day histories will have to be rewritten.

It is the story of that once mighty and highly cultivated race, the Mayas, whose appearance and disappearance have so mystified scientists. Moreover, though little conclusive evidence has come to light as yet, there is every reason to believe that here is the preface to a still greater story — the story of the Mother of Civilizations — the much discussed Lost Atlantis, whence, I believe, the Mayas came.

Who were the Mayas?

Who were the Mayas? Whence did they come? These questions have mystified the savants as well as the lay minds for the past one hundred years. Since the time John L. Stephens told of his remarkable journeys among the Maya ruins in Yucatan and Central America, explorers and archeologists alike have floundered in a mire of speculation.

It has always appeared to me that some center other than the present designated Maya area must have existed — a center in which their civilization originated and developed to maturity. I have never been able to reconcile myself to the hypothesis that the

territory which they at present occupy was the birthplace of such a stupendous culture. Such a hypothesis seemed contradicted by an abundance of evidence.

Seeking the Maya birthplace

In seeking to reconstruct the Maya family tree, I soon learned that while there were many leaves and twigs and even a few slender branches to be found, the main trunk and most of the main limbs were missing. Moreover, the roots were lacking and even the mother soil rested in unknown parts.

Not only was a starting point essential but it was perfectly evident that to erect a reasonably sound argument, some still unknown center must be assumed to exist or to have existed. If the known environment did not fit the rest of the data then some other spot must be discovered which would. There appeared to be enough evidence, moreover, to obviate the necessity of selecting that spot by chance or mere guesswork. Presumably, then, the first act was to test the existing evidence. These investigations and the consequent intensive research work in numerous branches of scientific thought, occupied a period of more than fourteen years.

Although early in my studies I admitted the high probability that a continent once existed in the Atlantic Ocean, the evidence did not appear sufficient to warrant its acceptance. The best evidence already provided suggested a direct connection between the assumed inhabitants of Atlantis and the Mayas of Central America; but, I was also faced with an abundance of apparently conclusive evidence to the contrary. Furthermore, I discovered early that the student is confronted with uncompromising dogmatism of the most unyielding type in addition to a host of conflicting hypotheses and arguments. However, after a very careful survey, I selected what I believed to be the clearest course and endeavored to correlate what I considered the most acceptable data gathered by ardent adherents to the Atlantean hypothesis, together with considerable information supplied from numerous other sources. What little I am able to add personally is of minor consequence.

Confusion of Evidence

There are many reputable students who do not agree with the Atlantean hypothesis; yet in recent years thousands of thinking persons are becoming its enthusiastic supporters, in the face of the fact that the essentially materialistic majority always experiences difficulty in accepting even the most convincing circumstantial evidence. The contents of this volume might be termed a succession of hypotheses;

but I believe that the reader will admit that they are here strongly supported by unquestionable facts and that the circumstantial evidence is of a very acceptable character.

The story is far from complete. Many links in the chain are missing; but research in the Maya field is approaching completeness almost daily. A sufficient number of clues will eventually be found to solve the remaining mysteries.

First Expedition

In 1930, good fortune enabled me to conduct my first expedition into the heart of Yucatan. I hope to lead many more expeditions into the Maya area in an endeavor to rescue from the jungle the lost and forgotten pages of civilization's book of history.

In tracing the Mayas back to prehistoric times, I shall endeavor to show their profound influence upon all the great civilizations; but I do not infer that *all* culture, science and art originated with the Mayas. It is my belief, however, that they began the last great cycle of civilizations.

To students of the human race as a whole it will be obvious that other cycles and perhaps even grand-cycles of civilizations, possibly of a very high order, rose and subsided, long prior to the origin of the first Maya ancestors.

What the Mayas gave us

It is a significant fact that for the past seven thousand years mankind has not developed a single food-plant to compare in importance with those produced prior to that period.

In Spinden's *Ancient Civilization of Mexico,* he includes many tribes or races of Central America, who contributed the following list of items to civilization. I have, however, in view of the evidence, given the entire credit to the so-called Mayas.

The progenitors of the Mayas in Yucatan gave to the world such priceless gifts as: maize, potatoes, cacao, sweet potatoes, tomatoes, pumpkins, squashes, lima beans, kidney beans, peppers, pineapples, strawberries, persimmons, peanuts, alligator pears, cassava, quinine, cascara sagrada, cocaine, copal, balsam, anil, cochineal, alpaca, llama, guinea pig, turkey, etc., and where would we be today, without the Maya gift of rubber, not to mention tobacco?

To have developed from the natural seeds and plants, the fruits of the soil as enumerated above, is naturally the work of hundreds, nay thousands of years.

Further testimony to the great antiquity of the Maya race is evidenced by their remarkably accurate calendar.

It took us almost two thousand years to develop a calendar which would work with scientific accuracy. The ancient Mayas established their calendar over five thousand years ago, and it is so accurate that it differs from our own but a few minutes in a year. Even so, the Mayas were aware of that inaccuracy and took care of it every fifty-two years. And bear in mind that our present, or Gregorian calendar is not yet three hundred and fifty years old. As with our predecessors, so with the Mayas, they too experimented with previous calendars prior to discovering a successful chronological measure. With these thoughts in mind the centuries are easily rolled back. It is further important to learn that they were able to predict simple eclipses with extreme accuracy, due to carefully recorded observations of the sun, moon and stars over many centuries.

It is certain that they had observatories in which to study this intricate science, but apparently they lacked anything approaching the elaborate mechanical equipment and finely-ground lenses of today, yet they must have possessed some device to ensure accuracy. It is possible that they used a specially designed building, such as the so-called Caracol, and stone monuments scientifically positioned over an extended area, as basic points of measurement and computation. It is conceded that this method, although crude, is practical. Whatever the method, the observations of the Maya astronomers were remarkable. The extreme accuracy of their work elevates them scientifically above all of their contemporaries; in fact, it is highly probable that future discoveries will establish the early Mayas as among the greatest astronomers of all time.

Their calendar was more accurate than the Julian, and is possibly superior to our present Gregorian calendar which was put into effect in 1582.

The following quotation from Spinden's *Ancient Civilizations of Mexico* (pages 107-9) describes the extraordinarily accurate calculations of the Maya astronomers: "The revolution of the moon around the earth was used by the Mayas in what may be called the lunar calendar. It has already been explained that an early lunar period of thirty days seems to have been arbitrarily changed to a notational one of twenty days. Now the exact duration of a lunar revolution is 29 days, 12 hours, 44 minutes, 2.87 seconds. If the customary period of 29.5 days is taken for convenience there is an error of about two full days in five years. Such an error was too great to pass the

Maya calendar makers. On pages 51 to 58 of the Dresden Codex their solution is recorded unmistakably. A succession of 405 lunar revolutions, or nearly 33 years, is calculated by the addition of groups of five and six revolutions, — the former given as 148 days and the latter as either 177 or 178 days. This method of calculation may have been a device to carry fractions, or it may have been based upon ecliptic data. The steps of the calculations are put down in a sort of double entry, first by numbers; second by named days. The numbers add up to 11,958 while the total difference between the named days is 11,959. The purpose appears to have been to approximate 11,960. This last number of days contains the *tonalamatl* (cycle) an even number of times and would thus form a re-entering series since it would always begin with the same day. Now it is a remarkable fact that the total obtained by modern astronomers for 405 lunar revolutions is 11,959.888 days, or only 0.112 of a day less than 11,960. Therefore, the re-entering series of the Maya astronomers can be used nine times before an error amounting to one whole day has accumulated. In other words, the lunar calendar was brought into a fixed relation with the day count with an error of one day in 300 years."

Accuracy of Maya astronomers

According to Juan Martinez Hernandez, Sr., the Maya calendar began September 4, 3,113 B. C. of our Gregorian Calendar. As a table of time they used the following:

1 Kin	Equals	1	Day			
1 Uinal	Equals	20	Days	Equals	1	Month
1 Tun	Equals	360	Days	Equals	1	Year
1 Katun	Equals	7,200	Days	Equals	20	Years
1 Cycle	Equals	144,000	Days	Equals	400	Years

Authorities differ

One of the outstanding paradoxes in studying the Maya subject is the fact that no two experts agree. For example, opinions as to the date of the Maya origin range from within the Christian era to 9,500 B. C. Some writers go far beyond that date. Many students believe in an Asiatic origin, others favor a European. In general the arguments are unsubstantiated and some lack even logic. In many cases no valid evidence is offered to support the contention.

A few exceedingly informative but highly technical volumes have been written by learned Maya students. Some have been recognized as authoritative, others discredited. Unfortunately some critics condemn many of these works as a whole, without recognizing and giving credit for the obviously valuable original research work. In view of the present very meagre acceptable knowledge and the vast amount which remains to be learned in this field of thought, it is unwise to condemn hastily. For instance, Herbert Spinden in his *Study of Maya Art* refers to Le Plongeon's opinions on the Maya subject as "far fetched theories", and Lord Kingsborough's ideas he dismisses briefly as "in keeping with the speculative age in which he wrote." Yet both these men rendered at least some valuable service.

Opinions

In addition to the more technical works, numerous "popular" books and articles on the Maya subject have been published. But the authors apparently commercialized the subject without regard to accuracy, and are not to be considered. The following excerpts from various sources, including some early Spanish writers, will serve as examples of a few important prevailing opinions open to argument. [In each case the italics are mine].

One writer says: "Their (the Maya's) origin is largely a matter of conjecture. One account derives the race *from the East*. The more probable derivation, however, is *from the West,* as tradition, mythology, art and geographical conditions point in this direction more decidedly than in any other."

In *Tribes and Temples,* issued by Tulane University of Louisiana, Frans Blom says: "The theory of an Asiatic origin is probably nearest to the truth, but the tribes who migrated from Asia left that continent *at a very low stage of development.* They drifted slowly down the North American continent into Central America."

From Asia

Sylvanus G. Morley in *An Introduction to the Study of the Maya Hieroglyphs* says: "The ancient Maya emerged from *barbarism* probably during the first or second century of the Christian era."

Herbert Spinden, in his *Study of Maya Art,* makes it clear that the Maya civilization was "developed upon its own ground."

Regarding the obvious connection between certain so-called foreign art and the Maya architecture and decorative ornaments, Spinden dismisses the subject by saying: "The evidence

these writers present is always insufficient and usually wrong. When real similarities exist they probably can be explained by *pure chance,* or by *psychic unity.*"

Frans Blom in *Tribes and Temples* says: "Many things indicate that the Maya culture was indigenous to Central America Only this much can be stated—that when we first meet the Maya, i.e., when the monuments were executed *which carry the oldest dates,* they already had *a fully developed system of writing and were experts in handling numerals,* chiefly for the purpose of astronomical calculations." Later, we read: "We have already spoken of the Tuxtla statuette as having the *oldest date on record on the American Continent* (98 B. C.)."

Similarities due to pure chance!

In a paragraph previous to the above quotations the writer says: "In most archeological fields, one is able to follow the development of culture from a very primitive stage. The deeper one digs the more primitive are the objects found. This is called archeological stratification. . . . *But no such stratification has yet been found in the Maya country.*"

It is logical to expect that if, as the writer says, the Mayas migrated from Asia at a very low ebb, some evidence of that culture, or the root of it, would exist in Asia, or some evidence of their civilization would mark the route they travelled. To this date, however, there is not the slightest shred of testimony to prove either contention.

The writer states further that "many things indicate that *Maya culture was indigenous to Central America*" (Italics are mine) yet he admits that no evidence of their primitive art, and positively no testimony indicating progress from the primitive to the advanced stage of culture, has yet been discovered. Further, he admits that at the time the oldest dated object yet discovered, bearing the date 98 B. C., was inscribed, the race of Mayas "already had a fully developed system of writing and were experts in handling numerals."

Mayas indigenous to Central America!

Later, I hope to show that the Maya civilization in Central America arrived in that area fully developed, its origin and growth having taken place in some center other than the American continent.

J. Leslie Mitchell in his book *The Conquest of the Maya* (published by Jarrold's in England and recently in America) says: "The founding of the Maya old Empire was not the work of the ancestors of the present day Maya, either of the old triangle or of

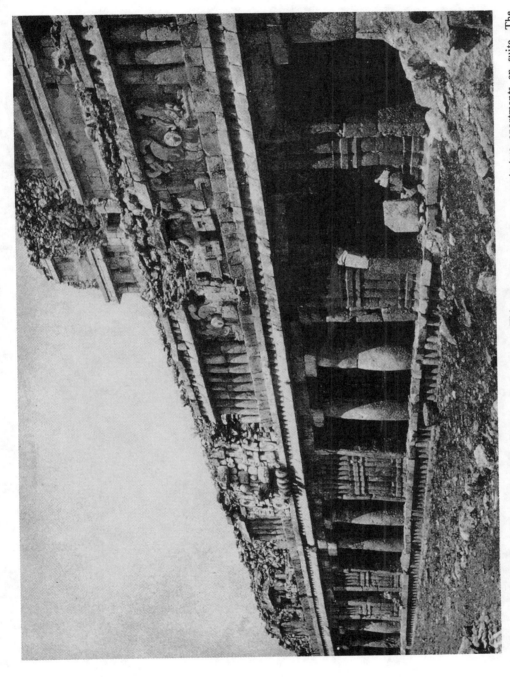

The "Palace," Zayi, Yucatan. Detail of a second story. This structure possesses seventy-two apartments en suite. The general plan—mass grouping, magnificently proportioned outline, and judicious use of ornamental detail—has resulted in an architectural masterpiece. As no evidence exists to support the claims of either American or eastern origin of Maya art, whence did it spring? (Photograph by the author)

Yucatan. It was an alien importation from that ferment of cultural activity which reared the palaces and temples of the Chams and Khmers in Cambodia which inspired the Buddhist Temple of Voro-Budor in Java and the Temple of Kalasan." Further he states that the old Empire architecture "was substantially founded on a few principal designs which arose in remote Mediterranean and Mesopotamian countries and passed across the world eastward, in ebbing circles of various speeds and reach."

He points out as conclusive support of the latter hypothesis the resemblance between the Maya Rain-God Chac and the Indian Indra-Ganesha, and between the Maya Monkey-God and the Hindu Hanuman.

A fearful civilization

He is convinced that the elephant motif, so frequently apparent in Maya art (in a country where the elephant certainly did not exist at the time of, or subsequent to, the arrival of the Mayas) is further argument in favor of Hindu origin.

He admits that the Maya civilization produced two wonders of history, its architecture and its highly complex calendar. The latter he describes as "one of the most remarkable mental instruments ever fashioned." Later he turns face about by minimizing Maya achievements. *"It was largely a civilization of fear,"* he says, "a fearful civilization, in many respects an aberrant civilization *its contribution to human history is negligible* it left to the common mind of man *not a single thought or aspiration of importance."*

He refers to the Maya religion as being as dreadful as the world has ever seen. He submits as evidence of the latter contention a description of tortures, flayings alive and human sacrifice which he declares were practised by the ancient Mayas. He says they were ferocious, sadistic and even cannibalistic. It is his opinion that the earth can seldom have seen such creatures of nightmare as the blood-matted *nacons,* or priests, whose ghoulish function it was to tear the heart from the living victim or to perform the ceremonial dance in the skin stripped from his body. "Their mental life is a thing as remote from modern concept as the mental life of the dinosaur."

Maya contribution to history negligible!

As we shall see later Mr. Mitchell is ignorant of, or entirely disbelieves, the evidence opposed to his contentions. His repulsive conception of "life in a city of the ancient Maya" arises from a misguided imagination.

Even a cursory study of Mr. Mitchell's statements regarding the social life of these people, shows that his condemnation is, to say the least, an error of judgment. Such debased people as he would have us believe the Mayas were, could scarcely have progressed to the cultural heights the evidence indicates. Further, it is important to remember that he produces no testimony to support his accusations.

Contradictions

Any astronomer will concede that the compilation of a calendar and its establishment are the result of an incalculable number of experiments, covering a period of at least many, many hundreds of years. The extreme accuracy of the Maya calendar alone, would indicate its origin at least thousands of years ago.

Similar comment applies to the establishment of a classic architecture and its allied arts. These two Maya sciences Mr. Mitchell, strangely enough, admits should be classified as *two wonders of history*. Referring to the Maya calendar he eulogizes the makers by stating it was "one of the most remarkable mental instruments ever fashioned — it was a remarkable farmer's calendar", yet, he tells us, they were licentious, drunken, human butchers, and smelled "stalely". What a contradiction! Almost identical comments are recorded in the work of another writer. This writer actually devotes a chapter in his book to the "drunken Mayas"; in fact he speaks disparagingly of them throughout the work.

Maya Abominations!

Can Mr. Mitchell, or any archeologist or historian, produce evidence to show that any other civilization was master of the two highest sciences known to man, and "barbarians" practising the lowest conceivable abominations, at one and the same time? Degeneracy of a once highly cultured race is a condition frequently substantiated in history, but the periods of culture and degeneracy are separated by a transitional period. We are not concerned with the degenerate period of the Maya civilization, which, as the evidence will show, is comparatively recent. Mr. Mitchell ostensibly is concerned with informing his readers of the civilization of the *ancient* Mayas. Obviously the later period of degeneracy, especially when it embraces the abominable practices set forth by Mr. Mitchell, is irrelevant. The Maya civilization is represented by its extraordinary structures, its colossal engineering feats, its advanced sciences. Evidence more or less of these phases of culture, is all that can be utilized in compiling a history of the Maya race. Dwelling on the abominations of a period after

their creative genius had subsided, is unjust. It is also untrue, since the abominations ascribed to the Mayas were introduced by the Aztecs and enforced by them after their subjugation of the Mayas.

Also untrue is Mr. Mitchell's remark in reference to the Maya religion, "as dreadful as the world has ever seen." The almost total absence of warriors and warfare in the sculpture and paintings of early Maya art in Central America is significant of their peace-loving disposition. As a writer in *Living Races of Mankind* says, the Mayas were "a people of delicate, almost feminine physiognomy and of equally gentle disposition." All accounts refer to them as a peaceful people. The evidence shows that the basis and practice of their religion was sublime. They believed in one god, and in the immortality of the soul; and it was not a mutilated man, but flowers and fruit that they placed on their altars. *They did not practise human sacrifice.*

Maya Idols!

The gentleness, love of beauty, artistic accomplishments and creative genius of the ancient Mayas, bespeak an abhorrence of degrading practices and brutality, and from the extraordinarily numerous extant examples of their works it is obvious that the Mayas have been greatly maligned by such writers as Mr. Mitchell.

Dr. Gann, in his *Maya Cities,* shows a photograph of what he terms an "idol". The reader searching for information, naturally assumes that the Mayas were, in the literal sense, idol worshippers. It is possible that Dr. Gann, for whose deep knowledge I have much respect, did not intend to create that impression, nevertheless, I have read many similar remarks in the works of others who obviously borrowed the expression.

An idol is an image or object of worship. The Mayas, however, worshipped the one god, Hunab-Ku, and believed in one creator of all things. I believe the stone figure that Dr. Gann refers to as an idol is one of the many standard-bearers frequently seen in the Central American area.

Maya Barbarians!

Another writer says: "It appears that there are few ties of language with the Aztecs or other Mexican peoples though there are numerous and striking analogies in art and customs, *and it is not improbable that in the course of their history the Mayas have come into close contact with the great tribes of the Plateau of Mexico . . .* they were still, properly speaking, *barbarians,* but in several *respects seemed to be on the very threshold of civilization."*

The foregoing clearly indicates little more than poor guesses on the part of many present-day writers.

The belief of a number of scientists is that the Mayas — and some add the Mexicans and Peruvians, — were without metal tools. This belief is without foundation. I offer one or two excerpts expressing the above opinion and follow with evidence to the contrary.

Metal tools

Lewis Spence says: "The ancient Maya, Mexicans, and Peruvians were without metal tools."

Herbert J. Spinden in *A Study of Maya Art* says: "The stones used in the temples and monuments *were cut and carved with stone implements.* The Maya might have accomplished greater wonders if they had had . . . iron or bronze chisels instead of stone knives."

According to the evidence, the remarks of these authorities are not quite accurate. As a practising architect of wide experience, I have had an intensive theoretical and practical training in architecture and the allied arts, and after a very careful examination of scores of Maya structures in all the principal known cities in Yucatan, it is my opinion that metal tools were used extensively in the execution of the work. In support of my belief, I quote as follows from an article by T. Athol Joyce, M.A., *South American Marvels in Masonry*: "It is true that the Peruvians possessed tools of copper, which, owing to accidental admixtures of tin, were, in some cases, bronze."

Proof

T. A. Willard, who was more than casually interested in the contents of the immense cenote in Chichen-Itza, Yucatan, records in his book, *The City of the Sacred Well,* a list of items of inestimable value raised from the bottom of the one hundred and forty-foot well, including several hardened copper tools. Speaking of the salvage operations, he says: "Specimens of well modeled *hard copper chisels* were recovered at various times. Some are small, others of the customary size and shape of modern chisels, *but with the heads burred, showing much use.*"

Landa notes tools

Archbishop Landa says: "They had some certain kind of white brass with a little mixture of gold from which they made . . . a small chisel with which they made their idols."

It must be remembered that the Mayas of Landa's time represented the decadent members of the race. For hundreds of years prior to the arrival of the Spanish invaders, no

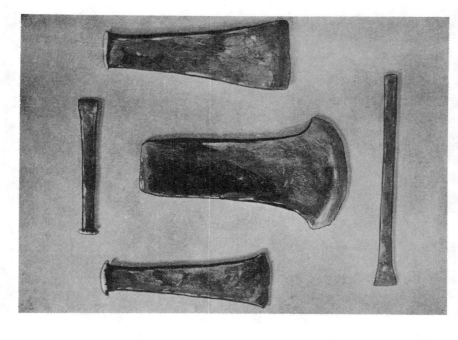

It is generally believed that the Mayas lacked metal tools. The examples in the above photograph are made of hardened copper and were recovered from the Sacred Well at Chichen-Itza, Yucatan. The Spaniards sent shiploads of similar tools to Spain, believing them to contain gold.

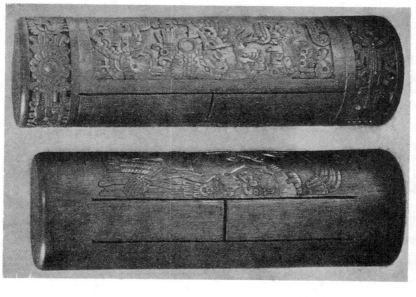

The marks of metal tools show in the exquisite and intricate wood carvings executed by the Mayas. Numerous examples exist such as those found on beams and drums. Reproductions of ancient Maya books show artisans working with many types of metal tools.

structure of note had been erected. The Maya race as a cultured civilization had ceased to function. As there are no metal ores available in the Maya area, they were forced to trade with those who possessed them. With the decline of their cultural activity, commerce likewise diminished. This is one reason why Landa saw little of metal tools.

Another reason is that, prior to Landa's arrival, at least one shipload of metal axes—according to an early report—was stolen from the Mayas and sent to Spain in the belief that they contained gold. That they actually contained a small portion of gold is true, but the brightness of the metal tools deceived the Spaniards as to the amount.

Analysis of Maya metal tools

In an early account of Columbus' first contact with the Mayas, the reputed first white man to discover them, we learn of an interesting incident. Coming toward the shore, Columbus "beheld a great canoe or boat arriving as if from some distant and important voyage. He was amazed at its size and contents." Later the report states: "There were hatchets for cutting wood, *not formed of stone but made of copper.*"

Willard says: "An analysis of a sample of metal from the Maya area was found to show gold, tin and some silicious substance, evidently used to harden it, along with the copper which was the basic metal."

Those who possess a knowledge of the practical arts and who have examined the abundant works of art in the Maya area will conclude that it was impossible to have executed some of the highly refined, even delicate carving, with such clumsy media as stone, nephrite or obsidian tools.

An examination of the superb carvings in hard sapote wood, and the exquisite artistry displayed in the sculptured stelae, leave no doubt as to the extensive use by the Mayas of metal tools of varying sizes.

Defaming Master Minds

It is also inequitable to accuse even the present day Maya of drunkenness. Only a thoughtless person or one ignorant of these people could do so. When applied to the living descendants, this stigma is vilifying. They are not degenerates, neither are they drunkards nor barbarians.

When I read these defamatory remarks which appear from time to time, I am more and more convinced that part of the equipment of an archeologist should include, first, a thorough

knowledge of general history, ancient and modern, and the history and science of architecture; second, a comprehensive grasp of language roots, and third, a broad understanding of ancient religions, philosophy, mythology, legends and metaphysics. An archeologist should also be well versed in all subjects concerning the social activities of the human race. I admit that to acquire this knowledge is no mean undertaking, but when one considers the meager material and the baffling clues which confront a student of ancient cultures—especially the lesser known civilizations—all this equipment seems to be essential.

Rule of Warfare

There are no true living descendants of the great Maya leaders—their architects, priests, historians or astronomers. Consequently it must be clearly borne in mind that the Maya savants who conceived these magnificent works which Time has consecrated for all future generations, have disappeared forever. Culturally they are a vanished race and therefore there is no possibility of their revival.

The rule of warfare (and that rule persisted between the Mayas and their enemies) has always been that the leaders of the vanquished must be put to death. Naturally, there is always danger of revolt if the ruling classes are spared. The highly trained and skilled workers and the plebeians survive, for obvious reasons. The mechanic's skill and ability can be utilized by the conquerors; the plebeians can serve as common laborers, for the general drudgery of life.

The descendants of these two classes, the mechanics and the plebeians, are what we find in the Maya area today. It is therefore difficult to establish a positive characterization of the classic Mayas by a study of these middle-class descendants. Nevertheless, they retain such admirable qualities as to be tangible evidence that the classic Mayas were an extremely cultured race. Only a distinguished background would make it inevitable that such commendable traits would persist through the years and descend to the present generation.

A maligned race

To those who have contacted and become acquainted with these people of today, such appellations as drunkards, barbarians and so forth, are merely ridiculous. The facts are entirely to the contrary. Free of extraneous influence they are honest, truthful, clean-living, home-loving and happy people. Personally, I esteem it a privilege to call any one of them my friend. I speak from experience,

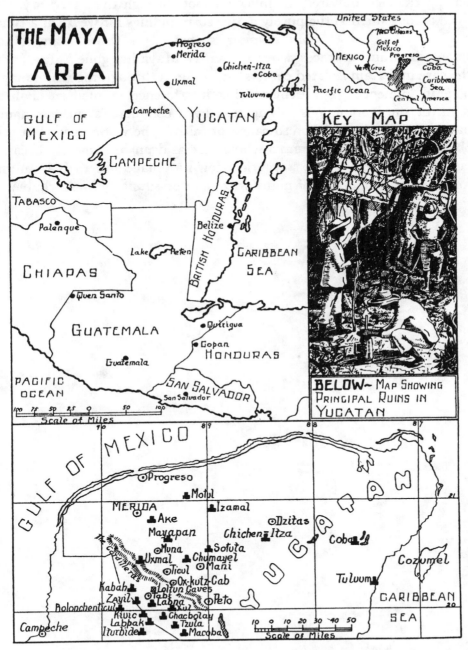

THE MAYA AREA

KEY MAP

BELOW— MAP SHOWING PRINCIPAL RUINS IN YUCATAN

One early Maya account states that at least 150 cities were erected in the Yucatan area alone. What untold esoteric and intrinsic wealth lies beneath this vast, almost impenetrable jungle! Is the key to all history secreted in this, one of the last archeological frontiers?

having traveled hundreds of miles on foot through their territory and lived among them in the purely native surroundings for weeks at a time.

My opinion is that, as with so many other remnants of ancient races, when the native Maya has gone astray (as is the case in certain isolated centers) it has been through the white man's baneful influence. The demoralizing interference of modern civilizations, or the ignominious subjugation by a conqueror's ruthless hand, has stamped its mark upon so-called primitives the world over. But it is obviously unfair to condemn a whole race as drunkards merely because one of its subjects is seen staggering down a village street. It is an unfortunate characteristic of many writers to be similarly uncharitable.

Chapter Two

Conjectures and Opinions

NNUMERABLE volumes have been written concerning the probable birthplace of man and the origin of his culture. The quasi-scientific investigator has appeared to regard opposing opinion as a personal affront to his intelligence. Some otherwise reputable scientific proponents have resorted to disparaging personalities. The genuine scientist, however, regards intolerance askance. For so little is known that all must be greeted with tolerance if we would make progress.

Man's birthplace

Nature's secrets are never disclosed in their entirety; the barest scraps of evidence are often discovered without even meager sequence. Upon almost insignificant clues the patient scientist begins to weave an admittedly somewhat fanciful structure. Later discoveries tend either to substantiate his original theory, modify it, or cause him to construct a new one. The advent of additional investigators into any field of research increases the possibility of further knowledge; the broader expanse of thought, the employment of scientific knowledge and open-minded discussion, disclose the strong and weak points to the sincere research worker. After gathering minute particles of evidence and correlating them, his hypothesis may develop until a comprehensive and acceptable theory is built up. In such a manner does science progress.

When I first undertook the task of seeking the origin of Maya culture I sought the works of leading authorities. But as so frequently is the case I found in this instance a maze of contradictory opinions. A preliminary consideration of the various theories left me highly confused. But a more careful study indicated that the evidence available has been interpreted from vastly different viewpoints; varying in accordance with the specialized subject training and experience of each theorist. The specialist in any particular field of research may contribute to general knowledge, but if in specializing he *Misinterpreted* has, metaphorically speaking, rendered himself 'color-blind' to im-*evidence* portant evidence in lines of study foreign to him, his contribution is not only valueless, it is confounding. To make myself still further clear, let me quote an analogy. The student of psychology finds, let us say, three individuals recording their versions of a happening witnessed by all three, at the same time and under exactly the same circumstances. Consider an automobile accident for example; the machine in question is really of a dark green color. Witness A swears it was blue; witness B, that it was green; and witness C, that it was dark red. In the same manner, opinions vary in the field of scientific research.

In view of the above it can readily be seen why, in seeking a trail which would lead to my objective, I found many conflicting opinions as to the course I should pursue. Each offered ample "proof" of its correctness. In the face of so much assurance, surely nothing remained to be discovered. But was the path indeed so clear? Was the story complete beyond all argument? Uncertainty bred doubt, urged a personal survey of all the channels of available information. Some were narrow and dark, leading nowhere in particular. Others proved to wander away from my objective; but at last I came upon one which was wide and well lighted. This I followed to the end.

Many centers My first investigations taught me that many *to consider* parts of the known earth-surface—and more of the unknown—were claimed as the cradle of mankind, the birthplace of culture, the center from which all races sprang; the original site of the Tower of Babel, the one and only Garden of Eden, the land of Adam—and the area in which the ancient Maya civilization originated.

I felt that the Maya race could have had only one center for nativity. But there were many centers to be considered. The Gobi Desert, various parts of Asia and Europe, the lost continents of Gondwanaland, Mu, Lemuria, and Atlantis were all apparently ideal

locations. Naturally, they cannot all be right, but many of the hypotheses are ingeniously argued and who shall say which is right and which is wrong? Personally I lend a more appreciative ear to a builder than to a critic. Whether I agree with his opinion or not, at least he is constructive.

Knowledge gained through many years of architectural training and practice, early led me to believe that the Maya art in Central America and Yucatan was *brought* there, and brought there hurriedly, from some center foreign to the Americas. I was further convinced that the Mayas colonized that area, not when their civilization was developing, not even at the height of its intellectual expression, but during a period of cultural decline.

Maya art foreign to the Americas

Yet I was unable to discover any civilization, flourishing immediately prior to the arrival of the Mayas in Yucatan, from which they could have sprung or have even borrowed their culture. Similarities of architectural detail suggested association with or influence of arts known in both the Old World and the New, but none to warrant further consideration of direct relationship.

On the other hand, I discerned obvious instances of *indirect* contact of the Mayas with early peoples of both hemispheres: Basques, Egyptians, Persians, Assyrians, Pre-Incas, early Panamanians, and lesser early races in America of undoubted common origin.

At this stage of my investigations, I took to serious study of the lost continents that have been conjectured in the hope that one of them might qualify as the probable birthplace of such a mother culture. For the next twelve years I diligently read scores of tomes, ancient and modern, covering every viewpoint of the subject, including geology, anthropology, ethnology, ontology, ancient theology, prehistoric races, mythology and a host of other 'ologies. And I found that it was difficult not to believe that man's beginning occurred earlier than a few thousand years ago, or to imagine that many thousands of years ago a civilization and a culture might have existed which were equal if not superior to our own. Yet the many books that I consulted showed that man's fundamental thoughts and problems of living have changed very little since the earliest recorded times. The deeper one goes into the remote past, the more evident it becomes that in his loves, hates, wars, social and political economics, customs, even his arts and amusements, prehistoric man had experiences and problems remark-

Comprehensive study

ably similar to those of our day. It is becoming more certain with every year of research that because of the ponderously slow-moving laws of evolution, the dawn of intelligence in the human race dates back hundreds of thousands of years.

Man, as far as we know, has existed in cycles grading from minor to major proportions. A succession of minor cycles form what might be termed a major or grand cycle. Any cycle, minor or major, is constituted by the birth, existence and death of a civilization. By the rise of a grand cycle is meant the birth and existence of dominant characteristics, springing from a single source and spreading through prevailing civilizations, fundamentally influencing a succession of world cultures. Its death knell sounds the birth warning of a new grand cycle. The end of a cycle or grand cycle need not indicate the obliteration of the race or races involved. Rather, it means that the creative forces, mental, physical and spiritual, have become worn out, tired—old. Dominant races become dormant—imitative but not creative—like the present-day Chinese; or dead (as far as prospects of future creative regeneration are concerned) like the present-day Egyptians, Greeks and Mayas.

Cycles of Civilization

Civilizations or cycles of civilizations which have ceased to progress may nevertheless live on, later to be absorbed by the new-born world influence, or dwindle to racially primitive insignificance.

It is my belief that from what I term a grand-cycle root (or the beginning of a basic or mother culture out of which other cultures sprang) the so-called Maya civilization originated, or was a part. In other words, I believe that between 25,000 and 50,000 years ago a grand cycle of civilization was running its course. Approximately 25,000 years ago, that grand cycle ended and another commenced. It is possible that the African Negro and the Bushman of Australia are remnants of that last grand cycle. The beginning of the present grand cycle apparently took place in an unknown area of the earth's surface. The culture originated and developed there and has, to my belief, influenced most of the known principal prehistoric and historic races.

The present exposed land surface of the world, to my mind, offers no definite area which could be pointed out as the center in which such a root culture germinated. Therefore it is natural to give consideration to the legendary existence of erstwhile inhabited continents now lying beneath the waters of the earth.

Many writers will not admit the possibility that a land having the dimensions of a continent could sink beneath the waters. Others, not definitely disputing the contention, cannot understand why such a catastrophe has not been clearly recorded. For instance, William H. Babcock in *Legendary Islands of the Atlantic,* referring to the theory of Lost Atlantis, says: "Moreover the sudden submergence of so vast a region as the imagined Atlantis would be an event without parallel in human annals, besides being pretty certain to leave marks on the rest of the world which would be recognized even now."

Let us review some of the principal theories concerning submerged continents and search for such recognizable marks.

Possibility of continents sinking

In a recently published article we learn that "the John Murray Expedition, of England, has reported the discovery of three enormous mountain ranges, one of them over 9,000 feet high,

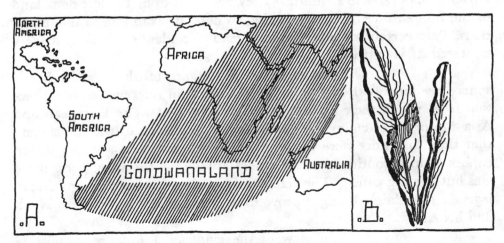

A. Sketch map showing (shaded portion) what geologists believe to be an erstwhile continent called Gondwanaland. B. Fossil of the Glossopteris plant, a long-extinct weed, which is found imprinted in Permian rock layers in South America, Africa, and the Indian Peninsula.

The Lost Continent of Gondwanaland

lying at the bottom of the Arabian Sea. Two hundred million years ago these mountains lifted their heads proudly in the air, bearing the clouds as majestically as the Alps and Himalayas do today. Then some great catastrophe overwhelmed and sank them . . . no one knows what caused this catastrophe or in what manner it came about. Thus scientists have located the outlines of at least a part of the great missing continent of Gondwanaland."

Continuing, the article states that this once existing continent was deduced through the discovery of imprints of a peculiar fern-like plant differing from any plant now in existence, and known as *Glossopteris*. Similar imprints were discovered in rock layers in India, Africa, Australia and South America. The rock layer referred to is known as *Permian* and was formed approximately two million years ago. It is argued that birds could not have carried the seeds because there were no birds at that time.

First scrap of evidence

Here we have the first bare scrap of evidence in support of a belief among European scientists (many American scientists do not hold to this theory) that in the great southern seas a vast continent once existed.

Many see the possibility that what some believe to be the lost continent of Lemuria was either a part or the whole of what geologists term Gondwanaland. Numerous traditions among African races refer to Lemuria. They believe it to be the lost homeland of the human race. It is interesting to note, in examining these traditions, that certain details of the legend are identical among widely scattered African tribes.

Among the inhabitants of the eastern hemisphere, we meet with two opposite statements in reference to the direction from which their earliest ancestors migrated. The European and Asia Minor races claim a *western* origin. But African traditions state that their ancestors were emigrants of a superior race arriving in big canoes from a continent to the *east*. Usually, as the story goes, there was but one big canoe. The reference to a single canoe among African legends, it is claimed, might prove to be the origin of the story of Noah and his Ark.

An African tradition

In view of the evidence I propose submitting later, it is well to remark here that the natives of Easter Isle, situated in the Pacific Ocean 2,000 miles west of Chile, state definitely that their ancestors did not come from Lemuria, but that they *are* Lemurians living on the peak of a Lemurian holy mountain, the only portion of Lemuria remaining above water.

Another theory of a once inhabited continent now lying beneath the waters pertains to a land known as Mu. In recent years James Churchward propounded a theory concerning such a lost continent, and his works have created much speculation and considerable controversy. I have no wish to discredit the works of this author;

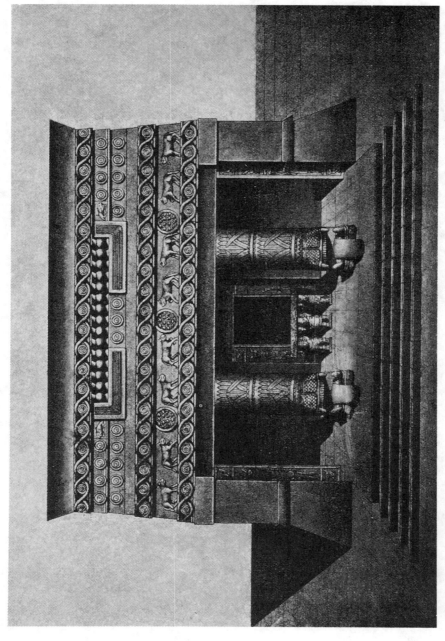

LePlongeon's theoretical restoration of the Temple of the Tigers, Chichen-Itza, Yucatan. Compare this with the actual restoration shown on page 28.

but his argument for that continent as the birthplace of Mayan culture is in my opinion not tenable. The lost continent alluded to by Churchward as Mu is assumed to lie now beneath the waters of the Pacific Ocean. (This must not be confused with Le Plongeon's Mu, which refers to a submerged continent in the Atlantic Ocean, referred to by others as Atlantis).

Churchward states that the "emigrant children of the continent of Mu [in the Pacific Ocean] were called Mayas." He further states that one of their many migrations followed a line "from Mu to Yucatan and Central America." From that point the emigrants went to Atlantis in the Atlantic Ocean and thence to the shores of the Mediterranean and Asia Minor. They continued on "through the Dardanelles to the southeast corner of the Black Sea."

The Lost Continent of Mu

In another place this author says that these "Mu" colonists, or Mayas, first colonized Atlantis on what he terms the "Eastern line" of migration. It is his belief, although he is not sure, that the Eastern and Western lines probably started at the same time, and that the eastern migration of colonists arrived in Egypt about 16,000 years ago. Apparently he accepts Plato's story which, for all argumentative purposes, definitely establishes the date of the sinking of Atlantis as 9,500 B. C. He gives no reason for the wide discrepancy.

Churchward expresses his belief that the various pigmentations of races originated in the lost (Pacific) continent of Mu. He claims that white, black, red, brown, and yellow races lived together on that immense island and that when it sank, each distinct color unit sought a particular spot on the earth in which to live. How the color separation occurred is not quite clear. In my opinion, such a theory is scientifically unsound and should have been left unexpressed. According to Churchward, social rank on the continent of Mu must have been sharply defined, a person's status being determined by pigmentation rather than by worldly possessions.

Skin color origin

For many thousands of years these groups of definitely colored tribes apparently suffered in silence the ignominy of rubbing shoulders with one another. The catastrophe which, he declares, sank their spacious continent, gave them excuse and opportunity to seek the furthermost parts of the earth. Their long-hoped-for desire was at last fulfilled, and it was then that they realized that politeness had gotten the better of them for some considerable time.

According to Plato's account of Atlantis, that continent was a veritable land of promise. Churchward raises no objection to this description of Atlantis which discloses that it was far more inviting than Europe and Asia Minor in climate, productivity and wealth. But we learn from him that his Children of Mu, after fleeing from their sinking homeland, travelled to the furthermost parts of the earth. Was the great American continent not large enough or sufficiently productive to take care of them, even if they had decided to remain no longer on speaking terms? And what was wrong with Atlantis that they should leave it? And why did some decide that Yucatan was among the choice spots on the American continent? Yucatan is most uninviting, a mere level ledge of rock, with little soil, no rivers, and no beauty of scenery.

Questions unanswered

The brilliant Haeckel, as well as many modern and ancient scientists, sought diligently to find the birthplace of the human race. To this day scientific expeditions, sustained at enormous expense, spend years in search of the cradle of man. The discovery of a Neanderthal skull, Cro-Magnon remains, or a Pitcairn cranium, immediately starts an avalanche of conjectures, each purporting the discovery of the Garden of Eden, birthplace of man, or the spot where conscious thought first sought expression. Churchward says very definitely: "There was once a large continent of land in the Pacific Ocean called the Land of Mu. On this great continent man made his advent on earth about two hundred thousand years ago."

Scholars of all ages have turned their attention to the study of anthropology. They have sought the causes and laws of ontological phenomena. They have investigated the first principles of nature and thought. The ancient metaphysicians so far excelled modern thinkers in philosophical research that no further advance or even equal enlightenment has appeared since their time. The profound truths expressed by the very early sages have remained unchallenged and unsurpassed to this day.

Man's origin in Mu!

In this twentieth century, more and more of the world's most brilliant minds are diligently exerting themselves to acquire even a modicum of the knowledge possessed by the early masters. Surprisingly, we learn in the works of the earliest known philosophers that they regretted their inability to equal the knowledge of still earlier thinkers, men who, they state, lived thousands and thousands of years prior to their time.

Therefore, with little more knowledge of the remote past than was apparently known to the earliest masters, progress in philosophy, metaphysics, and the abstract sciences may be said to be of long duration. The fact that none of the ancient philosophers definitely assigned a center for man's creation, (unless we are willing to consider the Brahmin, Egyptian or other early symbolic hypotheses), the additional disadvantage of the lapse of time since their period of existence—which obviously offered better opportunities for learning the truth—suggest that the present-day effort to locate the area of man's beginning is more than ever a hopeless task. To determine definitely such a center, or to assign even an approximate date to that even, is mere thoughtless speculation. So many complicated conditions arise in the path of the investigator, so many geological, climatic, and physiological changes since the very remote period of man's birth, that thousands upon thousands of years must have been necessary to develop man. After the origin of tribes and races, endless migrations, minglings and divisions took place, with environment playing an important part in each; so that to seek the spot where man first came into being might be termed the most elusive, most nearly insoluble problem known to the scientific world.

Man's birthplace a thoughtless speculation

Similar argument might apply to the origin of race coloring; wherefore I am constrained to remark that although we are not definitely concerned with Churchward's opinion regarding the birthplace of man and the origin of racial coloring, we are concerned with his statement that the lost continent of Mu was positively the birthplace of the Maya civilization. This, in my opinion, can easily be refuted by the evidence I propose submitting later. I cannot accept his arguments as they lack corroboration, are illogical and unconvincing. The reader, acquainted with the works of Churchward, may at this time entertain opposite opinions, in which event I ask that judgment be reserved until consideration has been given to all data herein set forth.

The Lost Continent of Lemuria

Scientists apparently agree that the Pacific Ocean, during the latter part of the Mesozoic era, covered the area now comprising the Andes, the present Rocky mountains, New Zealand, Melanesia, Papuasia, the Philippines, and Japan. It is further believed by some scientists that a continent existed in the Pacific. At the end of the Mesozoic era, this continent, known as Lemuria or Mu, began to

sink and the west coast of America began to rise. The numerous Pacific island groups form the last remnants of that once large continent.

One of the striking proofs of these beliefs is the evidence offered by coral formations. Scientists state that the minute organisms which form coral cannot live at a depth greater than 150 feet below the surface of the ocean. Professors Sollas and David, however, bored to a depth of 1,114 feet on the Funafuti atoll and the cores showed that the whole mass of rock was pure coral. This is conclusive proof that the land beneath sank slowly and continuously.

The evidence of coral

Professor Baur is of the opinion that the continent of Lemuria went beneath the waters at some time during the late Oligocene epoch, or the beginning of the Miocene epoch of the Tertiary era. As there is no evidence that man existed until the next epoch, namely the Pliocene, it would appear conclusive that a civilization could not have thrived on the continent proper. It would seem, therefore, that instead of an inhabitated continent, the theory of an empire which, at a later date, ruled over a large number of island groups, widely scattered, is more within reason.

An investigation of the ocean bed between Acapulco, in the State of Guerrero in Mexico, and the Galapagos Islands disclosed a condition not strictly oceanic. At each station investigated the trawl brought up sticky mud, logs of wood, branches, twigs and decayed vegetable matter.

A passage from *The Riddle of the Pacific* by Professor J. MacMillan Brown of Christchurch, New Zealand, is extremely significant. It reads: "Whether we assume a continental area in the central region of the Pacific or not, there must have been enormously more land than there is now, if not some land connection between the Hawaiian Archipelago and the southwest of Polynesia; for the American scientists, working from the former, find a close affinity between its flora and fauna and those of the latter, *while there is no evidence of connection with the American continent.*" (Italics are mine). Further, he says: "In the Pacific Ocean, at least, wherever there is a coral island there has been subsidence, even if followed by elevation."

As Professor Brown is an authority of undeniable repute, we can lean to a great extent upon his judgment.

The mariners who plied the great Pacific wastes in the seventeenth century chronicled many allusions to lands of

considerable area now no longer visible. During the last century many well authenticated instances of the complete submergence of islands of the Pacific have been recorded.

The strange cyclopean monuments on Easter Isle and other island groups, widely scattered, point, at first glance, to the possibility of a once mighty empire on a Pacific continent, of which these far-flung archipelagoes are the remnants. Geology, however, does not sustain the possibility; neither does tradition. The legends of Easter Isle declare that that center was once the hub of a large scattered archipelago. Because of the submergence of the island of Marae Ronga, so a legend goes, the culture-hero Hoto Matua was forced to land on Easter Isle to the east. According to the story, "the sea came up and drowned all the people." Other neighboring islands are also referred to in the traditions of Easter Isle. Professor Brown says that the monuments of that island "could not have been erected by an insular people but must have taxed the capacity of a contiguous archipelagic empire, maintaining thousands of people of the Polynesian stock."

The mystery of Easter Isle

On the little coral island of Oleai, one thousand miles to the west of Ponape in the Caroline archipelago, Professor Brown found a form of script writing which, though unlike any other in the world, is still in use. Further, he says that on the east coast of the island of Yap, in the same group, there is a village named Gatsepar. The chief of that settlement still levies tribute annually on islands hundreds of miles away. When Professor Brown asked the natives why they still contributed to the chief of Gatsepar, they replied that if they failed to do so he "would shake their island with earthquakes and the sea with his tempests."

This custom would indicate, as Professor Brown points out, that at one time all the islands surrounding Yap formed an empire with one island as the governmental center. The members forming this federation of states looked to such a center as the seat of the all powerful rulers, natural and supernatural.

A Pacific Islands Empire

We learn, therefore, that in all probability a vast continent once existed in the Pacific Ocean. That it was occupied by an advanced civilization or even a very primitive race is not quite probable; in fact, as geology tells us, it is highly improbable, because the continent sank beneath the ocean long prior to man's advent on earth.

It is interesting to learn of a form of writing among the aborigines of the Pacific Islanders unlike any other on earth, but in the absence of further information on the subject, comment is valueless. The custom of paying tribute is in keeping with the theory of the Pacific islands empire, but no evidence has yet been produced to show that the occupants were a root race, nor is there reason for the assertion that they were the progenitors of the ancient Mayas of Yucatan or Central America. It is admitted that the civilizations of the Pacific Islands contributed their arts and customs to the early people of the western shores of the American continent in a minor degree, but this influence in no manner penetrated into the root culture of the Mayas, nor did they materially affect any of the ancient American peoples.

Le Plongeon's Mu

Dr. Augustus Le Plongeon also believed in a submerged continent called Mu, but instead of it once having occupied a position in the Pacific Ocean, as Churchward assures us was the case, the site Le Plongeon selects is the Atlantic Ocean. Some students believe that Mu is the same as Lemuria, a center which many regard as the birthplace of the primitive ape-man. Others incline to the belief that Lemuria once formed part of the lost continent of Gondwanaland.

According to Le Plongeon, Atlantis and Mu are the same. He says: "The 'land of Mu' is that large island probably called 'Atlantis' by Plato." In his opinion the present Maya area once extended eastward, and included the present Antilles and now submerged lands in the Caribbean Sea area and northward, including the present Alacranes reefs and the intervening submerged lands. He declares that he made his great discovery through translating the contents of the Troano manuscripts. We read that he "discovered that several pages at the beginning of the second part are dedicated to the recital of the awful phenomena that took place during the cataclysm that caused the submersion of *ten* countries, among which was the 'Land of Mu'."

Le Plongeon's discovery

His discoveries led him to express the very definite assertion that the Maya ruins in Yucatan and Central America are all that remain of the original Maya culture, and that they are the original structures, erected many thousands of years before Christ.

In other words he believes that the great Maya empire was founded on the western end of the land bridge which once connected Europe with the Americas, part of which still remains.

There is no question but that Le Plongeon was a great student of ancient lore. He was particularly gifted and of con-

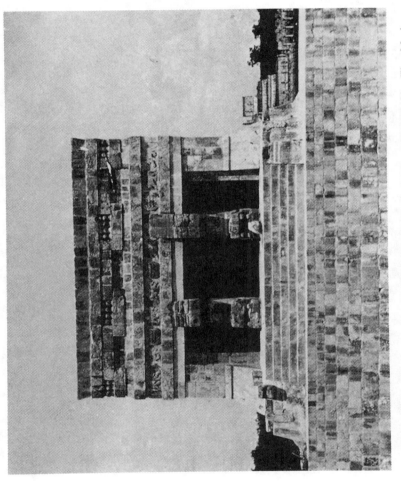

THE TEMPLE OF THE TIGERS, CHICHEN-ITZA, YUCATAN. The Mexican Government has recently completed actual restoration of this building, although a few details are lacking, such as the roof-crest tiling and feathered tasseling to the three medallions, one over each opening. But a careful examination of LePlongeon's drawing will disclose numerous discrepancies when compared with the present completed work. As an instance, what he erroneously terms the twisted rope and circle ornament at the top of the entablature (which he further misinterprets as meaning the "very valiant warrior") is actually the entwined serpent motif, the heads being plainly visible at each corner. Such exaggerated interpretations of ornament and alteration of Maya words and substitution of letters to suit his fancy nullify most of his fanciful deductions.

siderable learning in the Maya field, but his frequent disregard of the obvious facts in drawing his conclusions led him into many serious discrepancies. In numerous instances one is favorably influenced by his preparatory argument, only to recognize later the weakness of his deductions due to the inconsistency of his analytical procedure. For instance, he selects a word or a sentence bearing unmistakable Maya linguistic characteristics. To prove its Maya root he seldom hesitates to change the original construction to meet the translation desired, although in all languages even minor changes in but one word may alter the entire meaning of a sentence. His habit of not sticking to the facts applies not alone to language. In his definition of the reconstruction of the "Temple of the Tigers" in Chichen-Itza, Yucatan, as illustrated in his book, *Queen Moo*, numerous mistakes are evident. There can be no doubt as to the errors in view of the testimony offered by the fallen stones, comprised in the original design, all of which have been discovered lying at the foot of the structure. They were recently replaced by the archeological department of the Mexican Government under expert guidance.

Disregarding facts

However, Le Plongeon's interpretation of the details forming the facade is the ground upon which he based a fabulous account concerning a Prince Coh, the brother-husband of Queen Moo. He calls the building the Memorial Hall. The details exhibited in the completed structure, as I have said, differ considerably from those assumed by Le Plongeon, yet he submits in no uncertain terms "the true" definition of their meaning. To emphasize the extreme error of his ways and the degree of importance one must attach to what he claims as historical facts, I quote his own words "proving" the accuracy of his translation. Referring to the exterior decorations of the above-mentioned structure, he says: "From them we shall learn by whom, to whom, and for what purpose it was erected. Properly speaking there is not a single inscription, not a single letter or character, on any part of the building; and yet the architect who conceived the plan, and had it executed, so cleverly arranged the ornaments that they form the dedication. We must, of course, read it in the Maya language."

Le Plongeon's fabulous interpretation

After a lengthy detailed explanation he decides that the translation reads: "Cay, the highpriest, desires to bear witness that Moo has made this offering, earnestly invoking Coh, the warrior of warriors."

His carefully detailed analysis and conclusions, therefore, *are founded upon conditions in the facade design which never existed.* A further glaring error is seen in his ignorance of the true form of the two portico columns. (See examples, pages 23 and 28). He apparently was unaware of the "rattle" motif capitals, and the fact that the column designs are not Maya but Toltec. What he terms the "twisted rope" ornament is definitely the serpent motif; both the serpent head and tail are positively in evidence on all corners of the now restored building. Despite this error, obviously an unconscious one, he attempts to define its meaning. He says: "One of the names for rope, in Maya, is 'kaan'. There are two words for circle, 'hol' and 'uol'. Taking 'hol' to be the first syllable of a dissyllable suggested by the two distinct objects that compose the ornament, and 'kaan' to be the second, we have, *by changing the 'K' to 'C'*, the word 'holcan', which means a 'warrior'." (Italics are mine). In such manner does he distort facts and misconstrue the art motifs in an effort to create meanings to suit his fancy.

Glaring errors

It is to be regretted that Le Plongeon permitted himself to deviate unnecessarily from the evidence which came into his hands. However, his mistakes are easily forgiven in view of the much greater scarcity of available data in his day; but there is no excuse for his irrational assertions submitted as "facts" which surely, even to him, were without foundation.

His obviously limited knowledge of architecture, engineering, and construction principles is sufficient to explain his unsupported opinions regarding the extreme age of the Maya structures assigned by him.

Notwithstanding the severity of the above criticisms, and despite the irascibility of temper he frequently displayed toward what he terms the ignorant so-called archeologist, I feel that beneath his cloak of belligerence and complaint was a lovable character. At least, I want so to believe. It is, therefore, with some regret that I feel bound to dismiss further consideration of his theory on the Maya origin. His unsound arguments leave no alternative.

*Mayas of
Asiatic origin!*

J. Eric Thompson, of the Field Museum, has no such ideas as to the origin of the Maya civilization. He suggests that possibly a very primitive people first trod American soil approximately "fifteen thousand years ago." Continuing he says: "In all likelihood there existed then a land bridge connecting northern Asia

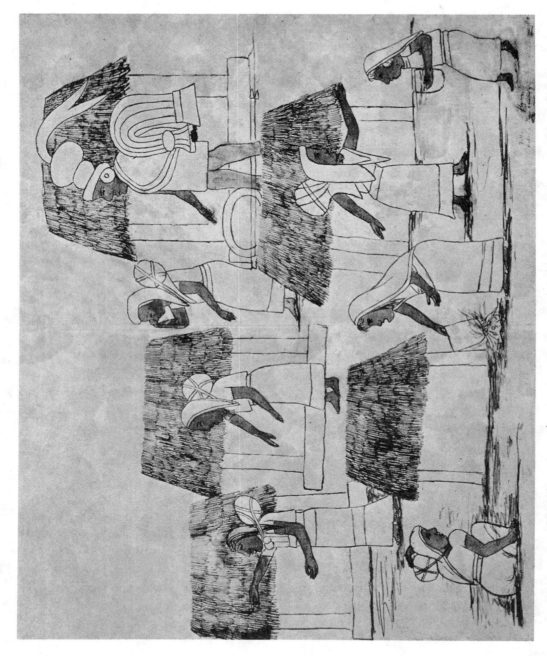

One of the murals in the Temple of the Tigers, Chichen-Itza, Yucatan. Much of the historical work displayed on the walls of this structure has, in recent years, been defaced by vandals. Fortunately, accurate records were made prior to their partial destruction.

with America." Later on we read: "Probably the first immigrants drifted across in small bands travelling southward slowly, and populating, in the course of thousands of years, the whole American continent. Their remains found in caves in Brazil and Chile demonstrate that they had exceedingly long heads, low retreating foreheads and beetling brows. Broadheaded people followed them in sufficient numbers to swamp the predecessors. Later arrivals may have brought with them new arts and crafts, new religious conceptions, and new forms of social organization . . . The complete absence of the Old World food plants in America . . . shows that the immigrants did not bring seed with them. An agricultural people is very seldom nomadic; but if a migration takes place, the husbandman will not leave for a new land without the one necessity for existence, namely seed. These later immigrants may have crossed from Siberia to America in boats as the land bridge possibly disappeared about the same time England became an island. Immigration across the Atlantic can be ruled out as extremely unlikely. There remains the Pacific. The question of possible arrivals from the islands of the Pacific is debatable, and although small numbers may have reached America in this way in comparatively late times, introducing some new customs, early immigration on a large scale from this quarter can be fairly safely rejected."

Thompson's belief

Thompson's opinion of the Maya origin is obviously based on a slow cultural evolution on Yucatan and Central American soil, from an archaic stock whose Asian progenitors arrived in America at a very early date. He says: "Immigration across the Atlantic can be ruled out as extremely unlikely." He suggests that "later arrivals may have brought with them new arts and crafts, new religious conceptions, new forms of social organization." We learn further that some long-headed, beetle-browed gentlemen, who, it is inferred, were the Maya ancestors, dragged their women and children across the Siberia-America landbridge and wandered over the American continent about 15,000 years ago. These were followed by "broad-headed" people, who we must presume also came from the same source.

Beetle-browed ancestors!

Apparently, by the broad expanse of territory covered, these early visitors were great travellers, nomads of extensive wanderings. However, it is assumed that finally they began to settle and become good citizens. From this beetle-browed stock emerged, if not the greatest known culture, at least a race surpassed by none; a people who developed art from an archaic beginning through to the

realms of the abstract; who builded cities almost unequalled in the annals of man's activities; who excelled as engineers, and who, among other scientific feats, created a calendar superior to all others.

*From India
and Egypt!*

We can visualize the arrival from time to time of foreign invaders who joined the struggling young nation and lent a helping hand. We see some wealthy potentate from India or Burma, paying a friendly call accompanied by some of his sacred elephants, in which the Mayas found motifs for their decorative art. We see the interchange of Maya and foreign professors of learning from Asiatic and European universities, the latter bringing such noble contributions to Maya art and science as the cross-legged Buddha, the pyramid, the arch, the art of writing, mythology, astrology, Egyptian burial and marriage customs, stories of the flood, and in fact a mass of helpful information.

*Hypothetical
Asiatic Inva-
sion of the
Americas*

For argument's sake, let us delve into the plain logic of the theoretical invasion of America from Asia via the Behring Straits. Fifteen thousand years is not a long time geologically speaking, so that we may assume the general climatic conditions of that period to have differed little from those of the present time. At least we may assume that Siberia and Alaska were then, as now, countries of ice and cold, and the route taken from those centers in a south-easterly direction would encounter rising temperatures toward the torrid zone.

*A ludicrous
hypothesis*

Let us carry our minds back 15,000 years and assume that we, ordinary thinking human beings, decided that our living conditions in Asia (obviously in or near Siberia) were, for any cause whatever, no longer conducive to pleasant living. As all migrations are primarily due to drastic reasons, we would naturally be seeking a better place in which to live. Impelled by these demands we decide to brave the rigors and dangers of crossing the Behring Straits, or a land bridge, if it then existed. Alaska, we find, is no better than the area we have vacated. The immense and forbidding Rocky Range decides that our progress shall be down the West Coast. We arrive in British Columbia. Despite the obvious fertility of the soil and bearable climatic conditions it fails to make an appeal. The states of Washington and Oregon—veritable lands of milk and honey—we ignore, believing the land of our quest will be far superior. California, salubrious land of sunshine, whose gentle shores are washed by a peaceful ocean, a land of magnificent possibilities—that too we find unsatisfactory. Then with that sublime incentive which characterizes the noble frontiersmen, we

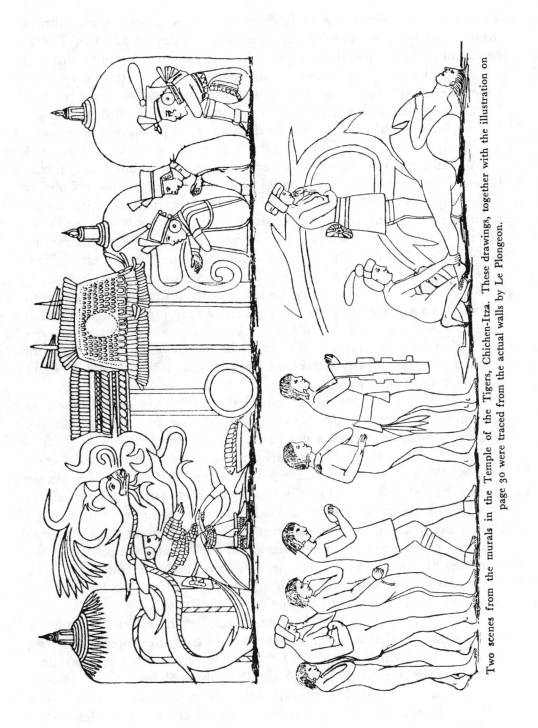

Two scenes from the murals in the Temple of the Tigers, Chichen-Itza. These drawings, together with the illustration on page 30 were traced from the actual walls by Le Plongeon.

assume the herculean task of leading our weary people across almost insurmountable mountain ranges toward the valley of Mexico. Desert heat and lack of water deter us not. Vast expanses of barren plain and uninviting land stretch before us, but with a determination amounting to fanaticism we push on. More mountains and perhaps a few tropical forests beset our path but eventually we arrive in Central America. At last we have found the land of our dreams. Our joy knows no bounds. Sublimely indifferent to the fact that this area (later known as Yucatan) is flat, uninteresting, devoid of rivers, and possessing but a few inches of soil, we enthusiastically proceed to establish our major colonizing activity in this territory. We work feverishly to erect vast cities *similar to those we had deserted.* I emphasize the last few words because in my belief the evidence shows that the Mayas arrived in Central America and Yucatan, not in their youth, not even at the height of their civilization, but more probably on the decline of their culture.

No evidence of progress

It may be argued that the interval between 15,000 years ago and 2,000 years ago is more than long enough in which to establish the greatest of cultures. Undoubtedly it is, but in support of such a contention there would surely be some evidence of the several steps of progress toward perfection. It is important to realize that there is *absolutely no such evidence.*

Where then, I ask, did the Maya civilization, as we know it, gain the fundamental knowledge for its indisputably advanced culture? Obvious similarities can be seen between Maya arts and religion and those of the early civilizations of Europe and Asia Minor. Which, if either, influenced the other? Why did the Mayas choose the forbidding land of Yucatan in which to settle? Their culture could not have sprung from a background of total ignorance. The similarities in their arts and cultures to those of Europe cannot be due to pure "psychic unity." The selection of such a site was obviously not a matter of choice. From this we can draw but one conclusion: the Maya civilization did not originate in any part of the Americas. It was born and cradled in a land foreign to that soil.

Hurried arrival

The evidence, some of which I shall submit later, indicates clearly that the ancient Mayas arrived on the shores of Yucatan hurriedly and without choice. That it was uninhabited at that time was probably due to its lack of suitable physical aspect and charm. It could have appealed to no one with the privilege of choice. It is further obvious that the castaways, fully aware of their defenseless

state, knew that they were in no condition to undertake extensive exploring for fear of encountering hostile peoples. The wisdom they displayed in not advertising their presence probably explains why they were able to establish there a semblance of their former magnificence and remain so long undisturbed. Hundreds of years passed after their arrival before the surrounding indigenous tribes became aware of their presence. The amazement of the latter must have been enhanced two-fold by their knowledge of the territory and its unsuitability for human existence.

It is probable that those who entertain the hope of proving that the Maya civilization came from Asia or Europe do not consider the possibility of a migration across the Atlantic; and invasion from the Pacific isles offers them even less upon which to theorize; hence, for want of evidence, the believers in an Asiatic or even a European origin of the Mayas invariably fall back on the Behring Straits as the logical course.

Equally mysterious and likewise a subject for much speculation is the abrupt disappearance of that erstwhile highly cultured race. Some theorists believe that they worked out the soil and died of starvation. Others conjecture that the waters washed the soil down the mountainsides and filled up the centers of their water supply. (As Yucatan is but a level limestone ledge, such a theory is obviously irrational). Others again assign wars, earthquakes, or pestilence as the cause. None, however, offers corroborative testimony in support of such contentions. It will be my endeavor in the following chapters to account for not only the origin of the Mayas and their disappearance, both substantiated by an abundance of evidence, but also to explain the presence of various peoples whom I believe to have occupied the Americas, especially in proximity to Central America, long prior to the Maya invasion.

Conjectures as to disappearance of Mayas

Chapter Three
The Atlantean Theory

HE average reader is no doubt well acquainted with Plato's story of Atlantis, so that it is not necessary to repeat it in full. Plato, it must be remembered, was a distinguished Greek scholar, philosopher and historian, who lived 400 years before Christ. Plato's ancestor, Solon, lived 600 years before the Christian era, and it is recorded that he visited the wise men of Sais in Egypt with whom he discussed philosophy and ancient history. Upon one of these visits a learned priest, who was of very great age, said: "O Solon! Solon! You Hellenes are but children,

Many destructions of mankind

and there is never an old man who is an Hellene . . . In mind you are . . . all young; there is no old opinion handed down among you by ancient tradition nor any science which is hoary with age. And I will tell you the reason of this; *there have been, and there will be again, many destructions of mankind arising out of many causes.*"

Solon probably fully realized the importance of a record which carried human history back, not only thousands of years before the era of Greek civilization, but many thousands of years before even the establishment of the Kingdom of Egypt; and he was anxious to preserve for his countrymen any such record of antiquity. The old

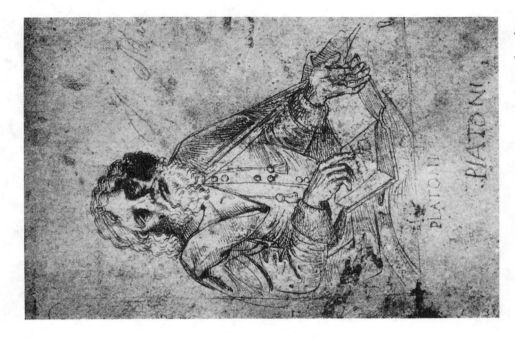

Plato, descendant of Solon, one of the profoundest minds of the ancient world. He came into possession of his ancestor's story of Atlantis and rewrote it.

Solon, the great law-giver of Athens (600 B.C.), and an authority on prehistoric lore, wrote in verse a description of the lost Atlantis.

priest told Solon that his knowledge was gleaned from the sacred Egyptian registers 8,000 years old. This means that *the records were made approximately 8,600 years B. C.* When the subject of a lost continent in the great ocean to the west of the Pillars of Hercules (Gates of Gibraltar) was mentioned by the old priest, Solon was eager to learn about it. The story as told to Solon was written down by him in verse. This record was handed down to Plato who preserved it for posterity in the form of a dialogue. But, by reason of his age alone, as Plutarch states, Solon was never able to finish his story of the lost Atlantis in verse. Plato, who started his dialogue on the subject late in life, also left the story unfinished.

Records 10,500 years old

In the conversation between the priest of Sais and Solon, the former, according to Plato, says:

"This power came forth out of the Atlantic Ocean, for in those days the Atlantic was navigable; and *there was an island* situated in front of the straits which you call the Columns of Hercules. The island was *larger than Libya and Asia (Minor) put together,* and was *the way to other islands,* and from the islands you might pass through the whole of the opposite continent which surrounded the true ocean; for the sea which is within the Straits of Hercules is only a harbor, having a narrow entrance, but that other is a real sea, and the surrounding land may be truly called a continent. Now in the island of Atlantis there was *a great and wonderful empire* which had rule over *the whole island and several others,* as well as over parts of the continent; and besides these, they subjected parts of Libya within the Columns of Hercules as far as Egypt, and of Europe as far as Tyrrhenia."

Later on the narrative recites: "But afterward there occurred violent earthquakes and floods and in a single day and night of rains all your warlike men in a body sank into the earth, and *the island of Atlantis in like manner disappeared and was sunk beneath the sea.* And that is the reason why the sea in those parts is impassable and impenetrable because there is such a variety of shallow mud in the way; and this was caused by the subsidence of the island."

Atlantis disappeared

Continuing, we learn that: *"Many great deluges have taken place during the nine thousand years,* for that is the number of years which have elapsed since the time of which I am speaking; and in all the ages and changes of things, there has never been any settlement of the earth flowing down from the mountains, as in other

places, which is worth speaking of; it has always been carried round in a circle, and disappeared in the depths below. The consequence is that, in comparison of what then was, *there are remaining in small islets only the bones of the wasted body,* as they may be called, all the richer and softer parts of the soil having fallen away, and the mere skeleton of the country left . . . ”

One scientist with whom I argued the point raised the objection that the names used by Plato in connection with the Atlantean story were not Maya, that in fact there was not even a slight resemblance. I have noticed this point in various writings. It is clear that these opponents of the Atlantean theory have not understood the explanation in Plato's narrative. It states therein that: “Before proceeding further in the narrative, I ought to warn you that you must not be surprised if you should hear Hellenic names given to foreigners. I will tell you the reason of this: Solon, who was intending to use the tale for his poem, made an investigation into the meaning of the names, and found that the early Egyptians, in writing down, had translated them into their own language, and he recovered the meaning of the several names and retranslated them, and copied them out again in our language. *My great-grandfather, Dropidas, had the original writing, which is still in my possession,* and was carefully studied by me when I was a child. Therefore, if you hear names such as were used in this country, you must not be surprised, for I have told you the reason of them.”

Plato explains

The word Atlantis has long been a bone of contention among philologists. In view of the evidence as to its origin, which I will give later, the following sentence from Plato's story is quoted: “And he (Poseidon) named them all; the eldest, who was king, he named Atlas, and from him the whole island and the ocean received the name of Atlantic.”

Naming an ocean

Continuing Plato's narrative we read: “For, because of the greatness of their empire, many things were brought to them from foreign countries, and the island itself provided much of what was required by them for the uses of life. . . . There was an abundance of wood for carpenter's work. . . . Moreover, there was a great number of *elephants* in the islandand the fruits having a hard rind, affording drinks, [cocoanuts] All these things they received from the earth, and they employed themselves in constructing their temples, palaces, harbors and docks.”

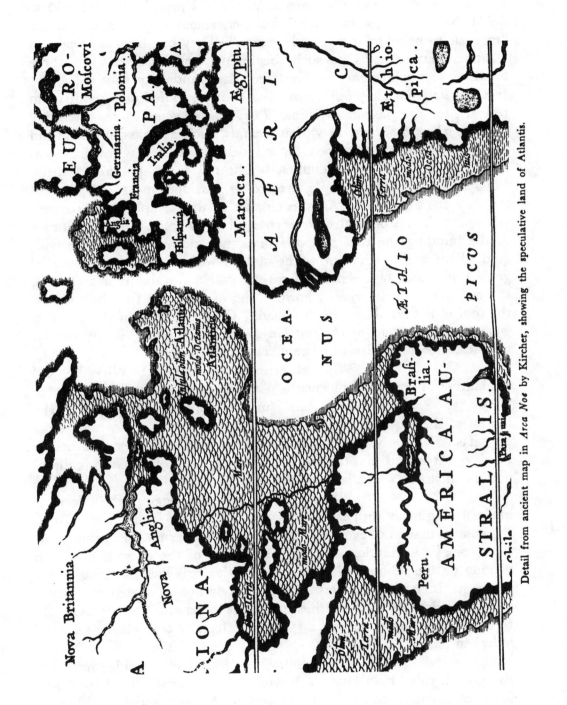

Detail from ancient map in *Arca Noë* by Kircher, showing the speculative land of Atlantis.

We learn from the old priest's story as told to Solon that the people of Atlantis built enormous palaces and temples, "marvels to behold for size and beauty." They constructed canals on a stupendous scale. One such, beginning from the sea, was three hundred feet wide, one hundred feet deep and fifty stadia (29,100 feet) in length. They *built numerous bridges,* roofed over, with room beneath for the passage of ships. *They coated some of the enclosing walls to their buildings* in various metals, such as brass and tin, and the wall which encompassed the citadel was coated with what was known to them as orichalcum, a bright red metal [an alloy, either brass or like it]. One temple, erected to Poseidon, measured 582 feet long by 291 feet wide. All the outside of this temple was "covered with silver", the pinnacles were covered with gold." In the interior of the building the roof was of ivory, and adorned everywhere with gold, silver and orichalcum. The statues within the temple *were of gold.* One statue represented a figure of Poseidon standing in a chariot, the charioteer of six winged horses "and of such size that he touched the roof of the building with his head." On the outside of the building were *statues in gold of the ten kings and their wives.* Many similar temples of this description were erected on Atlantis.

Stupendous structures

What stupendous conceptions! What colossal structures! What magnificence! What amazing engineering feats!

We learn further than "the canal and the largest of the harbors were full of vessels and merchants coming from all parts." Not only were the harbors of these vitally energetic people filled, but it is said that the royal "docks were full of triremes [galleys] and naval stores, and all things were ready for use."

Harbors and canals

When it comes to ditch digging, the efforts of modern engineers appear somewhat infantile. The Suez Canal, Panama Canal and even the lesser great modern engineering feats excite one's imagination, but the description of the outstanding ditch digging on the submerged continent of Atlantis is awe-inspiring to say the least. Imagine an undertaking of that nature excavated to a depth of one hundred feet, its width, throughout its length, not less than 582 feet, and "ten thousand stadia [5,820,000 feet, or over eleven hundred miles] in length."

The country, we learn, was divided into *ten parts,* each ruled by a king, each with a capital city, yet all combined for a common cause: a United States of Atlantis which perished at

least 11,500 years ago. Their constitution of the United States of Atlantis, if such it may be termed, was apparently constructed on lines similar to those of the Constitution of the United States of America. We read that "they were not to take up arms against one another, and they were all to come to the rescue if any one in any city attempted to overthrow the royal house. Like *their ancestors,* they were to deliberate in common about war and other matters."

There is no question as to their obedience to and reverence for the laws of their country. The story continues: "For many generations, *as long as the divine nature lasted in them,* they were obedient to the laws, and well affectioned toward the gods, who

A unique map suggesting the shape and position of Atlantis from Plato's description, oriented in reverse to common practice, the north symbol pointing downward. (From Kircher's *Mundus Subterraneus.*)

were their kinsmen; for they possessed true and in every way great spirits, practising gentleness and wisdom in the various chances in life, and in their intercourse with one another."

No better description could be given of the characteristics of the ancient Mayas of Central America and Yucatan than the following and last excerpt from Plato's description of the Atlanteans.

"They despised everything but virtue, not caring for their present state of life, and thinking lightly on the possession of gold and other property, which seemed only a burden to them; neither were they intoxicated by luxury, nor did wealth deprive them of their self-control; but they were sober *and saw clearly that all these goods are increased by virtuous friendship with one another,* and that by excessive zeal for them, and honor of them, the good of them is lost and friendship perishes with them."

Metaphysical Truths from Atlantis

If no other good may be gained from Plato's story than the metaphysical truths expressed in the last sentence, the world is better for its recital. The inevitable end of all that is worth while occurs when baser thoughts prevail. As with individuals, so with nations. No better example of this truth can be given than to relate the fateful words toward the end, an unfinished end, of Plato's narrative: "By such reflections, *and by the continuance in them,* all that which we have described *waxed and increased in them;* but when this divine portion began to fade away in them, and became diluted too often, and with too much of the mortal admixture, and the human nature got the upper hand, then, they being unable to bear their fortune, became unseemly, and to him who had an eye to see, they began to appear base, and had lost the fairness of their precious gifts . . . "

The final catastrophe

Shortly after the signs of decay had set in, which was approximately 9,600 B. C., the final great catastrophe occurred. Earthquakes rocked the continent, volcanoes belched forth their fiery destruction, floods and tidal waves joined in the titanic struggle and the magnificence that was Atlantean perished. The land vanished beneath the turbulent waters and slowly settled to a great depth. Few escaped this mighty burst of nature's wrath. Those who were fortunate escaped hurriedly with little if any of their possessions. As later evidence will show, it is probable that some refugees reached newly formed islands (now known as the Canaries) to the east of their vanished homeland, while others struggled on to the mainland of Europe. Apparently many refugees fled westward to other newly formed groups of islands (now known as the West Indies) as well as on to the mainland of the American continent.

If we are to accept Solon's story of the lost Atlantis as related by Plato, we must accept it *in toto.* It is either a brilliant fabrication or a narrative of fact. After careful consideration

of the vast accumulation of corroborative evidence—only a small portion of which is submitted here—the unbiased mind must be convinced that there is far more probability of truth in the story than of fiction. In order that the reader may be in a better position to judge fairly as to the value of the testimony, let us review some objections offered by a well known scientist.

William H. Babcock, in *Legendary Islands*, published under the auspices of the American Geographical Society, is not at all impressed by the Atlantean theory. He says:

"We may be safe in styling Atlantis the earliest *mythical island* of which we have any knowledge or suggestion, since Plato's narrative, written more than 400 years before Christ, puts the time of its destruction over 9,000 years earlier still. It seems *pretty certain* that there never was any such mighty and splendid island empire contending against Athens and later ruined by earthquakes and engulfed by the ocean. *Atlantis may fairly be set down as a figment of dignified philosophic romance,* owing its birth partly to various legendary hints and reports of seismic and volcanic action, but much more to the glorious achievement of Athens in the Persian war and the apparent need of explaining a *supposed shallow part of the Atlantic* known to be obstructed and now named the Sargasso Sea. Perhaps Plato never intended that anyone should take it *as literally true,* but his story undoubtedly influenced maritime expectations and legends during medieval centuries. It cannot be said that any map unequivocally shows Atlantis; but it may be that this is *because Atlantis vanished once for all in the climax of the recital.*"

Before quoting further from *Legendary Islands* let us consider some of the above remarks.

Babcock refers to Atlantis as the "earliest mythical island." Is he unaware of, or does he totally disbelieve, the legends of the Negro races of South Africa referring to Gondwanaland, a lost continent to the east of their country? The fact that to this day these legends are prevalent and uniform among numerous South African tribes, now widely scattered, is strong evidence that the story has come down through the ages comparatively intact. In view of the corroborating testimony it is conceivable that the legend was in existence long prior to the time when Solon heard of Atlantis from the priest of Sais.

Legend, moreover, sometimes provides the first clue to prehistory, whether of Gondwanaland, Lemuria, Mu, or Atlantis. Legend gave the clue to all the rich discoveries made since Schliemann dug at Troy a hundred years ago. In the light of these all histories have been rewritten. It is therefore not excessive to give serious consideration to Plato's story, even if only as legend, although we shall see that it is much more.

The value of Legend

Babcock is "pretty certain" that there never was an Atlantean empire which finally disappeared beneath the waters, and infers that the Azores, the Madeiras, the Canaries, and the Cape Verde group—supposed remnants of the Atlantean continent—are concrete evidence that no such empire existed. He says: "Some of them [the islands] must have been within fairly easy reach of Atlantis, if Atlantis existed."

Again: "Such advance in civilization, such elaboration in organization, such splendor and power would certainly have overflowed abundantly on the islands intervening between Atlantis and the continental shore."

Degrees of culture

We might reply that many degrees of culture are to be observed in a single race of people. For instance, there are certain remote areas of the British Isles which decidedly do not reflect the highest degree of British culture, yet these centers are but a few hundred miles from an extreme of intellectual development. A similar analogy might be offered between the lesser intellectual centers of the United States and American culture in general. The inhabitants of any of these backward areas, such as the Ozark and Kentucky mountaineers, left as sole survivors of the nation, would not represent the highest level attained by their race. It must be remembered that the existing Atlantic islands, assumed once to have formed part of the great continent of Atlantis, are not in this book mentioned as former Atlantean cultural centers. One would not expect to find evidence of an advanced civilization on such isolated remnants.

Culture not on mountain tops

Mountain tops are not all Sinais. They are the last spots where one would expect to find a high culture or its relics. What we do find is clear testimony, to be set forth later, that the early occupants of the eastern and western Atlantic island groups were direct representatives of a highly cultured race whose source cannot be assigned to any of the now-existing continents. Meanwhile there is nothing excessive in the statement that the sea was at first shallow

over the spot where Atlantis sank, and that afterward the lands sank slowly to the present level. Otherwise a succession of waves would have risen of such proportions that the lowlands of both hemispheres would have been inundated and whole civilizations obliterated. In such an event one could expect some evidence of such a catastrophe. None, however, is at present forthcoming.

So many mysteries lie hidden from man that only one who is supernaturally wise, or one who is very foolish, dares to make positive assertions about them. Even as late as the beginning of the present century, any prophecies of the immediate advent of radio, television, telephotography, travelling via air across a three thousand mile continent in a few hours, and other results of now-unfolded secrets, undoubtedly would have met with scorn and derision from the great majority. So also with the mysteries of the past, including the sunken Atlantis. Babcock remarks doubtfully that what is wanted is evidence of the great island of Atlantis.

Recorded Earth movements

Although possessing no historical record of a submergence of such magnitude, we have considerable evidence of numerous smaller catastrophes of the same kind. Vast disturbances and great movements are continually taking place. The earth's surface is a record of unnumbered risings and fallings. Geology shows that all the existing continents were once under water; it also shows that these changes took place not once but many times. The Scandinavian islands have risen from 200 to 600 feet within the last five thousand years; and Professor Winchell says: "*We have seen the whole coast of South America lifted up bodily ten or fifteen feet and let down again in an hour. We have seen the Andes sink 220 feet in seventy years.*" (Italics are mine). We learn that Great Britain at one time "was submerged to the depth of at least seventeen hundred feet. . . . The Desert of Sahara was once under water and its now burning sands are a deposit of the sea." It is recorded that in 1783 an earthquake and deluge occurred in Iceland and destroyed twenty villages of 9,000 souls. A mass of lava was thrown out "greater than the bulk of Mont Blanc." At that time an island was formed thirty miles off shore. It was named by the Danish King "Nyoe", or the New Island. It disappeared again within a year.

Continents rise and fall

The Cyclades of the Grecian Archipelago are in an active volcanic center. Pliny reported that in 186 B. C. islands began to appear from beneath the waters. In 1848 a violent disturbance

caused great havoc and an examination that took place some years later showed "that the whole mass of Santorin [an island of this group] has sunk, since its projection from the sea, over 1,200 feet." In 1819, 2,000 square miles of land including the village of Sindree, on the eastern arm of the Indus, above Luckput, sank beneath the waters after an earthquake.

Our unstable world

Undeniable proof of the appearance and disappearance of land surfaces exists in the following two records, quoted by Donnelly: "It is at that point of the European coast nearest to the site of Atlantis, at Lisbon, that the most tremendous earthquake of modern times has occurred. On the 1st of November, 1775, a sound of thunder was heard underground, and immediately afterward a violent shock threw down the greater part of the city. *In six minutes* 60,000 *persons perished.* A great concourse of people had collected for safety upon a new quay, built entirely of marble; but suddenly it sank down with all the people on it, and not one of the dead bodies ever floated to the surface. A great number of small boats and vessels anchored near it, and full of people, were swallowed up as in a whirlpool. No fragments of these wrecks ever rose again to the surface; the water where the quay went down *is now* 600 *feet deep.* The area covered by this earthquake was very great. Humbolt says that a portion *of the earth's surface four times as great as the size of Europe was simultaneously shaken. . . .* At eight leagues from Morocco the ground opened and swallowed a village of 10,000 inhabitants, and closed again over them."

The other record is an excerpt from the *History of Java* by Sir Thomas Stanford Raffles:

The Tomboro disaster

"In April, 1815, one of the most frightful eruptions recorded in history occurred in the province of Tomboro, in the island of Sumbawa, about two hundred miles from the eastern extremity of Java. It lasted from April 5 to July of that year; but was most violent on the 11th and 12th of July. The sound of the explosions was heard for nearly one thousand miles. *Out of a population of* 12,000 *in the province of Tomboro, only twenty-six individuals escaped.* Violent whirlwinds carried up men, horses, and cattle into the air, tore up the largest trees by the roots, and covered the whole sea with floating timber. . . . The town called Tomboro, on the west side of Sumbawa, was overflowed by the sea, which encroached upon the shore, *so that the water remained permanently eighteen feet deep in places*

where there was land before. The area covered by the convulsions was 1,000 English miles in circumference. *In the island of Amboyne in the same month and year, the ground opened,* threw out water and then closed again."

On November 24, 1934, the Associated Press reported the rising of an island in the ocean off the shores of Trinidad in the British West Indies. The report reads: "A vanishing island, unseen since it was swallowed by the 'serpent's mouth' twenty years ago, has suddenly popped up. . . In November, 1911, this strange island rose from the sea in Erin Bay, in Southern Trinidad." Commenting upon its appearance at that time the report continues: "Slowly the island began disappearing . . . and then it was suddenly gone."

Unsubstan-tiated evidence

According to an Associated Press report of December 6, 1934, we learn of an entire mountain vanishing into the earth in the Maya area. The name of the mountain is Cerroazul, and it was situated between Paraiso and Santa Rita near the ancient ruined Maya city of Copan in Central America. The report related that the mountain "sank from sight with a tremendous roar."

Unfortunately, in an effort to sustain the Atlantean theory, some writers have submitted evidence which apparently leaves no room for argument but which upon investigation cannot be substantiated. Spence, for instance, in his *The Problem of Atlantis,* (Published May, 1924) on page 38 says: "These conclusions have been surpassed in an extraordinary manner by fresh and surprising evidence collected by the agents of the Western Union Telegraph Company and others, *which prove that the bed of the Eastern Atlantic has altered greatly during the last twenty-five years.*" On page 205 he says: "The results of recent soundings taken by the Western Union Telegraph Company have sent a thrill of surprise throughout the civilized world. *A vessel belonging to this company* was searching (August 1923) for a lost telegraph cable which had been laid twenty-five years before, and the officers of the company found to their astonishment in taking soundings at the exact spot where it had been laid down *that the surface of the ocean bed there had risen during that time by nearly two and a quarter miles.*"

Story of Atlantic bed rising

Again, in *Current History* magazine, January, 1934, page 444, is an article by Richard Clavering entitled *In Quest of the Lost Atlantis,* which states that "great movement has taken place in the bed of the Atlantic Ocean and is still taking place, none can

doubt. Not longer ago than August, 1923, a vessel was sent out by the Western Union Telegraph Company to search for a lost cable, which had been laid about twenty-five years before. Soundings were taken at the exact spot and revealed that the bed of the ocean had risen nearly two and a quarter miles during that short period."

The story refuted

Various other articles containing the same information also have been written. But upon my written inquiry concerning the above reports, addressed to the Western Union Telegraph Company's Board Chairman, I received a reply dated July 8, 1936, which reads in part as follows: " the article mentioned by you did not emanate from this Company. Our cable ships take numerous soundings in the course of their work, *but have never yet found any appreciable rise in the sea bottom in deep water.*"

To confirm this statement I made similar written inquiry of the United States Hydrographic Office of the Navy Department, and received in reply a letter dated Oct. 16, 1936, signed by L. R. Leahy, Captain, U. S. Navy, Hydrographer, which reads in part as follows: "*There is no such record in the Hydrographic Office of such a phenomenon.* The reports of soundings sent in by Western Union Telegraph Company cable ship *Lord Kelvin* and also the *All America* of the All America Cables, Inc., for the year of 1923 do not mention such a phenomenon."

Where and how such a misstatement emanated is a mystery, but it is such unfounded reports offered as evidence in support of the Atlantean hypothesis that discredit an otherwise sound argument. On the other hand, the above authorities do not deny the probability of risings and fallings of the ocean beds. In the communication from the Western Union Telegraph Company it says: "It is our experience that there have been insufficient soundings taken in the past to compare with those of the present day to determine accurately whether or not there is any marked rise of the sea bottom."

In defense of Plato

Babcock's remark that: "Certainly no one will go the length of accepting it [Plato's story] as wholly true as it stands," should not go unchallenged, especially when he says: "We must remember that Plato did not habitually confine himself to bare facts If there were any corroboration of the tale, it would count on the historical side." Babcock not only casts doubt upon Plato's story but also upon the sincerity of those who support it: "The romancing may have been done in part by the priests of Sais or by Solon

or by Dropides, or by Critias, or possibly all these may have contributed successive strata of fancy, crowned by Plato."

Then, if it appears that we must rely upon Plato's narrative as the sole source of recorded evidence, we should seek to establish its veracity. Plato was known as a great thinker and one of the profoundest minds of the ancient world. His story of the lost Atlantis is given as a plain simple record of facts, as he, or Solon, believed them to be; he says that it is "certainly true."

That Plato's narrative is not beyond all reason is shown by authentic and far more gorgeous descriptions of cultures within historical times. In all histories of Peru, of Crete, of Babylon, we read of a magnificence of structures far surpassing the description of Atlantis as given by Plato. The more recent the historian the more the magnificence. "Plato's account of Atlantis falls short of Herodotus' description of the grandeur of Egypt," says Donnelly; and may we not assume that if Plato had had in mind the telling of a romantic story, purely fictional, he undoubtedly could—and would—have conceived a far more lavish fabrication? As it is, the tale is prosaically set forth and contains data and descriptions of little interest in a romance or allegory.

Plato's story surpassed

For the purpose of continuing, let us assume, for the time being, that we are agreed as to the veracity of Plato. With this assumption, let us consider the reference in his story to more than one deluge. This in my opinion is very significant.

My general argument is based upon my belief that Atlantis was not submerged bodily at one time, but piecemeal. I shall endeavor to show the probability of the presumed three major sinkings of that continent; the first of which is conservatively believed to have occurred approximately 23,000 B. C.; the second approximately 14,000 B. C.; and the third approximately 9,600 B. C. (In all probability minor sinkings occurred between those periods). Next, I shall endeavor to substantiate my belief that the beginning and progress of what I term the last grand cycle of civilization occurred in Atlantis, and that the various ancient cultures of both hemispheres sprang at various times from that source.

The evidence of Geology

First we must be convinced that large areas of land can rise above and sink beneath the waters, and have done so. For this information we must turn to the science of geology and learn what evidence it has to offer.

Considerable divergence of opinion exists among geologists, opinions which center around what Professor Charles Lyell calls "the actual posture of affairs", and the birthdays of various earth strata. For instance, Dr. Alfred Russell Wallace and others doubt the existence, since man's arrival, of any continent not now existent. Some geologists agree that the present continental formations, although the only ones, have been considerably changed, but opinion as to shape and area varies greatly.

Age of Glacial period

Concerning the age of geological periods, we also meet with a wide range of opinion. Sollas, in *Evolutional Geology,* estimates 400,000 years as the length of the Pleistocene or Glacial Period. Penck estimates 520,000 to 840,000 years. Geikie gives it as a minimum of 620,000 years. Spence says that the generally accepted opinion is that the duration of the Pleistocene was approximately 500,-000 years.

In order that the reader may understand what is meant by geological time, I herewith give a table showing the order of stratified rocks and the periods when life in its various forms first appeared. The lengths of the eras and periods are the most conservative among a wide range.

Scientific opinions

Among the older geologists who favor the Atlantean theory are Charles Lyell, who allowed its likelihood (*Elements of Geology,* London, 1841, p. 141.); Buffon, who dated the separation of the Old and the New World from the Atlantean catastrophe; Forbes, who declared his belief in the former existence of a bridge of islands in the North Atlantic; Heer, who attempted to show the necessity of a similar connection from the testimony of paleontological history; Unger, who tried to "explain the likeness between the fossil flora of Europe and the living flora of Asia by virtue of the Atlantean hypothesis"; and Kuntze, who saw the lost Atlantis as the center from which the banana was carried simultaneously to Asia and America.

The evidence of lava

Some geologists have attempted to prove that a large land area beneath the Atlantic Ocean was above the water level at a comparatively recent date, geologically speaking, by the nature of rock examples procured from those depths. The principal evidence is in the form of lava, the condition of which, it is claimed, could have resulted only from cooling in the air. On the other hand many scientists have disputed the claim that lava forms differently

TABLE SHOWING THE ORDER OF STRATIFIED ROCKS, AND THE PERIODS WHEN LIFE IN ITS VARIOUS FORMS FIRST APPEARED

ERA	PERIOD		LIFE FIRST APPEARS
Archaean or *Azoic*	Rock of Volcanic Origin		
Primary or *Paleozoic* which began approximately 100,000,000 years ago	Divided into	A. Cambrian	Invertebrates
		B. Silurian	Invertebrates
		C. Devonian	Invertebrates
		D. Carboniferous	Fish
		E. Permian	Amphibia
Secondary or *Mesozoic*	Divided into	A. Triassic	Reptiles
		B. Jurassic	Birds
Tertiary Conservatively estimated to have begun approximately 5,000,000 years ago	Early Tertiary divided into	A. Paleocene	Mammals
		B. Eocene—began approximately 3,000,000 years ago	Higher Mammals
		C. Oligocene	Anthropoids
	Late Tertiary divided into	A. Miocene	
		B. Pliocene	Java Man
Quaternary or *Neozoic* which began approximately 500,000 years ago	Divided into	A. Pleistocene, divided into Glacial and Post Glacial	Higher Man
		B. Holocene or recent	

under water, although they have not produced satisfactory evidence in support of their contention. The specimens of lava brought up in 1898 from a depth of 10,200 feet beneath the surface of the Atlantic Ocean, 500 miles north of the Azores, were believed to have congealed *under atmospheric conditions,* in other words *above* the surface of the waters. Dr. Frederick Finch Strong says that geologists "learned much from the phenomena that followed the eruption of Mont Pelée in the island of Martinique, West Indies." They found that part of the lava emitted from the volcano flowed into the sea, and part onto land. The experience showed that there is a marked difference between water-cooled lava and that which congealed on land. Dr. Strong further states that "lava exposed to sea water will disintegrate to a known extent in about 15,000 years." One may conclude from this testimony that the lava specimens raised in 1898 cooled *above water.* Summing up, Dr. Strong says: "The inference is obvious—the eruption which ejected the lava must have occurred above the surface of the Ocean, and therefore, what is now the bed of the Atlantic Ocean must have been above sea level less than 15,000 years ago."

Atlantean Cataclysm undoubted

The above evidence, then, points to the high probability that at a period not more than 15,000 years ago land now submerged existed in the Atlantic Ocean. It will be noticed that the date claimed for the Magdalenian, (or second Cro-Magnon) invasion of Europe agrees approximately with the above-mentioned geological findings.

From M. Termier we learn that near the African continent there certainly have been important movements during Quaternary times (period of man's known occupancy of the earth) when other changes undoubtedly took place *in the true ocean* region. "Geologically speaking," he says, "the Platonian history [narrative of Plato] of the Atlantic *is highly probable* . . . It is entirely reasonable to believe that, long after the opening of the Strait of Gibraltar, certain of these emerged islands still existed, and among them a marvelous island, separated from the African continent by a chain of other smaller islands. One thing alone remains to be proved— that the cataclysm which caused this island to disappear was *subsequent* to the appearance of man in Western Europe. *The cataclysm is un- doubted.*"

Sir J. William Dawson says "that the Pleistocene submergence of America and Europe came to an end not more than ten thousand years ago."

In the light of such a statement from so profound a scientist as Dawson, we may assume that the last eastern major migration from sinking Atlantis to Europe is correctly dated by Plato at approximately 9,600 B. C.

Professor Albert Gilligan, the British geologist, according to an Associated Press report dated October 6, 1934, does not affirm or deny that a continent of land now lying beneath the waters of the Atlantic once supported an advanced civilization, though he is convinced that such a continent once existed. According to the press report the learned geologist says "that evidence of its existence can be seen to this day in sediments, now hardened into rock formation, that were deposited by great rivers of this Atlantis in North America, Scotland, Scandinavia and Spitzbergen—all on the borders of the North Atlantic."

Further, Professor Gilligan believes that the "real Atlantis" covered a large part of what is now the North Atlantic Ocean, but that it vanished millions of years ago. He concedes, however, the possibility of a portion of that great land area remaining above water to a much later period—"the Atlantis farther south", as the report describes it.

Geologists agree

The authorities quoted above are not alone in their belief in the theory of a submerged Atlantis. In fact it may be said that most of the leading geologists, especially of recent years, are agreed that an Atlantean continent once existed at no very remote period in the past.

If any further evidence is required to convince the skeptic as to the geological possibility of a former continent in the Atlantic ocean, the reports of the Oceanographic departments of the United States, British and German governments should prove abundant. The combined result of these reports shows that there "is a great bank or elevation commencing at a point not far from the coast of Ireland, traversed by the 53d parallel, and stretching in a southerly direction, embracing the Azores, to the coast line of South America near French Guiana and the mouths of the Amazon and Parà rivers. Thence this bank stretches in a southeasterly direction toward the African coast, taking in the rocky island of St. Paul. Changing its course again, just

north of the island of Ascension, it stretches due south to the island of Tristan d'Acunha, where it ends. The general level of this ridge or plateau is *some* 9,000 *feet above that of the Atlantic bed* [italics are mine], and the islands connected with it are obviously the mountain peaks of the sunken continent." The evidence further shows that the inequalities of the mountains and valleys forming the submarine landscape "received their present contour whilst still above water." Geology also shows this.

Biological evidence

Many biologists as well as geologists believe that long prior to the assumed existence of the Atlantis island groups, an unbroken land joined Europe with the American continent. There is considerable biological evidence to corroborate the landbridge hypothesis, but we are not concerned with that, except to support the Atlantean assumption; so I shall give but an outline of the more important testimony.

T. V. Wollaston believes "that the Atlantic islands have originated from the breaking up of a land which was once more or less continuous." Kobelt is of the opinion that toward the close of the Miocene period, a decided rupture took place which destroyed the land connection between Europe and America. He bases his conclusions upon the close similarity between the land shells on the two continents.

Scharff says that the burrowing Amphisbaenidae, which consist of sixty-five species, are confined to America, Africa and the Mediterranean. This family of somewhat degraded wormshaped lizards lead an entirely subterranean life, in ants' nests. Such creatures, generally limbless, could hardly migrate across large stretches of water, or be carried to such widely distributed centers. The evidence points to a common center of origin.

Theory of a Land Bridge

When it comes to earth-worms, it must be admitted that the ocean becomes an impassable barrier to migration, yet we learn of a species in Northern Africa identical with one in Europe and in the islands of the Atlantic.

It is interesting to learn that a certain species of ants is to be seen both in the Azores and in America.

In their study of both mollusca and insecta, many scientists have become convinced that in all probability a landbridge across the Atlantic once connected the eastern and western

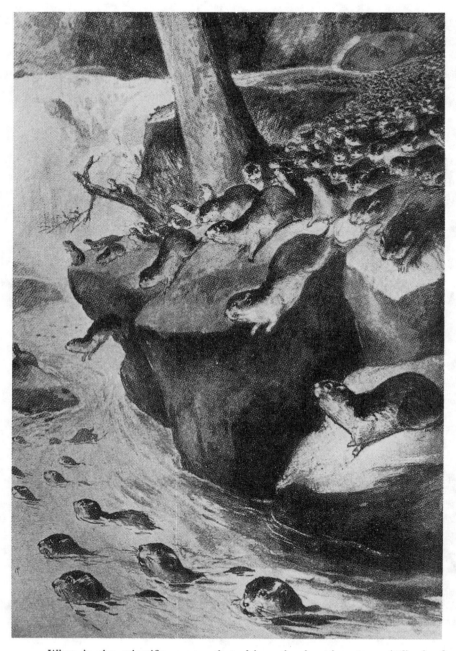

What is the scientific reason that drives the lemming to periodic horde suicide? Is it starvation through over-production, or race memory migration? (Illus. from "Popular Science")

hemispheres. Among them we find Forsyth Major, Howes, Drouet, Simroth, Von Ihering, Dawson, Germain, and others.

Consider also the Scandinavia lemming's fatal plunge into the Atlantic. Is it an instinctive repetition of an ancient migratory call to its homeland? It is observed that these rodents, in obedience to their uncanny impulse, swim *westward* toward a spot where they evidently expect to find land. Upon arrival at a certain area far out in the Atlantic, they circle about as though searching for land, until they drown from exhaustion.

This strange water migration of the lemming and its tragic death is not unique. The same instinct annually impels flocks of birds to a part of the Atlantic where there is no earth visible. They too appear confused at finding no land. They arrive over a certain area, fly in circles as though bewildered, then flutter in dismay and finally fall exhausted into the ocean.

The suicidal Lemming

Donnelly lays great stress on the evidence of the horse. He says that "the horse originated in America", but I do not find that science makes so positive a statement. The fact that certain fossil remains were discovered in the Bad Lands of Nebraska, and at the time were considered to be examples of the earliest horse form, is not sufficient to prove that the horse originated in America. Remains of the true horse are found in all parts of the world except Australia. The horse was common to them in the early part of the Age of Man. It could therefore be argued that a landbridge existed at that time, connecting Europe with America. But as the fossil remains of the horse are found in Alaska one could also argue a land route from Asia across what now is known as the Behring Straits to the American continent. However, that may be, cumulative evidence tends to support the theory of a landbrige between Europe and America and therefore accounts for their common possession of the horse, which, naturally timid, very averse to cold, and fleet of foot, would obviously confine itself to the more temperate zones. The abundance of fossil remains in the warmer areas, as against a scarcity in the colder regions, somewhat substantiates this.

The evidence of Fauna and Flora

Fossil remains of the camel are found in South America, North America, Africa and India.

The ancient bison of Europe, says Rutimeyer, was identical with the existing American buffalo. He states that every

stage between the ancient cave bison and the European aurochs can be traced.

The American moose and the Norway elk, (now practically extinct) are identical.

Domestication of animals

The reindeer of Northern America resemble the reindeer which once roamed the northern shores of Europe down to France. The same conditions apply to the European and American cave wolf.

Remains of a species of enormous cave lion found at Natchez, Mississippi, are similar to those discovered in the European caves.

It is a strange fact that during the historical period, covering approximately seven thousand years, there is no record of the beginning of the domestication of any species of animal. All domestication had taken place prior to the earliest record. Cro-Magnon art is the earliest evidence of civilization found in Europe; but it indicates an already advanced culture, and no evidence as yet discovered shows the preceding stages of progress in Europe. A similar abrupt advent of high culture is found on the American continent.

Origin of agriculture

These two facts should be laid beside the comparisons of the fauna of both hemispheres. Is it not then obvious that an explanation common to them all must be sought?

But there are still more indications of a common source. One of them is the origin of agriculture and the beginning of a staple diet. These are not within the historical period, nor is it known what race first successfully cultivated any of the now known foodstuffs from the natural plant. In other words, no new food has been cultivated from a natural plant for at least seven thousand years. Who, then, did first cultivate the tomato, wheat, rye, barley, beans, and the rest? Thousands of years of slow rise in culture are necessary to achieve such results. But there is no evidence of a beginning in natural plant cultivation in either Europe or America.

Domesticated tropical plants

We gather further corroboration from comparisons of flora. And first the banana, around which still rages an almost bitter controversy.

The seedless banana is found throughout tropical Asia and Africa as well as America. Professor Kuntze, who apparently gave little thought to the Atlantean theory, surmises that the impracticability of transporting the bulbs of the banana plant across a

large body of water was overcome by carrying the delicate roots from one continent to another *via a land route in the neighborhood of the North Pole,* when the Arctic regions had a tropical climate. It would seem that he means they were carried and planted in migratory stages. One objection to this surmise is that at present there is no evidence that man ever occupied the Polar area, and there is a mass of evidence to the contrary. But Professor Kuntze does offer data that are worthy of note; for he states that the red pepper, tomato, bamboo, guava, and mango, as domesticated tropical plants, are equally at home in Asia and America. As all these plants require an exceedingly long period for cultivation from the natural form, and as no evidence exists indicating any known land as a center for the necessary experiments, may we not accept the data he offers as evidence in support of the Atlantean theory? It is a significant fact that all the domesticated plants are found, in both continents, thriving only in the centers colonized by those whom we are considering as emigrants from Atlantis.

Great age of seedless plants

Professor Kuntze further says: "A cultivated plant which does not possess seeds *must have been under culture for a very long period.* . . . We have not in Europe a single exclusively seedless, berry-bearing, cultivated plantand hence it is perhaps fair to infer that these plants were cultivated as early as the beginning of the middle of the Diluvial Period."

Does it not seem highly improbable that plants of the kind mentioned by Kuntze, all requiring *a very long period* for perfecting them, could have been simultaneously cultivated from the natural form, in both Asia and America? Does it not seem fantastic that at least two distinct peoples independently conceived the idea of developing identical natural plants to the forms we see today, each people unaware of the other's experiments but both attaining the same results? Is it possible that two or more races, on opposite sides of the earth, might have had in mind the ultimate production of a seedless banana?

Race coloring

When we come to the subject of the origin of race coloring, we might, in view of the evidence, presume that the Atlanteans were the first white race; but the term "Atlantean" will not be taken as connoting this or any other pigmentation; for, in my opinion, Atlantis supported an influx of mixed races as North America does today, and as Europe comprises blendings of many racial colors;

for as Tylor says: "The distinction of color . . . has no hard and fast lines, but varies gradually from one tint to another."

In the narrative written in 1566 by Father Diego de Landa concerning the history, activities, and customs of the Mayas, he says in reference to the children: "They are not white, but a dull color caused more by the sun and *the continual bathing* than from nature." In another passage we read: "With the frequency their mothers bathe them and the sun, *they get brown.*"

As to origin

In this connection I might mention that during my first journey through the jungles of Yucatan I spent most of my time with the native Mayas. When possible, I lived with them, and while travelling through the jungles my constant companions included one, two or more Mayas. Throughout the daytime I invariably worked stripped to the waist, due to the intense heat. Before the end of the first month under these conditions, I had developed a tan the exact shade of the native Maya. In my book, *The Ancient Mayas,* I give an account of the journey which will convince the reader that my tan was certainly not acquired through excessive, or even moderate, bathing!

As to the origin of decided color distinctions, the truth may ever remain in obscurity. Perhaps the Negro was the first human being to appear. Perhaps black pigment protected the earliest man when the tropical belt wherein he dwelt had a much higher temperature than history chronicles. Climatic conditions, environment, dietetic changes, and chemical adjustments at various remote periods are believed to have caused pigmentary distinctions, in which event the red race developed in the tropical belt, under climatic conditions less hot but more humid than those experienced by the Negro. But who knows?

Mayas a white race

Whatever the cause of pigmentary divergence, there is good reason to believe that the white race possesses no earlier record than that of a race who apparently rose to a high culture in Atlantis. As we are endeavoring to show Cro-Magnon man in Europe, the Guanches of the Canary Islands, the early Egyptians, the early Antilleans, and the earliest arrivals in the Americas—including the Mayas—were originally from a single parent stock, perhaps we should expect a certain pigmentary uniformity. Here it is interesting to note that the Cro-Magnons were a tall, well-built people, having long skulls, fine foreheads, and were apparently of light or light brown-red complexion. The description of the Guanches is similar, and some add that

the latter possessed blue eyes. Dr. E. A. Wallis Budge says that the Egyptians "were red, or brown red, or reddish yellow in color. On the west of the Nile valley lived the *fair-skinned* Libyans." The Caribs of the Lesser Antilles are described as resembling the Mayas, who in my belief are not to be classed as red-skinned, but as of the white race. The present-day Maya skin color resembles a white skin tanned, but with an overlay of ashen-gray; a characteristic which may have come through environment, climatic and dietetic conditions, as in my own case.

Fair Peruvians

According to tradition, we learn that the early Quichuas of Peru were originally fair, had blue eyes, and sometimes auburn hair. This nation extended over an area of South America more than two thousand miles long. The first Spaniards to arrive under Pizarro found evidences of a highly cultured, prosperous, and advanced people *of vast antiquity*. Testimony offered later suggests that parallel cultures existed in Europe and Asia Minor in Cro-Magnon Magdalenian times.

Striking confirmation of my beliefs, in part at least, is seen in the recently published article quoting Dr. Ales Hrdlicka of the Smithsonian Institution. Dr. Hrdlicka is an anthropologist of international repute, for whose scholarly work I have profound respect. The compilation and writing of my present manuscript has occupied many years of labor, and the new theories herein submitted were developed prior to commencing the final correlation, and long prior to the appearance of Dr. Hrdlicka's article and similar recent conclusions of others, but all somewhat substantiating one or more of my opinions. As considerable of this manuscript is already in the hands of the printers, it is impossible to insert more than one or two corroborating items from such sources.

Dr. Hrdlicka's opinion

From the article quoting Dr. Hrdlicka and syndicated through the Associated Press (too late to verify but which I presume to be correct) I shall take a few excerpts in the hope that they are entirely authentic. Dr. Hrdlicka is reported as stating that " . . . more similarities than differences exist between the two races, [referring to the American Indian and the white man]. The *Indian is more like the white man than like the Asiatic* . . . The differences between the Indian and the white man are hereditary, but are due to some extent to the effects of different environments. The *races are strikingly similar* . . . Anthropologists generally agree *that*

the American Indian originally came from Asia in prehistoric times over a then existing land bridge across the Behring Strait and spread southward over North and South America . . . " According to the foregoing excerpts *"two closely related races with similar origins* apparently moved directly opposite each other around the world, to meet in the Americas."

I, too, endeavor to show that the so-called American Indian, as well as all other ancient races of the Americas, are "closely related races with similar origins", and of white extraction. But, contrary to the opinion expressed in the last excerpt, I show that instead of coming from Asia via the Behring Straits and meeting the white man in the Americas, they, in my opinion, *both came from an easterly direction*; the earliest arrivals from Atlantis, the white man from Europe.

Chapter Four
Cro-Magnon Man

AN, of very early periods of civilization, can usually be traced through the strata of soil in which domestic utensils, tools, and hunting weapons are discovered, isolated or lying beside his remains. As the science of geology assumes approximate dates for the beginning and ending of each stratum of the upper crust of the earth, we are enabled roughly to tabulate the stages of human activities. Future discoveries may enable us to possess a more accurate chronological sequence of man's progress from most primitive times.

Man's appearance

Man is assumed to have first appeared in the Late Tertiary Period, which (see table on page 51) is divided into Miocene and Pliocene (meaning less recent and more recent), the latter being that in which man is assumed to have first appeared. The so-called Java man is presumed to be of this period.

The next period, the Quaternary, is divided into the Pleistocene, (meaning most recent), also called the Ice Age, and is subdivided into Glacial and Post-Glacial ages or periods; and the Holocene, or "wholly recent" age, epoch, or period—(the nomenclature of divisions of time is still unsettled).

Some scientists hold that the beginning of the Pleistocene, or Ice Age, was about 500,000 years ago. More definite evidence of man's beginning appears in this age than in the Pliocene or last division of the Tertiary Period. The discovery of flint implements at Chelles in France would seem to assign the dawn of man to at latest the Pleistocene or Ice Age, were it not for discoveries made in gravel beds of Western Europe, consisting of tools, hunting weapons, bones of tropical fauna, and remains of man, discoveries which point strongly to an ante-glacial beginning.

An ante-glacial beginning

At whatever point we place man's cultural development, his presence upon the earth must be placed at a much earlier date. If we accept the minimum age of man's intelligent existence as 60,000 years, then there is nothing unreasonable in accepting evidence assigning man's culture as late as 25,000 years ago. Educational institutions in the very recent past fostered the belief that man's cultural beginning dates back to only a little more than 6,500 years ago. It is, therefore, somewhat difficult to expect those so schooled to be convinced that highly civilized races existed many thousands of years earlier, without a substantial argument backed by very sound evidence. To convince the average mind of the probability that a highly cultured race existed on a lost continent, ten to twenty thousand years ago, is still more difficult. Fully aware of this, I have endeavored to prepare the ground for acceptance of such prehistoric concepts, including the part that the Maya civilization plays in them.

To convince fundamentalists

As we have learned, geology and other sciences disclose the one-time existence of recurrent ice-ages and the devastating phenomena of titanic deluges. From scientific research in these fields, we also learn that the contours and general physical characteristics of continents existing today differ vastly from the land formations of earlier periods. Therefore, I shall presume that we are agreed as to the *probability* that a continent such as Atlantis once existed, and as to the *possibility* that on this continent a great civilization developed to a high degree of culture. I shall now endeavor to change the "possibility" to a second "probability" by submitting further evidence. We shall begin by examining the earliest known history of man and reviewing a few of the generally accepted conclusions.

The Basques

At present there is a people, known as Basques, occupying the provinces of Vizcaya, Guipùzcoa, and Alava in Spain, and the departments of the Upper and Lower Pyrenees, Ariège, and

Upper Garonne in France, all in the southeast corner of the Bay of Biscay.

The Basques of today are the sole representatives of the earliest known inhabitants of Europe. In remote times they were known as Iberians. Winchell says: "It is thought that the Iberians from Atlantis and the northwest part of Africa settled in the southwest of Europe at a period earlier than the settlement of the Egyptians in the northeast of Africa." The Iberians are presumed to have spread throughout the entire peninsula of Spain, from the Mediterranean to the Pyrenees and to the southern part of Gaul as far as the Rhone. Dr. Bodichon says: "The Atlanteans, among the ancients, passed for the favorite children of Neptune: they made known the worship of this god to other nations . . . in other words, the Atlanteans were the first known navigators." *The Basque tongue*

According to Paul Broca, the Basque language "stands quite alone, or has mere *analogies with the American type*. Of all Europeans, we must provisionally hold the Basques to be the oldest inhabitants of our quarter of the world." (Peschel, *Races of Men*, page 501).

Important to remember is a statement by Duponceau concerning the Basque tongue. He says: "This language, preserved in a corner of Europe by a few thousand mountaineers, is the sole remaining fragment of perhaps a hundred dialects constructed on the same plan which probably existed and were universally spoken at a remote period in that quarter of the world. Like the bones of the mammoth, it remains a monument of the destruction produced by a succession of ages. *It stands single and alone of its kind,* surrounded by idioms that have no affinity with it." *Cro-Magnon discoveries*

Within the territory of the Basques have been discovered, in recent years, examples of the earliest known works of man. The first discoveries were made in 1879 by Don Marcelino de Sautuola in an alcove within a cavern immortalized under the name of a neighboring meadow, Altamira, and not far from the Bay of Biscay near Santander, in Spain. Two decades later, a learned French abbé, Henri Breuil, made similar discoveries in a cavern at Font-de-Gaume, Dordogne, France, about three hundred miles from the Altamira find. Other discoveries were made later. *World's oldest picture gallery*

Apparently the art displayed in these first picture galleries is not all of one period. Henri Breuil and other workers

have recognized four main phases in its history, beginning with the early Aurignacian meanders and culminating in the Magdalenian frescoes.

Pre-historic modelling in clay

The subjects of all the earliest art examples were animals; later, human beings were freely introduced, also fish and sometimes birds. Among the animals, such as are seen at Font-de-Gaume, we find extraordinarily lifelike drawings "of about eighty bison, forty horses, twenty-three mammoths, seventeen reindeer and stags, and a dozen oxen and goats." Even cave-lions, wolves and other beasts of prey are depicted. The mention of bison in the list of animals is interesting as it clearly indicates that that animal was a native of the European continent as well as America.

Even these earliest discovered works display an unusual freedom of style. Harmer, in *Wonders of the Past*, says: "There is, for example, a drawing of the long extinct woolly rhinoceros, sketched in with swift red strokes upon the wall." An examination of the reproductions painstakingly made by Abbé Breuil indicates an amazing knowledge of anatomy and perspective. The action displayed in these earliest murals would put to shame the so-called modern

Mark of the hand

artists. As J. A. Hammerton says: "It is humiliating to our pride of progress to contemplate the perfection of line and the highly developed technique attained by artists who painted in dark caverns more than 20,000, and possibly 50,000 years ago."

The art of these earliest people in Europe is not confined to mural paintings alone. In the later phases of their culture we discover remarkable examples of lifelike modelling in clay. The first indication of this art was discovered in Tuc d' Audoubert (near the border of France and Spain) in the form of a male and female bison fashioned in clay. Numerous examples of sculpture in stone also indicate extraordinary fidelity to nature.

Religion and customs

According to Harmer's account we read further that: "Some caves contain silhouettes of human hands, stencilled around or *impressed by the living hand*." (Italics are mine). This statement is of great importance, as we shall see.

Another significant sentence is: "At Gargas, in the French Pyrenees district, where there are 150 such designs (hands) most of them show amputated fingers." This will be referred to later.

In tracing back the earliest doings of the human race, we find that religion and customs play dominant parts. Therefore

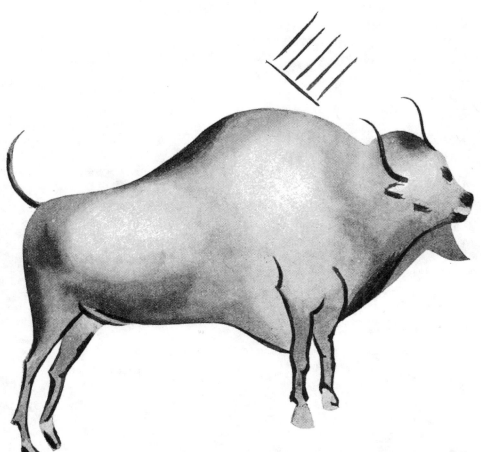

Black bison painted on the roof of the Altamira cave in Spain. Aurignacian art executed at least 25,000 years ago. The effect of relief, perspective, and boldness and freedom of line elevates the art of this period far above the known work of the Egyptians, Cretans, and early Greeks.

Water color sketch by author from accurate drawing made by Abbe H. Breuil.

when we learn that the use of animal masks among these Aurignacian and Magdalenian peoples was customary as an accessory for stalking big game, we discern a decided connecting link between them and the much later civilizations in which the masks were so used. This information becomes all the more important when we find that this custom developed, still in prehistoric times, into the practice of masked dances and ritual masking, and descended to all the principal historic civilizations, and is even prevalent among certain races to this day.

From the drawings it is very evident that the so-called dawn-men recognized "the existence of invisible powers more potent than their own", and that, "these early worshippers sought to bring themselves and their daily needs into contact with the unseen by graphic means." Summing up, Harmer says of the Cro-Magnons: "Thus the general conclusion emerges that the impulse behind this pictorial art was a magical one."

Dawn man and the Magic arts

It is therefore clear that the magic arts, which already appear in these drawings, were evolved thousands of years prior to the time when the seats of the Magi were established in Media (in what is now Persia) and in neighboring centers of culture. In connection with the assumption that Persia was the seat of the magic arts, the *Encyclopedia Americana* says of the word Magi "that it is an Accadian term, recently brought to light by Assyrian scholars; Accadian being the language of the people of Babylon and Media." The Accadians, earlier known as the Akkads, were presumed to be colonists from Atlantis, as we shall see.

Another feature of "dawn-man" art is a sculptured figure of a woman holding a horn in her right hand. This example was discovered in a rock shelter at Laussael in the Dordogne district of France. The chief characteristic of this figure is the steatopygous, or fatty development of the thighs among the females. (p. 66).

Mystery of Cro-Magnon man

Some writers view the Cro-Magnons as a root race indigenous to the Biscayan area, while others, although believing them to be colonists, frankly admit their inability to suggest a source. The Cro-Magnons are the first recorded civilized people in the eastern hemisphere, yet they have displayed an advanced draftsmanship described as "sketched with swift, red strokes." Their knowledge of perspective, as in the position of the limbs and in the shading, and their true presentation of animal forms, compare favorably with the work

Aurignacian Female figure carved in oolite limestone. Showing that a definite steatopygous type was prevalent in those days.

Extreme type of steatopygous present-day South African woman. Drawn by the author from a photograph reproduced in *Origin and Evolution of the Human Race* by Dr. Albert Churchward.

Steatopygous types are to be observed among the present-day Hottentot and Bush women of South Africa. The Bushmen were developed from the Pigmy and the Hottentots from the Bushmen. The Pigmy of Africa is considered by many to be the earliest form of man, and in all probability his evolution took place in the conjectured continent of Gondwana-land, of which Africa is presumed to be a remaining part. Steatopygous types are recorded in stone carvings dating from Aurignacian Cro-Magnon times, such as those discovered in the Palæolithic remains in Austria, Malta and elsewhere, and later among the Egyptian images.

of modern artists. These characteristics alone would indicate a much earlier beginning.

Remote centers chosen for art display

A point—perhaps of significance—is that all these prehistoric works of art are to be found only in the deepest parts of caverns. Some of the works are 100 yards from the entrance, others are not seen until a distance of at least half a mile back is reached. All are executed in almost inaccessible spots, either where the roof of the cavern is no higher than three to six feet, or high on a lofty wall, or

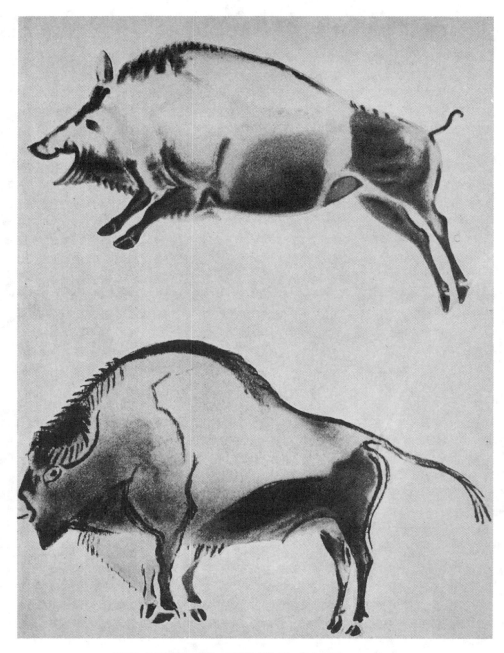

THE BISON AND THE BOAR IMMORTALIZED
BY THE EARLIEST RECORDED ARTISTS

The lower picture is of a lowing bison superimposed upon another, much defaced. This, together with other evidence, indicates two distinct divisions of Cro-Magnon art many thousands of years apart, known as Aurignacian and Magdalenian respectively. The astonishing artistic ability and advanced knowledge of anatomy displayed prove the culture must have persisted elsewhere for many thousands of years.

in the most remote grottos. Very few paintings are to be seen in cave chambers which were occupied by the people themselves. Are we to infer that they entertained a perpetual fear, not so much of the attack of animals or human beings as of something still more ominous, as a dread cataclysm? Or were these pictured but unoccupied chambers in the nature of temples or abodes of the gods? Many of the cave entrances are "high up on a cliffside"! Does this fact indicate that these artistic people feared the sudden rising of the ocean waters—another flood?

Cultured Cro-Magnons

As no evidence of progressive stages in their art has yet been discovered and as their knowledge, appreciation, and understanding of beauty are probably the outgrowth of thousands of years, it appears conclusive that their civilization began elsewhere than in Spain and France.

The four widely-spaced successive invasions of the Aurignacian-Magdalenian people into western Europe are indicated by the four main phases of their art. The Abbé Breuil is of the opinion that these invasions took place, either from the south or Mediterranean direction, or from the Atlantic coasts of Spain and France. He refuses to contemplate any area east of the Biscayan region as a possible source of Cro-Magnon culture.

Our modest delight in our high civilization no doubt somewhat distorts our view of prehistoric cultures, especially that of Cro-Magnon man. We are inclined to regard our very early ancestors as savages and barbarians, or worse. Darwin's *Origin of Species* undoubtedly would have received earlier general acclaim had he been able to show our descent, not from the higher animals, but from beautiful angels. But a careful study of the works left by very ancient civilizations is liable to minimize our self importance materially.

Cro-Magnon man among world's best

Many have the idea that very early man, such as the Cro-Magnon, was covered with long hair, possessed a low, receding brow, repulsive features and long gangling arms. Perhaps it may assist us to a better opinion to say that when first examining specimens of this ancient race, anthropologists expressed astonishment at their extraordinary height and brain capacity. Paul Broca, for instance, discovered that the brain-content of a female Cro-Magnon skull surpassed that of the average male of today. The average height of this race was six feet, one and one-half inches. As an indication of high racial development, the shoulders were broad but the arms were short as compared with the legs. Sir Arthur Keith in *Ancient Types of Man* says that *the Cro-*

Magnons were one of the finest peoples, mentally and physically, that the world has ever seen.

This information immediately suggests certain questions. If the Cro-Magnon man was such a highly developed physical and mental being, what ancient civilization did he represent? At what period in prehistoric times did his progenitors found such a culture? If at all, for how long did his forefathers dwell in Atlantis; was it from the inception to the completion of their cultural development?

Atlantis and Antillia

We shall continue, however, upon the assumption that the Cro-Magnons, whose art was known as Aurignacian and Magdalenian, actually existed in Europe in the Paleolithic or Old Stone Age, at a period variously estimated between 20,000 and 50,000 years ago, and that they were not indigenous to the Biscayan area but were undoubtedly of a western origin.

Geology provides us with the presumption that in the Miocene Age, i. e. the first half of the Late Tertiary Period, a body of land in continent form occupied an area in what is now known as the Atlantic Ocean. Toward the end of the Late Tertiary Period, i. e. in the Pliocene, this continent, due to successive volcanic and other disturbances, began to disintegrate.

Spence suggests that "disintegration resulted in the formation of greater and lesser insular masses", with which I agree. Two of the larger insular masses he names Atlantis and Antillia. The former was situated near the European and African shores. The latter was in the region of the present West Indies. These islands, and their connecting chain of smaller islands, persisted until the late Pleistocene Age, otherwise the beginning of the Post-Glacial epoch.

Europe's first colonists

The theory of a succession of geological divisions and changes in the Atlantic Ocean area is supported by considerable and varied evidence. From this same evidence we may presume that numerous major volcanic eruptions, upheavals, and sinkings took place on the continent of Atlantis, and that from one of the major sinkings which occurred in the eastern area of that continent, escaping hordes arrived hurriedly on the shores of Europe. These people, who I believe were the Cro-Magnons, invaded the area of Biscay in Spain and France, and were no doubt small in number. They may be termed the first colonists from sinking Atlantis, although there is nothing illogical in assuming that prior migrations had taken place.

Spence assumes the date of the first European invasion by Cro-Magnons as approximately 25,000 years ago. He further assumes that the art of these people, known as Aurignacian, flourished from that period until 8,000 B. C. I have purposely accepted his arrival date, primarily for its modesty. The majority of opinions assign a much earlier one.

Spence assigns 14,000 B. C. as the approximate date of the second Atlantean migration to Europe. These people, whose art is known as Magdalenian, apparently influenced succeeding civilizations of Europe and Asia Minor to a great extent, and thus become vitally related to our story.

Le Plongeon's opinion

It is not clear as to the exact territory which was occupied by the second invasion. Spence and others infer that it covered practically the same area as was settled by the first migration. The evidence indicates the probability of this surmise, but it is possible that at a later date the migration spread south and east. By following other channels of thought, the latter hypothesis becomes, as we shall see, more acceptable, and it appears that this second migration may throw some light upon mysterious peoples which existed along the northern shores of the Mediterranean and beyond, in southern Asia and the Valley of the Euphrates, long prior to historical times.

Augustus Le Plongeon says: "The Mayas seem to have penetrated the interior of Asia as far as Mesopotamia, and to have dwelt a long time in that country as well as Asia Minor, . . . although from remote ages they had sojourned in the Dekkan and other localities in the south of India. . . . Although the Greek language was composed in great part of Maya, and the grammars of both these languages were well-nigh identical, they and the Aryans, so far as shown by philology, never had intercourse with each other." This statement he follows later with the question: "Shall we say that when the Mayas colonized the countries of the south of Asia, then the banks of the Euphrates, then the Valley of the Nile, and later Asia Minor, it was in ages so remote that the Aryans, regarded as a primitive people living at the dawn of history, had not yet multiplied in such numbers as to make it imperative for them to abandon their native country in search of new homes?"

Aryans and the dawn of history

It will be noticed that Le Plongeon has no hesitation in stating the early people in the above mentioned areas were Mayas. But whereas he believes they went to Asia Minor direct from Central America, my opinion is that, although directly related, they

were not from that area, but from a common motherland not now in evidence. It will also be noticed he mentions the Aryans being "regarded as a primitive race living at the dawn of history." Perhaps I shall be able to show that the Aryans were also from the same root race as were the Mayas and other earliest peoples of Asia Minor.

In view of the evidence pointing strongly toward the conclusion that the people of the Cro-Magnon invasion of Europe, 23,000 B. C., were Atlanteans, and that the next major migration from the lost continent, approximately 14,000 B. C., spread as we shall see, over the area referred to by Le Plongeon, is it not possible that the Aryans, known to have occupied that area, were members of the same stock and originally from Atlantis?

Aryan Philological root unknown

In support of the hypothesis, we learn from the *Encyclopedia Americana* that (speaking of the Aryan languages and commenting on a prevailing opinion that the Sanskritic group spoken by the old Brahmins is the root): "It is more correct to consider it [Sanskrit] as the first branch *and assume the existence of a root not now accessible to direct investigation.*" In other words, philologists confess they do not know the Aryan root.

It is admitted that a definite root language is known to have existed at some remote time from which the Aryan languages sprang. Under the heading "Aryan Race" in *Americana* we read: "From a multitude of details it has been established that the original mother tongue of all these peoples was the same." But there is not even a guess offered as to whence came such mother tongue.

Under the chapter discussing the Maya language we shall review further evidence on this point.

Exploded beliefs

All histories of Egypt assign no earlier date to that civilization's beginning than approximately 4,500 B. C., or the reign of King Menes. That Egypt has a much earlier culture is now undeniable, although there are still a few archeologists and historians who view with considerable skepticism, the probability of prehistoric culture possessing any degree of importance.

Until comparatively recent times the scientific world has not admitted the possibility of man's antiquity beyond a few thousand years. A literal acceptance, *in toto,* of the narrative and ages and period assigned to events as set forth in Genesis was a foregone conclusion, and to question that which was told by divine revelation was horrifying, ridiculous, and impious.

Until the year 1859 the scientific and the lay mind accepted as fact that man's beginning on earth was not more than 7,000 years ago. Cuvier, the great French anatomist and zoologist, laid down an axiom that no human remains had been found in a fossil state, or in conjunction with the remains of the extinct animals. (See *Problems of the Future* by S. Laing). Archbishop Ussher clung steadfastly to the Genesis story and declared man's dawn was not earlier than 5,000 B. C. But when, in 1859, Sir Joseph Prestwich read his paper to the Royal Society in England, confirming the discoveries of M. Boucher Crèvecoewi de Perthes, which proved that flint implements fashioned by human hands were found *in Quaternary gravels* and brick earths, scientists began to realize their limited vision. The finds were made alongside remains of mammoth and other extinct animals 100 feet below the present river bed in the valley of the Somme.

Man's beginning 5000 B.C.

With proof of man's existence as early as the Quaternary period, and the high probability of established civilizations in very remote ages, let us turn to the ancient writers and other sources of information for verification of the latter claim. It is surprising, at times, to learn how much reliance may be placed upon the writings of some of the earliest scribes. Previously, the significance of their works rose little above that of the simple fable. Advancing science and additional knowledge, however, are rapidly authenticating material in these works to the point of historical importance.

Early scribes reliability

It is conceded that all legends and myths are founded more or less upon truth. Distortion, naturally, is the inevitable result of time, but by careful comparison with somewhat analogous accounts from widely scattered areas, fundamental characteristics frequently show remarkable parallels. If, therefore, extraneous data disclose that a certain amount of fact underlies most myths and legends, let us, for the time being, consider them as a medium of information, subject to more definite acceptance upon substantiation through other sources.

Legends and myths founded on truth

To trace accurately the human spoor in its tortuous windings, from the dawn of culture, through countless centuries to historic times, is an impossible task, but occasionally some definite knowledge is discerned through the dense veil of mystery. Pre-eminent among these odd links with antiquity is, in my belief, the so-called oldest remaining structure erected by man—the Great Pyramid.

It is generally believed that the Great Pyramid of Cheops in Egypt was erected by Khufu, or Cheops, as he was later known to the Greeks. According to Herodotus, Khufu was "a most flagitious tyrant." Some modern theorists say he was not a tyrant but that owing to the inundation of the land at that period and consequent impossibility of agricultural labor, Khufu conceived the immense building project to give work to the vast army of unemployed. Other good guessers say the pyramid was built by slaves under the orders of an arrogant ruler. All of which is flatly contradicted by far more convincing evidence.

The Pyramid of Cheops

To begin with, the Great Pyramid of Cheops is, among existing structures, without a rival. It exhibits not only an advanced knowledge of mechanics and constructive ability, but undoubtedly indicates learning of a very high order. It was not the result of labor conditions, not an emergency measure to appease a hungry horde, but the outcome of calm, scientific calculation.

It is practically agreed among Egyptologists that the Great Pyramid of Cheops was erected during the fourth Egyptian Dynasty, or approximately 3,733 B. C., though some believe in a much later date. A great deal of reliance as to the origin of Cheops is placed upon the reports of Herodotus, the Greek historian, who was born about 484 B. C. He gathered his information concerning ancient Egyptian history from Egypt's learned priesthood. That he did not believe all he learned from these sages is evident by his scoffing remarks in reference to the Egyptian claim that their ancestors came *from the direction of the setting sun* and that those ancestors were the *"most ancient of men."* He regarded the last expression as boasting. (See Herodotus, *Hist.* Lib. II. II).

Herodotus' disbelief

On the other hand the earliest known Egyptian philosophers state that the Great Pyramid was in existence long prior to the so-called historical times. It is perfectly evident that this, one of the world's most stupendous monuments, was not erected by a people just emerging from savagery. My experience as an architect convinces me of its supremacy in engineering skill. Even assuming for it an age no greater than 4,000 B. C., it is obvious from the structure itself that long centuries of progression in the structural sciences must have preceded the erection of the Great Pyramid. Later, it will be seen that in all probability the Pyramid of Cheops forms a strong connecting link between the Atlanteans and what might be termed their post-

humous colonial possessions, on both sides of the Atlantic Ocean. (See Chapter IX).

Another convincing point as to a great age of Egyptian culture prior to the dynasty of King Menes is a statement in the so-called *Book of the Dead*. Translated, we read: "A hieratic inscription upon the sarcophagus of Queen Khnemnefert, wife of Mentu-hetep, a King of the eleventh dynasty (c. 2,500 B. C.), states that a certain chapter of the *Book of the Dead* was *discovered* in the reign of Hesep-ti, the fifth King of the first dynasty, who flourished about 4,266 B. C." It will be noted that at that date, 4,266 B. C., the chapter was *discovered*. Its *discovery* was in the so-called beginning of Egyptian history.

Book of the Dead

The *Book of the Dead* is a collection of chapters of rituals, beautifully illuminated and consisting of one hundred and eighty-six chapters, treating of psychostasia, or weighing of souls, in the "Double Hall" before Osiris. This legendary Egyptian King, (Osiris) we shall discuss later.

From the structure of the Great Pyramid and the statement about the *Book of the Dead* it appears that there is evidence to prove the existence of an Egyptian culture long centuries prior to both. At present I shall not submit further data in support of this, as we are now attempting to trace the course of the Cro-Magnon migration from sinking Atlantis to Europe, thence to Asia Minor and eventually to Egypt.

We have learned that a people who once occupied the Valley of the Euphrates were known as Akkadi, who it is suggested were members of the second major exodus from disintegrating Atlantis. It is interesting to note that according to Sir Henry Layard in *Ninevah and Babylon,* the ancient name of the Mediterranean was Akkari.

The Akkads

The Akkads are said to have passed the barbaric stage when they invaded what is now known as Chaldea. Scientists admit that they do not know at what period the Akkads immigrated into that territory "since at the dawn of history they are already merged in the Semitic conquering race." The Akkadi were skillful architects, excellent engineers, as is testified by the efficient dams and canals they erected. Their laws mark an advanced social organization. Their religious influence affected the Babylonians, and through them, eventually

the whole of Christendom. They knew the use of metals, and were proficient in numerous arts and crafts.

Some of the most important information, however, is in the fact that they revered the holy mountain of Bel. They "lifted their eyes unto the hills" on the northeast, "the Father of Countries", and imagined it *the abode of the gods.*

"The type of holy mountain was therefore reproduced in every palace and temple by building it on an *artificial mound* with trees and plants watered from above."

Holy Mountain of Bel

The Hittites, kinsmen of the Akkads, likewise erected structures upon *artificial mounds.*

This information is decidedly reminiscent of the "Sacred Hill" of Atlantis. A further strong link in our chain of testimony, in my opinion, is the evidence of not only the artificial earth-mound but also the squared, stepped pyramids, *"having their corners adjusted to the four cardinal points."* Here we learn of an Akkadian method of construction and orientation identical with those of the Egyptian and Maya. The stepped pyramid is seen in the Valley of the Euphrates, Egypt, the Maya area in Central America, and in the Valley of Mexico. It is further of importance to remember that the pyramids erected by the aforementioned peoples are presumed to have been used for astronomical purposes.

The following description of the great mound Babil (a Maya word) among the ruins of Babylon, which represented the temple of Bel, is not only interesting, but it furnishes additional evidence connecting the early races of both hemispheres with the Mother of Empires theory.

The Temple of Bel

In Anderson's *Extinct Civilizations of the East,* we read that the temple of Bel "was a pyramid of eight square stages, with a winding ascent to the top platform. There stood *an image of gold forty feet high,* two other statues of gold (forty feet by fifteen), and two other colossal objects *all of the same precious metal."* This reminds us of the descriptions of Plato's Atlantis and also pre-Inca magnificence.

The famous mound Birs Nimrud has been proved to be the ruins of the "Temple of the Seven Spheres." It was a national structure and was rebuilt by Nebuchadnezzar the Great. This illustrious monarch of the New Babylonian or Chaldean Kingdom, who ascended the throne as his father Nabopolassar's successor in the year

604 B. C., informs us that the original tower *"had existed many ages previously."*

"The entire height of this temple was only 156 feet, but the general effect of its appearance would be very striking to any modern observer, since each of the seven stages was a mass of one color different from all the others, and representing symbolically one of 'seven stars of heaven.' The first, Saturn, black, the *masonry* being covered with bitumen; the second, Jupiter, orange, by a facing of orange bricks; the third, Mars, blood-red, by bricks of that color; the fourth, the Sun, *covered with plates of gold;* the fifth, Venus, pale yellow, by suitable bricks; the sixth, Mercury, blue, *by vitrification,* the whole stage *having been subjected to intense heat after building;* the seventh stage, the Moon, probably covered with plates of silver."

Here we learn of further comparisons in the description of the palace in Atlantis, as narrated by Plato. In Chapter X we discuss the origin of Mound-Building in detail.

Until recent years the oldest known example of cuneiform writing was that displayed on a porphyry cylinder seal of the Semite King, Sargon I, who flourished about the year 3,800 B. C. But in the light of discoveries made by the University of Pennsylvania's Expedition to Nippur, the age of King Sargon's seal pales into insignificance.

Dr. Peters, reporting on the epigraphic material secured by Mr. Haynes, says: "We found that Nippur was a great and flourishing city, and its temple, the *temple of Bel,* the religious center of the dominant people of the world at a period as much prior to the time of Abraham as the time of Abraham is prior to our own day. We discovered written records *no less than six thousand years old,* and proved *that writing and civilization were then by no means in their infancy.* Further than that, our explorations have shown that Nippur possessed a history extending backward of the earliest written documents found by us, *at least two thousand years."*

We have learned, therefore, that written records exist *at least six thousand years old,* and proof of historic happenings at least two thousand years earlier. Eight thousand years! Proof also that the pyramid, writing, and an advanced culture flourished in Asia Minor thousands of years prior to Egyptian historic times.

Commenting upon the above discoveries, Dr. Hilprecht says: "I do not hesitate to date the founding of the temple of

Bel and the first settlements in Nippur *somewhere between 6,000 and 7,000 B. C., and possible earlier."*

We see, then, that scientists are being forced into a belief in the existence of highly cultured races at least 7,000 years B. C., "and possibly earlier." But it is inconceivable that such culture was born and matured overnight. It is a foregone conclusion that to attain such an intellectual level the process of evolution occupied many more thousands of years. Are we wrong, then, in presuming that an advanced culture, or cultures, existed in Asia Minor approximately between 9,000 and 10,000 B. C.?

Temple of Bel founded 9000 years ago

In view of my deductions, submitted later, based upon the Sacred Mound, the squared pyramid, Osiris worship, and scores of other identical Akkadian and Atlantean features, the importance of the above testimony concerning the Akkads must be borne in mind. I believe it to be merely a matter of time when, through more definite information coming to light, a comprehensive and fascinating story of ancient Akkadian life will unfold. In the meantime we must be content with the crumbs of knowledge which fall from the table of the gods.

Continuing, we learn that, later in their history, the Akkadi were known as Kaldi, and later still Chaldeans.

In the *British and Foreign Review* of January, 1870 A. D., there is a statement that: "Babylonia was inhabited at an early period by a race of people entirely different from the Semitic population known in historic times. This people had an abundant literature and they were *the inventors of a system of writing which was at first hieroglyphic . .* Of the people who invented this system of writing very little is known with certainty, and *even the name is a matter of doubt."*

Early Asia-Minor hiero-glyphic writing

To indicate the almost entire lack of knowledge of ancient history among some of the modern historians, we read under the heading "Babylonia" in the *Encyclopedia Americana*: "Discoveries of the recent decades *seem to confirm the idea that Babylonia is the cradle of civilization."*

Another piece of possibly corroborating evidence connecting the early cultures of Europe, Asia Minor, and the Americas with the Mother of Empires—Atlantis—is the practice of sun worship. Later I shall attempt to show how this strange rite plays an important part in man's biography.

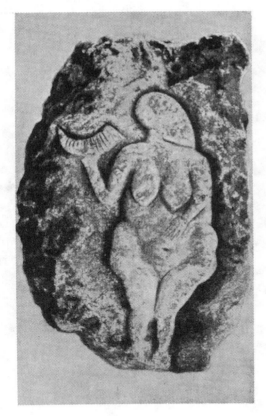

Mark of the Hand among Cro-Magnon man. This strange custom was prevalent in Aurignacian times. The above example, however, is from Altamira and belongs to the Magdalenian period. The method employed in this case consisted of smearing the hand with a red pigment and pressing it against the cave wall. The sketch was accurately copied by the author from an illustration in "Altamira", by Abbe H. Breuil.

Upper left. Mark of the Hand on the wall of a building in Chichen-Itza, Yucatan.
Lower left. Steatopygous female figure holding horn, from rock shelter at Laussel, Dordogne, France.

The present-day Basques are essentially sun-worshipers. There is no evidence to show that their ancestors, even in remote times, were other than sun-worshipers. The so-called American Indians are also sun-worshipers. Sun worship was practised in very remote times by all of the ancient civilizations, including Babylonians, Persians, and Egyptians.

Mark of the Hand

Thus it would seem that the people of the first two migrations from Atlantis to Europe, namely, those known as Aurignacians of the first migration 23,000 B. C., and the Magdalenians, who arrived approximately 14,000 B. C., brought with them the practice of sun worship.

Another strange link which appears to connect the culture of the Aurignacian Cro-Magnons with that of the North American "Indians" and the Mayas of Yucatan, is the unique mark of the hand.

In *A Textbook of European Archaeology,* by Macalister, referring to Aurignacian art we read: "The oldest remains are not human figures but human hands which are traced upon the walls of certain caves by the following method: a hand was pressed against the wall and coloring matter projected upon it, either with the other hand or by expulsion from the mouth of the artist. The process finished, the hand would be left silhouetted, or rather stencilled upon the wall . . . A very curious feature of the Gargas (caves in the Hautes-Pyrenees district) hands *is the mutilation of the fingers which they display.*"

Method of Hand Stenciling

We find the identical practice in many parts of America. Beckworth says that among the Crow Indians "fingers were dismembered as readily as twigs." Slaves in Mexico before sacrifice stencilled their hands on the door posts of their captors. To this day the "hand of Fatima" is to be seen in the plaster beside Arab doorways. Many times I have seen the mysterious "sign of the hand" impressed on the walls of ancient Maya structures in Yucatan; some examples were in red, others in blue, yellow, or black, each color apparently of symbolic significance.

Land bridge of coral

The curious hand sign, impressed on the Maya buildings in Yucatan, so interested John L. Stephens that in 1843 he wrote to Mr. Schoolcraft for an explanation. That great student of the American Indian answered that he had met the sign of the red hand in many parts of the United States, principally among the Dakotas,

Winnebagoes, and other Western tribes. He said that the sign of the hand stands, in the system of picture writing, as the symbol of strength, power or mastery thus derived.

It is possible that this strange sign denotes supplication to the Deity, or Great Spirit. The priests smeared the hand with white or colored clay and impressed it on the breast, the shoulder, or other parts of the body. This act conveyed the idea that a secret influence—a charm or mystic power—was given to such, for instance, as the dancers in religious ceremonies. Figures lacking the hand imply weakness, cowardice, or impotence arising from fright, subjugation, or other causes. Oddly enough, the strange custom prevails among civilized peoples to this day. All legal documents, it will be remembered, bear the words "under *my hand* and seal."

While on the subject of Aurignacian and North American "Indian" culture, we cannot ignore the extraordinary resemblance between the lifelike drawings of the bison on both continents. Spence says: "Compare the pictures of a stag and buffalo hunt from Cogul with the drawing taken from the book of an Indian prisoner at St. Augustine, representing the same thing, or the Aurignacian wall painting at Alpera depicting a great hunt, with the petroglyph at Millsboro, Pennsylvania. If these do not spring from the same artistic sources then there is no resemblance between any two forms in the whole range of art."

It will be remembered that in Plato's narrative we learn that elephants were numerous on the continent of Atlantis. In Aurignacian art the mammoth is frequently seen. The murals on the walls of the cavern of Font-de-Gaume, in the Dordogne valley in France, depict among other animals twenty-three mammoths. Statuettes of the mammoth have been found at Predmost and other places.

Coming to this continent, we find the elephant considerably in evidence in the art of the Mayas.

It is significant that the undisputed form of the elephant used in Maya art is seen only in the earlier works of the Mayas, such as at Copan. Some students believe that what might be termed the conventionalized elephant form is to be seen in the God "B", and other divinity forms. Quoting Spence we read: "The so-called elephant gods with mammoth characteristics were *invariably associated with the eastern point of the compass,* and not the west. Thus God B—as he is usually called, an 'elephant-headed' god who is probably Quetzalcoatl, is

associated, says Schellhas, with the signs of the east, and like Quetzal-coatl, is also associated with the mystic western land of Tlapallan in the Atlantic. He carried Quetzalcoatl's peculiar perforated staff, the *caluac*, and is connected with the tree of life, another Atlantean or Hesperidear. symbol."

Another probable connecting link between the Mayas of Yucatan and Cro-Magnon man is seen in the custom of the use of shell ornaments.

Painting of bones

Macalister says that the early Cro-Magnon man was evidently buried in "wrappings of hides and certainly in elaborate ornaments, presumably of leather into which devices of shells had been sewn . . . In addition, there were necklets, armlets, anklets, and girdles of shells, fish vertebrae, and teeth of animals." It is interesting to learn that the shells were "perforated for suspension as ornaments, either singly or grouped in collars or similar decorations." Macalister's description as to how the shells were worked and grouped is analogous to the wampum made by American "Indian" tribes. The wampum is made from beads laboriously ground from various species of shells. The striking analogy lies in the fact that, whereas shell ornaments are found elsewhere, the manufacture of the wampum "was an art which Aurignacian man had in common with prehistoric and historic American man."

Regarding the Cro-Magnon custom of the preservation and painting of bones, we see exactly the same practiced among the Mayas.

Returning to Southern Asia for further evidence of late Cro-Magnon, or Magdalenian art, we find few more direct data, except possibly the remarkable resemblance between the highly skilled strokes of the Biscayan cave artists when depicting animals and, for instance, the head and shoulders of an Indian zebu as portrayed on a tablet discovered in Mesopotamia. Indirect evidence (submitted later) will tend to strengthen considerably the hypothesis that the mysterious people who antedated the earliest Egyptians were known as Akkadi, that they progressed eastward along the north Mediterranean shores and eventually settled in the valley of the Euphrates, and, further, that they originally formed the second major migration from Atlantis.

The third Major sinking of Atlantis

We now come to the third major migration to Europe from sinking Atlantis. This, perhaps the most important eastward migration, is known as the Azilian-Tardenoisian, and took

place, approximately, between 9,500 and 10,000 B. C. The date approximated in the Plato narrative is 9,600 B. C. Considerably more evidence exists in support of this great exodus from sinking Atlantis than for the two previous major events, although I shall refer to but a very few of the more important points.

In my opinion there is considerable evidence to show that at approximately this time (9,600 B. C.), cultured civilizations, linked by art and other affinities with the European Cro-Magnons, existed on the American continent. The evidence now to be submitted, therefore, is intended to show a direct connection between these ancient peoples of the two hemispheres.

Reader to draw own conclusions

The interested reader must draw his own conclusions after a careful analysis of the complete testimony. Friendly constructive criticism and discussion will contribute far more toward a possible final solution of the mystery of the prehistoric past than vitriolic, blanket denunciation. My efforts are primarily confined to the construction of a reasonably acceptable complete story of man's history in an endeavor to clarify the true origin of the great Maya civilization, its termination, and its rightful place among the cultures of all time.

Chapter Five

East is West

S before remarked, I believe that it is reasonable to presume the erstwhile existence of at least one grand cycle, and possibly more, of human civilization, prior to that which we will term the Atlantean.

It is possible that the true West African or Sudanese Negro is a remnant of one such previous cycle of Gondwanalanders, for instance. The origin of the Negro race is admittedly lost in antiquity. Sir Harry Johnston, in *Living Races of Mankind,* says: "The negro species . . . originated probably in India *at an extremely remote period.*"

Likewise, the origin of the Bushman is lost in the very dim past. Lydekker, in *Living Races of Mankind,* says of these primitive people: "Among all the numerous questions connected with the origin and relationship of the various aboriginal branches of the human race, none has proved a greater puzzle to anthropologists than the ancestry and affinities of the natives of Australia." One branch of thought allocates the Australian aborigines to Negro stock. Another theory is that they resemble the low Caucasian stock of Veddas, Todas, and Ainus of Asia.

Mystery of Bushman's origin

The aborigines of Tasmania, now extinct, were on the other hand, as Lydekker states, "Oceanic Negroes" and "their case presents one of the most remarkable ethnographical phenomenons in the world."

Dr. A. H. Keane says that the first people recorded as occupying India was a *black people.*

India's first people were black

Here we have seen that the first peoples to occupy Africa, India, Tasmania, and Australia were Negroes. We learn that the traditions of India and other Asiatic countries reveal stories of a former continent which connected India with Africa, Australia and possibly South America. We have also seen that far scattered African tribes possess traditions which tell identical stories of just such a southern continent, which they refer to as *a lost homeland.* Whether or not this refers to the lost continent of Lemuria or to Gondwanaland, geology apparently establishes the fact of the one-time existence of such a mighty land-bridge.

We are somewhat assured, therefore, that a previous cycle, or grand cycle, of civilizations existed, but we have no evidence to prove that they in any way influenced what I term the Atlantean grand cycle of civilizations.

Similar corroborative testimony can be offered in support of the theory that the Pacific Ocean once possessed a continent but, as with the occupants of Gondwanaland, there appears no evidence directly to connect those people, either in arts, language, or customs, with the races I am endeavoring to include as migrants from the now submerged Atlantis.

Probability of earlier civilizations than Atlanteans

That the inhabitants of vanished Gondwanaland and Lemuria possessed a certain advanced culture is highly probable; that their civilization was born and thrived prior to that of Atlantis is also probable; that their culture definitely influenced the development of the Atlantean civilization is questionable; but, in view of the similarities to be observed among some of the legends and myths of the Negroes and those of other very early races, it appears possible that some of the religious rites, customs and perhaps other branches of culture—whose seat of origin we now seek to ascribe to Atlantis—actually began among those pre-Atlantean peoples. In other words, I do not wish to convey the impression that it is my belief that the early Atlanteans founded *all* the principles of intellectual development. Undoubtedly, other cultured race-cycles preceded them, possibly many grand cycles, and naturally

certain characteristics of the fading cycle influenced the new-born races. The cataclysmic earth disturbances of the past have possibly placed a permanent barrier between present man and records of his earliest forefathers, but there is no testimony denying extremely early cultures —cultures which thrived long prior to that which we are endeavoring to assign to Atlantis.

So far in our discussion it has proved interesting to follow the succession of data in an effort to show the possibility at least of verity in Plato's narrative. It is of still further interest to learn that Plato is not alone in recording the story of the lost continent of Atlantis. Perhaps some of the following evidence will assist in vindicating the venerable sage.

Verifying Plato's story

Seylax of Caryanda, a contemporary of Plato, mentions an island off the African coast which "is twelve days coasting beyond the Pillars of Hercules (Gates of Gibraltar) where the parts are no longer navigable because of shoals, of mud and of seaweed."

We learn of similar reports from Aristotle (a pupil of Plato) and Avienus (4th century A. D.). Writing of Himileo's voyage about 500 B. C. Avienus says of the waters beyond the Pillars of Hercules: "That the sea has no great depth and that the surface of the earth is barely covered by a little water . . . Farther to the west . . . there is boundless sea."

Donnelly says: "An extract preserved by Proclus taken from a work now lost, which is quoted by Boeckh in his commentary on Plato, mentions islands in the exterior sea, beyond the Pillars of Hercules, and says it was known that in one of these islands the inhabitants preserved from their ancestors a remembrance of Atlantis."

Later he informs us that: "Theopompus (400 B. C.) records an interview in which Silenus reported the existence of a great continent beyond the Atlantic," and: "Out of curiosity some of them crossed the ocean and visited the Hyperboreans."

Others who mention Atlantis

Diodorus Siculus states that the Phoenicians discovered "a large island in the Atlantic Ocean, beyond the Pillars of Hercules, several days sail from the coast of Africa."

Cosmo, the old monk who lived one thousand odd years ago, published a book, *Topographia Christiana,* in which he refers to "the land where men dwelt before the flood." Further, he supposes that Noah came to the shores of the Mediterranean from

another land which was *in the West beyond the ocean*. This is interesting, in view of what follows later concerning Noah.

Visitors from Atlantis 7450 B.C.

Schliemann states that there is a papyrus roll, written in the reign of Pharaoh, relating how that monarch sent an expedition *to the west* in search of traces of *The Land of Atlantis*, whence, 3,350 years before, the ancestors of the Egyptians arrived, "carrying with themselves all the wisdom of their native land." Pharaoh Sent, or Senta, lived in the Second Dynasty, or about 4,100 B. C., although he is mentioned in connection with a writing of the First Dynasty. This date, added to 3,350, places the date of the arrival of the ancestors King Sent refers to as 7,450 B. C.

Homer and Thucydides allude to a race of barbarian navigators called Cares or Carians, who occupied the isles of Greece before the Pelasgi, and who antedated the Phoenicians. The Carians are supposed by the Abbé Brasseur de Bourbourg to be identical with the Caribs of the West Indies and the Cares of Honduras. The occupants of ancient Athens claimed to be Carians, and, as we know, the Caribbean Sea was named after the Carians. Incidentally, Herodotus claimed to be a Carian.

Negro origin

Homer, Marcellus, Plutarch, and several other ancient writers mention islands in the Atlantic Ocean.

Contrary to some views, my opinion is that the Negro was not a native of Atlantis, and in all probability never visited or knew of that continent. My conclusions are based upon the fact that African traditions, prevalent among widely scattered tribes, agree in claiming that their ancestors were emigrants of a superior race, who arrived in big canoes, *from a continent to the East.* Further supporting the theory of a possible Negro origin in the lost continent of Gondwanaland, we learn that "traditions of India, and other Asiatic countries, reveal curiously similar stories of Lemuria." Lemuria, no doubt, is the name for either the whole or part of Gondwanaland.

Prehistoric Egyptians

On the other hand, when we turn to the races of Europe for evidence as to the origin of their earliest ancestors, we find they all agree on one point, namely *that they came from the west.*

In the British Museum's *Guide to the Egyptian Collection* by Dr. E. A. Wallis Budge, we read: "Toward the end of this [Neolithic] period, Egypt was divided into two Kingdoms, of the South and of the North; of the Kings of the latter a few names are known from the Palermo Stele. . . . No date can be assigned to

The Egyptian Story of Creation.
(From *Gods of the Egyptians*, E. A. Wallis Budge.)

the rule of these Kings, but they probably all reigned before B. C. 4,500. While Egypt was divided into two Kingdoms the country was invaded, *probably more than once,* by a people who made their way thither *from the East or South-east,* and settled as conquerors in the Nile Valley and Delta. They brought with them *a civilization superior to the African,* and appear to have *introduced wheat, barley, the sheep, the art of writing, a superior kind of brick-making, etc."*

Here we have actual historical evidence that a superior race of people invaded Egypt *from the East, or Southeast, prior to 4,500 B. C.,* and that they introduced wheat, barley, and the art of writing. As we have already learned, to cultivate wheat from the natural plant was undoubtedly the work of centuries, possibly many thousands of years. The art of writing is also the result of long centuries of evolution. It is stated by reliable authorities that these people came from the East, or Southeast, of Egypt. The direction indicated obviously includes the Valley of the Euphrates, the center of the Akkadi civilization—the people who, scores of centuries prior to their Egyptian invasion, in all probability came from sinking Atlantis, bringing with them a knowledge and culture totally unknown to the peoples of Europe, Asia Minor, and Africa.

Who gave agriculture and writing to Egyptians?

Le Plongeon, who was a great scholar and who lived with the present-day Mayas for more than twelve years, declares that the word Akkad is of Maya origin. He changes the word Akkad to Akal so as to introduce the Maya word meaning "pond," or "marshy ground." Akil, also a Maya word, he says means a marshy ground full of reeds and rushes, such as was, and still is, a description of lower Mesopotamia and the localities near the Euphrates. (But, according to Willard, Akil or Ak-il, means shooting up like rays of light. This is a more acceptable definition in the light of recent knowledge). Later he says the Akkadi became known as Kaldi. Kaldi or Kalti—Kal, meaning enclosed, and Ti meaning place. Later still the Kaldi, or Kalti, became known as Chaldeans.

Le Plongeon's theory on Maya word parallels

In all probability, the word Akkad is of the same root as the Maya tongue. It is further probable that the word Chaldea sprang from Akkad, but I am not convinced by Le Plongeon's argument as to the derivation. As usual, he unfortunately takes undue liberties with the original word to justify a version to his liking. Ak and Ka are Maya words, but the addition of the letter "D" (there is no "D" in the Maya tongue, hence the reason Le Plongeon changed

it to a "T") as a terminal, or any other change or addition, obviously alters—possibly entirely—the original sense of the word. In the circumstances, therefore, it is not wise to place too much reliance upon Le Plongeon's translation. Emphasis is given to the word only because of my belief in its Maya affiliation.

Pre-historic Europeans came from West

Returning to a consideration of the evidence, it is interesting to learn that all the ancient races of Europe, *except the Negro,* claim that their ancestors arrived in boats from a land which sank beneath the waters, toward the *setting sun,* or west.

Spence says that: "All authorities are agreed that a large proportion of the stock which went to make up the composite people known as the ancient Egyptians had a western origin."

The western origin, as I have endeavored to show, is roughly traced back from the Egyptians to the Chaldeans, then to the Akkads and by still earlier racial links to the Azilian-Tardenoisians, the Magdalenians and thence to the Aurignacians, or first Cro-Magnons in Europe.

Flood legends

Further, I believe that the first of the Cro-Magnon stock came at least 25,000 years ago direct to Europe from the then disintegrating Atlantis. With this brief reminder, let us continue.

Lenormant says that with one exception (which bears evidence of later introduction) all branches of the Aryan race allude in their legendary memories to a universal flood. The exception is Egypt. As Egypt is one of the principal civilizations connecting the two hemispheres racially with Atlantis, this statement appears to be a powerful rebuttal of the claim. Naturally, one would assume that Egyptian history or legends would contain marked allusion to such a stupendous catastrophe as a world-wide flood chronicled in the Bible and numerous other early religious writings. Donnelly gives a very logical explanation of this seemingly inexplicable condition. He says: "To my mind the explanation of this singular omission is very plain.

Egypt and Flood story

The Egyptians had presumed in their annals the precise history of the destruction of Atlantis out of which the flood legends grew; and, as they told the Greeks, there had been no universal flood but only local catastrophes. Possessing the real history of the local catastrophe which destroyed Atlantis, they did not indulge in any myths about a universal deluge covering the mountain tops of all the world. They had no Ararat in their neighborhood."

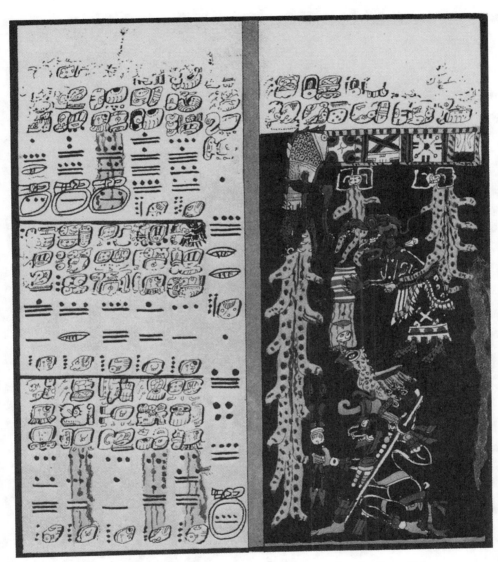

Portion of the Dresden Codex (Kingsborough) describing the Great Deluge.

On the other hand we have the evidence of the flood legend as recorded in the Egyptian *Book of the Dead,* chapter CLXXV, by the scribe Ani. Referring to this account E. A. Wallis Budge says: "A general destruction of mankind was caused by the Flood which was brought upon the world by the god Temu, who announced his intention of destroying everything in it and of covering the earth with the waters of the primeval ocean Nu. The flood appears to have begun at Henensu, in upper Egypt, the Khânês of *Isaiah* xxx, 4, and the Herakleopolis of the Greeks, and to have submerged all Egypt. All life was destroyed, and the only beings who survived were those who were in the 'Boat of the Millions of Years', i.e., the Ark of the Sun-god, with the god Temu. The mutilated state of a large portion of the text makes it impossible to piece the details together, but it seems that, after the earth was covered by the Flood, Temu sailed over the waters to the Island of Flame, and took up his abode there."

Osiris and the Flood legend

Again, we have the indirect evidence of Plato, Diodorus Siculus, and Plutarch, all of whom refer to Osiris as, in one manner or another, connected with the Deluge. Plutarch in particular specifically refers to the ark and Noah episode in his description of Osiris entering the fatal chest by quoting the date on which Noah was understood to have entered the ark, namely November 17, the second month after the autumnal equinox, where the sun passes through Scorpio. It might, therefore, be construed that a Flood legend *was* known to the Egyptians. The question, then, is to what flood do these accounts refer?

Before rendering a verdict, however, we must bear in mind the words of the old priest of Sais, who when talking to Solon said: "There have been, and there will be again, many destructions of mankind arising out of many causes." And later where he says: "Many great deluges have taken place." As already expressed, my belief is that the sinking of Atlantis did not occur as one body, at one time, but piecemeal. Numerous sinkings took place, some on a large scale, some small, covering, from the first to the last submergence, a vast period of time. It would seem, therefore, that the so-called *universal* deluge of the Bible was, to the Egyptians, purely a local catastrophe. Recent discoveries at Ur bear this out.

The world according to the Book of the Dead

The scribe Ani, who wrote chapter CLXXV of the *Book of the Dead* approximately 1,500 B. C., evidently believed the earth surface comprised merely the area mentioned in his writings,

a common belief in those days. He says: "The earth *was covered* by the Flood", and that *"all life* was destroyed."

Considerable change was made in each rewriting of the *Book of the Dead,* and it is my belief that the scribe Ani actually recounted the story of the last great deluge which presumably occurred in Atlantis, but ignorantly assigned the area to the then known lands of the earth. The fact that he refers to the period when Temu went to the Island of Flame, and later was succeeded by Osiris who "ruled triumphantly", infers the beginning of Osiris worship. If we accept the other evidence herein submitted, then Osiris worship originated in Atlantis, and it appears logical to assume that the flood mentioned by Ani refers to an Atlantean cataclysm, and not one which inundated the lands of Egypt and contiguous countries.

Egyptians recorded Great Flood

The same argument might also apply in reference to Plutarch's story concerning Osiris. The universal story of the Flood could not apply to Egypt. In that land there are no mountain-tops to cover, neither is there a Mount Ararat upon which the fabled ark could have alighted.

It is my belief, therefore, that the evidence indicates the earliest Egyptians possessed historical records of a cataclysm which overwhelmed the land of their ancestors, a land which once was situated in the waters toward the setting sun. Further, that the continent now known as Atlantis finally vanished beneath the ocean approximately 9,600 B. C. The catastrophe, being one of major importance to their people, was carefully recorded in the original or earliest Egyptian historical annals, thousands of years prior to the so-called Egyptian historical period. The period between the invasion of Egypt and the so-called historical times naturally saw considerable destruction and loss of records, and occasioned numerous rewritings of the original version. The truth became lost in legend and the locality was assigned to the only world area known to the writers in historical times.

All prehistoric Europeans had legends of Flood

With these thoughts in mind I shall proceed to offer further evidence that, in addition to the Egyptians, all the earliest races in both hemispheres possessed almost identical stories of the great Flood as recorded in the Bible.

The national epic of the Akkad hero King Ishdubar contains a tablet which gives an account of the Deluge. This legend agrees very closely with the story in Genesis.

Mullil, the Bel of the Semitic creed, was called "Lord of the world of Spirits", "Ruler of Mankind", and to him one of the inscriptions ascribed the Deluge.

It is admitted that the legends of the Creation, the Fall, and the Deluge were freely circulated among the early Babylonians, long centuries before the Book of Genesis took shape, thus showing that those people were well acquainted with and possibly possessed positive proof of the cataclysm. Chilperic Edwards, in *The Witness of Assyria,* referring to legends of the Flood, says they "can very well have existed in Palestine. It was invaded by the Israelites who would have learned them from the people they subdued, and would have found plenty of time to modify them into the forms in which they appear in Hebrew literature."

Though the argument sounds logical, I cannot agree with the assumption that the Jews were entirely ignorant of the Deluge. It is possible, of course, that this prehistoric event had been forgotten by them when they again assumed literary importance, but it must be remembered that the early Jews preserved no records of their very early history, due to the low social status that was theirs for many centuries prior to their historic beginning.

Jew's knowledge of Flood

Nevertheless, Edwards' belief is well founded in the absence of more definite evidence to the contrary. It is my opinion, however, that the prehistoric Jews were fully cognizant of the Deluge, which was in all probability identical with the disastrous event assumed to have occurred approximately 9,600 B. C.

Le Plongeon says: "The Egyptians themselves claimed that their ancestors were strangers who, in very remote ages, settled on the banks of the Nile, bringing there, with the civilization of their mother country, the art of writing and a polished language; that they had *come from the direction of the setting sun,* and that they were of the most ancient of men."

This author remarks upon the strange fact that the Egyptians point to the *west* as the birthplace of their ancestors, whereas the first settlers in Egypt came from the Valley of the Euphrates, which is *east* of Egypt, not west. He offers a solution of the seeming discrepancy in what he terms a *fact* that there were two distinct Maya migrations to Egypt, the second and more important of which came, he says, "direct from Mayach." What he terms Mayach is the present-known Maya area in Yucatan and Central America.

Although I agree as to the probability that there was more than one migration into Egypt, evidence seems to contradict Le Plongeon's theory of a migration into Egypt direct from the American continent. My explanation for the one or more influxes of the Iberian stock into Egypt after the first invasion from the Euphrates area is that, with each successive subsidence of the disintegrating Atlantis, escaping hordes invaded the northern shores of the Mediterranean, and slowly pushing their way eastward, they learned of the fertile lands of Egypt—already settled by advance colonists from their own mother country—and sought refuge in that land.

The Flood not worldwide event

That a great deluge took place at some remote prehistoric time is not denied. Other references besides those of the Biblical and Chaldean records fully substantiate that fact. That it was not a world-wide event we now know. The cultured race which migrated in waves from sinking Atlantis, bringing their knowledge of sciences, arts, and writing with them, would undoubtedly be the only people to record and preserve systematically accurate accounts of the events. Without access to these records, other, lesser peoples would receive their accounts more or less secondhand; hence legends, myths, and consequent distortion.

There can be no dispute as to the importance of the last great flood. We find reference to it in scores of writings in widely scattered countries, covering the entire world.

India affords an account of the deluge strikingly coincident with that of the Bible. It is somewhat far-fetched but is undoubtedly based on knowledge of the historical event.

The Sphinx in India

According to the records held by the Asiatic Society of Calcutta, India, of about 100 years ago, the ancient Hindu books frequently refer to the lost Atlantis. In these books the island has received various names, such at Atala, Atlantis, The White Island, the White Devil. In volume eight of the *Asiatic Researches,* page 286, we read: "This Atlantis was overwhelmed by a Flood." Also, in this remarkable collection of Hindu records, we learn that the early Egyptians conquered and ruled India. In one of the volumes is a plate showing a gigantic sphinx erected in that country. It is said that the Brahmins knew little about it.

The ancient Hindu books further record that the Mahometans rushed into Egypt with pious fury. They destroyed all the books of science and the annals of the country, except such as

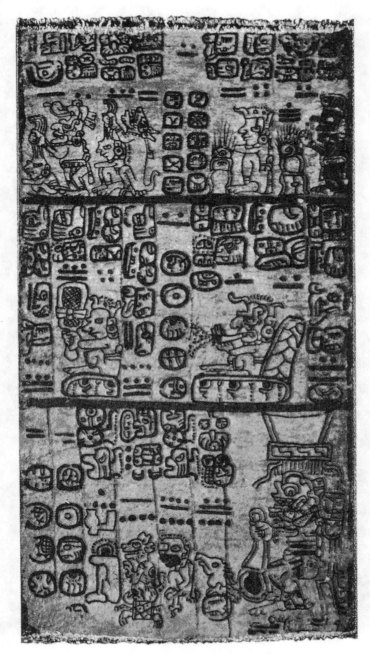

The Troano Codex of the Mayas depicting the Deluge

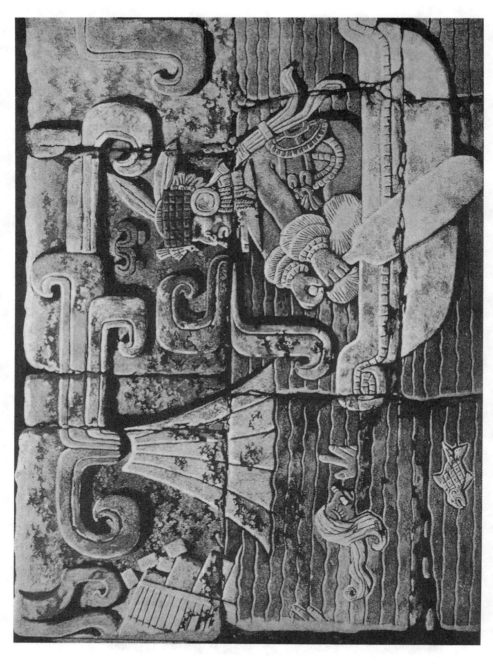

MAYA STORY OF ESCAPE FROM ATLANTIS

The beginning of a continuous bas-relief frieze discovered by Maler in Yucatan, which suggests to a remarkable degree the Atlantean cataclysm. The above photograph describes a pyramid and temple collapsing, a volcano in eruption and the land sinking. The figure in the water suggests destruction of life by drowning. Many escaped as symbolized by the figure in the boat.

were saved *"at the bottom of the wells."* It may be nothing more than a curious coincidence that the Maya books of science and arts suffered a similar fate, and for precisely the same reason, except the few which were saved *at the bottom of the wells.*

It may be argued that Aristotle (being a pupil of Plato), Diodorus Siculus, and others, fabricated their accounts mentioning Atlantis, basing their information upon Plato's narrative. In which event, what explanation is offered of similar references to Atlantis in the ancient Hindu books?

Truth lies at the bottom of the wells

Is it possible that races existing in opposite hemispheres would independently have acted identically when subjected to exactly similar circumstances, such as just described, or was the thought-germ generated on a common ground? And who were the sages of a remote past who coined the proverb: "Truth lies at the bottom of the well"?

Another obvious distortion of facts is seen in the sacred books of the Iranians, which contain the fundamental Zoroastrian doctrines. (See Lenormant's *Vendudid*). The Greeks had two principal legends referring to the cataclysm as of universal magnitude. The Persian Magi, as Donnelly says, "possessed a tradition in which the waters issued from the oven of an old woman. Mohammed borrowed this story, and in the Koran he refers to the Deluge as coming from an oven."

In Wales the Deluge is recorded in the bardic poems, and although a far more recent legend, it is interesting to notice that as is usual, the story is localized in that country.

In the Scandinavian *Ealda* there is a vestige of the same tradition. In the *Edda of Socmund* "The Vale's Prophecy", there also is mention of the terrible catastrophe. There is some evidence, as we shall see later, which shows that the Druids were a very ancient people. Apparently they had knowledge of the Flood, for in Faber's *Pagan Idolatry* we learn that they possessed books "more ancient than the Flood." Among them were some styled the *Books of Pheryllt,* and the *Writings of Pridian.* Reference to their knowledge of the Flood is seen in a sentence from Faber's work which says: "Ceridwen consults them before she prepares the mysterious cauldron which shadows out the awful catastrophe of the Deluge."

Druid's book more ancient than Flood

As it is important that we become reasonably well assured that a continent once occupied a position in what is now

American
Flood legends

the Atlantic Ocean, perhaps we should first be convinced that Plato's narrative is supported by evidence other than that which is referred to above. If, as is my belief, the earliest and the present cultures of Europe, and the so-called North American Indian tribes, and the Mayas, all sprang from the Mother country of Atlantis, then we should find some evidence on the American continent corroborating the claim that Atlantis once existed.

Even at the outset of our investigation we are not disappointed. Alfred Maury remarks "that we find in America traditions of the Deluge coming infinitely nearer to that of the Bible and the Chaldean religion than among any people of the old world."

This fact alone should prove sufficient to discredit the theory that the Mayas, or any of the so-called American Indian races, migrated from Asia to the American continent via the Behring Straits. The legend of the Flood, preserved as we shall see by the indigenes of the Western Hemisphere, was derived not from hearsay but from actual knowledge. The Mexican story of Noah, for instance, is almost identical with that of the Bible, yet there is no evidence from Asia Minor worthy of comparison.

Mexican
story of Noah

The various stories of the Deluge among American indigenes may all refer to a single event of major importance, although it is quite possible that other catastrophes of a devastating nature may also have been recorded by these people. It is further possible that each succeeding wave of emigrants from the piecemeal disintegration of Atlantis hastened after their arrival on these shores to record in some permanent form the disaster which occasioned their migration. In other words, it is conceivable that the various pictorial records of a deluge do not all refer to the major event. This surmise I submit in view of a photograph in my possession (see page 91) which undoubtedly refers to a flood and land submergence. The picture was taken by Teobert Maler in a remote and at the time unknown spot deep in the jungles of Yucatan. Maler stated just prior to his death that the recorded scene was but a portion of a continuous frieze which surrounded the interior of an underground chamber. The picture shows a temple falling off a pyramid, a volcano in eruption, *the water line far above the baseline of the pyramid and the volcano,* a man drowning and another escaping in a boat. Perhaps this mural record chronicles a catastrophe which occurred only a few hundred years B. C. —the one which was the cause of the Maya invasion into Yucatan.

Maya
pictorial story
of the Flood

It is equally possible, of course, that the mural record refers to what might be termed the last great major deluge that wrecked the mighty Atlantean civilization in approximately 9,600 B. C.—an outstanding disaster which might well be indelibly preserved in their memory for all time. Whatever the explanation, one thing is assured—they possessed positive knowledge not only of the Great Deluge but of numerous other events recorded in the Bible.

The following translation, from Donnelly's work, of a Mexican story of the Great Flood, which bears remarkable similarities with the Biblical story, is offered as additional evidence

Canoe of the Egyptians. Horus seated in his sacred boat Phre, the hawk's-head prow ; and Apis, the bull-head poop. (From C. W. King's *Gnostics and Their Remains.*)

Mexican story of Flood

Canoe of the Mayas. Portion of a mural. Chichen-Itza, Yucatan. (From *Popol Vuh,* De Bourbourg.)

that a positive connection exists between the peoples of the two hemispheres.

"The Noah of the Mexican cataclysm was Coxcox, called by certain people Teocipactli or Tezpi. He has saved himself, together with his wife Xochiquetzal, in a bark or, according to other traditions, on a raft made of cypress wood. . . . It [the legend] tells how Tezpi embarked in a spacious vessel with his wife, his children, and several animals, and grain, whose preservation was essential to the subsistence of the human race. When the great god

Tezcatlipoca decreed that the waters should retire, Tezpi sent a vulture from the bark. The bird, feeding on the carcasses with which the earth was laden, did not return. Tezpi sent out other birds, of which the humming-bird only came back with a leafy branch in its beak. Then Tezpi, seeing that the country began to vegetate, left his bark on the mountain of Colhuacan." Further of interest is *Nata* who is the *Noah* of the Toltec version of the Flood episode.

All Indian tribes formerly one

Major James W. Lynd states that the Iowa Indians, a branch of the Mandans, have a legend of the Flood in which it is stated that: "All the tribes of the Indians were formerly one, and all dwelt together on an island, or at least across a large water *toward the East, or sunrise.*"

Certain Flood rituals of the ancient Jews, the people of the ancient Greek States, and the Mandan Indians, all were performed almost identically. The image of the ark among the Mandans was in the form of "a large hogshead, some eight or ten feet high. . . . They called it the *Big Canoe*. This representation of the ark stood in the center of the village and was *an object of great religious veneration.*"

Legends of the great Flood are prevalent among the Chickasaws, the Sioux and the Iroquois, as noted by Lynd in *MS. History of the Dakotas*. Bancroft in *Native Races* also refers to the Okanagans as possessing a similar legend. In addition we find almost identical recitals of the Deluge among the Apaches, the Pimas and the Nicaraguans.

Is it not somewhat conclusive when we find widely scattered tribes on the American continent, each having myths of a great cataclysm, of an island that sank into a great sea toward the rising sun, or *east*, and that each such myth specified the arrival of early ancestors in boats from that direction?

American Indian Flood legends

Lewis Spence speaks of a legend among the Okanagans which states that "a great medicine woman named Scomalt *ruled over a lost island.*" We also learn that the Delawares have legends telling of a mighty influx of rushing waters and a hasty folk-migration in consequence. (See Rafinesque, *The American Nations*, 1836). Brinton lists a large number of American Indian tribes "among whom a distinct and well authenticated myth of the Deluge was found." The natives of the Caribbean Islands offer numerous and varied items of evidence, among which is a legend describing the Great Flood. In

far-away China we find almost the identical story of the Flood recorded in their mythology.

We now come to that mysterious character of myth and legend, Quetzalcoatl, who is so firmly woven into our story. This Mexican god-hero has long been a figure of much speculation among archeologists. Some believe him to have been a purely mythical character; the general opinion, however, is that he was a real personage who was later deified.

Quetzalcoatl and the Flood

On one occasion while I was doing some research work in Mexico City, a Mexican Senator—a man of apparent learning—told me that he and many of his fellow students on the subject were convinced that Quetzalcoatl had appeared to the early peoples of Mexico on two widely separated occasions, the first of which was ten to twelve thousand years ago, and the second, toward the end of the tenth century. The Senator believed that many of the legends applied to the Quetzalcoatl of the tenth century, A. D., properly referred to that same personage on his first appearance, approximately 8,000 B.C. Torquemada, in his *Monarquia Indiana,* says that Quetzalcoatl "was the leader of a body of men who entered Mexico from the north by way of Panuco, dressed in long robes and black linen cut low at the neck, with short sleeves. They came to Tollan, but finding the country there too thickly populated, passed on to Cholula. Quetzalcoatl was a man with ruddy complexion and a long beard." Quetzalcoatl, the Toltec god, was known as Kukulcan among the Mayas. He was called Gucumatz by the Quichés and in Peru he was known as Amaru, but all these names have an identical meaning, i. e. the Feathered, or Plumed Serpent. Incidentally, from the Peruvian name comes Amaruca, out of which many students believe the name America resulted. This derivation appears to me more reasonable than the one popularly believed.

The man with a beard

Shahgun says that Quetzalcoatl's followers were known as "the swift ones who serrate the teeth."

There is no evidence to corroborate Torquemada's statement that Quetzalcoatl came from the north of Mexico by way of Panuco; but there is good reason to believe that he came from the *east,* across water. In Aztec mythology we find it said that the god Texcatlipoca gave Quetzalcoatl a draught which caused him to remember his ancient home in Tlapallan. He then went from Cholula to the coast—obviously the body of water to the east—and

The land of Tlapallan

"commanded that a raft of snakes should be constructed for him. In this he seated himself as in a canoe, put out to sea and set out for the land of Tlapallan." Another version is that given by the interpreter of the *Codex Vaticanus,* saying: "Of Quetzalcoatl they relate that proceeding on his journey, he arrived at the Red Sea, which is here painted and which they named Tlapallan."

God of the sea

Quetzalcoatl is supposed to have founded the city of Palenque in the Chiapas, Central America, but if the Quetzalcoatl referred to arrived in Mexico toward the early part of the tenth century A. D., the supposition that he founded Palenque is without foundation. Most authorities agree that Palenque was founded in the beginning of the Christian era, some believe much earlier. Fact, to a greater or lesser extent, is the basis of all legends and myths. Primarily, then, it remains to decide what shall be accepted as fact and what is fiction. This can be accomplished only by a process of correlation and elimination. As an example of evidence leaning more toward fact than fiction, we must consider the following:

It will be remembered that Plato refers to Poseidon as the ruling god of Atlantis. Poseidon, or Neptune, is represented in Greek mythology as a sea-god. He is depicted as standing in a war chariot drawn by horses. It is logical that, if Atlantis was the center where the horse was domesticated, the ruling god would be symbolized as steering the destiny of a land in the sea, in a horse-drawn vehicle. Incidentally, it seems further evident that if the Atlanteans domesticated the horse they invented the chariot and the wheel. Continuing our line of reasoning, we find that Poseidon, or Neptune, was a Greek sea-god; we also learn from the Popol Vuh that Quetzalcoatl, the Aztec god, was spoken of as the "Heart of the Sea."

Supporters of the earth

Atlas was the son of Poseidon, according to mythology. Atlas was a dual god, so was Quetzalcoatl. Atlas is shown as the heroic figure supporting the earth. We find that Quetzalcoatl also is depicted as supporting the world. He is also shown as one of four figures supporting the four corners of the earth. The Mayas possess similar deities—the four Bac-cabs who support the earth. The Greek caryatid figures are identical in motif with the architectural supporting figure of Atlas.

It seems certainly beyond mere coincidence, then, that the Biblical story of the Tower of Babel, the reason for its construction, and the subsequent confusion of tongues should find its

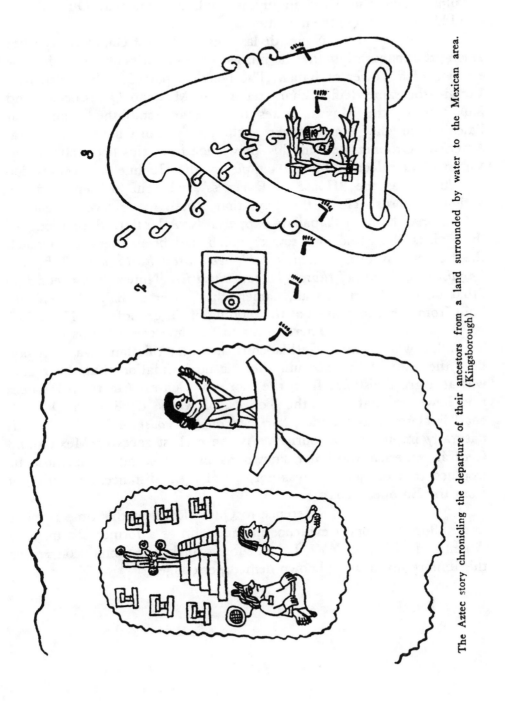

The Aztec story chronicling the departure of their ancestors from a land surrounded by water to the Mexican area.
(Kingsborough)

parallel among the Mexican myths, and, further, that Quetzalcoatl should be mixed up in the narrative.

Nunez de la Vega, Bishop of Chiapas, says that among the manuscripts that he burned he found a book describing the erection of a Tower of Babel. The book purported to be written by Votan—the same deified character as the Mexican Quetzalcoatl and Kukulcan of the Mayas—states that Votan established himself at Palenque, in what is now known as the province of Chiapas in Central America. Ordonez, deriving his knowledge from this book, states that Votan (Quetzalcoatl) built a temple by the Huehuetan river, which was known as the "House of Darkness", wherein he deposited the national records. He further says that Votan made several visits to his original home (Tlapallan—apparently Atlantis). Upon one of these visits "he came to a tower, which had been intended to reach the heavens, a project *which had been brought to nought by the linguistic confusion of those who conceived it.*" Nunez de la Vega says "that he saw the great wall, namely the Tower of Babel, which was built from earth to heaven at the bidding of his grandfather Noah."

Maya book describing Tower of Babel

There seems to be some confusion as to where Tlapallan was situated. Ixtlilxochitl says that this land was a region *near* the sea. In this account there is no intimation that the region was at a great distance from the shores of Central America. He does say, however, that they, the Toltecs, of whose civilization Quetzalcoatl is claimed as founder, "*arrived on the coast* of Mexico." This naturally implies a sea journey. As the earliest races of Mexico and Central America were not known as great navigators, it must be assumed that the journey was not one of great distance, certainly not from the European coast.

Where was land of Tlapallan?

Reference to Quetzalcoatl at this time is made in an effort to support evidence in the claim of a former continent of Atlantis. In Chapter XVI, I shall submit further testimony concerning this important but little known deified personage.

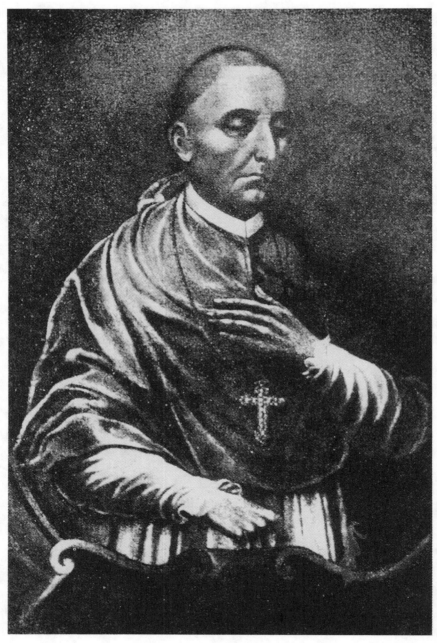

Father Diego de Landa, Second Bishop of Yucatan. Believed to be the only portrait of the fanatical priest extant. His ruthless order compelling the Mayas to destroy all their books and manuscripts caused an immeasurable loss to archeology.

Chapter Six

And West is East

HAVING submitted considerable evidence showing that races and tribes (which I believe to be descendants of a common stock) widely scattered over the North American continent possessed through their legends the story of their ancestors coming from a land in the waters *to the east* of the American continent, and that there are similar legends among all the early civilizations of Europe and Asia Minor which indicate that the land of their origin was toward the setting sun, in the waters *to the west,* it now remains to see what data on the subject are available among Maya records.

Landa, the fanatic

Fray Diego de Landa, second Bishop of Yucatan, after the Spanish conquest in 1542 wrote *A Narrative of the Things of Yucatan* in 1566 A. D. This bishop, rigidly pious and extremely fanatical in the execution of what he believed to be his religious duty, cost the future student of the fascinating Maya subject an irreparable loss.

In his narrative he says, quite naively, (translation): "We found a large number of their books of these letters, and because they did not have anything in which there was not superstition

and falsehoods of the devil, we burned them all, which they felt very sorry for and which caused them grief."

Landa gave orders that the conquered Mayas were to bring all the books, including all manuscripts in their possession, into the public square of Mani, in Yucatan, where they were burned.

It is a very natural sequence that, whenever one nation conquers another, fear urges the victors to destroy immediately the leaders or brains of the subdued people. It is exactly the same motive which impels them to destroy all the writings of their victims when the contents are, to them, unintelligible. Landa's mandate, under such circumstances, is not unique. History records many similar acts of ruthless destruction through fear, and the losses so incurred raise effective barriers against our knowledge of the past. Had all the ancient historical documents been preserved, what amazing pages of human history would now be at our disposal!

*Landa's ruth-
less act*

In Landa's case we learn that later he became somewhat contrite. After the wholesale destruction of these priceless relics, he attempted to utilize the Maya characters to produce an alphabet with which to write the Catholic prayers so that the natives could get the sounds of the Spanish words from their own characters. This feeble attempt at a halfway measure made confusion worse confounded. However, there was one saving grace in Landa's unfortunate ecclesiastic rule which is of immense value archeologically. Time soon convinced the holy bigot that he had come among a people gentle, lovable and exceedingly human. Stories of their amazing past came to his ears. First, he was skeptical, then interested, and finally he desired nothing better than to write an historical record of the people whom he first despised as imps of the devil. Meager and biased as the account is, it forms one of the most valuable documents we have concerning the Mayas of Yucatan.

*Landa regrets
destruction*

The chronicle, as one would imagine, is a strange combination of historical data and topography, pious denunciations, facts and customs, told with a mixture of intolerance, admiration and prejudice. Despite his skepticism, obviously born of religious fervor, much of his information bears confirmation. It seems reasonable, therefore, to rely to a great extent upon the facts as he records them.

As Landa's account consists of information gathered through direct contact with the Mayas, (bearing in mind his official prominence in Spain's new domain), it seems that the data

selected from his chronicles, which I here submit, may be considered authentic. His skepticism and intolerance, which he makes no pretense of hiding, must be put down to religious prejudice and are therefore excusable.

I have made this explanation in view of the fact that frequent reference is made to the works of Fray Diego de Landa. Let us now consider what he has to say in reference to the origin of the Mayas in Yucatan.

Landa writes: "Some old men of Yucatan say they have heard from their ancestors that certain people populated that land *who entered by the east.*"

In Landa's "Chronicles"

In a commentary of his own he says that if this story be true, the people "of the Indies must have come from the Jews, because, having crossed the Strait of Magellan, they would have to go more than two thousand leagues of land that today Spain governs."

If, as the old Maya men said, their ancestors *came from the east,* what has the Strait of Magellan to do with the journey? Evidently, Landa assumed that the *east* mentioned by the old men implied the east of Europe, therefore he argued that as the center of the Jews was in Europe, in order to visit Yucatan they would travel *east* of Europe and round the south of South America through "the Straits of Magellan"—an illogical and unnecessary procedure.

Shortly after the so-called Spanish conquest, King Charles V, of Spain, sent out a questionnaire of fifty items to his governors of the new Provinces in Yucatan, all those who had taken major parts in the conquest, and all those who had received grants of land from the Spanish Crown. One of the questions asked was "Where did their [the Maya's] ancestors come from?"

The answer, from practically all sources, was: "Long ago a people came to the land known as Yucatan. *They were the first to appear after the flood.*"

King Charles' questionnaire

Daniel Brinton, one of the best Maya scholars, says: "He [Itzamna] was said to have come in his boat *from the east across the water.*"

Cogolludo, another authority, says: "Zamna [Itzamna] *came from the east.*"

Turning to the *Documentos Inéditos,* published in Spanish, in 1898, (a work which is considered by some Maya students of almost equal importance to the *Chronicles* of Landa), we discover

further evidence that the Mayas of Yucatan originally came from a land across the waters toward the rising sun.

In that portion of the *Unedited Documents Relating to the Discovery and Conquest and Organization of the Ancient Spanish Possessions Beyond the Seas,* under the heading of the *History of Tiquinbalam,* by Juan Gutierrez Picon, we read (translation): "It is our opinion that the Ekbalamites were of the emigration of the Chanes, or Itzaes, because, according to their traditions, *they had come from the east,* like the Itzaes." The Itzaes were Mayas, of whose Yucatan invasion we shall learn later.

Excerpts from the "Documentos Ineditos"

In *The History of Zodzil* by Juan Darreygosa, forming part of the same document, we read that "the most ancient people who came to populate this land were those who populated Chichen-Itza [Yucatan] . . . *and were the first after the flood."*

In the *History of Mutul* (now Motul) by Martin de Palomar, we read, referring to the first lord of that city: "He came with the people *from toward the east."*

In the *History of Tical* by Diego Briseno, we read: "The ancients say that those who formerly came to inhabit this land were those who founded Chichen-Itza," and that they were "the first who, *after the flood,* inhabited these provinces."

In the *History of Cicontum,* by Martin Sanchez, it reads: "The ancients say that those who formerly came to populate this land were . . . *the first who came after the flood."*

In the *History of Zuzal and Chalante* by Alonzo de Rrojas, we read almost the identical wording.

Whence came ancestors of ancient races?

It seems quite clear that the ancient races of the Eastern Hemisphere believed that their earliest ancestors came from a land across the water *from the setting sun, or west;* and, also, that all the so-called American tribes, as well as the Mayas of Yucatan, state that their earliest ancestors came in boats across water from a land toward *the rising sun, or east.* All have the identical story of a great flood and subsequent sinking of their homeland.

Having now surveyed the documentary evidence in support of the theory of a common origin of the ancient peoples of both sides of the Atlantic Ocean, let us turn to other sources for further corroboration.

The term "psychic unity" is frequently used by the skeptic in an effort to explain parallels in customs, arts and legends

among diversified and widely scattered races of the earth. This term might be applied when speaking of certain metaphysical conditions, it is true, but is warrantable only in cases obviously beyond the bounds of mere coincidence. The simultaneous, almost parallel, discoveries by Wallace and Darwin concerning the origin of species, wireless telegraphy discovered by both de Forrest and Marconi, and other simultaneous inventions are rare coincidences born either of general knowledge or of research in a specific field of thought shared by others. Seldom, however, do we find such coincidences spreading beyond two simultaneous conceptions. It appears logical, therefore, to use any such term as "psychic unity" when we find many distinct peoples of the earth possessing identical art motifs, customs, religion, and so forth.

The evidence of customs

A mummy "at least 4,000 years old." (wrapping removed). Discovered in Arizona, an example of American mummification. Bodies mummified and in a thrice bent position have been found in Egypt, Canary Islands, Peru, Mexico, and North America.

Continuing this line of reasoning, we might venture the opinion that if the evidence discloses parallels among the cultures of widely scattered civilizations, their origin must be sought for on a common ground. With no testimony forthcoming to indicate that such a center exists on the land surface of the earth, and with the possible solution of the problem found in the erstwhile continent of Atlantis, let us continue our review of the evidence in support of that theory.

As customs play an important part in all cultures, I now submit a few remarkable parallels to be observed between the ancient races of both hemispheres. We shall begin with that of head-flattening.

Head flattening

This custom is an extraordinary one, yet we find many races employing the painful art. The custom prevailed among the Carib Islanders, the Peruvians, Mexicans, numerous tribes of North America, the Magdalenian Cro-Magnons, the Scythians, the Turks, French, the Huns under Attila, and numerous others, including the Mayas. The practice appears to be an exceedingly old one, and is identified on ancient skulls discovered in Lower Austria, and as far away as Peru. In other words, the strange rite was prevalent among most of the early races on both continents, but in view of the theory under discussion, it is very significant that it is to be found among *all* those people who in my belief were either direct or indirect colonists from Atlantis.

The Aztec goddess Ciuacoatl is usually depicted carrying a child, and is described as wandering about, crying and moaning. This description fits perfectly the Egyptian goddess Isis. Both wear similar headdresses.

Another unusual custom assisting in forging a new link in the chain of evidence is that referred to by Henry Gilman in *Ancient Man in Michigan.* He says: "The Mound-Builders and Peruvians of America, and the Neolithic people of France and the Canary Islands, had alike an extraordinary custom of boring a circular hole in the top of the skulls of their dead, so that the soul might readily pass in and out." This custom prevails to this day among the Tibetans.

Circular hole in skull

Next we learn that the burial customs among the ancient races on both sides of the Atlantic are in many instances identical.

The articles associated with the dead are the same on both continents. In the Mississippi Valley vases were discovered which had been constructed *around* the bones of the dead. This is proved by the fact that the necks of the vases were too small to permit of the extraction of the skull. Precisely the same practice was discovered in the burial sites of the Chaldeans.

Among the Peruvians, Egyptians and Mayas, it was the custom to suspend around the neck of the dead the "Vase of

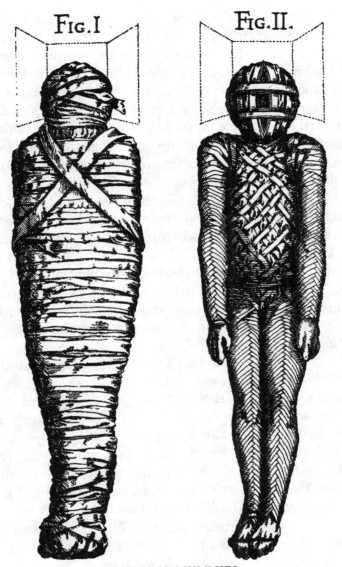

Mummifica-
tion

EGYPTIAN MUMMIES
Egyptian mummification sees its parallel in the Americas. (From *Oedipi Aegyptiaci*, by Kircher)

Justification." Blue was the color of mourning in Chaldea, Egypt and Yucatan.

At Egyptian funerals it was customary for the mourners to cry: "To the West, to the West." Does this indicate a universal prayer among those people that the departed may be consigned to the land of his ancestors?

The use of burnt offerings and incense was common among the ancient races of both continents.

Mummification was practised among the earliest known civilized men in Europe. The testimony shows that the Aurignacian immigrants of Cro-Magnon man were acquainted with the art of preserving the body. When we turn to the Canary Islands we discover further evidence of an Atlantean link. It is conceded that the Cro-Magnon man not only occupied the island group, but that he employed a custom and form of mummification similar to that discovered in the caves of Aurignacian man in France.

M. R. M. Gattefosse says that the dead among the Guanches, who formerly occupied the Canary Islands, were enbalmed with care. The method employed was almost identical with that of the Egyptians.

On the American continent almost similar rites maintained. The Mexicans, Peruvians and Mayas all embalmed their dead. A significant parallel to the European connection with Atlantis is seen on the American side in the custom of embalming among the earliest people of the West Indies.

In the case of the Mayas in Central America the bodies of chiefs and kings were buried in elaborate stone sarcophagi. Similar canopic vessels to those of Egypt accompanied the bodies. Another Egyptian parallel is seen in the lids which bore representations of the gods, or *bacabs,* of the four parts of the compass. Both the Egyptians and the Mayas associated certain colors with the several organs of the body and with the cardinal points. The symbols which decorated the Maya mummies resemble, to a marked degree, those which were employed on the Egyptian dead.

In many parts of North and South America there is abundant evidence of the practice of mummification, although. as may be expected, in a lesser or debased form.

A strange connection between the Cro-Magnon remains in France and Spain and ancient burials in America is seen in the custom, which both employed, of painting the bones red.

How, it may be asked, did the art of mummification reach the Cro-Magnons in Spain and France, the Egyptians, Cro-Magnons of the Canary Islands, the ancients of the West Indies, the Peruvians, the Aztecs, the Mayas and North American tribes, if not from a common source? It was apparently impossible for the unusual

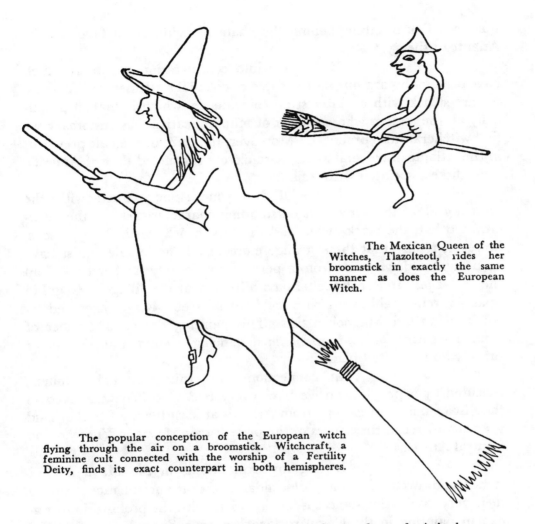

The Mexican Queen of the Witches, Tlazolteotl, rides her broomstick in exactly the same manner as does the European Witch.

The popular conception of the European witch flying through the air on a broomstick. Witchcraft, a feminine cult connected with the worship of a Fertility Deity, finds its exact counterpart in both hemispheres.

Witchcraft

custom to have reached the American continent through Asia by way of the Aleutian archipelago. The logical assumption is that the center from which the art sprang was *between* Europe and the American continent; in other words, the continent of Atlantis.

Witchcraft has formed an important part in the lives of all the early races, and even in those of a much later period including our own. The very unusualness of the cult, existing even among those whom we might term enlightened races, acts as an aid in tracing the strange activities of man throughout all ages. That it occupied an important place in the lives of certain peoples, is of historical knowledge. Its practice, therefore, may be entitled to considera-

tion as a link in strengthening the chain of evidence in favor of the Atlantean theory.

If we take into consideration the areas which have been in this argument designated as colonial settlements of Atlantis, we are struck with an interesting coincidence, which is that in practically all the regions where the art of mummification was customary we find witchcraft also practiced. Moreover, the form of the cult prevalent in the Atlantean colonial areas more closely resembled that of America than those associated with Asia.

A 25,000-year old Painting of dance

Practically everyone is acquainted with the typical garb of the witch. Its outstanding characteristics are the peak-crowned hat, the black cloak, and the broomstick steed. Few persons, however, realize that these strange emblems of the female cultist have been handed down to us from a period considerably farther back than the dark ages. In a rock shelter on a hillside near the village of Cogul in Spain, a remarkable wall painting is to be seen. It was executed by Aurignacian Cro-Magnon artists. This painting depicts a number of women wearing *pointed-crown hats,* dancing around a male idol or priest who is painted black.

Similar to modern Maya dance

In connection with this remarkable mural, executed by a people who we have every reason to believe arrived in the Biscayan area of Europe from Atlantis at least twenty-five thousand years ago, I recall the dances of the present-day Mayas in Yucatan and Central America.

The Maya dance

During my explorations in the Maya area, I visited and dwelt with many descendants of that ancient race. Among their very fascinating dances is one identical with the prehistoric Aurignacian painting in the Cogul rock-shelter on a Spanish hillside. The women gather around in a large circle. They hold hands, to form a complete chain; only, instead of their arms being extended, they are held down to their sides. Modestly and with expressionless faces, they look groundward. They move in a sidewise direction, alternately swinging from toe to heel, both feet at once. After a certain number of steps in one direction, they reverse the movement. In the center of the ring formed by these women, a man dances in rapid tempo. When either the women or the man become exhausted during this prolonged dance, others replace them. The natives speak of this as a very, very old dance, the origin of which is associated with the beginnings of their people. This dance so strikingly identifies itself with the earliest (and also later)

forms of witchcraft, that it seems probable that it is actually a rite of the cult which has come down to us uninterruptedly through the ages.

Witchcraft, in a general sense, is an exceedingly ancient female magic cult. It probably developed from the still earlier worship, by women, of the bull or the goat, symbols of fertility supposed to grant the gift of offspring. Eventually, the cult took on a more sinister aspect. The witches, having renounced the sacraments of the church, were assumed to possess supernatural powers. They were supposed to have entered into a compact with the devil and to practise the infernal arts.

The scene depicted in the Aurignacian painting might well compare with sabbatic dances of the witches of three or four hundred years ago.

The Witches' Sabbath dance

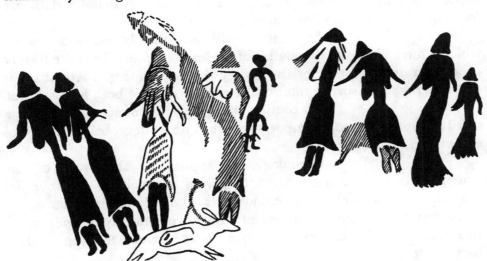

WITCHCRAFT WAS PRACTISED IN AURIGNACIAN TIMES
The above scene from a rock shelter at Cogul, Spain, depicts nine women wearing *skirts* and *conical hats* dancing round a nude man. The costumes are exactly similar to the popularly-known witches' dress of much later times. Sketched by the author from an accurate drawing made by Abbe H. Breuil.

In ancient Mexican lore, we learn that the Witches' Sabbath was celebrated on lines identical with those which obtained in Europe. This earliest version of the witch in the Americas includes the wearing of *a conical hat and the riding of a broomstick*.

Ethnological evidence

If we are to believe the writings of Diodorus Siculus, we learn that a strange people lived on the island of Hesperia in the Fortunate Islands group, between Mount Atlas in Africa and the far western ocean. Among these people were female cultists practicing

sorcery. Among the Guanches of the Canary Islands we find that witch-craft was also much in evidence.

We have seen therefore that witchcraft, having as a part of its strange creed the worship of a deity of fertility, was prevalent among the Cro-Magnons, the people of the Fortunate Islands and the Canary Islands, and the ancient races on the American continent. It appears very evident that this form of sorcery did not come to America by way of Asia. It is seen to have existed from the earliest times in both Europe and America. If we believe that Atlantis once existed, and further, that the people who practised witchcraft so identically on both continents came from its submerged lands, we would expect to find traces of similar practice among the people who were left on the only surviving parts of Atlantis. The evidence above fulfills our expectations in part, though for the time being no definite data are forthcoming from the West Indies.

In common with all other branches of science which I have cited, an abundance of evidence is available in the history of witchcraft in support of the theory that a submerged Atlantis was the center whence sprang most of the earliest races of both hemispheres.

Aleutian Islands route

To continue my procedure of submitting only a small portion of the more important data, I now offer a brief synopsis of ethnological evidence.

Ethnology, as applied to the races of the American continent, has proved to be an exceedingly controversial subject. The theories of the ethnologists who believe that man originated on this continent are apparently not borne out by geological data. In no instance do they offer corroborative evidence to support their contention.

The science of geology, according to Dr. W. D. Holmes, tells us that the first retreat of the glacial ice from middle North America took place between ten and twenty thousand years ago. This makes it obvious that Tertiary man was never present in that area. It is more than possible that man existed in America at a very early date, but I can find no trace of his advent via a northeastern or northwestern route.

There are those who firmly believe that the Maya culture, as well as that of all the races of the American continent, came to these shores by way of the Aleutian islands. It must be admitted that there is evidence pointing to the likelihood of many invasions of the

western shores of America, from lands in the Pacific Ocean. It is also probable that these colonists brought their various arts and customs with them; but there is no evidence that they possessed and introduced into America a matured classical culture such as is exemplified by the Maya civilization. The invasion of Polynesian arts and customs into America is also admitted, but again I state that early arts and cultures do not owe their inception to, nor were they greatly influenced by, the Polynesians. This is especially true of the Maya race, whose art, like their language, is a true root.

Maya and American Indian relationship

Since commencing my study of the ancient Mayas, I have come to the belief that they are in one sense related to the so-called American Indian. I believe that they both sprang from the same genealogical tree, but the branch later known as the American Indian left the parent stem and arrived in the Americas long before the full development of the arts and cultures of the Mayas in the homeland had been achieved. Therefore the culture of these earlier settlers was on a lower plane and (in my belief) never did arrive at the stage of advancement which the last members of the Maya race brought with them in their flight from sinking Atlantis to the American continent.

It is well within reason to accept the probability of invasions by Asiatics via the Bering Strait into America, but the influence of their arts and customs upon the American indigenes is negligible. Evidence of such invasions is to be seen in Asiatic characteristics among the Eskimo and Indian tribes of the north, but this evidence is largely physical. Where such characteristics are to be noted among the more southern tribes they possibly can be accounted for by the fact that the North American Indian is generally nomadic, and his periodic northern visits during the summer seasons brought him in close contact with the northern residents.

Asiatic influence negligible

The Negro blood which has mixed with the tribes of Central and South America can also possibly be accounted for. If we are to believe in the one-time existence of the mighty continent of Gondwanaland, (and there is no logical reason to doubt it), we can look there for the explanation. The true Negro type, at present, is confined to Africa and Australia, but when his homeland continent existed it extended from the Indian peninsula across Africa, joined Australia, and continued in an unbroken line to South America. (See map page 20). As I visualize the catastrophe, when vast areas of that land began to submerge, the inhabitants sought more congenial sur-

Negro admixture

roundings. The fleeing hordes from the southwestern portion of Gondwanaland journeyed up to the higher lands of South America, and later slowly spread farther north. By this it might be argued that the American continent's earliest inhabitants were possibly the Negroes. I have found some ground for belief in this idea. Admittedly, a large number of Negroes entered America in late historical times as slaves of the earliest European explorers, but I see no reason to believe this is sufficient argument to account for all the Negroes in America.

Jewish features in Maya art

I also see a possible reason for the obviously Jewish features frequently depicted in Maya art. Discussing the Jewish race in the chapter on Mormonism, the suggestion is advanced that they occupied Atlantis as members of its civilization. If the empire of Atlantis once comprised a succession of island groups, which might be said to have practically joined Europe to America, there is no reason to assume that the inhabitants were all of one race, ethnologically. The mixed racial conditions which prevail at present on both hemispheres could reasonably apply to the Atlantean period of existence.

Perhaps in Atlantis the religious instructions were exclusively in the hands of a defined body of men, those people known to history as Jews, whose duty it was to perpetuate that country's theological principles and rites from father to son.

As the so-called Semitic features are frequently seen in Maya sculpture, this fact offers evidence as to the prominence and esteem in which they were held by the Mayas. The religion among the ancient Mayas differed little from that of the early Jews in Southern Europe and Asia Minor, so we may presume that if the Jews were the religious preceptors of the escaping Atlanteans they continued their specialized offices upon arrival in Central America. Disputes between these obviously powerful theologians and the new ruling powers could easily account for the extermination of the former early in the Central American history of the Mayas.

Analogous customs among Jews and ancients of Americas

In support of my hypothesis, I might point out that religious and civil customs as practiced by the Jews have their counterpart among the ancient civilizations of the American continent. For instance, the rule that none but the Jewish High Priest might enter the Holy of Holies was almost identically observed by the Pre-Incas. Again, we find that both poured the blood of sacrifice on the earth, both marked persons with it, sprinkled it and smeared it upon the walls and stones. Both ate the flesh of atonement.

There is a Jewish custom of laying the sins of the people upon the head of an animal, and turning him out into the wilderness. The Aztec religion has a similar rite. Offering water to a stranger that he might wash his feet was both a Jewish and an Aztec formality. The Mayas, Aztecs, and Jews practised baptism and believed in the occult power of water. In Bancroft's *Native Races,* speaking of baptism, he says: "Then the Mexican midwife gave the child to taste of the water . . . Then, with moistened fingers, she touched the breast of the child and said: 'Behold the pure water that washes and cleanses thy heart, that removes all filthiness; receive it; may the goddess see good to purify and cleanse thine heart.' Then the midwife poured water on the head of the child . . . "

Similar customs among Jews and Mayas

Bishop Landa, in his *Narrative of the Things of Yucatan* (1566), speaking of the customs of the Mayas, says: "And they took all the children that were to be baptized."

In the Bible, Book of Numbers (xxv, 4 and 5) we read: "And the Lord said unto Moses, take all the heads of the people and hang them up before the Lord against the sun." This Jewish custom of hanging up the heads of sacrificed enemies was also practised by the Aztecs. Some authorities claim that the Mayas, too, observed it, but as with many other unsubstantiated accusations against these people, there is no evidence whatever to indicate that such barbaric acts were ever perpetrated by the Mayas during their occupancy of Yucatan and Central America. Even Bishop Landa denies such a possibility, although he has recorded many unflattering acts and customs among the Mayas in his time. In this connection it must be remembered that he was forced to rely on meager information, reluctantly given by a pardonably resentful people. The Mayas at that time were in a somewhat degenerate condition and only a very few possessed more than the scantiest knowledge of their history. What little knowledge they had was undoubtedly imparted very unwillingly to their despoiling conquerors. It is within reason, therefore, to disregard much of Landa's account of early Maya culture, which in his time had already changed materially for the worse.

Accusations against Mayas without foundation

It must be remembered that Landa typifies the ultimate in religious bigotry. His contemptuous references to barbarism among the Mayas, and his belief that most of their customs were "works of the devil" may well have debarred him from a true understanding of earlier culture among these people.

*The
practice of
circumcision*

Continuing in our consideration of parallel customs in both hemispheres, we learn that circumcision was practised among the Hebrews, the Phoenicians, Egyptians, early Central Americans, at least one American "Indian" tribe—the Chippewas—and the Mayas. (Landa refers to circumcision among the Mayas as an act of defiling the body).

Reginald S. Poole in *Contemporary Review* of August, 1881, speaks of the god in Egyptian faith as "the rewarder of the good and the punisher of the wicked." Egypt's earliest book, *Ptahhotep,* states that her people, colonists from Atlantis, received their pure faith from that mother country. They worshiped one God. The Jews carried on the faith when Egypt had ceased to revere its tenets. Thus we learn—if we accept this evidence—that this faith originated in the lost lands of Atlantis. From there it spread in both directions with the escaping hordes to far-away Egypt and to the Western Hemisphere. On the eve of its decline in Asia Minor, the Jews became its sole upholders. To the Jews then must go the credit. Later, in combination with its offspring, Christianity, it spread over the eastern and western continents.

*Jews and
Mayas wor-
shipped but
one God*

In the face of facts it is self-evident that an All-Seeing, All-Knowing Presence created all things and established the immutable laws of life. It is not strange, therefore, that a people of advanced culture—whom we now designate as Atlanteans—should have established far back in man's history a religious foundation the principles of which have remained practically unaltered to the present day. Their faith was based on a belief in one God and in the immortality of the soul. Despite the amplification and variation by which lesser peoples have seen fit to distort the original, the fundamentals remain.

*Not of the
Lost Tribes
of Israel*

We see, therefore, that neither the Mayas of Yucatan and Central America, nor the members of other ancient civilizations on the American Continent, are direct descendants of the Lost Tribes of Israel. There is the possibility, however, that members of the Jewish race actually dwelt among the Atlanteans in high religious esteem, and fled with those people to both Eastern and Western Hemispheres when escaping from the various cataclysms which, piecemeal, destroyed and submerged the archipelagic empire of Atlantis.

We shall now consider additional evidence in support of the contention that the ancient Mayas of Yucatan and Central America were in no way culturally influenced by any other

civilizations on the American continent. The data also add to the premise of a definite contact with the earliest civilizations in Europe.

In the paintings which adorn the rock walls at Alpera in Spain, the Aurignacian artist depicts the *panache* or head-dress prevalent among his people. The similarity between it and the Maya headdress is remarkable. There seems no question but that this striking headdress either passed across from Europe to America, or, more probably, as I believe, arrived on both the east and west shores of the Atlantic Ocean from the mother-source, Atlantis. The so-called North American Indian did not inspire the ancient Mayas to feather consciousness, as some believe, but on the contrary it was the Mayas from whom the "Indian" derived his desire for feather decoration. The earliest "Indian" tribes are always depicted as wearing but a single feather, not elaborate feathered headdresses and capes.

Headdress comparisons

Ethnological data again come to our aid in tracing the custom of artificial deformation of the children's heads. In the record books of the British Museum concerning Egyptian history we read: " . . . before the reign of Mena, or Menes (the first historical King of Egypt, circa, 3,500 B. C.), the Nile Valley was occupied by a race of men and women of slender build, who had *long narrow heads,* long hands with tapering fingers, feet with high insteps, reddish hair, and probably blue eyes; the people believed in a future life of some kind."

Tracing custom of artificial head deformation

In studying the cranial and facial characteristics of the ancient Mayas, we see a well formed oval face with high cheek bones, a salient nose, occasionally "Semitic" in shape, sometimes definitely Roman, and a high receding forehead. The receding forehead is an artificial formation. The mothers, immediately after birth, applied what is known as a cradle-board to the child's head, so that in after life the forehead sloped backward to a marked degree. This practice, as we have seen, was apparently in vogue among the Magdalenians in France and Spain at least 14,000 years B. C., and was also a universal custom among the Egyptians. Cranial distortion, or head-flattening, was also practised among the early Basques. This is an interesting point when it is remembered that the custom still exists among the Basques, the oldest people of Europe, who for long centuries have occupied almost the same territory as did their settler progenitors, the Cro-Magnons, presumed to be from Atlantis. When we turn to a study of the Haitians we learn that they too possessed this custom.

Head flattening still persists

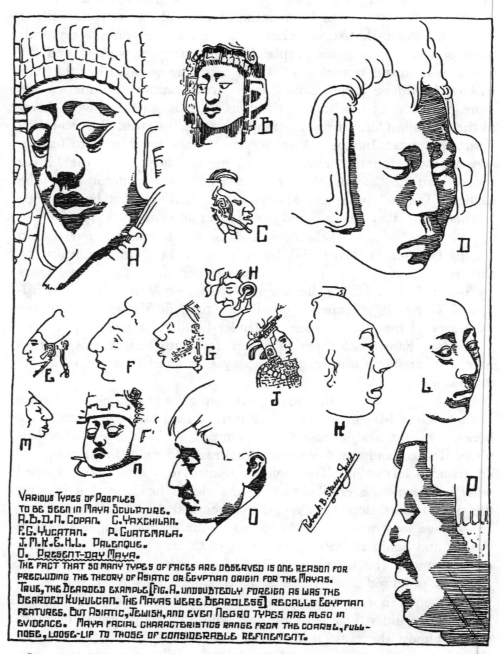

VARIOUS TYPES OF PROFILES
TO BE SEEN IN MAYA SCULPTURE.
A.B.D.N. COPAN. C. YAXCHILAN.
F.G. YUCATAN. P. GUATEMALA.
J.M.K.E.H.L. PALENQUE.
O. PRESENT-DAY MAYA.
THE FACT THAT SO MANY TYPES OF FACES ARE OBSERVED IS ONE REASON FOR
PRECLUDING THE THEORY OF ASIATIC OR EGYPTIAN ORIGIN FOR THE MAYAS.
TRUE, THE BEARDED EXAMPLE [FIG. A. UNDOUBTEDLY FOREIGN AS WAS THE
BEARDED KUKULCAN. THE MAYAS WERE BEARDLESS] RECALLS EGYPTIAN
FEATURES. BUT ASIATIC, JEWISH, AND EVEN NEGRO TYPES ARE ALSO IN
EVIDENCE. MAYA FACIAL CHARACTERISTICS RANGE FROM THE COARSE, FULL-
NOSE, LOOSE-LIP TO THOSE OF CONSIDERABLE REFINEMENT.

One reason why the author disagrees with prevailing opinion of Asiatic or Egyptian origin.

So-called enlightenment is far from universal on this earth of ours. Not only do we find, at least until quite recently, head-flattening still being practised among the Basques, but in some parts of France, Normandy, Gascony, Limousine and Brittany.

Other physical comparisons between the Cro-Magnon man of Europe and the ancient Mayas in Central America point to more than mere coincidence. The facial and cranial characteristics, the similarity in the full body and sturdy figure, and the high degree of cranial capacity are almost identical.

A migration of cultural aristocracy

It is true that considerable variation of these outstanding features is noticeable in many of the figures depicted in Maya sculpture. It is quite common, for instance, to find these figures with oblique or bulging eyes, a full nose, coarse features and thick lips. On the other hand, we also find good-looking figures, with regular features, lithe bodies, well proportioned limbs, finely formed heads with high sloping foreheads, shapely noses and small mouths with firm thin lips. The last description compares favorably with that given by Dr. Wallis Budge in reference to the prehistoric Egyptian sculptures.

It is not an easy task to carve a clear ethnological line of demarcation between the true Maya of Central America and Yucatan, and other ancient races. Naturally, due to invasions—of which we shall learn later—among these gentle people, numerous strains were grafted onto them. Personally, I see no reason to believe that the presumed Maya migration from Atlantis to what is known as the Maya area in America, was a large one. It was, without question, a migration of "cultural aristocracy, rather than a horde of immigrants." Furthermore, it is conceivable that the well built, fine featured figures seen in the Maya sculpture represent the true Maya race. It would seem also that two distinct physical types of the race were developed toward the end of the Maya civilization in America. One, the tall, well formed, athletic, aristocratic type; the other, a short, sturdy-legged, powerfully-torsoed plebeian. The former class comprising the brains, were therefore selected for slaughter by their conquerors, the Toltecs, Aztecs, and Spaniards, each in turn; while the latter were spared for menial work and slavery. It is the descendant of the latter class who is seen today in Yucatan and Central America.

Two types in Maya race

Chapter Seven

The Mormons and the Mayas

*Man, a slave
to his fears*

AN'S earliest beliefs originated in fear, and his religious observances developed from a policy of keeping on the best terms with such inexplicable forces as evidenced beneficence or maleficence toward him. The sun, therefore, became the principal beneficent object of the earliest form of religious attention, while storms, lightning, earthquake, and all destructive forces of nature were considered to be malignant.

In the early stages of theological understanding, emotions controlled man's actions because feeling precedes reason, and as ignorance is the mother of mystery, man became a slave to his fears. Among his early conceptions was that the sun journeyed around the earth, because he relied upon the testimony of his senses. In like manner he ascribed an indwelling life to everything that passed his comprehension, from the heavenly bodies to watercourses. He averted the wrath of his gods by buying their favors with sacrifices and in all cases he ascribed a personality to the unseen powers. It was thousands of years before he conceived an orderly relation of his surroundings.

But as cultural advancement brought with it an understanding of cause and effect, his system of religious practice de-

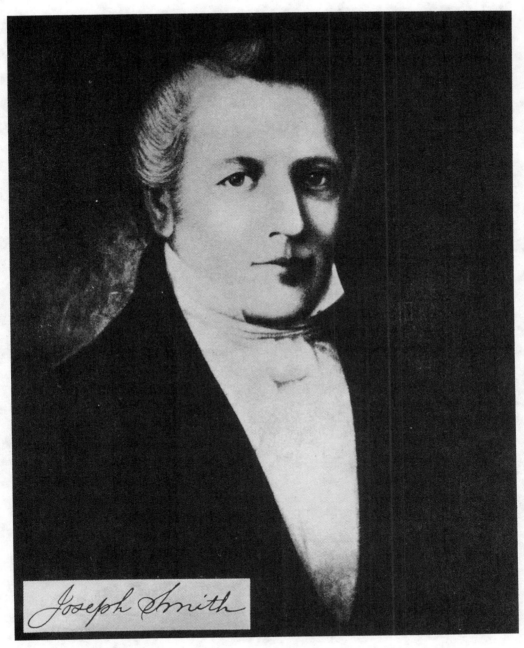

Joseph Smith

The Mayas of Yucatan play an important part in the Mormon faith, according to Joseph Smith, the founder.

veloped from propitiation of many gods and devils to so-called mono-
theism, founded on the premise of God as the supreme consciousness,
a universal creator, the Great Spirit, Jehovah, or Jove. As knowledge
increased, fear decreased. Self expression created diversified opinions
concerning the interpretation of theological principles resulting in the
establishment of separate creeds and religions. But as with languages,
so religious beliefs vary according to race, antecedents, customs and
environment; they all sprang, however, from a belief in a Father of all
things.

*Understand-
ing cause and
effect*

In the field of abstract sciences ignorance has
obstructed progress just as it retarded religious enlightenment, but no-
where more than in the study of psychic phenomena. In recent years,
however, wider experience and a greater understanding have paved the
way toward tolerance and the desire to learn.

With the present revival of interest in subjects
spiritual, philosophical, and esoteric, the erstwhile ridiculed psychic
phenomena are rapidly being credited with foundation in fact. In like
manner the forecasts of both ancient and later prophets are being
treated with increasing respect. Thousands of cases are on record of
almost unbelievable psychic demonstrations; more than sufficient to
prove the positive existence of unseen forces. It is probable that the
remarkable advance in radio science and the extraordinary uses to which
its laws are applied have had a pronounced influence in creating general
belief in the existence of forces viewed hitherto with skepticism if not
absolute denial. Nowadays, it is a wise man indeed who makes bold to
say "it is not so."

We now come to the Mormons and the Mayas.
My reason for introducing the foregoing remarks into this particular
chapter is that in the *Book of Mormon* (The Mormon Bible) evidence
is offered connecting that doctrine with the Maya culture, evidence
which I believe may prove helpful to us. But as the circumstances con-
cerning the manner in which Joseph Smith, (founder of Mormonism)
obtained his knowledge, and the information he reveals pertaining to
the Maya civilization, are extraordinary, I have prefaced the subject
with a brief outline of the growth of religious thought, metaphysics and
psychic phenomena.

*Who shall say
"It is not
so"?*

In the year 1838, when John L. Stephens first
visited the jungle area (from Yucatan to Guatemala) and wrote two
fascinating volumes on his travels, practically nothing was known of

the lost civilization of the ancient Mayas. Yet one Joseph Smith, a simple, small-town youth born of humble parents in the year 1805, was acquainted with the subject. From what source came his knowledge?

A biography of Joseph Smith states that he lived with his parents in poverty and had little or no opportunity for education. At the age of fifteen, in the year 1820, he went into the woods *to ask God for enlightenment.* It was the morning of a beautiful, clear day, and there, in the woods, a vision appeared to him.

Joseph Smith

The phenomenon of the vision can be accepted because it corresponds with countless recorded experiences in which prayer has been answered. Also, from a host of records, we learn that visions are common either by day or night.

I once knew a mere baby who frequently "spoke with God." According to his grandmother, this child could talk at the age of one year. One night while I was visiting his parents we heard him call: "Come at once!" We went quickly to his bedroom, where this young-old soul was kneeling on his bed looking upward. He said he had a message for us. The substance of it, spoken in unchildish words, was this: "God spoke and asked me to tell you to go out and inform the people that a big mountain has just blown up and it is very dark. All the houses in a large city near the water are being buried and all the people are being killed." *The following morning,* word was received by a horrified world that Mont Pelée, in the Island of Martinique, had erupted and destroyed thirty thousand persons. That was in the year 1902. In the year 1906 the same child again called the grandmother to his bedroom, saying: "God has just called me." He told that stupefied lady of another terrible disaster, describing in detail the earthquake, fire, and loss of life which befell San Francisco. These

A personal experience

visions took place in England and in each case the child's communication was many hours before news of the catastrophe was announced by cable. These are but two examples of this child's psychic messages, which continued and covered, to my personal knowledge, a period of more than five years.

Many similar incidents have come directly to my attention. Thousands of others equally authenticated have been chronicled. Are not, then, the experiences of the youthful Joseph Smith within the bounds of possibility? Let us follow his story.

He tells us that in the first vision a figure appeared and addressed him, claiming to be known as Moroni, son of

Mormon, "sent from the presence of God." Other "visions" followed. During his second appearance, Moroni informed young Smith, among other things, that he would show him where a number of gold plates were hidden. These plates, the message continued, contained writings in strange characters. Moroni termed these "revised" Egyptian. According to Joseph Smith's account, the story written on these plates contained information substantially as follows:

The Israelites (progenitors of the Nephites, who were led by Lehi, a Jewish prophet of the tribe of Manasseh) *came from the east* and landed on the shores of Yucatan in America, approximately 600 B. C. After their landing, the tribe was divided. One half was led by Nephi Son of Lehi, and the other half by Laman. The forefathers of Moroni who wrote the original plates were of the half led by Nephi. Moroni's father was named Mormon and it is he who was sanctified by the Latter-Day Saints and whose name is perpetuated by the Mormon denomination.

In the Book of Gold

Remember, this tribe of Israelites, according to the Mormon *Book of Gold, came from the east.* (All the Maya records state that their people *came from the east*). In the *Gold Book of Moroni* we read that the tribe *lived in peace* for 400 years. (The Maya civilization existed many hundreds of years in peace). It is said that the ancestors of Mormon and Moroni in Yucatan were Israelites. (Maya profiles as seen on bas-relief panels often show decidedly Hebraic features). The writing on the tablets is described as "revised Egyptian." (I have attempted to explain the connection between the ancient Maya civilization and the Egyptians).

Joseph Smith's first vision occurred in the year 1820, when he was fifteen years old. At the age of eighteen years the second visitation took place. It was at this time that the contents of the *Book of Gold* were revealed to him. In 1827 a translation was given by Joseph Smith to the world.

Parallel records of peace

Is it conceivable that a mere youth, uneducated, and bred in comparative poverty, would have had the knowledge of a lost civilization such as the Mayas, in the year 1827, when it was not until 1841 that John L. Stephens produced the first popular work on the subject? It might be argued that it was possible for him to have studied the works of the early Spanish writers. This alternative is not probable, in view of the fact that all such works were written in a

language foreign to him, and at that time their existence was practically unknown in the English-speaking world.

Where then, other than through the medium he claims, did Joseph Smith obtain his knowledge of the Maya civilization? Before we appraise the Mormon claim to a Maya association, let us digress briefly into early Jewish history.

Early Jewish History

History, or lack of it, shows that the origin of the Jewish tribes is lost in antiquity. This is partly due to their own neglect, partly because of their harassed and warring existence in early times, their servitude in Egypt, their captivity in Babylon—conditions which prevented them from compiling and preserving even a sketchy record. In Genesis we read that the sons of Noah were Shem, Ham and Japheth. If we concede that the descendants of these three major divisions of the human family, classified as Turanian, Semitic, and Aryan were originally from Atlantis, as all available evidence suggests, we can, for argument, state that the origin of the Jews is therefore traceable to that submerged continent. The great mystery of the Lost Ten Tribes of Israel and the singular significance of the mystic number ten appears in Atlantean history as elsewhere. Traditions of various nations refer to the *sacred ten*. The Bible mentions the ten antediluvian patriarchs. Berosus refers to the ten antediluvian kings in Chaldea whose consecutive reign extended to thousands of years. In India we learn of the nine *brahmadikas* and their founder Brahma, totaling ten, called the ten fathers. The Chinese enumerate the ten great emperors. The Germans believed in the ten ancestors of Odin. The Arabs have ten *mythical* kings of Adites (Lenormant and Chevalier). We have learned also of the ten kingdoms of Atlantis, as related by Plato.

The Sacred Ten

In the works of Bishop Landa, second Bishop of Yucatan after the Spanish conquest, he says: "Some old men of Yucatan say they have heard from their ancestors that certain people populated the land, *who entered by the east, whom God had freed, opening for them twelve roads to the sea.* If this be true, all these of the Indies must have come from the Jews, because, had they crossed the Strait of Magellan, they would have had to go more than two thousand leagues of land that today Spain governs."

Further parallels between Jew and Maya customs

Landa further records the fact that the Mayas had many habits and customs similar to those of the Jews. He says that they practiced baptism, as did the Jews, and both venerated one God, as did the Egyptians. *They made no image of God.* From other

authorities we learn that both the Jews and the peoples of Central America worshiped toward the east and both burned incense in the four directions. Both placed cleanliness next to godliness. Both believed in devils. The confession of sins and atonement were common to both. Both venerated the serpent. All four—the Jews, the Central Americans, the Egyptians and the Mayas—*were strictly moral.*

Now we return to the *Book of Mormon* which is apparently conclusive as to the Maya advent into America *from the east.* I shall quote from Dr. J. E. Talmage's description of the voyage of the Nephites to Central America under the leadership of Lehi. The company first left Jerusalem and journeyed "somewhat east of south, keeping near the borders of the Red Sea; then changing their course to the eastward, crossed the peninsula of Arabia; and there on the shores of the Arabian Sea, built and provisioned a vessel in which they committed themselves to divine care upon the waters." Assuming for the moment that this was actually the course taken, I again quote Dr. James E. Talmage. He says: *"It is believed* that their voyage must have carried them eastward across the Indian Ocean, then over the Pacific to the Western coast of America, whereon they landed about 590 B. C."

Journey of the Nephites

It will be noted it does not state definitely that the Nephites followed the course exactly as stated.

Bishop David A. Smith, who compiled *Suggestions for Book of Mormon Lectures,* quotes A. Hyatt Verrill as stating that: "Peru was inhabited by the most highly civilized race in the Western Hemisphere." Further he says "that most authors agree that from Peru northward to Yucatan are found evidences of the height of civilization of these people." From these statements he assumes the arrival of the Nephites in Peru from Jerusalem, and later, after a division of those people into two factions, then known as Nephites and Lamanites, the former spread northward into the Central American area and later still into the eastern parts of the United States. In what is now known as the State of New York, the Plates of Gold were found, bearing the engraved story of Lehi and his people.

No evidence Mayas borrowed from Pre-Incas

It is true that there are evidences of considerable similarity between the ancient cultures extending from Peru to Central America; but there is no evidence whatever to prove that the Mayas in Central America borrowed from the Pre-Incas or any other cultures of the Americas. Bishop Smith's conjecture that the earliest culture of

Peru progressed northward into Central America and Yucatan, is therefore without foundation. As we shall learn later, definite parallels exist in scores of architectural motifs, in legends, mythologies and elsewhere; but (at least in the case of Pre-Inca and Maya art) the evidence favors separate and distinct colonial migrations. I cannot agree with *No evidence ancient cultures originated in Americas* Ameghino that the so-called American Indian "evolved from lower forms of life on the American Continent." There is too much evidence to the contrary. Neither can I accept the statement of many ethnologists that the American Indian originated in Asia. In another chapter I discuss the extreme improbability of Asiatic emigration to America via the Behring Straits and the Aleutian islands.

There seems to be no evidence that either the Pre-Incas or the so-called Mayas began their culture or originated their advanced architectural styles on this continent. The Mayas, according to overwhelming data, did not arrive in Central America or Yucatan from the west, or the north or the south, or any land center on this continent. It is very definitely stated that they "came in boats across water, from the east."

I believe that there were many invasions into America by civilized peoples, but I believe that they came mostly from the east.

Suggested route of Nephites In view of the accumulated evidence that the Nephites made such a journey as described, I suggest that as the route taken by their migration under the guidance of Lehi is admittedly indefinite, two possibilities exist. Either these people journeyed from the shores of the Persian Gulf as assumed, (only instead of crossing the Indian and Pacific Oceans to western America, they swung south—rounded South Africa and thence to eastern America) or, as the Mormon records seem doubtful regarding the details of their land journey, it can be logically assumed that they left from the Mediterranean shore north of Arabia and journeyed directly west to the American continent.

Instructed to build ship In the *Book of Mormon*, Nephi, son of Lehi, says that after his father's people had journeyed through the wilderness, which took eight years, they beheld the sea and pitched their tents on the shore. After resting there a few days the Lord told Nephi to go into the mountain; there he received instructions to build a ship. Nephi asked the Lord where he should go to find ore to make the necessary tools. The assumption is that both the timber and the ore were available

in the immediate neighborhood wherewith to complete the ship. In due time the vessel was completed and the great journey begun.

According to the above information, the body of water they beheld could not have been the Arabian Sea, as Dr. Talmage suggests, neither could it have been the Persian Gulf. There are no forests adjacent to the shore of either coast line, and no evidence to show reversed conditions at the time Lehi's people made their journey. True, there are a few mountains bordering the Arabian Sea, but the country in general is a sandy, desert waste. Without either suitable forests or ore it is obvious that the place where the emigrants camped must have been elsewhere than the borders of the Arabian Sea. These observations suggest that the route taken may have been in the opposite direction, and the camp site on the Mediterranean instead of the Arabian Sea—unless the eight years of wandering, the ore, the ship, and the journey to the promised land are merely symbolic, with a yet undefined meaning.

Possible symbolic meaning

Conceding, however, the probability of a direct westward journey of the Nephites, the accumulated data of other scientific research tend strongly to support the account of Lehi. Considering lapse of time and insufficient detail, certain discrepancies are not only possible but highly probable. Perhaps the information set forth in other chapters will assist in clarifying at least some of the weaker points in Lehi's narrative.

Parting the waters

Nothing remains of the Maya writings from which we can learn of their history; but the Quiches, a branch of the Maya race, possessed a book now known as the *Popol Vuh*, in which much is to be learned. In this book we read that when their ancestors migrated to America, the Divinity parted the sea for their passage, as the Red Sea was parted for the Israelites.

Is it not noteworthy that both the Jews and the Central American races agree on many points of religious and civil custom? Both called the south "the right hand of the world." Both had an ark, the abiding place of the invisible god. Both considered women who died in childbirth as worthy of honor as soldiers who fell in battle. Both stoned to death those caught in adultery. Both tell almost identical stories of Samson, who, placed in a pit by his enemies, pulled down the building wherein his enemies were assembled, killing four hundred.

Parallel beliefs among Jews and ancients of Americas

We now come to the question of the authenticity of the records kept on brass plates as secured by Nephi from Laban, in

Jerusalem. Plates of four classes are referred to in the *Book of Mormon*. The plates which Nephi secured from Laban in Jerusalem are described as being made of brass; those which Joseph Smith secured through the agency of Moroni were of gold.

Secreting records

The Hindu *Bhagavata-Purana* tells us that the Fish-God, who warned Satyravata of the coming of the Flood, directed him *"to place the Sacred Scriptures in a safe place."* In the narrative given by Plato we read that the records of the Atlanteans were written on gold tablets "and deposited as memorials with their robes." In Berosus' version of the Chaldean Flood, he says: "The deity Chronos . . . warned him [Xisuthhros] that . . . there would be a flood by which mankind would be destroyed. He therefore enjoined him *to write a history of the beginning, procedure, and conclusion of all things, and bury it."*

History records numerous instances of just such procedure under threat of impending doom. The Mayas were no exception to this rule. It is therefore reasonable to accept the Mormon story of the burial of gold tablets or plates, upon which the record of the Jews is inscribed. It is my belief that many Maya records will yet be discovered, perhaps in the depths of the numerous caves that riddle Yucatan; and if Joseph Smith's story is finally discovered to have complete basis in fact, similar possibility exists for the re-discovery of the Plates of Gold.

It appears evident, considering the infinitesimal number of records recovered, that the Mayas, long prior to their conquest, by Cortez, were aware of their doom and took pains to secrete their valuable records and their wealth. I believe that at least some of these hiding places will be revealed eventually, and many startling finds of intrinsic and esoteric value will come to light.

The despised Jew

The Mormon belief is that much of the early history of the Lehites lies hidden in Yucatan. There is no logical reason to disagree with this opinion.

For many centuries, the Jews have been wanderers over the face of the earth, nomads, a nation without a country, and despised by almost all other peoples. Nevertheless, the mere fact of a small body of ignorant shepherds, long humbled to the dust, taking up the burden of promulgating a belief in but one God —which belief the Egyptians later denounced—and carrying that faith in increasing proportions throughout the world down to the present

time, points, in my opinion, to but one conclusion; namely, a background of religious culure long prior to their days of degradation in Egypt.

Just why the Jews have remained an outcast race for so long is still a mystery. But whatever the cause it is evident that they were always a highly religious people. They are undoubtedly of very ancient stock, and there is the probability they came originally from Atlantis to Palestine, if not as indigenes, then—as the evidence suggests—they were, at least, occupants of Atlantis for some considerable time. The evidence points to a definite affinity between the arts and sciences of the Egyptians and those of the Mayas of Yucatan and of Central and South America. The evidence is primarily religious and in general shows that the God of the Jews, together with numerous customs and rites of their faith, prevailed among the ancient races of America, including the Mayas.

Jews of ancient stock

In addition, we find evidence pointing to a common source for both the language of the Jews and that of the early peoples of the Americas. I endeavor to substantiate in Chapter XV my belief that the root of the admittedly branch languages of Hebrew and Aramaic—and possibly others—is the same as that of the so-called Maya. This hypothesis may serve definitely to connect the Jews with my suggested Mother Empire.

A common source for languages

Many students believe that the Mayas are one of the lost tribes of Israel; but, in view of the evidence, I am inclined to a contrary opinion. The Jews are not and never were a race of architects or great builders. The prehistoric races of the Americas, on the contrary, were past masters in those sciences. It is possible, however, as I stated before, that they ranked merely as the religious preceptors among the Atlanteans. It is further possible that, as many had joined the various escaping hordes from sinking Atlantis in eastern migrations to Europe and Asia, so the Jews occupying the more westerly areas of the Atlantean group of islands joined those we know as the Mayas in their western migration to the American continent when the last of their Motherland sank.

Mayas, a lost tribe of Israel!

The fundamentals of religion, mythology, customs, arts and sciences of the great racial divisions of Europe and Asia are also strikingly prevalent among the earliest known settlers of the American continent. Further, there is apparently abundant proof that Aryan, Semitic, and Hamitic languages sprang from a much older

mother tongue. Where, then, did the mother tongue originate? The evidence points to Atlantis.

Much as I respect the Mormon religious philosophy, I am not affiliated with the faith, and at no time have been connected with any member or any part of the Mormon organization. My endeavor throughout this work has been to consider each and every clue, old and new, in an effort to strengthen my belief that the Mayas of Yucatan and Central America were not indigenous to the Americas, and, further to refute the claim that they were "born, flourished and died" in the Central American area. The accumulated evidence points strongly to the fact that the so-called Mayas were colonists from Atlantis. Likewise, considerable evidence indicates that the prehistoric Jews were either one of the Ten Kingdoms of Atlantis, referred to in Plato's narrative, or they dwelt among those people for a considerable time. Mormonism claims Jewish origin. If we argue that the Jews occupied Atlantis, then it is conceivable that when the eastern section of that continent began to sink, they together with other Atlantean subjects fled to the nearest haven of refuge, the European shores. This would account for an otherwise unknown Jewish origin in Asia. As previously stated, the evidence suggests that the earliest Jews, and all other inhabitants assumed to have migrated east from Atlantis, knew of a western continent. Again, if we are to believe the evidence, then we must concede the probability of an erstwhile continent in the Atlantic Ocean. We must further concede that an advanced race of people existed there who, in addition to being masters of the arts and sciences, were master mariners and world-wide travellers. Obviously, then, they traded, not only with the peoples of Europe and Asia Minor, but also with those of the Western Hemisphere. Therefore, from the self-same evidence we may reason that when Lehi, the Jew, as recorded in the "Book of Mormon", received, in a vision, instructions to seek a land of safety—"the land of promise"—he knew of the existence of the continent which is now America.

An unbiased opinion

Did Lehi know of America?

Chapter Eight

Astrology in Two Hemispheres

HE present unsatisfactory, or perhaps I should say discredited, status of the subject of astrology in scientific circles forbids the use of whatever evidence I believe it may contribute to support my general theory, unless I am able to show that astrology is definitely a science, that it was so recognized and practised by most of the early civilizations in both hemispheres (as I shall endeavor to prove), is today being rediscovered, and can contribute material evidence concerning Maya origin. If the evidence to be presented does not convince, it should be discarded without prejudice to the main argument. To request a hearing is an invitation to reason, and, as Sir William Drummond says: "He that will not reason is a bigot; he that cannot reason is a fool; and he that dares not reason is a slave."

An appeal to reason

Further to confirm my belief that a defense of astrology in this work is material I am reminded, first, that recently I received a letter from a well known scientist chiding me for mentioning astrology in my article in a popular magazine. He says: "To me, astrology is without scientific or philosophical validity." Again, the astounding display of ignorance of facts which appeared in the May,

1938 issue of *The Commentator,* an American national magazine, entitled *That Gigantic Fraud, Astrology,* is a further example of the cultural status among certain present-day writers, who unfortunately command large audiences. In this instance the writer exhibits an appalling lack of broad education, especially concerning the subjects of science and history. And I am reminded, second, of the significance of a statement in *Living Races of Mankind* (p. 744.), referring to the Mayas, which says: " . . . divination is still practised by the astrologers to forecast the future and the promise of good harvests." It is obvious, therefore, that before astrological evidence can be deemed worthy of consideration, prevailing disbelief, doubt, prejudice, and skepticism must be banished.

"That Gigantic Fraud, Astrology"

From a voluminous mass of data from various sources, I have extracted the evidence which follows. With the author's permission, I have also freely used the information contained in a recently published volume, *The Story of Astrology,* by Manly P. Hall, to whom I make grateful acknowledgment.

Before submitting the evidence, however, I wish to repeat an interesting incident recorded in that volume. It relates that "when the astronomer Halley, of comet fame, made a slighting remark as to the value of astrology, Newton (Sir Isaac Newton) gently rebuked him: 'I have studied the subject, Mr. Halley,' he said, 'you have not.' "

The Newton-Halley incident recalls to my mind an analogous experience which happened to me after completing a lecture before an undoubtedly intelligent audience. "I am surprised," said a perturbed member, "that you should spoil an otherwise good story by mentioning such a discredited subject as astrology. No intelligent person gives it a moment's thought."

What Newton said to Halley

"Which raises the question, what is intelligence?" I replied.

Let us now consider the evidence. It may surprise many to learn that a host of mental giants whose names are outstanding in world events, from the beginning of historic time until now, were staunch believers in astrology and its predictions; not only were many of them ardent students of this complicated science, but personally able to formulate noteworthy forecasts. Following is a list of some famous men in history who firmly believed in a definite influence of the heavenly bodies on the lives of human beings. I also mention a few

of the more important historically recorded instances of astrological predictions.

Among the earliest well known philosophers we find such men as Berosus, priest of Baal, whom Vitruvius describes as the first and greatest of the Chaldean astrologers and historians; Al Hakim, the venerable Persian astrologer; Petosiris and Necepso, the earliest known Egyptian astrologers, reference to whom as astrologers is made in the writings of Pliny, Galen, Ptolemy, and others; Plato, Aristotle, Alexander; Hippocrates, the father of medicine; Horace, Virgil, Julius Caesar; Vitruvius, the master of architecture; Placidus, the mathematician; Genghis Khan; Roger Bacon; Copernicus; Galileo; Kepler; Sir Francis Bacon; Flamsteed, the first astronomer royal and founder of the Greenwich Observatory; Sir Isaac Newton; Sir Walter Scott; Shakespeare; Goethe; Byron; Pope Leo X, and other pontiffs; Napoleon I; George Washington, and Benjamin Franklin.

Distinguished Host of Believers

Cicero observes that the Chaldeans had records of the stars for the space of 370,000 years. He further asserts that the Babylonians, over a period of thousands of years, kept the nativities (horoscopes) of all children who were born among them, and from this enormous mass of data calculated the effects of the various planets and zodiacal signs.

Hippocrates predicted, astrologically, a great plague at Athens, which came to pass. Tycho Brahe, the Danish astrologer, predicted that "in the north, in Finland, there would be born a prince who would lay waste Germany and vanish in 1632." The Prince Gustavus Adolphus was born in Finland, ravaged Germany during the Thirty-Year War, and died as the astronomer had predicted, in 1632.

The great mathematician-astrologer Jerome Cardan, at the request of the Archbishop of St. Andrews that he cast his horoscope, predicted in 1552 that in the year 1570 the archbishop would be hanged. The prediction was fulfilled.

Predictions fulfilled

In Lord Bacon's *Essay on Prophecy* we learn that "the Queen Mother . . . caused the king's, her husband's nativity to be calculated under a false name, and the astrologer gave a judgment that he would be killed in a duel; at which the Queen laughed, thinking her husband to be above challenges and duels . . . " The king was slain in the manner predicted.

Marsillio Ficino, the astrologer of the household of Lorenzo the Magnificent, casting the horoscopes of the children of that illustrious Medici, predicted that little Giovanni was destined to become a Pope. Not only was the prediction fulfilled, but Giovanni became a distinguished patron and believer in astrology.

Napoleon I frequently consulted an astrologer. The latter repeatedly warned Napoleon against a Russian campaign. But Napoleon trusted to the star of his destiny, as he saw it, and paid the price of ignoring the warning.

Irrefutable evidence

Al Hakim, the Persian astrologer, in one of his books entitled *Judicia Gjmaspis* predicted, astrologically, the coming of Christ, that Mohammed would be born, and that the Magian religion would be abolished.

Alexander of Macedon was forewarned by astrologers of the time and manner of his death. When he reached the walls of Babylon the astrologers warned him away. "Flee from this town where thy fatal star reigns," they said. Though much impressed and somewhat hesitant, Alexander finally entered the city and met his fate as predicted.

Sir Henry Cornelius Agrippa was astrologer to Charles the First of France, but lost that office because of the consistent manner in which he predicted misfortune. Nostradamus, the most famous of the French astrologers, and physician to King Henry the Second and Charles the Ninth, astrologically predicted the fire of London in 1666, the French Revolution, and the advent of Napoleon; yet he died in the year 1566. In quaint verse he predicted London's historic fire:

In middle of 16th century Nostradamus predicted fire of London

"The blood o' the just requires,
Which out of London reeks,
That it be raz'd with fires,
In year three score and six."

Guido Bonatus, a famous Italian astrologer, was uncannily accurate. On one occasion, happening to be in a beleaguered city, the Earl of Montserrat, chief military official, consulted him as to the most propitious time to lead an attack against the besiegers. Bonatus astrologically decided the most auspicious moment for success, but declared that the Earl would receive a slight wound in the knee. So certain was the astrologer of his predictions that he accompanied the Earl on the sortie, carrying with him the necessary bandages. The

Nostradamus, most famous of French astrologers, died in 1556 A. D., yet he predicted the Great Fire of London would occur in 1666 A. D. (From Lilly's *Monarchy or Monarch in England*)

enemy was routed and the Earl received the slight wound as predicted.

William Lilly, the famous English astrologer, was called before the House of Commons where he was informed that, as he had predicted the great fire of London fifteen years before the event took place, they desired to know from him the causes or authors thereof. Lilly also advised King Charles the First, when the latter consulted him, to travel eastward for safety. The King travelled westward to his doom. In recognition of Lilly's astrological ability, King Charles the Tenth of Sweden presented him with a gold chain.

*Famous
American
Astrologers*

It is worthy of note that George Washington and Benjamin Franklin, both believers in astrology, attended meetings at which a man proficient in astrology was present in an advisory capacity.

Sir John Hazelrigg states definitely that "not a few" of those illustrious patriots who drafted the Declaration of Independence "were versed in the tenets of astrology . . ." This statement is warranted by annotations on the margins of the astrological books in the Thomas Jefferson Library (in Library of Congress); Franklin was a self-confessed votary, confirmed by his scientific delving and his *Poor Richard's Almanac.* Numerous authentic records exist to prove that Benjamin Franklin's astrological predictions were fulfilled. Mention here of but one incident should prove sufficient to verify the many. Thomas Leeds, a friend and fellow-student of Benjamin Franklin, requested the latter to set up his horoscope. Among other incidents foretold there he says: "He dies by my calculation, made at his request, on October 17, 1733, 3 hours 29 minutes P. M., at the very instant of the conjunction of the Sun and Mercury." The prediction was fulfilled.

*American
flag and
astrology*

In a little book *Our Flag,* by Robert Campbell, we read that the flag of the United States was actually patterned by a man who was not only well versed in astrology, but who in the presence of Washington and Franklin described the symbolism of the flag and the nation which it represented in terms of astrology and the zodiac.

*The Japanese
and astrology*

The German government solicited the assistance of Raphael, the English astrologer, in the choosing of a propitious time for the commencement of the Franco-Prussian War. Later Raphael received from the Germans one hundred pounds "in appreciation" of the accuracy of the advice he had given astrologically. The Japanese Government recognizes astrology and uses it as a necessary feature in

William Lilly astrologically predicted the Great Fire of London fifteen years before it occurred.
(From *Monarchy or Monarch in England*)

the administration of its affairs. They used the science successfully throughout the Russo-Japanese war.

Count Louis de Hamon

Count Louis de Hamon (Cheiro), probably the best known modern astrologer, stated that he was requested once by the late Czar of all the Russias to calculate the horoscopes of the royal family. He claimed to have predicted accurately the fall of the house of Romanoff. Among his remarkably accurate predictions were the time and circumstances surrounding the death of Lord Kitchener, the tragic end of Mata Hari, and the birth of a child to Mrs. Cleveland, wife of President Grover Cleveland. He was also consulted by other world figures, such as King Edward VII, Leopold II King of the Belgians, Admiral George Dewey, and General Nelson A. Miles. (See *Confessions of a Modern Seer,* by the late Count Louis de Hamon, Cheiro).

It is said that Signor Mussolini always consults Rosconi, the astrologer, whenever he visits Milan. In that city he is known as "Mussolini's astrologer." Rosconi, among his many accurate forecasts, predicted that the great war would end in November, 1918. Authorities at the time endeavored to confine him to an insane asylum.

Mussolini and astrology

Throughout history, astrologers have been honored at the courts of kings and by famous warriors. Celebrated men throughout the ages have revered the science and respected its predictions.

In the *Jewish Encyclopedia* is a sentence which reads:

> "Abraham, the Chaldean, bore upon his breast a large astrological tablet on which the fate of every man might be read; for which reason—according to the Haggadist—all of the Kings of the East and of the West congregated every morning before his door in order to seek advice."

Lord Bacon on astrology

Lord Bacon says that astrology may be "more confidently" applied to prophecy. "Predictions may be made of comets to come which (I am inclined to think) may be foretold; of all kinds of meteors, of floods, droughts, heats, frosts, earthquakes, eruptions of water, eruptions of fire, great winds and rains, various seasons of the year, plagues, epidemic diseases, plenty and dearth of grain, wars, sedition, schisms, transmigrations of people, and any other or all commotions or general revolutions of things, natural as well as civil."

The drafting of the American Declaration of Independence was not without astrological influence. (From Sibley's *Astrology*)

Fatalism is in no sense a doctrine of astrology, as the ignorant suppose. Lord Bacon says: "There is no fatal necessity in the stars." Claudius Ptolemy, in his *Centiloquy*, says: " A skillful person, acquainted with the nature of the stars, *is enabled to avert many of their effects and to prepare himself for those effects before they arrive.*"

The learned Franciscan Monk, Roger Bacon (*Opus Majus*) comments on the above statement as follows: "It is not Ptolemy's thought that the astrologer should give any particular and fixed judgment and one sufficing in individual cases; but that his judgment should be a general one and a mean between what is necessary and what is impossible, and the astrologer is not able in all cases to give a final judgment. . . . The rational soul is able to change greatly and impede the effect of the stars, as in the case of infirmities and pestilences, of cold and heat and famine, and in many other matters." Later Bacon says: "When Isaac says, 'Evil does not happen to a man unless he is restrained by ignorance of the celestial science' . . . it is clear that philosophers do not maintain that there is an inevitable happening of events in all cases due to celestial influences, nor is their judgment infallible in particular instances . . . True mathematicians and astronomers or astrologers, who are philosophers, do not assert a necessity and an infallible judgment in matters contingent on the future. Therefore, any persons attributing these erroneous views to these men are clearly proved guilty of ignorance of philosophy, and reprobate the truth of which they are ignorant."

Roger Bacon defines astrology

Astrology, as a science, has been practised by the learned of all countries and of all ages. Richard A. Proctor in *Old and New Astronomy* says that "none of the races of antiquity rose above a certain level of civilization without developing a belief in the influence of the heavenly bodies and without devising systems for reading and ruling the planets."

Right application of the knowledge which the science of astrology imparts has always been the aim of the learned astrologists. The science has "encouraged useful institutions and promoted the progress of useful discoveries. Its moral influence was on the side of virtue, and its political influence in favor of the advancement of civil liberty."

Astrology is a science

Proponents of astrology, and of all metaphysical and abstract sciences, have been ridiculed as charlatans and even tortured as sorcerers; on the other hand they have been raised to the highest honors. Though disparaged and vilified in culturally dark ages, as well as in enlightened times, astrology has risen again and again, vindicated and evidenced by Nature herself.

It is of record that astrology was classified as of divine importance among all the ancient races. Astrology was

practised by the earliest civilized peoples of the earth. Within the historical period we find that the science was accorded cultural eminence among the Egyptians, Chaldeans, Hindus, Chinese, Arabians, Greeks, Romans, Tibetans, Toltecs, Aztecs and Mayas. In this period of the twentieth century we see such a revival of the science that it might be said the whole world is 'astrology conscious.'

Astrology among all ancient races

Having examined a very small portion of the abundance of available evidence in favor of astrology as a definite, universally employed science, let us review the references to this subject discovered in the histories and writings concerning the Maya civilization.

The few records of the long since vanished civilizations of this hemisphere now available have remained until very recent times in almost complete oblivion. The methodical and patient work of scientists and archeologists, however, is slowly revealing astounding cultures which, to all appearances, will take their place among the greatest in human history. The inaccessibility of the vanished Maya empire center, and the almost total lack of workable clues in the past, have increased the difficulty. But little though the knowledge be, it provides important connecting links in the stupendous chain of human endeavor. Naturally, the absence of information has led to various hypotheses, many of which soar into the realms of wildest speculation. It is, admittedly, a tedious procedure to preserve and arrange the various scraps of evidence; but by careful analysis, comparison, and cataloguing of facts and hypotheses it is anticipated that the Maya civilization will soon take its place as a vital link in the grand chain of world civilizations.

Astrology among the Mayas

When a highway to a given center cannot be discerned, it is sometimes possible to approach the goal by travelling over byways. To a certain extent we may use the analogy in approaching the subject of astrology and its inclusion among the sciences of Maya culture.

To establish the fact that this science was included among the "imperishable arts" in the Maya philosophic and spiritual period, we shall begin by reviewing its practice among the Aztecs.

Astrology among the Aztecs

Culturally, the Aztecs are not to be compared with the Mayas. The fact, however, that the former borrowed extensively from the arts and sciences of the latter, and the further fact that

they exhibit little original genius, indicates that all their astrological knowledge was also borrowed from the Mayas.

We learn from Prescott's *History of the Conquest of Mexico* that the Aztec Indians (so-called), when a child was born into their nation, instantly summoned an astrologer (*Adivino*) whose duty it was to ascertain the destiny of the new-born babe. Lucien Biart in *The Aztecs* says: "The sign that marked the day of his birth was noted and also the one that ruled during the period of the last thirteen years. If the child was born at midnight, they compared the preceding day and day following."

The Tonalamatl

Lewis Spence says: "*Before undertaking a magical act the Naualli consulted his Tonalamatl* and satisfied himself that the astrological omens were favorable. He then applied himself to the study of the ritual procedure. . . . These preliminary steps accomplished, he next betook himself to a desert place and called upon one or other of the presiding deities of magic, and possibly the god of the hour, for assistance in his task."

The *Tonalamatl*, the book of good and bad days, or of Fate, contains a perpetual calendar of benefic and malefic periods. This work was not only consulted at the birth of a child but was also used as a textbook of electional astrology from which is determined the most auspicious period for the commencement of an enterprise or for the accomplishment of any desired end.

Quetzalcoatl and the Tonalamatl

It is generally assumed, according to early codices, that the greatest known leader of the Aztecs revealed to his people the doctrines of astrology in addition to all other branches of their learning. This man was given the title of Quetzalcoatl, meaning Feathered Serpent. (This personage is not to be confused with a later character in Aztec history bearing the same name, who visited Yucatan in the early tenth century A. D., where he was known as Kukulcan. Quetzalcoatl, in my opinion, was a title conferred upon outstanding leaders, as I explain later). Quetzalcoatl is credited with having devised the astrological cycle of the Aztecs and the *Tonalamatl*, or *Book of Fates of Men*.

Astrology unknown among ignorant peoples

An interesting fact in tracing the course of the practice of astrology through all civilizations is that the science apparently was never concerned with, or cultivated by, the ignorant or superstitious. The science has always formed a cultural part of the highest intelligence. In Aztec history three of the greatest names

Augustus LePlongeon, M. D.; who for more than twelve years lived with the natives in Yucatan and spoke the Maya tongue. His theory concerning Maya origin has been severely criticized, often deservedly so; nevertheless he has contributed data of considerable value.

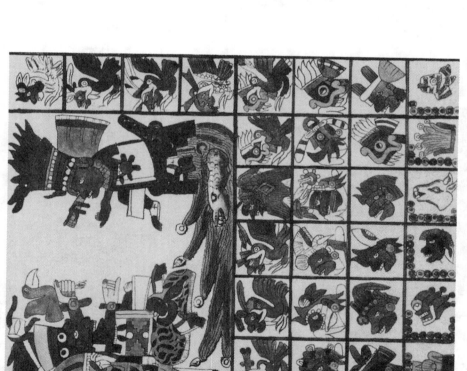

Portion of the Tonalamatl, or Mexican Book of Fate of Men. (Aubin Collection)

associated with astrology are Quetzalcoatl, of early historical Aztec times, Nazahualpilli, and Montezuma.

Nazahualpilli was King of Tezcuco. In the second book of the *Indian Monarchy*, by Torquemada, it says: "They say that he was a great astrologer and prided himself much on his knowledge of the motions of the celestial bodies; and being attached to this study, that he caused inquiries to be made throughout the entire of his dominions, for all such persons as were at all conversant with it, whom he brought to his court, and imparted to them whatever he knew, and ascending by night on the roof of his palace, he thence considered the stars, and disputed with them on all difficult questions concerned with them. I at least can affirm that I have seen such a place on the outside of the roof of the palace enclosed within four walls, only a yard in height, and just of sufficient breadth for a man to lie down in, in each angle of which there was a hole or perforation in which was placed a lance upon which was hung a sphere, and upon my inquiring the use of this square space, a grandson of his, who was showing me the Palace, replied 'that it was for King Nazahualpilli'."

Montezuma and astrology

It is recorded that it was King Nazahualpilli who stood before Montezuma when that young man ascended the throne of Mexico, and congratulated the whole nation on the election of a king "whose deep knowledge of heavenly things ensured to his subjects his comprehension of those of an earthly nature." (*Antiquities of Mexico*).

History records that Montezuma, the last of the Aztec kings, was the outstanding genius of the Aztecs. He was a skilled militarist, and, as we learn from the *Collection of Mendoza*, "by nature wise, an astrologer and philosopher and skilled and generally versed in all the arts." King Nazahualpilli, the astrologer, indicated that he was early aware of the coming downfall of Montezuma's empire. This wise old savant, long prior to the event, revealed to Montezuma that his cities would be destroyed and his empire fall.

Prediction four generations ahead

Mendieta says that prophecies were current *four generations* before the coming of the Spaniards, to the effect that bearded men with sharp swords, strange garments and casques on their heads would arrive from across the sea, destroy the Aztec gods and conquer their lands.

In attempting to link the cultures of the two hemispheres, it is of value to learn that according to Alexander von

Humboldt, there is frequent correspondence between the astrological symbols of the Aztecs and those of the Chaldeans, Greeks and Egyptians. For instance, the Aztec astrologers divided both day and night into hours known as good, bad, and indifferent, which they termed Lords of the Day and Night. They demonstrated that to be born in the first hour of the night was fortunate, the second hour of the night unfortunate, the third hour fortunate again, the fourth hour indifferent, and so on. These Lords of the Day and Night correspond with the planetary hour deities of the Chaldeans.

Macrocosm and Microcosm

In the Vatican Aztec Codex is depicted, on page 75, the Tonalamatl cycle in the form of a macrocosmic man. (See p. 146). This figure is strikingly similar, (see p. 143), in all respects, to the macrocosmic man in the medieval almanacs, which are copied to this day.

It is worthy of note that the branch of philosophic research which deals with microcosm and macrocosm was taught by the learned among the Hindus, Chinese, Egyptians, Chaldeans, Hebrews, and Greeks. Man, according to this doctrine, is a *microcosm* when compared to the universe; when compared to some single organ within himself he is known as a *macrocosm*. (See Hall's *Man, The Grand Symbol of the Mysteries*). The ancient astroanatomists designated zodiacal signs corresponding to all the functional parts of the human body. In this respect it is somewhat remarkable to learn that the Aztec astrologers followed a very similar system.

Having briefly outlined the Aztec history showing definitely the presence and practice of astrology among those people, let us now turn to records establishing a similar practice among the ancient Mayas.

Maya astronomical records

Stuart Chase says: "In astronomy the American mind reached its climax, and the Mayas were its High Priests. Starting, as we have seen, with observations of the heavens some 4,000 years ago, the Maya calendar was developed to a point where it was possible to distinguish without duplication any given day in 370,000 years. This was far in advance of European astronomy; more accurate than anything so-called western civilization achieved until recent times." Elsewhere he says: "The Aztecs borrowed the Maya principles but never achieved such mathematical elegance." It is more generally believed that although the Mayas carried their calculations into vast cycles of time, the Aztecs had no method of chronology beyond the fifty-two

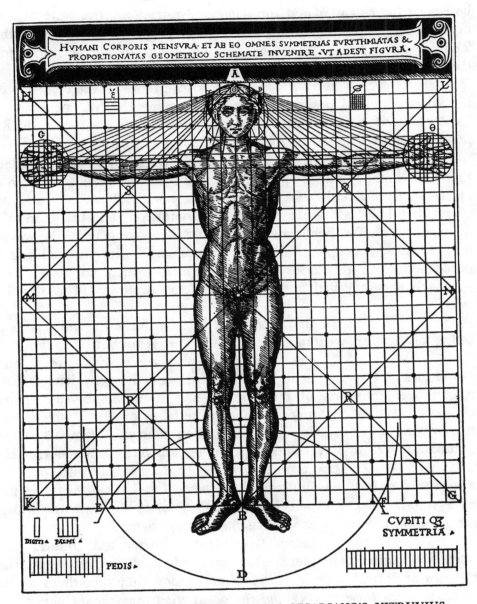

THE MYSTERY OF MACROCOSM, FROM CESARIANO'S VITRUVIUS.

Vitruvius says: "Since nature has designed the human body so that its members are duly proportioned to the frame as a whole, it appears that the ancients had good reason for their rule that in perfect building the different members must be in exact symmetrical relations to the whole general scheme." When compared to the universe, man is a microcosm. When compared to some functional part within himself he is a macrocosm.

year cycle. This statement would indicate the fact that the Aztecs borrowed the calendar and the science of astronomy from the Mayas in the belief that the former utilized the perpetual calendar of the *Tonalamatl*. They were not capable of understanding and applying the complicated mathematical computations of the superior Mayas.

We now come to the more direct evidence of the knowledge and practice of astrology among the Mayas, which I have gathered from numerous sources. These additional data should prove conclusively that astrology is definitely a science.

Evidence of astrology among the Mayas

In the *Documentos Inéditos,* by Juan de Aguilar, Francisco Tamayo Pacheco, and Alonzo de Aguilar, 1589, we read that (translation): "A chief Indian, who was a priest called Chilan-Balam, whom they held as a great prophet and soothsayer, and this man told them that within a short time there would come from (*Likin*), where the sun rises, a people, white and bearded and who would bring a raised sign, like this cross (*Ushom-che*) to which no gods could approach and they fled from it. That these people would master the land."

In the records left by Bishop Landa, second Bishop of Yucatan, written in the year 1566, we read that (translation):

"As the Mexican people had signs and prophecies of the coming of the Spaniards and the cessation of their rule and religion, those of Yucatan also had them. Some years before Governor Montejo conquered them, in the lands of Mani, which is in the province of Tutulxiu, lived an Indian named Alcambal, whose occupation was to have charge of giving answers to the devil. He told them, publicly, that soon they would be despotically ruled over by a strange people who would preach to them of a God and of the virtue of a wood which in their language they caled *Ushom-che,* which means wood erected of good virtue against the devils."

Maya predictions fulfilled

Later, Landa says: "After the children are born they bathe them, and when they have taken them from the torment of flattening their foreheads and heads, they take them to the priest to *learn their destiny and the occupation they should have.*"

In the *History of Yucatan,* written by Carrillo y Ancona, an early Spanish writer, we read (translation): "The histories say they had a foreboding of evil. The oracles and prophets predicted the upheaval of the country, the subduing of the people and the misfortune that befell them. They predicted that afterward they

would be consoled by arriving at and comprehending the true religion which was represented by the figure of the cross."

This prediction was realized as they had hoped.

In the *Encyclopedia Americana*, under "Magic" we read of "Media, Persia and the neighboring countries, famous for their knowledge of astronomy and astrology . . . "

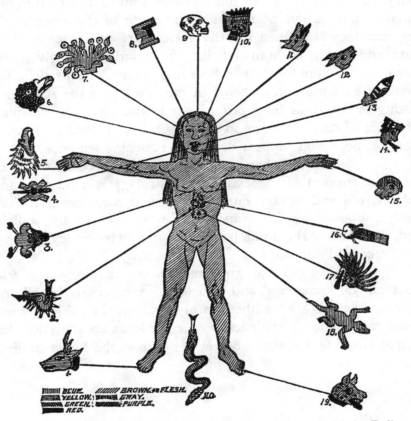

Modern trend of thought regarding astrology

Macrocosmic Man of the Aztecs, with ancient symbols of the Zodiac. From an original *Aztec ms.* in the Vatican Library. This form is almost identical with, and possesses the same symbolic significance as Fludd's macrocosmic man in *Collectio Operum,* and that of Cesariano's *Vitruvius.* The philosophy of sympathies between causes and effects, such as between spiritual man, his body and the universe, persisted among the ancient cultures of Europe, Asia, Asia-Minor and the Americas.

It is an interesting commentary at this time to note the recent change of attitude toward astrology.

In the ninth edition of the *Encyclopaedia Britannica,* the most reliable—most scholarly—compendium of general information on earth, we read as follows under "Astrology":

"The so-called science by which various nations, in various ways, have attempted to assign to the material heavens a moral influence over the earth and its inhabitants. . . . It is no longer necessary to protest against an error which is dead and buried."

Now let us see with what result the wave of more recent intellectual enlightenment assailed the editors of the *Encyclopaedia Britannica*. In the fourteenth and latest edition of that inestimable compilation, be it said to the credit of the aforementioned editors, astrology is defined as "the ancient art or science of divining the fate and future of human beings from indications given by the positions of the stars and other heavenly bodies." This definition is followed by an admission of belief in the efficacy of the science. It is interesting to note that the word science in the article is not qualified by inference of doubt such as so-called pseudo, or quasi; neither does the word "superstition" appear once in the opening sentence.

What the "Britannica" says

I have endeavored to provide corroborative testimony in support of the claim that astrology is a science, and an exceedingly old and revered one. The ancient races believed that the knowledge supplied by this branch of abstract philosophy, judiciously applied, would serve them in a benefic manner. Its efficacy is proved in a host of recorded instances.

An ancient and revered science

If, as appears obvious, astrology is a science, and as such was recognized and utilized advantageously by all ancient races, including the Mayas, then, in my opinion, the subject is worthy of employment, and its evidence is acceptable as an analytical instrument in attempting to assign a center of origin to the Maya civilization.

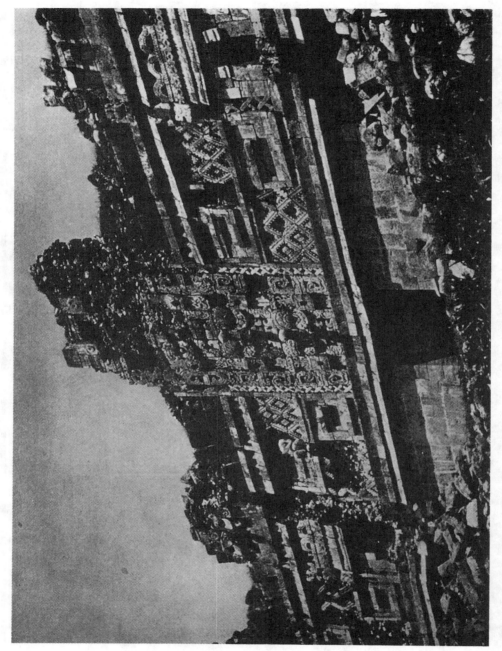

The author's discoveries in Yucatan led him to the opinion that a large number of Maya buildings in that area were built over, that is, the present facings are placed over facades of older structures. The Casa de las Monjas at Uxmal, Yucatan, is so refaced, at least in parts. The style of architecture of the covered facade presumes an origin hundreds of years earlier than previously estimated. (Photograph by the author)

Chapter Nine
The Language of Architecture

Architecture identifies a civilization

HEN individuals, with distinctive personalities, develop culturally to a certain level, they establish a characteristic style of expressing themselves. So definite are the style-motifs that it is often easy to recognize the author solely through his work. Therefore, whether the individual be a writer, artist, architect, poet, or a creator in any branch of activity, "by their works ye shall know them." As with the individual, so with nations. Their artistry and craftsmanship bear the indelible stamps of their individualities.

Of all the creative arts, no other so positively identifies a civilization as architecture. Oldest of all the professions of man, it becomes his most reliable historic document. The higher the cultural development, the nearer a race approaches the classic. True, few attain that enviable level, but those who do so establish a record worthy of emulation. Their status in world history is that of mastership.

The hackneyed term "frozen music" is frequently applied to architecture, and, if the expression can bear alteration, it may be extended to "a symphony dedicated to posterity" when a civilization reaches the classic stage in architecture. Such strains,

however, are not to be profaned by lesser minds who seek to improve them. A style recognized as classic is the ultimate of a national culture. It is the finished product. It is the end.

To attain such a degree of perfection, we find that the process, in all cases, is the same.

Style is a language

A style in architecture is a language spoken in lasting substances, by which the history of its people is recorded and intelligent understanding is made possible for succeeding ages. It is a tongue silent but legibly written, easily readable, and possessing a definite alphabet and grammar. It possesses letters, words, and sentences. As with the spoken language, architectural sentences are formed by the proper arrangement of definite detail motifs. These motifs are the letters and words, and constitute such items as piers, buttresses, pinnacles, spires, domes, cornices and their decorative detail, openings, depth or undercut of moldings, mass-grouping, height, and general planning. Change in the general form, or the alteration of any one of these details, represents a milestone in the history of a style. Such is the course of true architecture.

Through study of this intriguing science, the beliefs, religion, government, sciences, loves, hopes, and fears of a nation may be learned. Once a style is established, its period—though lost—may be recovered, and even the age of its individual structures assigned. Without an individual style in architecture no nation is truly great. With it come the true spirit of power and the grace of the mighty. It is the emblem of intellectual attainment, and signifies an inspired race.

No nation great without architecture

Dr. Augustus Le Plongeon, noted French scholar and Maya student, readily saw the importance of applying to architectural science for aid in his endeavor to solve the mysteries of ancient civilizations. He says: "Architecture is an unerring standard of the degree of civilization reached by a people, and constitutes therefore an important factor in historical research; it is as correct a test of race as is language and more easily applied and understood, not being subject to change."

It has always been my belief that if all archeologists were to include in their curriculum of study a full course in the science of architecture, including the fundamental principles of architectural design as well as its history, it is highly probable that there would be less unnecessary controversy and fewer diametrically opposite opinions. Unquestionably, such knowledge would prove of

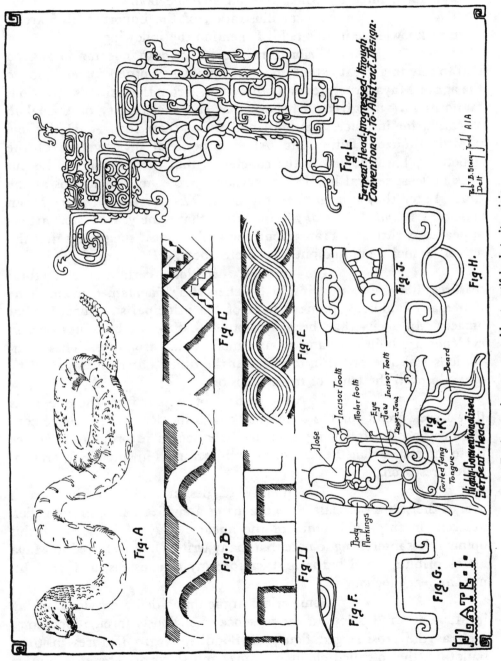

Fig. A

Fig. B

Fig. C

Fig. D

Fig. E

Fig. F

Fig. G

Fig. H

Fig. J

Fig. K.

Fig. L.
Serpent·Head·progressed·through·
Conventional·to·Abstract·Design.

Highly·Conventionalised·
Serpent·Head.

Body
Markings

Nose

Curled·fang
Tongue

Incisor Tooth

Molar Tooth

Eye
Jaw
Lower·Jaw

Incisor Tooth

Beard

Pub·D·Stacey-Judd AIA
Delt

PLATE·I·

Tracing an important world art motif back to its origin.

inestimable value. At present, it is unusual to find any two archeologists of undoubted integrity who agree on any one point.

As an illustration of the importance of architectural knowledge in this field, I mention the following:

Prior to my expedition into Yucatan in 1931, I had to rely to a great extent upon the opinions of others in reference to the age of Maya structures and other data. From the writings of various authorities I was given to believe that the ancient city of Uxmal in Yucatan, for instance, was built not earlier than 1007 A. D., by one named Ahuitzok Tutul Xiu. After a personal investigation of the structures, I was forced to the conclusion that the date should be put back at least several hundred years, and wrote my conclusions at the time. Later they appeared in my book, *The Ancient Mayas.* In an issue of *Arts and Archeology* in the fall of that same year, a short article appeared, written by Frans Blom, the archeologist, suggesting that the age of Uxmal should be put back from 1007 A. D. to 500 A. D.

On another occasion, certain architectural features that I was studying in Chichen-Itza, Yucatan, convinced me that many buildings, perhaps most of the principal structures in that ancient Maya city, had been over-built, that is, the buildings now in evidence are built over and around much older structures. These conclusions I also recorded in the field at the time. Later investigation by others proved the truth of my conclusions.

I ask the reader not to infer from these remarks that I seek credit for the somewhat trivial incidents. The above conclusions and the following data are volunteered in order to convince those interested that the science of architecture is invaluable in archeological research.

The quality of design and execution which assigns the status of "classic" to the art of a civilization is, in my belief, inherent in the architecture of the ancient Mayas. In view of this opinion, it is interesting to note that many writers have referred to Maya art as primitive and barbaric, therefore my conclusions, at first sight, may appear illogical.

Some critics argue that a definite style is lacking in Maya art, and point out the presence of obviously foreign inclusions, such as the cross-legged figure of Buddha, Negro features in their sculpture, the so-called elephant trunk, and so forth, These decorative details, in my opinion, form no part of the true Maya style; any more

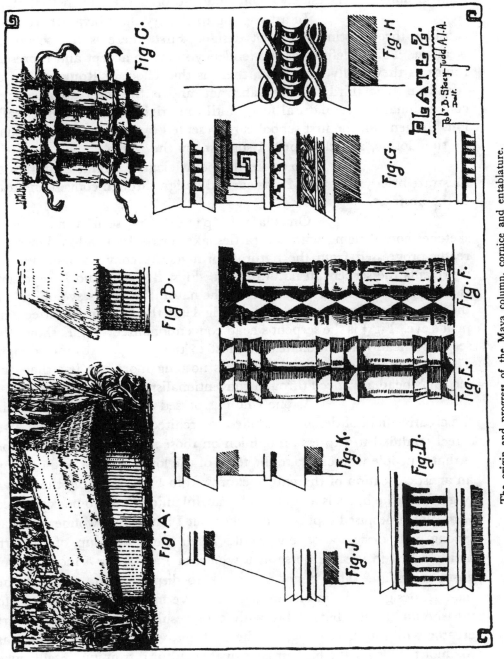

The origin and progress of the Maya column, cornice and entablature.

than does a Greek statue or a Chinese god standing in the hall of an English half-timber residence contribute to or detract from that style.

In attempting to classify the Maya art we must consider three distinct types of design. First, there is the school of Realism. This is defined as the tendency in art to accept and represent things as they really are. Next, there is the school of Romanticism or Idealism. The third school is abstract, and is the most advanced; it conventionalizes the natural form until the original motif is practically lost. In general, the first school is represented by the Greek, the second by the Gothic, and the third, I suggest, by the Maya.

To make the point clear I submit examples to illustrate briefly how the Mayas carried design through conventionalism to the abstract.

On Plate I (p 149) are seen a number of sketches commencing with the rattlesnake form. Its head is shown already progressed from the natural form to the conventional. Fig. A represents the serpent in natural form. Figs. B, C, D, and E represent radicles in progression. Fig. F shows the natural serpent's eye. Fig. G is the conventionalized upper eyelid. Fig H is the conventionalized serpent's eye. Fig J is the serpent's head conventionalized. Fig K shows the serpent's head conventionalized almost to the point of abstract design. Fig. L is an exquisite design which is nothing more nor less than the serpent's head advanced through conventionalism to total abstract.

As one who has passed a long and active life in the creative field of design as applied to architecture and the allied arts, I feel qualified to express an opinion on those subjects. My conviction is that a people who can take the form of the lowly serpent and develop an artistic creation of the nature expressed in Fig. L deserve the crown of genius. The horse is a noble and graceful animal, not to be compared with such a despised reptile as a snake; but I have often wondered what incongruous design abortions would result were a group of modern artists asked to use the horse as a whole, or in part, as a motif for an abstract design. This is not a remark to disparage the work of the modern designer. I am one myself and have many times attempted to use similar motifs, but so far with poor results. As any modern art creator will admit, to design in the abstract, with the natural form as the motif, calls for the highest conceivable cultural training, intelligence and ability.

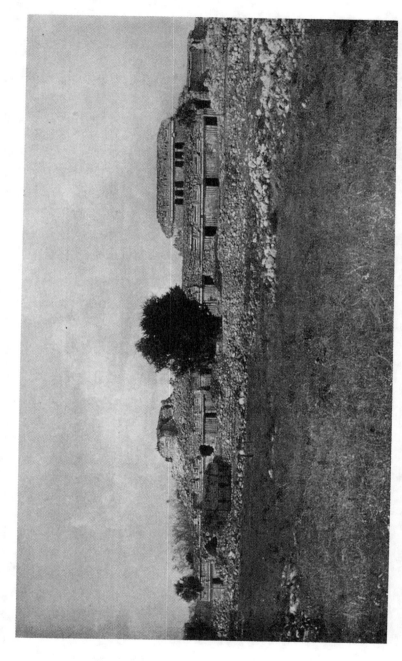

The imposing palace at Labna, Yucatan, speaks eloquently of a long and brilliant Maya cultural past. Contrary to the belief among scientists, the evidence indicates that the birth and growth took place elsewhere than in the Americas. (Photograph by the author)

Further to illustrate my belief that the ancient Mayas were past-masters of the art of conventionalism in design, I submit Plate II. Fig. A on this plate shows a typical Maya hut of today, similar in all details to the earliest type used by these people. One proof that the Mayas of Central America and Yucatan came from a land other than that known as the Maya area, is the native hut and the progression of its details in design through to classic proportions. The details shown on Plate II indicate, first, that the hut design is exceedingly old, and second (as the prototype supplying the original motifs is still in evidence), that the ancient Mayas were a root race, at

A Maya art motif

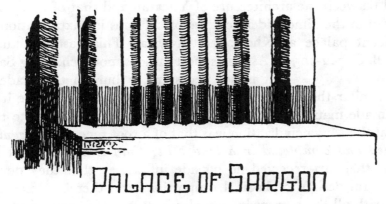

PALACE OF SARGON

Khorsabad, Assyria, B. C. 722 to 705. Sir Banister Fletcher in *A History of Architecture* says of this detail— " . . . form of wall ornament . . . obtained by the constant repetition of Half-Columns . . . like Half-Tree Trunks standing side by side, and it is tempting to refer this to a tree origin, were it not for the scarcity of timber in Babylonia . . . " Exactly the same ornament is to be seen in the architecture of Yucatan, and a similar comment may be applied.

least so far as concerns their art. The total absence of progression in design in the Maya area is significant proof that these people came to America at the height of their civilization, or, as I believe, when it was actually on the decline. None of their science or art was originated and developed on this continent.

Continuing with a description of Plate II, the reader will notice, in the sketch of a hut, that the walls consist of saplings placed in close juxtaposition to form a solid surface. In Fig. B it will be seen that the saplings are bound top, middle and bottom. This innovation was made to prevent the saplings from warping in the tropical heat after the rainy season. Warped saplings meant space between, thereby admitting birds and torrential rains. Fig. C is a detail showing how bark, palm leaves or animal skins were used to prevent the binding from in-

Progressing the motif

juring the protecting bark of the saplings. Figs. E and F show how the bound saplings were used as motifs when the civilization advanced to the period of building permanently in stone. In Fig. D, it will be noticed, are two cornices with a belt of columns between. The motif for the cornices was the sapling binding. Figs. J and K are variations of the sapling-binding cornice. Fig. G shows an elaborate entablature composed of top and bottom cornices with further variations of the sapling-binding motif, a "lip of the serpent" motif in the panel between, and the intertwined serpent in the lower cornice. Fig. H is an elaborate cornice, which I discovered on a building in Uxmal. (A remarkable parallel between the architecture of Yucatan and that of Asia Minor is to be seen in the almost identical use of columns in juxtaposition in the magnificent palace at Khorsabad, Assyria. This vast structure was erected B. C. 722-705 by Assyria's most famous monarch, King Sargon).

It is not necessary to burden the reader with further similar though interesting data of this nature. Suffice it to say I have made many deductions along these lines all pointing to the one fact, that the Maya civilization was that of a root race, *whose genius was developed and completed in a land other than America;* that fundamentally their art received no outside influence; that they developed architectural design to classical proportions and thereby deserve to be ranked with all the present-known classic races. If I wanted to become enthusiastic I would say that in consideration of their mastership in many other cultural branches, they should rightfully be recognized as the greatest of all known civilizations.

In submitting architectural comparisons between the civilizations east of the Atlantic Ocean and the Mayas of the American continent, it is natural to begin with the pyramid. For many centuries arguments and theories as to the origin, reason, and age of the Great Pyramid in Egypt have occupied the attention of a host of scientists and also of laymen.

Although in Egypt there are scores of pyramids, of which only a few have been identified, there is but one which is outstanding—the so-called Pyramid of Cheops.

Sir Harry Johnston points out that the pyramid was not confined to Egypt alone, "but arose, no doubt, quite independently . . . in the early civilizations of Greece, Italy, Assyria, India, China, and even Mexico and Central America." It is universally conceded however, that the Great Pyramid of Cheops, called Gîzeh, or

Maya art not developed in the Americas

The Pyramid

Pyramid not confined to Egypt alone

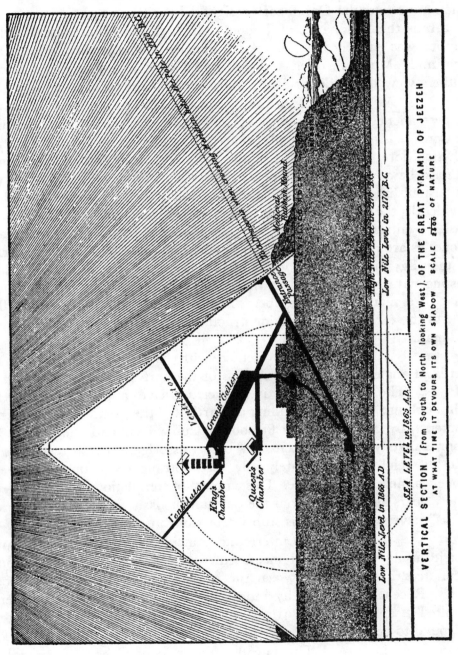

Section of the Great Pyramid of Gizeh, Egypt. (C. Piazzi Smyth.)

Gîzah, at Gîzah in Egypt, is one of the oldest extant. On this mysterious structure many volumes have been written. Some see it as nothing more than a mere tomb. One theory designated the three great pyramids at Gîzah as the "Granaries of Joseph", although it is apparent that the author was entirely ignorant of the hopelessly small space within the pyramid. Many theories, too, are based upon religious significance. Others view the building astronomically or astrologically.

That the Pyramid of Cheops was constructed as a permanent record of astrology and astronomy is a theory within reason. It is quite possible also that symbolism and esoteric and meta-physical lore may form part of the knowledge contained therein, and it must be admitted that some earnest students have deduced much of an astonishing and convincing nature along these lines of thought. Evidently the structure was intended to last indefinitely. The titanic task of cutting and placing such an immense number of cyclopean stones as are required to form the pyramid, at an admittedly very early date in Egyptian history, and the fact that no other structure of a similar lasting nature was erected at that time, bears significance far beyond that of a mere burial chamber. The Great Pyramid is undoubtedly one of the earliest known major structures—if not the earliest—erected by man.

Description of Great Pyramid

It is oriented with its four faces to the four cardinal angles, as are the pyramids of the early Babylonians and the Mayas. The area covered is between twelve and thirteen acres. Although not the tallest building on earth it is the greatest. Its present contents are approximately 85,000,000 cubic feet, and the weight is approximately 5,273,834 tons. Its base was originally 768 feet square and its height approximately 482 feet. Strangely enough the apex stone was never put in place. This emblem of completion was discovered a few years ago not far from the permanent base. Why was the word "finis" never written to this stupendous story in stone?

An interesting coincidence (?) is that William Petrie, using the Pyramid measurements as a basis of computation, estimated the distance between the earth and the sun as 91,840,000 miles. Recent calculations by an international gathering of astronomers resulted in an estimate of 91,500,000 miles. Will Petrie's figures later be found to be correct?

The so-called Pyramid of Cheops is generally assumed to have been built by the ruler of that name, although Cheops

is the Greek name for Khufu. According to an early report the Egyptian name was Yakhet-Khufu. For this information we must rely, to a great extent, upon the Greek historian Herodotus, who is said to have received his knowledge from the Egyptian priests. Diodorus, on the other hand, says that the builder of the Great Pyramid was Chembes, or Chabryes. A third account by Manetho and Eratosthenes

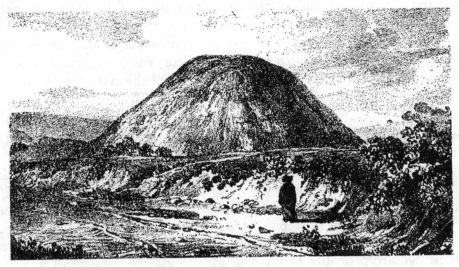

Sacred Mound. Silsbury Hill, Avebury, England. The pyramid and its prototype, the sacred mound, are prevalent in both hemispheres. For description see page 172.

Origin of Great Pyramid

states that he was Suphis. Colonel Vyse, during his investigations in 1835, deciphered some hieroglyphs on stones he discovered which indicated that Shufu was the name of the builder. This definition is considered to correspond with Suphis.

If, for the sake of argument, we accept Khufu as the builder of the Great Pyramid, let us check some of the data offered in support of that belief. Khufu was the second King of the Fourth Egyptian Dynasty, and as that dynasty began approximately 3,733 B. C., we can assume by rough estimate that Khufu came to the throne sometime before the year 3,700 B. C.

King Seneferu, who preceded Khufu, was also a builder of pyramids; but according to Dr. A. E. Wallis Budge in the Egyptian books of the British Museum, the earliest pyramid in Egypt was built by King Tcheser-sa, in the Third Dynasty, approximately 3,966 B. C. This first pyramid is known as Sakkarah. It is described as of six great steps, and is more than 350 feet square at its base. It is

important to remember that the ancient Mayas of Yucatan built "stepped" pyramids.

Going back another step in Egyptian history, we learn that Hesepti, the fifth king in the First Dynasty, (approximately 4,400 B. C.), was a well informed man. It appears that his period was one of great literary activity. Sciences and art apparently reached a high level, and among the outstanding evidence in corroboration we have an interesting book on the practice of medicine. One of the most extraordinary items of testimony, however, is an amazing work known as the *Book of the Dead*. In it is a surprising statement concerning that period. It tells us that a short form of the sixty-fourth chapter of that work *was found* during King Hesepti's reign.

That a chapter of the *Book of the Dead* was *found* in approximately the year 4,266 B. C. is an astonishing piece of information, and of considerable importance in our argument.

In the Third Egyptian Room of the British Museum, King Hesepti is to be seen represented as "dancing before a god, who wears the White Crown, and is seated within a shrine placed on the top of a flight of steps. As in later texts, Osiris is called 'the god on the steps' and the White Crown is one of the most characteristic emblems, we are probably justified in identifying the figure in the shrine with that of Osiris."

The cult of Osiris was evidently solely connected with the preservation of the body after death. The god is usually depicted "as wrapped in mummy bandages and wearing the white cone-shaped crown of the South." It is generally assumed that Osiris is essentially of Egyptian origin, but the evidence, as we shall learn, tends to show otherwise. Dr. E. A. Wallis Budge says of Osiris: "His home and origin were possibly Libyan."

In the culture of the Aurignacian Cro-Magnons as preserved in the caves of Spain and France we learn of their knowledge and practice of embalming: "The amulets found on the remains of the Aurignacian period in Spain," says Spence, "are practically the prototypes of those encountered upon the various parts of the Egyptian mummy, and the universal use of shell as the symbol of life among the early peoples of Spain is paralleled in Egypt. The prehistoric cave paintings of the Pyrenees in some places seem to portray a ritual which resembles that of the pyramid texts with startling fidelity."

It is said that Druidism is merely the cult of

Book of the Dead

A remarkable discovery

Whence came Osiris Cult?

Druids and Dolmens

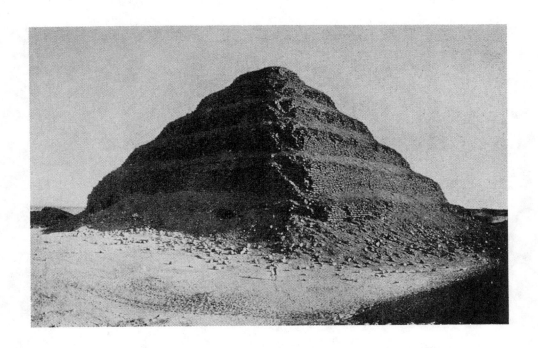

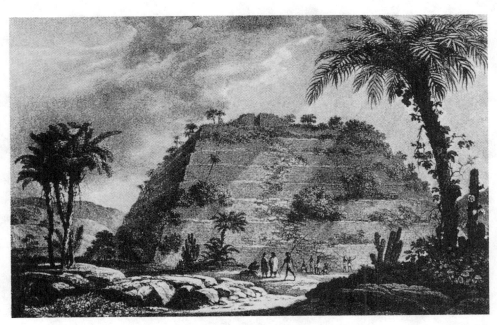

The upper photograph is of the stepped Pyramid at Sakkarah, Egypt. A remarkable comparison is seen below in an illustration (from Kingsborough's *Antiquities of Mexico*) showing a stepped pyramid in Mexico.

Osiris in another form, and the dolmens, or stone tables supported by two or more erect stones, which are all that is left to us of that type of architecture, are the rude parallels of the pyramid.

We have seen therefore, that the worship of Osiris is apparently not indigenous to Egypt. It appears evident, however, that the cult was practiced not only by the Egyptians but also by a much earlier people, the Cro-Magnons. Elsewhere will be seen numerous references substantiating this claim. For the time being, we are considering the alleged origin of the pyramid in Egypt in general, and the Pyramid of Cheops in particular, and the reason why and how its identical form appeared in the Americas. We have learned that the Great Pyramid is the most unusual of all similar structures in Egypt, but we were met with the apparent evidence that it is not the oldest. In a very brief manner, I have traced backward the cult of Osiris and its apparent connection with the Pyramid of Cheops. The result is evidence of a nature contradictory to the prevailing theory of the birth date of the Great Pyramid.

Evidence contradicts prevailing opinion

At the present time there is no evidence to show convincingly that the Pyramid of Khufu, or Cheops, was erected in the Fourth Dynasty. Its extraordinary characteristics, unlike any other pyramid, assign to it far more importance than a mere burial mound. Surely we cannot condemn apparent scientific and esoteric affinity as mere coincidence. If built *at the beginning* of so-called Egyptian history, then the stupendous work is a contradiction. The execution of so vast a project reflects very high engineering skill, as all scholars admit. The workmanship is of the most advanced order. The idea that the Egyptian civilization of that period was primitive is entirely without foundation. As a matter of fact the evidence shows that an advanced culture existed in that country *thousands of years prior to the historic period of Egypt.*

Advanced culture prior to building Great Pyramid

In one of the British Museum Egyptian books we learn that a highly civilized race invaded the Valley of the Nile long prior to the reign of King Menes, or Mena, which period was approximately 4,400 B. C. *"They brought with them* a civilization superior to the African and appear to have introduced wheat, barley, the sheep, the art of writing, a superior kind of brickmaking, etc." This admission from such undoubted authorities as Dr. Budge and others is surely conclusive testimony that advanced cutures existed long prior to historic times.

Cultures prior to Historic Times

It is possible that the above reference to an early invasion into Egypt may refer to a period not long prior to historic times, but, as I endeavor to show in the form of corroborative evidence, a much earlier cultural invasion took place. The one I refer to apparently occurred approximately nine to ten thousand years B. C., and it is possible that the Great Pyramid was erected at that time.

That the pyramid form did not originate in Egypt I will endeavor to show through the following testimony and argument. After weighing all the evidence the reader must judge accordingly.

Bull Worship

To establish the truth on any subject we must, if possible, trace back the facts to their source. Naturally, there is a reason for all happenings. The Great Pyramid in Egypt is no exception to the rule.

In our search for the origin of the strange pyramid form in building construction, we find valuable evidence—as is so often the case—in religion. Religion, which embraces the benevolence of man as well as his fears, is his continual incentive to erect a tangible and permanent expression of his belief and faith in the Deity.

Before we review and discuss certain data in reference to the origin of the worship of Osiris, I bring to the attention of the reader Plato's account of Atlantis, in which he mentions sacred rites wherein the bull symbol figures very prominently.

In Egypt the bull was worshiped under the form of Apis. "Apis was merely a form of Osiris, the calf of the sky-goddess Nut, and to the bull which represented him other cattle were sacrificed. The cult of Serapis (Osiris-Apis) was of widespread distribution, and was brought by the Romans to Britain, where it flourished chiefly at York."

The Trail of Bull Worship

Spence says: "The founders of the Osirian religion, who came from the west, were Iberians." Rhys and other learned scholars believe that the founders of Druidism were Iberians. The bull was sacred to the Druids and was sacrificed by them at the ancient rite of Beltane (Biles Fire). Bull-cult, in one form or another, is discerned in various parts of Europe, Asia Minor, and the Americas. The Spanish national sport of bull fighting undoubtedly is a survival from bull sacrifice earlier practised by the Iberians.

To summarize, then, we learn that the Atlanteans practiced the sacred rite of bull sacrifice. If we care to agree that

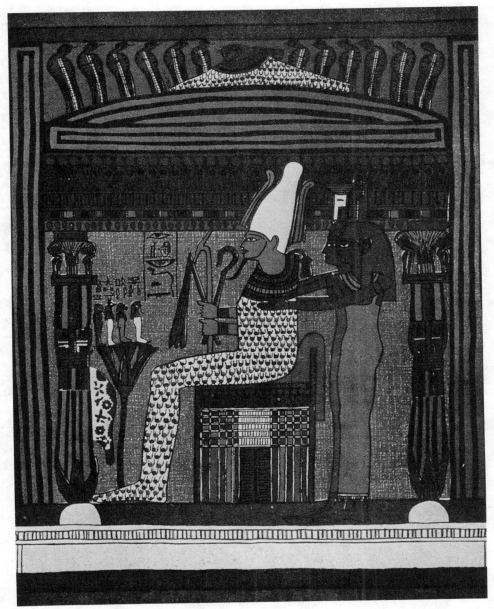

THE EGYPTIAN GOD OSIRIS ENTHRONED from papyrus MS. of Ani (Budge, *Gods of the Egyptians*), wearing the white cone-shaped crown of the south. The origin of Osiris worship is unknown. Egypt is generally credited (although without foundation) as the birth-place. Budge suggests Libya. But does the evidence herein offered point to Atlantis?

the Iberians were of the original Atlantean stock, the argument becomes much easier. These original Iberians, or Atlanteans, I believe, migrated to Europe after the sinking of their mother country approximately 9,500 to 10,000 years B. C., and settled in parts of what is now known as Spain and France. They brought with them, among other forms of their culture, the rites of bull-worship. In all probability, other groups of escaping Atlanteans at that period wandered around the northern

Iberians and Bull Worship

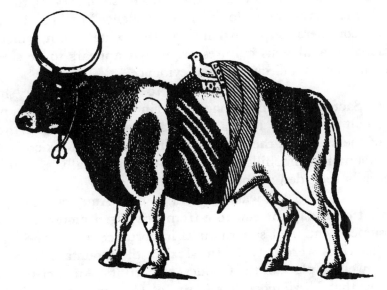

THE EGYPTIAN SACRED BULL APIS, a form of Osiris. Bull worship, an Osirian rite, is first recorded among Aurignacian Cro-Magnon culture. The cult spread throughout Assyria, Phoenicia, Chaldea, Egypt and India. The same rites were practised among the Pre-Mound and Mound-building American Indians. (Ill. from *Oedipus* by Kircher.)

shores of the Mediterranean. Upon their arrival in Egypt they established their arts and customs, among which was the worship of the bull.

Thus far we have traced back, more or less satisfactorily, I hope, the origin of the worship of Osiris,—or more specifically, one of its sacred rites known as bull-sacrifice. It now remains to connect this strange and exceedingly ancient cult with the pyramid. If the knowledge gained thus far is of an acceptable nature, it may be assumed that a number of links in the chain of evidence are complete. The next important link must show that the pyramid motif of both Egypt and America sprang from a *mother source*—which

Did the pyramid motif spring from a mother source?

source, in my belief, was Atlantis, now submerged. Further, it must explain the present apparent mystery as to why the Maya pyramids so resemble those of Egypt, and also refute the contention that the Maya pyramidal structure—among many other so-called Egyptian art influences—was borrowed by the Mayas direct from the Egyptians. As before stated, there is no evidence in Yucatan and Central America of a direct invasion of either Asiatic or Egyptian cultural influences. Neither is it logical to state that the obvious similarity of the arts of the two hemispheres is due to "mere coincidence" or "psychic unity." Favorable consideration of Atlantis as the center from which these unquestionably analagous cultures originated appears to be supported by abundant fact and circumstantial evidence.

Again referring to Plato's story, we shall see that the "Sacred Hill" mentioned therein is undoubtedly connected with the cult of Osiris. It is a significant fact that among the early peoples of the Valley of the Euphrates, India, Egypt, Mexico and Peru, certain mountains and hills were considered unusually sacred. Some were actually regarded as totemic or tribal lodges.

It was a custom, in both America and Egypt, to believe that each day the sun rose from privileged mountains. Within these assumed centers of supernatural importance, distinguished members of the tribes were buried. In Mexico, the mountain is considered to be the dwelling place of the Goddess of Fertility. An ancient Mexican legend says that Uitzilopochtli, the son of Coatlicue, was reborn each day as the sun. A remarkable parallel is seen in some Egyptian texts, in which we learn that certain Egyptian pyramids are referred to as "the mountain of Ra" from which the sun-god rose each morning.

Many of the earliest forms of the Akkadian and Egyptian pyramids were simple mounds of earth. Likewise the earliest Mexican pyramids were just masses of earth, or adobe. In both instances they were raised as imitation sacred hills. Are these facts to be taken as mere coincidence?

It is my belief that the Akkadi, the earliest occupants of the fertile Valley of the Euphrates, were either colonists direct from Atlantis—after one of two major cataclysms which occurred approximately 14,000 years B. C. and 9,600 years B. C., respectively— or they were a colonizing group known as Aurignacian Cro-Magnons who had wandered from the land of their forefathers in Spain and France and whose advent into that territory occurred through a major

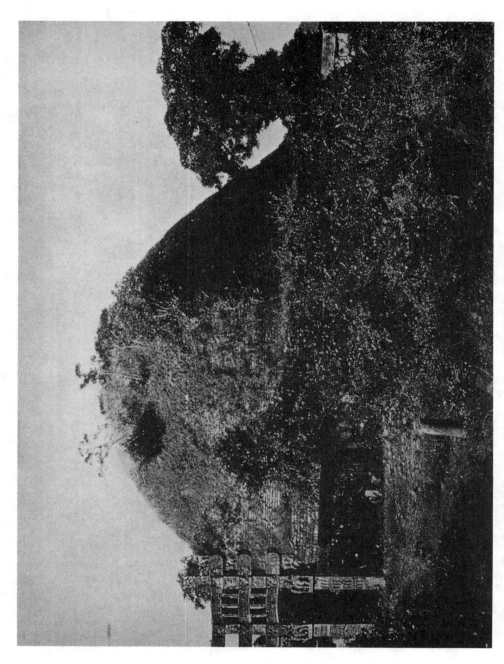

The Tope, or Stupas (artificial mound) of India (From Fergusson's *Tree and Serpent Worship*)

Atlantean cataclysm and partial submergence which occurred approximately 14,000 years B. C.

Further, I believe that the Akkads were members of the same root race of people from which sprang the Pre-Incas, Pre-Panamanians, the so-called American Indians, and the Mayas; and that the early Egyptian culture was founded by the Akkadi from the Valley of the Euphrates. Whether or not the Akkadi remained in the Euphrates area for a long period prior to establishing themselves in Egypt, is not yet quite clear. My opinion is that they did.

One line of argument indicates that the Egyptian culture began between 9,000 and 10,000 years before Christ. In this event, in view of the evidence that the Akkad civilization apparently was well established in the Valley of the Euphrates for a considerable period prior to founding an Egyptian colony, it would seem that the Akkadi arrived in the former area shortly after the major cataclysm of Atlantis (approximately 14,000 B. C.), either directly from that continent, or from the Cro-Magnon area in Spain and France.

In any event, it appears evident that the Akkadi were definitely related to the earliest arrivals in both Europe and the Americas. Among the few strong points in support of that belief is the evidence that the Akkadi practised Osiris worship, held a deep reverence for a sacred hill, and erected artificial mounds and, later, pyramids.

Certain scientists concur in the belief that the birth of civilizations occurred in the Babylonian area, although they offer no convincing evidence in support of their theory. In the *Encyclopedia Americana* we read: "Discoveries of the recent decades seem to confirm the idea that Babylonia is the cradle of civilization."

In *Extinct Civilizations of the East* by Robert E. Anderson, we are told that the "Akkad pyramids served as observatories, if not originally partly designed for that end, and therefore *have their corners adjusted to the four cardinal points.*" This is precisely the method employed by the Egyptians and the Mayas.

This writer says elsewhere: "That the Akkads or early Babylonians were essentially a literary people is also proved by the 'libraries' or stores of inscribed tablets and cylinders left in their palaces and temples."

Suggesting an earlier beginning for Egyptian culture

Akkad and Maya Pyramids

An Akkadian Library

Undoubtedly the later people, known as Chaldeans, derived their culture, including religion, from the Akkads. Anderson says: "A remarkable feature of the religion of the Chaldeans has been used to explain the shape of their palaces and temples. They *lifted their eyes unto the hills'* on the northeast of the Father of Countries, and imagined it *the abode of the gods.*" Is this not reminiscent of the Sacred Hill of Atlantis, the Sacred Mounds of Egypt, and the Sacred Mounds of the Americas?

Reading further from *Extinct Civilizations of the East,* in reference to the Chaldeans we learn that: "The type of the holy mountain was therefore reproduced in every palace and temple, sometimes by building it on *an artificial mound* with trees and plants watered from above; and on a larger scale by the ziggurat, or 'mountain peak'. The latter device was a sort of *pyramid of three, five or seven stages, each being square, and less than the one under,* with a shrine at the top."

Here we see a practice identical with that of the Egyptians, as shown by the Pyramid of Sakkarah, and the Maya pyramids in Central America and Yucatan.

Mythology helps us in the next step. In Plato's narrative he says that Poseidon fell in love with Cleito, the only daughter of Evenor and his wife Leucippe. Evenor is described as "one of the earth-born, primeval men of that country." *The family lived in the mountain.* After Poseidon married Cleito, he broke the ground which "enclosed the hill in which she dwelt." Spence indicates the strong similarity between the names of the goddess Cleito of Atlantis, and Coatlicue of Mexico. *Each presided over a sacred hill.* Each of these goddesses had a son. Cleito's offspring was named Atlas, and Coatlicue's boy was known as Uitzilopochtli. Both children were "twin brothers", both were mountain born, and *both were supporters of the world.*

We have seen that certain sacred mountains in Mexico were considered to be the dwelling place of the Goddess of Fertility. In far-away Scotland we learn of a Goddess of Fertility. Ludovic McL. Mann, President of the Glasgow Archeological Society, recently wrote in the *London Illustrated News* concerning a newly-unearthed sculpture of a female torso, dating back to the Paleolithic Age. He says: "It is supposed to represent the Goddess of Fertility. It is cut out of a pebble of hard, copper-colored igneous rock. The arms

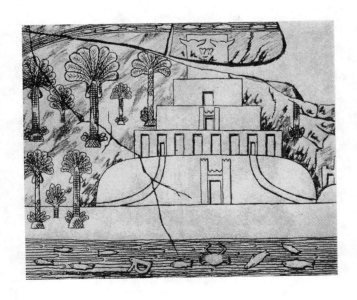

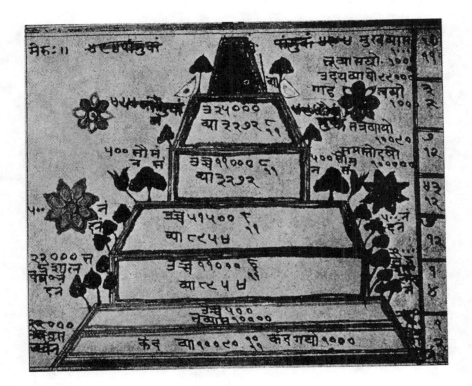

are finely carved in high relief across the chest; while the hands and even the fingers are carefully modeled. The torso has been fashioned headless and without the lower part of the lower limbs; and thus it resembles some of the continental portrayals of the Mother Goddess. This find fortifies the evidence afforded by many place-names that the

A headless torso

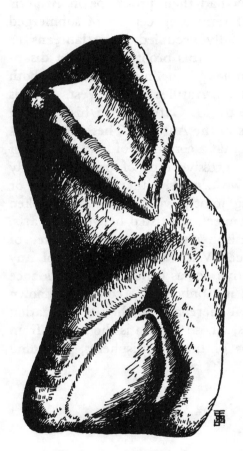

Sketch of a Paleolithic torso representing the Goddess of Fertility. Unearthed at Kirkintilloch, Scotland.

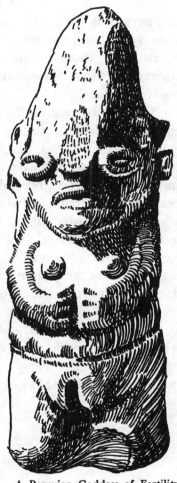

A Peruvian Goddess of Fertility. (In possession of the author).

worship of a female Fertility Divinity was carried on in Scotland from the most remote ages."

When we turn to study Egyptian mythology we find exactly similar beliefs. The goddess Isis, wife of Osiris, is the Egyptian Goddess of Fertility. On the head of Isis is the ideogram of her name which means the "House of Osiris." Osiris was a "dead" god

Isis Goddess of Fertility

and was depicted as reclining in his pyramid tomb. The pyramid tomb and the ideogram on the head of Isis obviously indicating "a hill or high place crowned by a shrine" definitely associate the Egyptian worship of Osiris with the worship of Cleito who presided over the Sacred Hill in Atlantis.

If the argument is sound, then the claim that the pyramids of Egypt and America had their prototype in Atlantis should find corroboration in the last remaining centers of submerged Atlantis—if those centers were actually occupied by Atlanteans or their immediate descendants. In seeking this proof we are not disappointed. The "pyramid culture-complex" is definitely traced in both the Canary Islands of the East, and the Antilles of the West. This is confirmed through discoveries made by M. Gattefosse in his research work in the Canaries, and by Fewkes in the Antilles. These discoveries tend to prove one of two things: one, that a continent of land capable of sustaining a large and culturally progressive race of people actually existed at one time between those two centers, either as an island or a series of archipelagoes, or forming jointly with them an unbroken mainland; or, two, that a definite connection existed between the arts, customs, and religions on both hemispheres, having as its center of origin a land at present in existence. With a total absence of any data in support of the latter alternative, let us continue with evidence to make acceptable the theory that not only was a continent known as Atlantis once in existence, but that thereon flourished a civilization which I term the Mother of Empires, whose culture is the source from which sprang the early civilizations of both hemispheres, including that of the ancient Mayas.

Pyramid culture in Canaries and Antilles

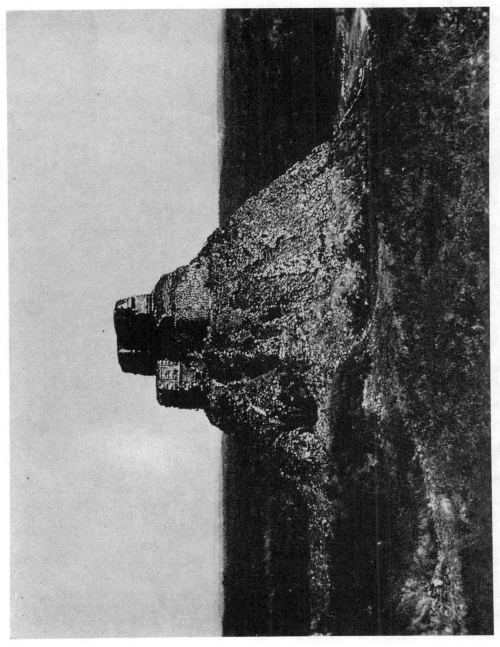

The mysterious Adivino, Uxmal, Yucatan. This pyramid is unique in that it has a rounded oblong base and supports two temples, one below the other. A single staircase approaches each temple, rising on opposite sides of the pyramid. The author believes that within the sloping stone-faced walls lie relics of historic and intrinsic value. (Photograph by the author)

Chapter Ten

The American Indian

*The spread of
Osiris cult*

E now have learned that the earliest form of the pyramid was a mere artificial earth-mound erected to conform with religious rites which we are assuming to have originated with the Sacred Hill and the Goddess of Fertility in what is believed to be the lost Atlantis. My belief is that the cult of Osiris, after arriving on the shores of Europe in the Cro-Magnon period, approximately 9,600 B. C., spread easterly and southerly in a clearly defined route, until it reached the Valley of the Euphrates, and later Egypt. The rich valley of the Nile became a fertile center in which culture of a high order flourished. With the acquisition of wealth, the arts of the people became more advanced. Building projects increased in size and importance, and a race of highly skilled artisans was developed. Structures of permanence rose as proficiency in stone masonry increased. The crude mound of earth became the symmetrical pyramid encased in enduring stone and granite.

It is generally believed that the stone pyramids of Egypt originated in the Third Dynasty, approximately not much earlier than 2,800 B. C. This may be true in reference to all the stone-faced pyramids, with the exception, in my belief, of the one known as

Khufu, or Cheops. In this structure the unusual is obvious. It is unlike any other on earth. We cannot totally ignore the pyramid's apparent connection with astronomy, astrology, symbolism, and esoteric lore, merely because we do not understand. Science in general is admittedly still floundering in the mire of ignorance, and comprehension of the Egyptian mysteries is not to be expected. However, in the near future persistence may unravel a few of the Great Pyramid's secrets. Unquestionably the advanced skill displayed in cutting, raising and placing such immense stones with machine-like precision is indicative of previous long centuries of continuous experience.

The Mound Builders of America

It is conceivable that the Mound-Builders of America were the remnants of a very early migration to the Western continent, which in succeeding generations progressed little beyond the point attained by the original immigrants. Possibly these earliest immigrants arrived "from a land which sank in the ocean toward the rising sun" at a very remote era, as their legends imply, possibly prior to the Aurignacian Period, 23,000 B. C.

That the early Mexican races faced their pyramids with stone is significant in view of the evidence which shows that they did not borrow that custom from the Egyptians. The Egyptians are assumed not to have erected stone-faced pyramids earlier than approximately 3,800 B. C. How is it, then, that we find the earliest known Mexican builders employing the same system? And where did the latter gain their knowledge of Osirian rites and pyramid building, if not from a common source?

Whence came the architect's skill?

Lacking proof that the Great Pyramid of Cheops was erected in the Fourth Egyptian Dynasty, it appears reasonable to allot to it an origin dating back to 10,000 years B. C.; otherwise, if we concede that there is no evidence of progression in the building sciences prior to the Third Dynasty, where did the architect obtain his knowledge—and the artisans their skill—to erect such a technically accurate structure? Is it not reasonable to assume that a civilization which, as the testimony shows, migrated to Egypt prior to King Menes (approximately 4,400 B. C.), and brought with it *cultivated wheat, barley, a written language and an advanced culture,* might logically be versed in the building arts? It is admitted that the graves of Egyptian kings erected prior to the Third Dynasty were mere sand-pits lined with bricks made from Nile mud. Would an advanced race, such as invaded Egypt prior to historic times, be content to follow such

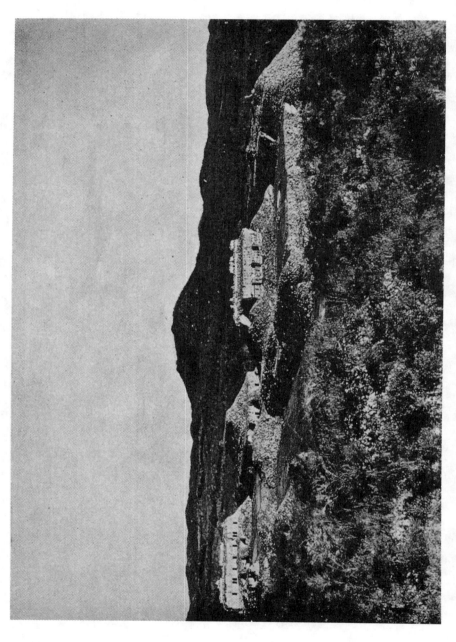

The Great Palace, Kabah, Yucatan. Erected in sections grouped around quadrangles on an immense artificial terrace more than 30 feet high. All Assyrian palaces also were grouped around quadrangles and raised upon artificial terraces ranging up to 50 feet in height. (Photograph by the author)

examples? And remember, the Akkads were advanced pyramid builders. There are almost 200 pyramids in Egypt all of which are obviously burial mounds. Most of these are dedicated to the memories of single individuals. Is it not possible, then, that the builders of the Third and Fourth Egyptian Dynasties, after a dark age in their history, were unaware of the fact that the pyramid or artificial mound was definitely symbolic of the Sacred Hill of Atlantis—that Holy Mountain wherein dwelt the mythical Evenor and his wife Leucippe and their daughter Cleito—from whence sprang the cult of Osiris? Is it not possible that the so-called Great Pyramid of Khufu never was intended as a burial mound, but as a permanent monument or record, to commemorate the safe arrival of a greatly harassed people who had lost their homeland? In other words, is it not the work of a prehistoric people, perhaps the Akkads from the Valley of the Euphrates, emigrants from Atlantis, the continent which sank beneath them; a people who, after seeking suitable land on the northern shores of the Mediterranean, located for a time in Asia Minor, became dissatisfied or desired additional territory, and finally settled in Egypt?

Possible misconception

According to Plato's narrative, structures of immense area and magnificence filled the cities of Atlantis. Stones of different hues, rare metals and precious stones went into the construction of their buildings. The Atlanteans were master architects, past-master masons and skilled mechanics. When they escaped from their sinking homeland they naturally took all their arts, crafts and sciences with them. Is, then, the Great Pyramid the only structure left by these people? Is it not possible that beneath the burning sands of Egypt, and elsewhere, in Asia Minor, lie vast ancient cities of supreme Atlantean magnificence yet to be discovered?

Do ancient cities lie beneath Sahara?

If we are to concede as highly probable that the various waves of emigrants to Egypt prior to pre-historic times (and no doubt there were many) were colonists from Atlantis who took with them, among other cultural expressions, the master skill of stonemasonry, it is obvious that the art was developed in the land whence they came, presumably Atlantis.

It is my belief that throughout the long period during which these waves of colonists were invading Europe and Asia Minor, similar waves of escaping hordes from Atlantis fled westward and arrived on the shores of America. These enforced emigrants met with climatic conditions and other natural influences and environments

Colonists invade the Americas

quite different from those experienced by the members of their race who fled east. Some settled in Mexico, some landed farther south and drifted over into Peru, no doubt in separate waves at various intervals. Wherever they settled they endeavored to establish a civilization similar to that in the land from which they had been forced to depart so hurriedly. Among the cultural arts which they took with them was that of considerable skill in stone-masonry. A similar situation prevailed, it will be remembered, in connection with the arrival of the earliest peoples in Europe and Asia Minor.

Similarity of pyramid building in both hemispheres

The Egyptians and the early races of Mexico built pyramids of an almost identical nature. Both erected immense earth-mounds. As we have seen, the earliest form of pyramid was an earthen mound. Thousands of examples are extant on the American continent, and it is conceded that many more such structures may be discovered. The practice of constructing these pyramidal forms in earth was not confined to one period, and apparently the custom continued long after the advent of the well-defined stone-faced structure. This, in my opinion, is a valuable point to remember, in view of the hypothesis I intend offering later concerning the origin of the so-called American Indian.

It is very apparent that mound pyramids, as sepulchers for distinguished personages, were erected in Egypt long prior to the earliest historical period.

We know that these early people in Egypt practised embalming of their dead. Wood and stone sarcophagi were used to contain the bodies. On the American continent we find precisely the same customs.

Mexico's Pyramid of the Sun

Another extraordinary fact is that the enormous Pyramid of the Sun at Teotihuacan, in Mexico, "has an opening sixty-nine feet from its base, entering upon a gallery in which it is possible to make progress on hands and knees only. This gallery inclines gently for a distance of twenty-five feet, ending in two chambers each five feet square, obviously intended for the reception of mummies." The gallery, according to Lowenstein, is 157 feet long, and as it penetrates the pyramid the height increases until it exceeds six and a half feet. The "well is over six feet square, extending apparently to the base and up to the summit. Other cross-galleries are blocked by debris." This description shows similarity in a marked degree with the Great Pyramid of Cheops in Egypt. Another striking resemblance between the two

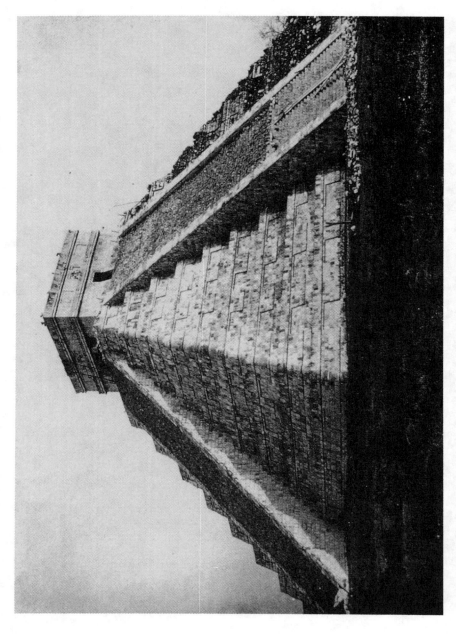

El Castillo, Chichen-Itza, Yucatan. A stone-faced stepped pyramid. The surmounting temple is approached by four wide staircases, one up each of the four sloping sides. Each staircase consists of 91 steps. The total number added to the single step platform on top equals 365, symbolizing the number of days in a year. The Maya calendar is the most perfect ever conceived by man. (Photograph by the author).

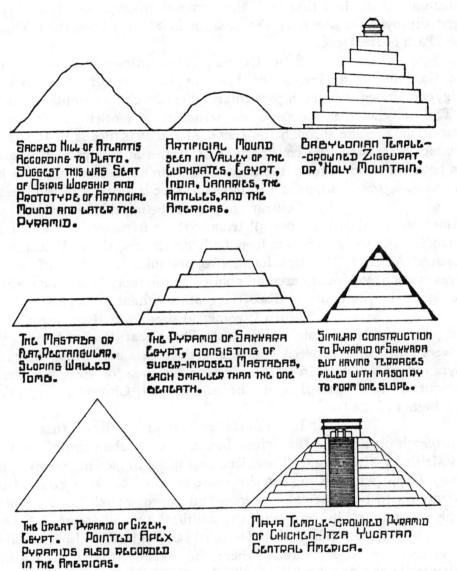

SACRED HILL OF ATLANTIS ACCORDING TO PLATO. SUGGEST THIS WAS SEAT OF OSIRIS WORSHIP AND PROTOTYPE OF ARTIFICIAL MOUND AND LATER THE PYRAMID.

ARTIFICIAL MOUND SEEN IN VALLEY OF THE EUPHRATES, EGYPT, INDIA, CANARIES, THE ANTILLES, AND THE AMERICAS.

BABYLONIAN TEMPLE-CROWNED ZIGGURAT OR "HOLY MOUNTAIN."

THE MASTABA OR FLAT, RECTANGULAR, SLOPING WALLED TOMB.

THE PYRAMID OF SAKKARA EGYPT, CONSISTING OF SUPER-IMPOSED MASTABAS, EACH SMALLER THAN THE ONE BENEATH.

SIMILAR CONSTRUCTION TO PYRAMID OF SAKKARA BUT HAVING TERRACES FILLED WITH MASONRY TO FORM ONE SLOPE.

THE GREAT PYRAMID OF GIZEH, EGYPT. POINTED APEX PYRAMIDS ALSO RECORDED IN THE AMERICAS.

MAYA TEMPLE-CROWNED PYRAMID OF CHICHEN-ITZA YUCATAN CENTRAL AMERICA.

NOTE~THE ZIGGURATS WERE ORIENTED SO THAT THE ANGLES FACED THE FOUR CARDINAL POINTS. THE PYRAMIDS WERE SITUATED SO THAT THE SIDES FACED THOSE POSITIONS. OSIRIS WORSHIP AND ITS RITES WERE COMMON IN BOTH HEMISPHERES. SACRED MOUNTAINS, MOUNDS, MASTABAS, STEPPED PYRAMIDS, POINTED PYRAMIDS, AND PYRAMIDS SURMOUNTED WITH TEMPLES ARE RECORDED IN EUROPE, ASIA~MINOR, THE CANARIES, THE ANTILLES, AND THE AMERICAS.

The amazing fact is that parallel examples of all stages in pyramid evolution, from sacred mound to temple-crowned structures, are in evidence in both hemispheres. Does this knowledge contribute to the belief in a mother source foreign to those areas?

examples is the fact that both the pyramid group at Gîzeh in Egypt, and the pyramid group at Teotihuacan in Mexico have their Valley, or "Path of the Dead."

Senor Garcia y Cubas believes that the pyramids of Teotihuacan in Mexico were built for the same purpose as those in Egypt. Among the eleven particulars which he cites as similarities are: "The site chosen is the same, the structures are oriented with slight variation, the line through the center of the structure is in the astronomical meridian, the construction in grades and steps is the same, in both cases the larger pyramids are dedicated to the sun, the Nile has a *Valley of the Dead,* as in Teotihuacan there is a Street of the Dead."

Contrary to general belief, the pyramids on the American continent are not all truncated, or flattened at the top, although both types are found on both continents. Near Palenque in Central America, Waldeck found two pyramids in a state of perfect preservation, square at base and pointed at the top. There is no reason to doubt the possibility of discovering other similar examples.

When it comes to size, we find both small and large pyramids on both continents. The Great Pyramid in Egypt covers an area of between twelve and thirteen acres, while the great

pyramid at Cholula in Mexico covers an area of forty-five acres, practically four times that of Cheops, although Cheops is very much the higher of the two.

In *Prehistoric Nations* we learn that in the thirteenth century the Dominican Brocard visited the ruins of the City of Mrith, or Marathos, in Phoenicia, and spoke in glowing terms of the magnificent pyramids in that city constructed of blocks of stones from twenty-six to twenty-eight feet long and approximately six feet thick. The pyramid or its prototype the artificial mound, then, has been found in Egypt, India, and as far north as England (Silsbury Hill at Avebury); in Mesopotamia, where the Akkads dwelt; the Canary Islands; in the Antilles and on the American continent, from Peru to the center of North America.

When seeking evidence concerning the connection between the Osiris cult and the pyramid, we first turn to Plato. In the latter's narrative, we learn that the Atlanteans sacrificed to the bull. To them the bull was a sacred animal. In the caves of Spain and France we learn that the bull was sacred to Cro-Magnon-Aurignacian man. The people of Assyria and Egypt worshiped the bull. The cult of

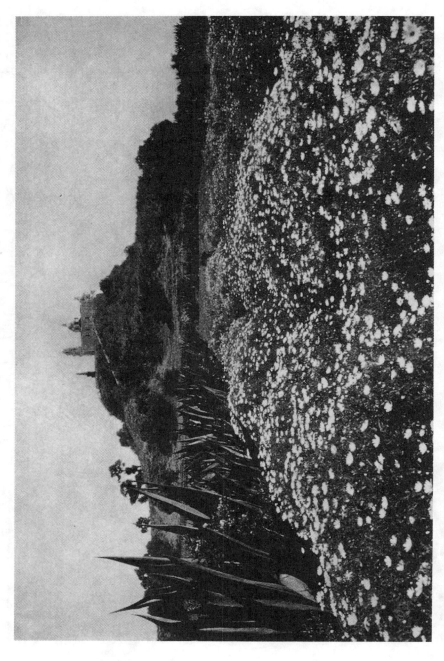

The Great Pyramid of America, at Cholula, Mexico. This pyramid occupies by far the largest ground area of all pyramids in the world, almost four times that of the Great Pyramid of Egypt. It is approximately 1440 feet square at the base and 177 feet high, and Bernal Diaz counted 120 steps although none now remains. The four square terraces face cardinal points. On top once stood a semispherical chapel dedicated to Quetzalcoatl. The low doorway, erroneously leading many archeologists to believe the builders of this and other structures in Mexico and Central America were a race of dwarfs, was so designed that all who enter shall bend in humility.

the bull—changed to the bison or the buffalo—was a sacred ritual among the so-called North American Indians. The sport of bull-fighting, or wrestling, was practised among many ancient races including the Cretans, Hebrews, Philistines and in fact among all peoples throughout the Mediterranean area. Its outgrowth is to be seen today in the Western American rodeo. In Egypt the bull was worshiped under the form of Apis—another form of Osiris—the calf of the Sky-goddess Nut. In other words, the cult of Osiris, or bull-worship, either brought the pyramid into being, or originated almost simultaneously with the first Sacred Hill, the prototype of the pyramid. This evidence points strongly to the theory that the origin of the pyramid was not in Egypt or Europe, not on the American continent, but in Atlantis.

It must be remembered that we are still considering the evidence concerning the origin of the pyramid, its introduction into America, and my belief that the Maya civilization in particular did not "borrow" the motif, or form, from the Egyptians or any other race. At this point, however, it becomes necessary to introduce the important subject of American Indian origin, because much of the evidence it has to offer is interwoven with data concerning the pyramid and its earlier form the artificial mound. Carrying out my policy of investigating each clue to its source I first offer evidence to confirm my belief that the American Indian is an ancient inhabitant of the Americas. My approach may appear roundabout, but in consideration of the hypothesis I shortly intend to submit, the course chosen is, it is hoped, excusable.

American Indian Origin

To indicate the almost total lack of knowledge concerning the origin of the American Indian—excluding, for the time being, the Maya, Toltec, and Aztec—I shall first refer to Lewis Spence's opinion on the subject. Briefly, he believes that the earliest occupancy of the American continent by any civilization does not much antedate the Christian era. He says: "To the best of my belief no American civilization antedated 100 B. C." However, he qualifies the remark by saying elsewhere, "but there is much more dubiety regarding the megalithic culture of Pre-Inca Peru, *which would seem to date from an earlier period.*" In another passage by this author we see that he refers to the American Indian tribes as "uncivilized." In view of the above remarks I wish to postpone a discussion of them until we have considered one or two items which bear upon the subject.

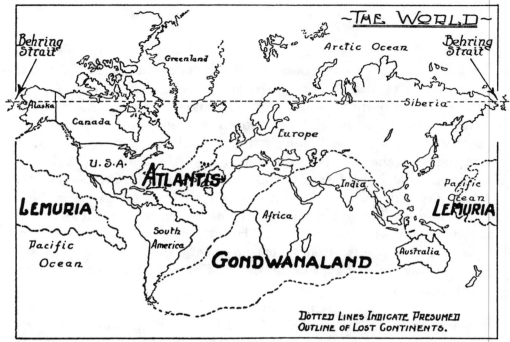

Three Lost Continents

Atlantis. Three Major sinkings 1st. Approx. 23,000 B. C.
 2nd. Approx. 14,000 B. C.
 3rd. Approx. 9,600 B. C.

Lemuria. Continental form approx. 3,000,000 years ago.
 Final disappearance approx. 10,000 B. C.
Gondwanaland. Continental form at least 2,000,000 years ago.
 Last submergence 50,000 to 100,000 years ago.

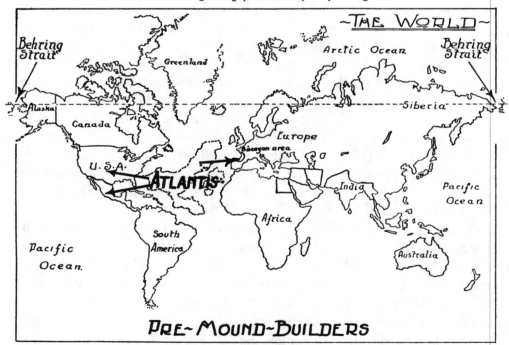

1st Major Sinking of Atlantis. Approx. 23,000 B. C.

The pre-Mound-Building American Indian migrated from Atlantis to the Americas at this time. Earlier migrations westward from Atlantis likewise probable. Also, at time of this submergence, Aurignacian Cro-Magnon Man fled from Atlantis to the Biscayan area in France and Spain. Author believes the American Indian, as well as all early cultured races of the Americas and the Cro-Magnon people, to be of White Stock.

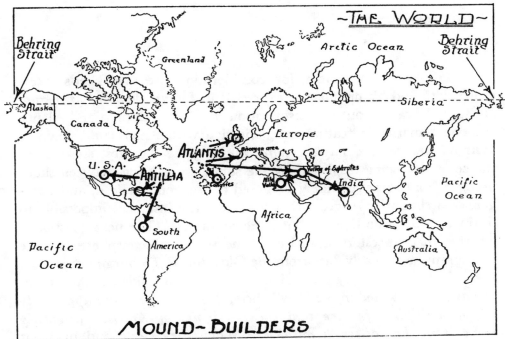

MOUND-BUILDERS

2nd Major Sinking of Atlantis, Approx. 14,000, B. C.

American Indians, Pre-Incas, and earliest Panamanians, (all Mound-Builders), probably fled from sinking Atlantis to the Americas at this time. Simultaneously, escaping Atlanteans fled to the Biscayan area, (to be known as Magdalenian Cro-Magnons), then spread to the valley of the Euphrates, (to be known as Akkado), later to the Valley of the Nile, (early Egyptians), India and the British Isles. Antillia and the Canaries are remnants of Atlantis.

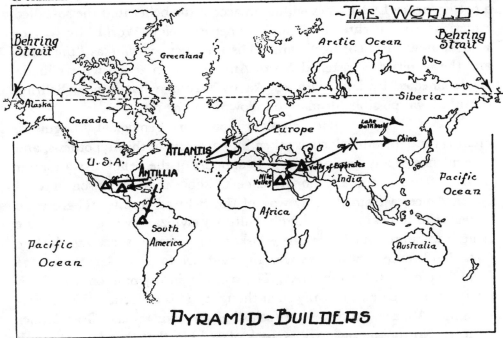

PYRAMID-BUILDERS

3rd Major Sinking of Atlantis. Approx. 9,600, B. C.

Peoples designated by the author as Classic Panamanians, and classic Pre-Incas, and the Toltecs and Aztecs, probably fled from Atlantis to the Americas at this time. He suggests that, simultaneously, other migrant waves spread eastward to the Biscayan area, thence to the Valleys of the Euphrates and Nile. Later, mixed waves, travelling still further east, became Eurasians, eventually to invade China. This latter probability, the author further suggests, may be the reason for the physical and cultural affinities observed between Asiatics and Americanas. He believes the theory of an Asiatic invasion of the Americas via the Behring Strait is illogical and without foundation.

Next for consideration are Lydekker's interesting data and his opinions as expressed in *Living Races of Mankind*. He says: "Leaving out of consideration the Arctic Eskimo and Aleuts, the one remarkable feature in connection with American Indians is *their adherence to a single general racial type;* the most striking instance of this being displayed by the similarity existing between skulls brought from areas so widely sundered as Vancouver, Peru, and Patagonia—a similarity so great that it is in many instances impossible to distinguish between them." Later, he continues: "The next question is whether their ancestors originated in the Western Hemisphere, or were immigrants at an early date from the Old World. *To this question . . . there is but one reply . . .* Since we have no evidence that manlike apes ever existed in the New World, *it is an obvious and apparently incontrovertible inference that the aborigines of America originally came from the eastern hemisphere.* When they came and by what route they travelled are, however, questions much less easy to answer; although from the evidence of prehistoric remains *it is quite clear that man's first advent in the New World was at a date relatively remote.*"

Similarity in type

As with so many other scientists, for want of a better theory Lydekker is willing to accept the belief that the so-called American Indian entered what is termed the New World "by way of what is now the Behring Strait." His argument is that as "the bison and the wapiti deer reached North America at an epoch when Siberia was connected by land with Alaska by way of what is now Behring Strait" it was possible for man to follow the same route.

Is the Behring Strait Theory erroneous?

No consideration for geological, linguistic, architectural, or other facts is taken into account in this hypothesis, and no evidence of any kind is offered in support of the belief. As a matter of fact, there is actually no evidence to show that the bison entered North America from Asia by way of the Behring Straits. There is no evidence to indicate that a highly cultured civilization migrated to the American shores via either the Alaskan, or as some speculate, by the Greenland route. Neither is there any evidence to show that they came from "the eastern hemisphere." The truth is, in my opinion, that both evidence and logic refute any such thought. It is conceded that migrations into America, and meager fusings of the Mongol and Greenlander with the North American tribes, took place; but that they brought with them a culture, or even contributed to any marked extent toward the

arts, religion, customs, and crafts of the so-called Indian races, are statements far from being substantiated at this time.

We have one admission from those who lean toward the above theory, namely that man's advent into America was at some remote date. It is believed that man's earliest arrival in North America was during what is known as the Inter-Glacial period. Dr. W. H. Holmes assigns such a period and the possibility of man's arrival as not less than 10,000 years and not more than 20,000 years ago. Holmes admits, however, that there exist "Mediterranean cultural affinities in America . . . Along the middle Atlantic shores."

Wissler's opinion

Some writers, on the other hand, such as Clark Wissler, suggest marked parallels between earlier types of Western Europe, or Cro-Magnons, and types in America, parallels which arise in a much earlier period of man. Also he says: "That the New World native (American Indian) is a direct descendant of the Asiatic Mongolian is not to be inferred, for the differentiation is evidently remote." Lydekker gives us an illuminating description of the North American Indian. He says: "The American Indians, as a whole, may be described as tawny yellow or yellowish brown, *beardless people,* generally with lank black hair and without the oblique eyes, broad and flat faces, or small and concave noses of the Mongols." Elsewhere he states, speaking of the American "Indian", that the *forehead is retreating . . .* both long-headed and round-headed types of Americans are met with in each division of the continent."

This writer further states that it is true that Mongoloid facial characteristics exist but that they are "much more marked in North American than in South American Indians." The nose, he points out, is prominent and frequently convex.

American Indian distinct type

It would appear therefore that the American Indian varies little in his ethnological characteristics from Alaska to Tierra del Fuego, the extreme south of South America. That he is a distinct type of being is admitted. Where the principal facial and cranial characteristics vary, as in the obvious Mongoloid features seen among northern tribes, such divergence is traceable to the fusion of blood from contact with the admittedly possible Asiatic migrations via the Behring Straits. Other minor variations are accounted for by intermarriage with Polynesian and Negro influxes.

It is a significant point to remember that the various references which I have emphasized in all the above data con-

cerning the North American "Indian" could refer almost identically to the Mayas.

They, too, were a beardless people, possessed retreating foreheads, and had high prominent convex noses.

Lewis Spence gives it as his opinion that the American Indian came to America at no remotely distant date, but he declines to theorize as to whether the race came exclusively from Asia or Europe.

Beardless people

It appears to me that further consideration of the American Indian and the possibility of his racial connection with the Mayas would tend to strengthen Spence's deductions. This painstaking efforts in correlating such an abundance of data, and the able manner in which he has marshalled the evidence are worthy of high commendation. I am particularly interested in his arguments, for they imply a lack of dogmatism and egotistical finality. Further, he appears at all times willing to change his opinion when reason, logic, or sound argument so warrant.

It is therefore in a spirit of friendliness that I suggest that in his effort to provide ethnoligical evidence to support his main theory there is no need for him to disregard the American Indian races, or seek to show that those tribes are comparatively recent newcomers to these shores. It is my belief that they are a vital link in the long chain of evidence, and an asset to any argument in support of the Atlantean Theory.

My personal conclusions are that the Mayas arrived on the shores of Central America not earlier than two to five hundred years B. C. But a vast mass of fact and circumstantial data suggests the probability that the so-called American Indian was a dweller on American soil many thousands of years prior to the arrival of the Mayas.

Learn of interesting comparisons

To begin with, it is conceded by most leading authorities that all the indigenous tribes in North and Central America and the northern part of South America are definitely linked together under the heading of American Indians. The Mayas, on the other hand, are defined as a distinct race of people. The origins and historic significance of the Pre-Panamanians and Pre-Incas are matters of a controversial nature among all scientists for the time being.

The American Indian tribes, then, are widely scattered branches of a common stock. We have learned that in ethno-

The Mexican Goddess of Fertility, Coatlicue, wife of Citinatonali and mother of Quetzalcoatl. She reputedly bore seven pairs of twins as did Cleito, wife of Poseidon (founder of Atlantis) and mother of Atlas. Both had sons who were "world supporters." (Photograph, Musco Nacional de Mexico.)

The American Ziggurat. This Mexican example (from Dupaix's *Monuments,* Kingsborough) is identical in form with the ziggurats of the Babylonians. (See illus. pg. 171). It takes more than "psychic unity" to explain this remarkable similarity.

logical characteristics there is but slight variation to be seen among all the tribes from Alaska to Tierra del Fuego. We shall now learn of numerous and convincing comparisons, which show close racial ties between the earliest peoples of Europe and the American Indians. Religious beliefs among at least some of these people are strikingly similar to those found in ancient Egypt, Greece, and other centers in Europe and Asia Minor. If Plato's narrative is acceptable, then we must conclude that the fundamentals and numerous rites of those beliefs were prevalent among the Atlanteans; in fact we now have Atlantis under consideration as the seat of their origin. Witchcraft was, and in some centers still is, general among American Indian tribes. Its rites and practices were common also among the Cro-Magnons, the Guanches of the Canary Islands and many other early peoples of Europe and Asia Minor. Again, if we are to believe Plato, the origin of this strange cult was in Atlantis.

Customs compared

The customs concerning burial and mummification as practised by the indigenes of America find their counterparts among the Cro-Magnons of Spain and France, the Canary Islands where the Cro-Magnons of Atlantis were marooned, the Egyptians, Pre-Incas, and the early inhabitants of the West Indies. Likewise, we find pictographic writing among the earliest Americans and the earliest Egyptians.

Lydekker says: "Although the Indians of the country *eastward* of the Mississippi grew maize, beans, pumpkins, melons, gourds, tobacco, and sunflowers, agriculture was not practised at all by the majority of the tribes." We also find the general use of some of these domesticated plants in widely scattered centers on the American continent. Is it to be assumed, therefore, that all the tribes, from Alaska to South America, received agricultural experience from the Mayas—a people who undoubtedly possessed a greatly superior knowledge of the subject? I do not think so, and as there is no evidence that the American Indian acquired the information from any other race on this continent, we must look elsewhere for the source. Later evidence will indicate that the Mayas lived on this continent for many hundreds of years after their arrival *practically unknown to all other inhabitants*. In fact, their influence upon the Toltecs and Aztecs was not felt by the former until approximately the seventh century A. D., and did not reach the latter until the eleventh century. Yet all the religious rites, customs, foodstuffs, and so forth, as above enumerated,

Knowledge of agriculture general

were apparently well known to the American Indian long prior to the arrival of the Mayas. Another point to remember is that the Mayas were not a warlike people, had no dreams of conquest, and never went outside the bounds of the area first occupied by them on this continent. Is it conceivable, then, that all the tribes comprising the American Indians from Alaska to South America paid friendly visits to the Mayas, and—despite the fact that those people possessed cities of unparalleled magnificence and vast intrinsic wealth—departed in the same friendly spirit, taking with them nothing but the arts, customs, and foodstuffs which directly appealed to them?

Tobacco smoking

The practice of smoking the tobacco leaf appears to have had religious significance originally. It is a custom almost universal among the indigenes of the American continent, yet we find that tobacco was smoked in pipes by remote tribes of savage Negroes of Africa who are not known to have held any intercourse with Europeans. Tobacco smoking in pipes was, in remote times, a religious rite performed only by the priests; the burning of tobacco was an incense offering to the gods. The pipe used in which to smoke tobacco is therefore seen on the American continent and in Africa. The pipe is also discovered in ancient mounds of Ireland and in stone-age deposits in New Jersey and Denmark, so that pipe-smoking and the burning of incense are very ancient practices. If pipe-smoking was first practised by the priesthood and became a custom among peoples widely scattered on both continents, then it is conceivable that the practice, together with incense burning, originated in Osiris worship.

The fact that pipe-smoking was prevalent among the Iberians in Ireland—a people who either came direct from Atlantis or descended from the early Basques or Iberians of Spain, the Azilian-Tardenoisian wave of Cro-Magnons from Atlantis—apparently eliminates the idea that the custom originated with the Negroes of Africa. It is my opinion, in view of the entire lack of evidence to the contrary, that the Negroes obtained their knowledge of pipe-smoking from the early Egyptians. The practice among the African Negro tribes apparently bears to religious significance.

Practices associated with pyramid

Conceding that the American Indian practised witchcraft and other religious rites similar to those of the Aurignacian Cro-Magnons, the Guanches of the Canary Islands, and the Egyptians, and as much of such practice is definitely associated with the pyramid or its prototype the Sacred Hill, one expects to find evidence of the latter

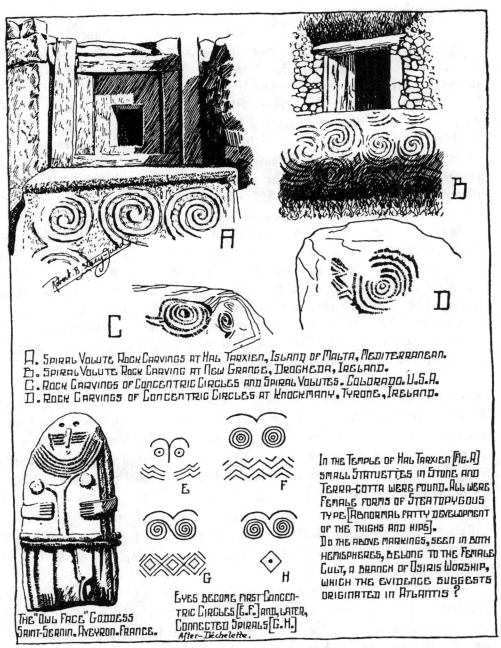

A. SPIRAL VOLUTE ROCK CARVINGS AT HAL TARXIEN, ISLAND OF MALTA, MEDITERRANEAN.
B. SPIRAL VOLUTE ROCK CARVING AT NEW GRANGE, DROGHEDA, IRELAND.
C. ROCK CARVINGS OF CONCENTRIC CIRCLES AND SPIRAL VOLUTES. COLORADO. U.S.A.
D. ROCK CARVINGS OF CONCENTRIC CIRCLES AT KNOCKMANY, TYRONE, IRELAND.

IN THE TEMPLE OF HAL TARXIEN [FIG. A] SMALL STATUETTES IN STONE AND TERRA-COTTA WERE FOUND. ALL WERE FEMALE FORMS OF STEATOPYGOUS TYPE [ABNORMAL FATTY DEVELOPMENT OF THE THIGHS AND HIPS].
DO THE ABOVE MARKINGS, SEEN IN BOTH HEMISPHERES, BELONG TO THE FEMALE CULT, A BRANCH OF OSIRIS WORSHIP, WHICH THE EVIDENCE SUGGESTS ORIGINATED IN ATLANTIS?

THE "OWL FACE" GODDESS SAINT-SERNIN. AVEYRON. FRANCE.

EYES BECOME FIRST CONCENTRIC CIRCLES [E. F.] AND, LATER, CONNECTED SPIRALS [G. H.]
After—Déchelette.

The author suggests these strange markings contribute additional evidence linking the early peoples of Europe and Asia Minor with the ancient civilizations of the Americas.

on the American continent. In this respect the investigator is not disappointed.

We have learned that the Sacred Hill of Atlantis was the home of the gods, the worship center of bull-cult, and that it was connected with the rites of the fertility deity, and was the original center from which sprang the Osiris cult.

Conclusions concerning American Indian origin

In Mexico, the Sacred Mountain was in many cases a natural pyramid. It was likewise the dwelling place of the Goddess of Fertility, as well as her altar. The earliest pyramids in Mexico were mere masses of earth or adobe, just as were the earliest recorded in Egypt. It is within reason, therefore, to assume that they were imitations of the Sacred Hill of Poseidon in Atlantis. At a later period the pyramids were faced with stone, a procedure also followed in Egypt. The pyramids constructed by the tribes known as the Mound-Builders, however, were all built of earth alone.

The Mayas, on the other hand, did not build earth-mound pyramids without facing them with stone. In fact the Maya type is vastly superior to any other extant on the American continents. The facings, stairways, and structures surmounting them are all exquisitely executed. Even the earliest examples exhibit the highest architectural and engineering skill.

Is not this fact alone sufficient to show that the American Indian Mound Builders *could not have borrowed the idea from the Mayas?* Would the former have been satisfied with erecting such poor imitations? Even assuming that they did borrow the design from the Mayas, would they have absorbed so completely the various religious rites, customs and mythological fundamental principles which

Mayas did not build earth mounds

must be associated with the pyramid?

It is unquestionably true that they were not only well acquainted with these rites, but possessed legends which tally accurately with those prevalent in Europe and Asia, as well as those recorded among the Mayas.

I advance my hypothesis as to the origin of the American Indian, therefore, for what it is worth. As with all other personal opinions herein expressed, it is not offered in a sense of intolerant finality but in all humbleness. No one individual is capable of supplying all the facts and evidence upon which a theory is constructed. Briefly, my conclusions are as follows:

In remote times—more than 500,000 years ago —prior to the late Pliocene Age or toward the end of the Tertiary Period, a vast continent of land existed in the Atlantic Ocean. Possibly not long prior to that age, that continent actually formed a land bridge between the two hemispheres.

Toward the end of the Late Tertiary Period, titanic volcanic disturbances resulted in the submergence of certain portions of that continent, and the formation of possibly two immense island continents and a succession of smaller island groups. One of the two larger islands was situated near the shores of Europe and Africa, the other bordered the shores of America. Spence names the former Atlantis, and the latter Antillia. For want of better names I take the liberty of using these throughout this work.

Summarizing geological evidence

At a period known as the late Pleistocene epoch, or Post-Glacial age, approximately not less than 23,000 years B. C., the continent referred to by Plato as Atlantis possessed rich, fertile soil and vast wealth in natural resources, including rare stones, gold and other precious metals, and immense quantities of permanent building materials.

On this archipelago dwelt a people—either indigenous or from an unknown center—who had long been residents. At the approximate period mentioned (23,000 B. C.) when these people had attained a certain degree of civilization, a disaster of great magnitude occurred to their country. Volcanic disturbances on a major scale caused a large portion of the land in the eastern area to subside beneath the waters of the ocean. Although the loss of life was tremendous, some of the inhabitants were enabled to escape to the shores of Europe. These early immigrants from sinking Atlantis occupied extensive caves in a comparatively small area in what we now know as Spain and France. Considerable evidence of their occupancy of this area exists in the form of wall paintings of remarkable proficiency. These people were known as Cro-Magnons, and their art is classified as Aurignacian. It is possible that at the same time other escaping groups invaded a more southwestern area of Europe and spread along the north shores of what we now know as the Mediterranean Sea. It is further possible that subsequent waves of immigrants, because of minor Atlantean subsidences, invaded the European shores, although at present no evidence exists to substantiate this theory.

First major sinking

The next major sinking of the Atlantean conti-
nent occurred approximately 14,000 years B. C. It also affected the
eastern portion of Atlantis, and the wave of immigrants settled in
approximately the same parts of Europe as did the first race. The
art of these people, though similar to the Aurignacian Cro-Magnon,
was much more advanced, and is known as Magdalenian.

In view of the evidence, it is apparent that
during the whole of the period between 23,000 B. C. and 14,000 B. C.,
Second major constant social contact was maintained among all the remaining groups
sinking of islands forming what may be termed the Atlantean Empire. The
inhabitants were proficient mariners and navigators, as is evidenced by
the obviously successful long sea journeys undertaken by those who
escaped from sinking Atlantis.

I deduce that continual Atlantean social unity
existed throughout that period, from the fact that each migration wave
to Europe carried with it a civilization and culture more advanced than
the preceding. Parallel progress is also recorded in the various invasions
of the American continent from the western area of the Atlantean
Empire. This is still further evidence to indicate a common source for
the earliest cultures on both hemispheres.

During the period between the two approximate
dates above mentioned, namely 23,000 B. C. and 14,000 B. C., we have
learned that certain religious fundamentals, rituals, customs, and arts
existed among the Aurignacian and Magdalenian Cro-Magnons; and
these facts are clearly recorded in the caves of France and Spain.
Among the evidences of culture enjoyed by these people are the building
of sacred mounds or earth pyramids, bull-worship, witchcraft, and
obvious acquaintance with the rites associated with the Goddess of
Fertility. Without evidence to the contrary, and if we accept the theory
Record of that these practices originated in Atlantis, then the Sacred Hill in
achievement Plato's narrative is logically the prototype of the artificial earth-mound
and subsequent geometric pyramid. We also know that the cult of
Osiris did not begin in Egypt, but, by the same line of reasoning,
obviously originated in Atlantis. We have seen that earth-mound or
sacred-hill building was a common practice among the pre-historic
Egyptians, and that the Atlantean goddess Cleito is identical with the
Egyptian goddess Isis. We have further seen that the imprinting of the
human hand on the cave walls at Gargas, in the Hautes-Pyrénées, was

A Mexican goddess of Fertility (From Kingsborough's *Antiquities of Mexico*.) The Sacred Mountain (prototype of the mound and the later stone-faced pyramid) was the dwelling place of all the various goddesses of Fertility. Similar characteristics and attributes are associated with these mythical figures of both hemispheres and also Atlantis.

AN ALGONQUIN INDIAN

The early American Indian apparently wore but a single feather, and in his later existence borrowed the elaborate panache from the Mayas. The latter's feather headdress is almost identical with the panache of Aurignacian Cro-Magnon man, as seen in the painting from Alpera, Spain.

a custom brought to that area by the early race whose art is known as Aurignacian.

Another interesting fact to remember at this time is the strange tectiform or tent-shaped device which is frequently seen on the flank of the bison drawing as executed by the Aurignacian artists. The almost idential device is to be discerned in a similar position on the bison drawings executed by the American Indians.

Apparently acceptable is the evidence that the Cro-Magnons practised the art of mummification. In Egypt we find that, although the practice of mummification exhibits little science or expertness until the Eighteenth Dynasty, there is no doubt the art was known and used by her prehistoric people, and further, that it was connected with ancestor worship, a rite which formed part of the Osirian cult.

Trailing Cro-Magnon man

When we turn to the Canary Islands, we find that the earliest recorded inhabitants were also Cro-Magnon, or Atlantean stock, known as Guanches. The evidence shows that the Canary Islands are, in all probability, the high lands of Atlantis which were left above water after the general submergence, and on which some of that country's people remained in safety. Among the evidence of culture left to us by those people, we find that they too built earth-mound pyramids and practised mummification and witchcraft among other expressions of their civilization. The presence of the artificial pyramid indicates also that they possessed knowledge of and practised a form of Osiris worship.

Crossing the Atlantic westward, we find islands known as the West Indies, or Antilles. These isolated lands are presumed to be all that it left above the ocean level of Antillia, the western major island of the erstwhile complete Atlantean Island Empire. There also we find traces of mummification and earth-mound pyramids, among other corroborative data.

Cro-Magnon man and the American Indian

On the American continent, we find that the American Indian culture resembles that of Cro-Magnon man. The former was well acquainted with, and practised practically all the above rites and customs. Among these people, the earth-mound pyramid is well represented. Basic principles of Osiris worship are also to be discerned. Head-flattening, the use of the bow and arrow, the *atlatl*, or throwing stick, the strange tectiform or tent-shaped device on the flank of the bison, as used by the Aurignacian artists, the cult of witchcraft,

sun worship, the impress of the hand, the preservation and painting of human bones are all to be found, and the method of embalming the dead is identical with that employed in early Egypt and the Canary Islands.

When we transfer our attention to the Mayas of Yucatan and Central America, however, we see that they did not practise witchcraft in its true sense, did not build crude, unfaced earthmounds or primitive-type pyramids, did not practise Osiris worship or any recognized outgrowth of that cult. Most of these outstanding customs, on the other hand, were definitely associated with the Cro-Magnons of Spain and France, the Guanches of the Canaries, the early Egyptians, the prehistoric West Indians, or Antilleans, and the American Indian.

Cro-Magnon man and the Mayas

It is true that the Mayas practised embalming, built pyramids, and were a highly religious people, but the method employed in mummification was of a high order, similar to the best system employed by the historic Egyptians. Their art of pyramid building is in advance of the Egyptian, and their religion was a philosophy, a recognition of a Supreme Consciousness. They believed in one god, Hunab-Ku, believed in the immortality of the soul, and placed flowers and fruit on their altars. They *did not* practise human sacrifice.

The Mayas were a people of advanced intelligence, a cultural race almost without parallel. They were brilliant architects, consummate engineers and builders, artists of the highest order, were versed in many sciences, and possessed considerable esoteric lore. They were the ultimate in a root race of people, possessing a root language and a root art. It appears inconsistent, therefore, to include them among the "Indian" tribes of the American continent. They stand alone.

Mayas highly cultured

I shall not at this time comment upon the third wave of European colonists from sinking Atlantis, as I do not wish to confuse the reader with evidence extraneous to the particular hypothesis under consideration.

In conclusion, then, we learn of a striking similarity between the customs, practises, and rites which definitely associates the three Cro-Magnon European waves, the Guanches of the Canary Islands and the prehistoric inhabitants of the Antilles, with the American Indian. This suggests that they were all of the same root race,

though of various colonizing migrations, occurring possibly at widely spaced intervals.

Continuing in this line of deduction, I offer the hypothesis that the American Indian is not *a comparatively late comer to America, but an ancient inhabitant.* If the advent of the Aurignacian Cro-Magnon race is assigned to a period approximately 23,000 B. C., then I suggest that during a period commencing shortly before 23,000 B. C. and extending to approximately 11,000 B. C., or even as late as 10,000 B. C., various waves of so-called Indians at various stages of their culture invaded the Americas from the area of the slowly submerging Western Atlantean Islands.

An important point to remember is that the so-called Indian tribes of the Americas are characteristically uniform from Alaska to Tierra del Fuego. This uniformity over such a vast area would at first thought suggest one of two conclusions. One, that a single, stupendous colonizing wave, or a series of waves in rapid succession, and of unheard-of proportions, took place along the entire coast line of North and South America—a somewhat improbable eventuality. Or, two, that numerous migrations took place along a wide stretch of the eastern coast with comparatively long intervals between; each succeeding wave of immigrants slowly distributing themselves over virgin territory according to their choice, until all the available land on the continent was known to them. In either circumstance, it seems obvious that whether by a single invasion or numerous ones, the colonizers came from one source—a common root; which source, as we have seen, is claimed by them to be toward the east.

But when we consider the fact that identical cultures are definitely discerned between the American Indian and the Cro-Magnon Aurignacians of approximately 23,000 B. C., as well as the Cro-Magnon Azilian-Tardenoisians of approximately 9,600 B. C., the latter hypothesis has reasonably acceptable probability.

I reason by this, therefore, that a succession of Atlantean invasions of the Americas took place, covering a period, as I have already stated, between approximately 23,000 B. C. and 11,000 B. C., and possibly beginning even earlier than the Cro-Magnon Aurignacian invasion of Europe.

The outstanding feature in this theory, if it is to be considered of value at all, is, in my opinion, the much discussed question of an Asiatic invasion of America via the Behring Straits, and

the increased difficulty in attempting to substantiate this hypothesis by the present testimony.

It would seem that the evidence is abundant in support of a parallel growth in cultures, basically similar, in three centers practically simultaneously—one in the Eastern Hemisphere, one in the Western Hemisphere, and the third in the common ground from which the first two sprang. This third or common ground, in my belief, was Atlantis. The growth in the Eastern Hemisphere spread first south and east, then northeast, toward the Asiatic area. To argue, then, that the great early cultures in the Americas sprang from an Asiatic source, would be, according to the evidence, writing history backward.

Writing history backward

I admit that certain Asiatic influence is discerned among the far northern tribes, and such is well within reason, and easily accounted for, as the geographical barriers are by no means impossible to overcome. But the influence culturally throughout the Americas is small. Likewise, Polynesian cultural influence is discernible among early American peoples farther south, and likewise, too, is of little consequence.

Reason for lack of progress

The slight divergence in customs and arts observed among the "Indian" tribes is, I believe, easily explained. Visiting Polynesians and Asiatics brought with them a certain amount of their culture, which naturally mingled with that of a few American indigenes in defined centers, with whom they came in contact.

The fact of a very early arrival upon an almost, perhaps totally, uninhabited land ·of vast extent, such as was the American continent at that time, by a people obviously in the early stages of culture, partially accounts for the slight intellectual advance among the American Indians, from the period of their remote arrival or arrivals in the Americas to the present time. The immense stretch of new land, extending from north to south, and from east to west, invited widespread pioneering and much aimless wandering. The consequent wide dispersion, and the lack of competitive ideas derived through higher racial contacts, may also be a reason for the absence of their cultural advancement.

Nomads and progress

Another feature possibly contributing to the obvious absence of progress is that the wide expanse of territory naturally promoted a nomadic habit which time confirmed. A few more enterprising groups, satisfied with their geographic and climatic conditions, established themselves permanently. The facts as supplied

Isis (from *Le Franche-Maconnerie,* Lenoir), the Egyptian goddess of Fertility, wife of Osiris. Numerous practices ascribed to the Mexican Citinatonali and his wife Coatlicue, and to Osiris and Isis are identical. Likewise, in American mythology, we find similar parallels in the family attributes of Poseidon, founder of Atlantis.

by history, however, do not indicate that a sedentary people necessarily advances intellectually or culturally; in fact the result is sometimes the reverse. But such a people would be of the type to preserve the memory of ancestral religious rites, arts, and customs, in a comparatively accurate form. This assumption would easily account for the almost identical data to be observed in the legends and myths as preserved by the more advanced tribes.

Thousands of years after the arrival of the first American immigrants—the so-called Indians—and just prior to the Christian era, the Mayas arrived in Central America and Yucatan. It is seen, therefore, that the forebears of both the "Indian" tribes and the Mayas were in all probability Atlanteans from the western portion of the Atlantean Empire, widely separated in time and culture.

Logically, I assume that one or more western migrations from sinking Atlantis occurred between the "Indian" invasion of America and the arrival of the Mayas. These influxes probably included, among others, such tribes as the Aztecs and Toltecs. Obviously those races, more or less advanced, were members of immigrant waves of a much later date than the Magdalenian Cro-Magnon invasion of America, but not so late as that of the Maya.

After the Maya colony in Yucatan and Central America was discovered first by the Toltecs in the seventh century A. D. and second by the Aztecs in the early part of the eleventh century A. D., the close affinity of the arts, crafts and customs among all three races evidently impressed the latter two tribes. Recognizing the much greater advancement in culture of the latest arrivals (the Mayas), the Toltecs and Aztecs became willingly influenced; the result is easily discerned in the arts and sciences of both these intellectually lower peoples. The great family of so-called American Indian tribes, scattered far beyond easy contact with the brilliant Mayas, were naturally not affected. Among those peoples who had not degenerated to too low a level, the ancient customs and rites prevailed. Earth-mound pyramid construction continued without improvement, witchcraft prevailed in a perfunctory manner, the same system of mummification was indifferently maintained, and the memory of the legends of their ancestors was barely kept alive. Tribal laziness, the result of their nomadic existence, would easily account for these conditions. Lacking the knowledge of a proper time-measuring system, events of the past were handed down from one generation to the next without the possibility of chronological

Maya cultural influence

exactness. None of the legends or myths attempts even to suggest an approximate era. It is conceivable, nevertheless, that, due to a healthful outdoor existence and freedom, racial physical characteristics prevailed throughout their age-long occupancy of the Americas.

Brothers in adversity

The very nature of the customs and rites preserved, however, apparently links the American Indian directly with the Cro-Magnon of the Magdalenian Period. In other words, they both left the main ancestral tree at approximately the same time— which tree, I believe, was rooted in the fertile soil of Atlantis. (See chart facing page 217).

Remarkable evidence, recently announced, supports my belief in extremely early "Indian" occupancy of the Americas. An article published in the *Los Angeles Times,* March 22, 1936, says: "New evidence that Folsom Man, most ancient known inhabitant of North America, advanced to the eastern seaboard was reported today by the Smithsonian Institution—whose . . . antiquity has been placed tentatively at 10,000 B. C." Twelve thousand years ago!

Chapter Eleven

Pre-Panamanians and Pre-Incas

IN attempting to explain the next important arrivals of Atlantean immigrants on the American continent we will turn our attention to the Panama area and to Peru in South America.

A. Hyatt Verrill has given considerable study and much research to the ancient races which invaded and colonized the Panama area. He offers an hypothesis, in view of the marked similarity apparent between the architecture, art, and customs of those people and those of the Mexicans, Peruvians, and Mayas, that the culture originated in that area.

With this opinion I cannot agree. Admittedly, there is considerable similarity between the cultures of the races he mentions, but there is absolutely no evidence to warrant assigning to the early civilization which occupied the Panama area the honor of being the source from which sprang the inhabitants of Mexico and Central America.

Panamanians not the source

As I have previously stated, it is my opinion that only through a systematic correlation of all available data concerning the races in question, and a careful checking of comparisons between the cultural details of that civilization and those of all other ancient peoples, is the formulation of a theory made possible.

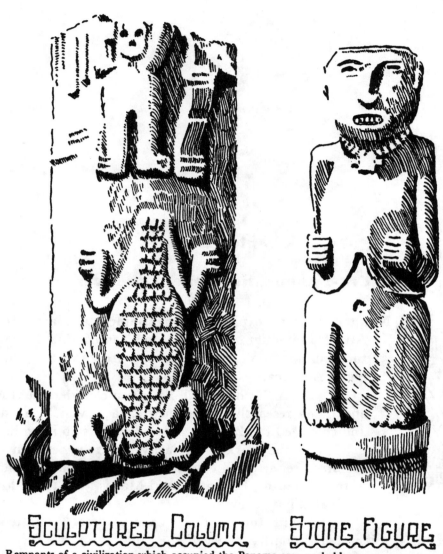

SCULPTURED COLUMN STONE FIGURE

Remnants of a civilization which occupied the Panama area probably 10,000 years ago.
Unearthed and photographed by A. Hyatt Verrill.

Let us, then, proceed on those lines to weigh the evidence Verrill offers in support of his ideas, and reserve our conclusions until all the data have received our full consideration.

Reviewing Verrill's evidence

Let us begin by reviewing a few of the outstanding items of evidence which Verrill has discovered. He says: "Remains of a civilization estimated to be 10,000 years old—far antedating anything hitherto discovered in this hemisphere—have

been unearthed recently on the Isthmus of Panama. *Stone monuments,* sculptured idols, wonderful *polychrome pottery,* and the ruins of a *vast temple,* all dating from the dim past, before the Mayas, the Aztecs, and the Incas had risen to power, have been found under thick layers of volcanic ash, *showing an advanced stage of development* and civilization that may require an entire reconstruction of preconceived theories of the progress of man in the Americas.

"We call the Western Hemisphere the New World, yet hundreds, perhaps thousands, of years before the inhabitants of Great Britain had risen beyond skin-clad savagery, centuries before the denizens of Europe were more than barbaric hordes, ages before Rome was built or King Tut saw the light of day, man in America had attained a high state of culture and a creditable civilization."

Analyzing Verrill's conclusions

Later he says: "And why the highest cultures and civilizations *should have been confined to tropical regions is a puzzle which no man has yet solved.* There seems little doubt, however, *that all these people were aboriginal Americans whom we erroneously call Indians.*"

If we are to give any credence to the Atlantean theory, even if we are confined alone to the information available in reference to the cultural attainments of the Magdalenian Cro-Magnon man, the Akkads, and the pre-historic Egyptians, then we cannot accept the hypothesis of a cultural beginning in the Americas. In no case up to the present writing has any evidence been offered to indicate origin and progression in the Americas of architecture, the allied arts, religion, mythology, language, or the remaining outstanding sciences. On the contrary, whenever and wherever the works of an advanced race of people are discovered on this continent, *we find them in a matured condition.*

Panamanians did not influence Maya art

That the ancient and advanced peoples of the Panama area were the progenitors or cultural forefathers of the Mayas, as Verrill suggests, is refuted by an abundance of evidence. It must be admitted, however, that the data and information which Verrill submits are of inestimable value, and tie in with our general subject; and his research work in that field must not be underestimated. In offering my own opinions, based upon his discoveries, I do so without any intention to belittle his efforts. My endeavor is to submit the evidence to the reader and to offer an hypothesis founded upon the testimony as I interpret it. The reader may have other views.

Among the items of interest mentioned by Verrill in reference to the ancient Panamanians, we learn of a *vast temple,* covering one hundred acres; of *earth-mounds;* immense *monolithic columns* "elaborately sculptured in symbolic designs"; ceramic work; carved, unmistakable *elephant figures;* statues of Assyrian affinity; *the plumed serpent;* feathered headdress; *phallic columns;* Semite cast of features of the sculptured faces; evidence of *sun worship;* the carrying of children *on the mother's back;* worship of many deities; the *burning of incense;* and the fact that all their idols *faced east.*

Verrill believes that the ancient Panamanians were indigenous to America, that they had "an entirely new culture", and that this culture was the nucleus of the Mayan and Pre-Incan civilizations. But when we use the measuring stick of the combined sciences, and apply the general knowledge of man's past works to Verrill's general theory, we learn that it is without foundation. Verrill tells us, among other things, that the Panamanians possibly built earth mounds, had statues of Assyrian affinity, were phallus and sun worshipers, and possessed customs which, although similar to Pre-Incan, Mexican and Mayan, are also associated with the cultures of ancient European and other races of the Eastern Hemisphere.

As there is no evidence of progress in Panamanian art in Central America, and as there is an abundance of data to substantiate the existence of the fundamentals and principles of the identical culture in Europe and Asia Minor, and, further, as those striking similarities also exist between the four great cultures of the Americas—namely the Pre-Incan, Panamanian, Mexican, and Mayan,

Remarkable items of interest

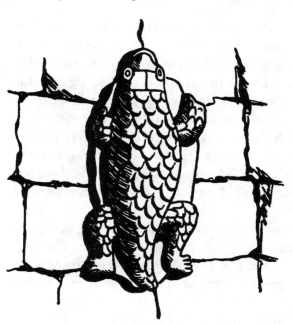

Detail of a stone carving, Mexico, (from Kingsborough's works) almost identical with that shown on the sculptured column from the Panama area. (See page 192).

Why not branches of a mother race?

not to mention the "Indian"—it is evident that all those civilizations are merely branches of a parent trunk—children of a root stock who migrated from a center which obviously was neither the American continent nor the Eastern Hemisphere.

Mention of the Panamanian temple, its vast area and importance, reminds us of the Atlantean temple descriptions given by Plato. The unmistakable elephant sculpture in the Panama area sees its counterpart in Maya art, and as there is no evidence to show that the elephant existed on this continent, at least during man's cultural period, where did these two peoples obtain the motif? On the other hand, as Plato says, the elephant was very plentiful in Atlantis. If we are to accept the Atlantean theory, then what better explanation for the presence of the elephant motif in the Panamanian and Maya art can be offered, than that both cultures were branches of a Mother Race which developed in Atlantis; and that when those branches migrated from the sinking continent, they brought with them, among other cultural expressions, the elephant motif?

Did not originate in Americas

The same argument applies when considering the origin of other parallel art motifs and customs among these two peoples. The method of carrying the child *on the mother's back,* for instance, as was the custom among the Panamanians, is precisely the same as is seen in Egypt. Dr. E. A. Wallis Budge, speaking of Egyptian customs says: "A child was wholly in its mother's care, and she *carried it about on her back.*" The fact that the Panamanian idols all face east is probably symbolic, and in sentimental recognition and commemoration of their tragic departure from their homeland which once existed in that direction—in other words, Atlantis.

Phallus worship, witchcraft, and ceramic work likewise *did not originate on the American continent,* yet we find among the principal ancient peoples thereon the knowledge and practice of those cults and arts. Later I endeavor to explain the origin of phallus worship, its peregrinations among all the ancient races, and the reason for its presence in the Americas. Witchcraft, known to the Panamanians, was also a universal practice, the birth of which took place elsewhere than in America.

Arduous labor in field research

None but those who in the name of science have penetrated and explored the heat-laden, fever-stricken, dangerous and pestiferous jungles, consisting of poison-infested, tangled vegetation and

spiny thorn thicket undergrowth, can even begin to appreciate the arduous labor of such research workers as A. Hyatt Verrill.

It is with considerable diffidence, therefore, that I offer my personal opinions in opposition to those expressed by Verrill concerning the early people of the Panama area, and to his belief that their culture may prove to be the prototype of that of the Mayas and other advanced races of the Americas.

Further, it is apparently unfair for me to criticize his hypothesis, which is obviously based upon tentative conclusions made after but a preliminary survey of the very meager facts available. My intention, however, is to use his remarks to point out the parallel of Panamanian culture with that of not only the early American races but also those of Europe and Asia Minor.

In the course of Verrill's description of his discoveries in the Panama area, he mentions the presence of mounds. Lacking enlightenment on this particular item of information we can only presume, at this time, that the mounds referred to are artificial. We might anticipate their presence in that area together with examples of the more advanced type—the pyramid—if the conclusions, drawn from the recorded evidence, are accepted as showing that the Panamanians practised a form of Osiris worship.

Probability of artificial mounds

If it is true that artificial earth mounds exist in that area, it would seem to indicate that another and still earlier arrival took place, and also definitely to ascribe the cult of Osiris—or a direct branch of that form of worship—to those people. In any event the evidence suggests that what may be termed the classic Panamanian cultural wave, whose traces were recently discovered and recorded by Verrill, had a much earlier advent into America than that of the Mayas.

So little is known of the "classic" period of Panamanian culture that it is folly at this time to advance a conclusion; in fact such a course is impossible. But with the few data available, and with the addition of circumstantial testimony such as is furnished by Verrill, we may conjecture to a limited extent in favor of an Atlantean origin for that civilization.

Among items of favorable comparison with ancient cultures on both continents is that of sun worship, also practised by the Cro-Magnons, the Basques to this day, Egyptians, Pre-Incas and the American "Indians". Phallus worship, which—as we shall learn later—was a ritual among all the early peoples of Europe and

Asia Minor and the Egyptians, is also observed among the peoples of the Americas, including the Pre-Incas and the Mayas. Its rites are definitely associated with the cult of Osiris; therefore by deduction, inference and circumstantial evidence (if we are to believe Plato), that form of worship originated in Atlantis; in which event the Panamanians, who also apparently had knowledge of and practised these rites, were colonists from that center.

Summing up the similarities between the possessions and customs of the Panamanians and the earliest peoples of both hemispheres, we find that they include carved and colored round, square or oval stone columns; the elephant motif; the construction of vast stone structures; cotton weaving; the carrying of children; ceramic work, and incense burning. The culture which the early Panamanians brought with them, therefore, is basically similar to that of the Mayas, but the latter—the latest arrivals in America—had the advantage of all the development which had accrued in Atlantis, or the remaining western portion of that Archipelagic Empire, prior to its final submergence. There are striking similarities between the architectural motifs and customs of the Pre-Incas, the "classic" Panamanians, and the Mayas, but unquestionably the general culture of the last-named is superior to the former two, and was in no way influenced by them, though in my opinion they all sprang from the same root.

Reason for similarity between art motifs of earliest cultures of the Americas

Possible Atlantean origin

The earth-mound, or the prototype of the symmetrically sided stone-faced pyramid, is of a period long prior to the ultimate form. The primitive state (with no evidence of any progressive steps toward regularity) of the mounds erected by the American Indian, points strongly to the conclusion that the arrival of those people in the Americas was, as I suggest, approximately between shortly before 14,000 B. C. and 11,000 B. C.

If my deductions—based upon present knowledge in respect to the similar parallels between the art, religion and customs of the "classic" Panamanians and other ancient civilizations of both hemispheres—are within reason, then we may consider two hypotheses.

Possibility of previous invasion in Panama area

First, if evidence is found that artificial earth mounds exist in the Panama area, it is possible that a previous invasion took place, long prior to that indicated by the immense stone temples and other similar erections. This I deduce from the apparent fact that

the artificial earth-mound form of building was in vogue long before the age of stone construction, although, in view of the evidence supplied by religious rites, arts and customs, both systems of building may have belonged to the same people. The time of the "earth-mound" culture invasion of the Panama district then, like that of the North American Indian, would approximate the period between shortly before 14,000 B. C. and 12,000 B. C. (or possibly as late as 11,000 B. C.).

Second, if no such evidence of earth-mound building materializes which would point to such an early colonization of the Panama area, then we are left with the single consideration of attempting to assign the age of arrival of the "classic" Panamanians.

Geological possibility of man's very early presence in the Americas

In such event, it might be suggested that the stone-building people of the Panama district—who apparently practised Osirian rites and exhibited a culture possessing similarities with those of civilizations which I believe flourished around an era approximately 10,000 years B. C.—arrived in the Panama area from Atlantis either shortly before or shortly after 9,600 B. C., the period assigned by Plato to a major eastern submergence of that island continent.

We have seen that using Holmes' geological hypothesis, man's advent into the Americas, if via the Behring sea, was not possible at a period exceeding between 10,000 and 20,000 years ago. As I do not hold with the theory of an Asiatic invasion from that direction, the time period is of no consequence from that point of view, but we have the admission from recognized authorities of the *possibility* of man's presence in the Western Hemisphere not exceeding 20,000 years ago. Geologically, therefore, there seems no reason to object to the belief in an invasion of America by man within and up to that limit.

The River of Ancient Ruins

We have learned that part of the escaping hordes from sinking Atlantis on the eastern trek entered the mouth of the Mediterranean Sea and continued their journey eastward along its northern shores into the Valley of the Euphrates, and later to Egypt. In other words, they followed a definite shore line until they arrived at a center which provided natural conditions favoring the establishing of a new empire.

According to Fountaine in *How the World was Peopled,* the "ancient people [American Indian] constructed 'levees' to control and utilize the bayous of the Mississippi for the purpose of

agriculture and commerce. The Yazoo River is called *Yazoo-ok-hinnah* —the River of Ancient Ruins."

Further, it is conceded that the "Mound-Builders" of North America were pre-eminently a river people. Most of the earth-mounds are to be seen near the Mississippi and its tributaries. These people penetrated far north from the shores of the Gulf of Mexico, actually to the shores of Lake Superior, where they carried on extensive mining operations. Again we find a race of people closely following a water course, just as did the people who migrated through the Mediterranean area.

Mound Builders a river people

In precisely the same manner, it is surmised that the Pre-Incas, or Quichuas, passed through the Valley of the Amazon and its tributaries, beyond the area of Brazil, until they reached the high, healthful regions of Bolivia, and on to Peru. The evidence suggests that these Quichuas, or Pre-Incas, were immigrants from disintegrating Atlantis—enforced colonists from that continent, as were the Cro-Magnons, Egyptians, American Indians and the Mayas.

Deep-sea soundings reveal a continental outline which we can roughly assume to be that of submerged Atlantis. The so-called "connecting ridge" approaches, at one point, almost to the shores of South America, just above the mouth of the River Amazon. Does not this area suggest a possible American landing point for the Pre-Incas?

The early Peruvians, or Pre-Incas, were an extraordinary race of people. They have left to us astounding examples of their civilization. The immensity of their architectural and engineering undertakings is almost unbelievable. The determination and fortitude with which they encountered almost insurmountable physical obstacles in establishing their cities and trade routes are beyond comprehension.

Astounding works of the Pre-Incas

Robert E. Anderson in *Extinct Civilizations of the West* says: "Those traces of the Cyclopean builders point to an extremely early date, but several students of the Peruvian antiquities point confidently to distinct evidence of *a still more primitive race.*"

Another authority tells us that those early Americans built "immense pyramidal structures, some of them *half a mile in circuit.*"

Cieca de Leon says that "great edifices" were in ruins at Tiahuanaca. Later he speaks of "an *artificial hill* raised on

a groundwork of stone." Continuing, we read "but in another place, farther west, are other and greater monuments, such as large gateways with hinges, platforms and porches made of a single stone." And again: "Enormous gateways, made of great masses of stone, some of which *were thirty feet long, fifteen high, and six thick.*"

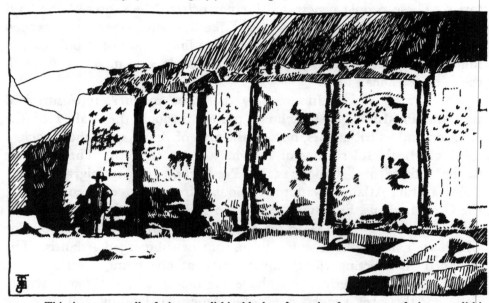

This immense wall of six monolithic blocks of granite forms part of the megalithic fortress at Ollantaytambo, Peru. The stones were quarried several miles away. Are not these stones and the method of construction employed reminiscent of the Pelesgic or Mycenæan works of the Early Greeks?

Referring to large and remarkable edifices found near Huamanga, de Leon says that the native traditions state they were built "by *bearded white men,* who came there long before the time of the Incas, and established a city."

One of the *great pyramids,* called the "Temple of the Sun", is 812 feet long, 470 feet wide, and 150 feet high.

Another extraordinary structure, now in ruins, lies at Cuelap, in Northern Peru. The ruins are described as follows: "They consist of a wall of wrought stones, 3,600 feet long, 560 broad, and 150 high, constituting a solid mass with a level summit. On this mass was another 600 feet long, 500 broad, and 150 feet high."

Imagine a structure 3,600 feet long and 300 feet high, in which were constructed numerous rooms!

When we turn to a study of the details of the culture of these people, the Pre-Incas, we find many data which, in

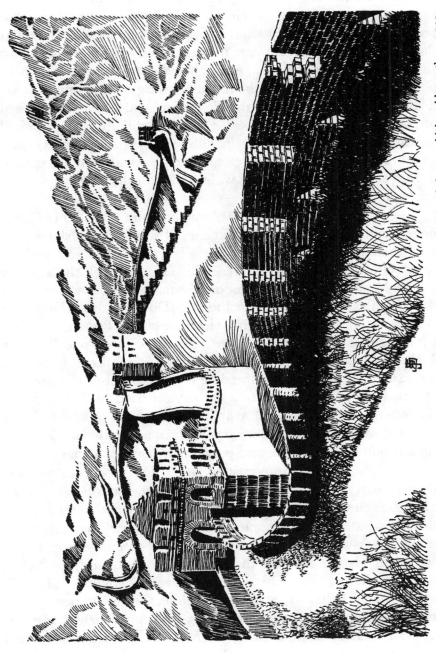

The Great Wall of China, fortified, more than 1,000 miles long, with additional loops which add another 1,000 miles. One of the wonders of the world, yet we find in Peru an almost identical wall which is believed to exceed this length.

my belief, relate them to the same family tree to which belong the Mayas, American Indians, and early races of Europe and Asia Minor.

These ancient and little-known Pre-Incas practiced phallus worship; had a form of mummification closely similar to the historic Egyptians; were past masters at city-planning on a vast scale, as were the Atlanteans, Aztecs, and Mayas; were superb architects and engineers, as were the Atlanteans, Egyptians, and Mayas; erected triumphal arches, as did the Egyptians and Mayas; possessed a comprehensive story of the Great Flood, as did all the principal early races of both hemispheres, including Egyptians and Mayas; placed their honored dead in stone sarcophagi, as did the Egyptians and the Mayas; and inclined their walls and wall openings as did the Egyptians and the Mayas.

Pre-Inca Culture

The earliest Peruvians, on the other hand were mound-builders, as were the Guanches of the Canary Islands, the Antilleans, the American Indians, and possibly the early Panamanians. They were Osiris worshipers, as were the Guanches of the Canary Islands, Cro-Magnon Magdalenians of France and Spain, the early Egyptians, Antilleans, and American Indians. Does not this information point to races inferior to that which I term the classic Pre-Inca? If so, then is it logical to bracket these two steps of culture—one low, the other high—as belonging to the same period? If there were two distinct invasions, may we assign the date of the arrival of the Mound-Building Pre-Incas to approximately the same period as I suggest for the so-called American Indians, who likewise were mound-builders and whose culture so parallels the early Egyptian, Antillean, Guanche and Magdalenian Cro-Magnon, and possibly the earliest Panamanians?

Meaning of the word Atlantic

An interesting side light concerning the probably very early American invasion by the Pre-Incas is seen in the remark by Montesino that at a period *approximating the Great Deluge,* America was invaded by a people with four leaders, named Ayar-manco-topa, Ayar-chaki, Ayar-aucca, and Ayar-uyssu. Senor Lopez says that *"Ayar"* is the same as the Sanskrit word *"Ajar"*, or *"Aje"*, and means primitive chief. The words *"Manco"*, *"Chaki"*, *"Aucca"*, and *"Uyssu"* mean believers, wanderers, soldiers, husbandmen. From the Greek historian Theopompus we learn that an ancient name for Atlantis was Mera, or Meron. If we turn to the dictionaries we find that the Atlantic Ocean was named after the Atlas Mountains in Northwest Africa. The assumption is untenable, because there is no

satisfactory etymon for those words in any known European language. We learn from Plato, however, that the son of Poseidon, founder of the Atlantean civilization, was named Atlas. The moment we turn our attention to the American continent we find not only the word but its meaning. In the Nahuatl language the radical *a, atl,* means water, war, and the top of the head. The Nahuatl word *atlan* means "amid the water", the adjective of which is Atlantic. (See page 204). Incidentally, when Columbus rediscovered America there was a city in existence situated at the entrance of the Gulf of Uraba, within the gulf of Darien in the Panama area, named Atlan. The present form of the name is Acla.

Suggested origin of word Peru

The Great Wall of Peru. Sketch made by the author from an aerial photograph. The explorers followed this wall for 45 miles by aeroplane and yet believed they had seen but a small portion of its length. It was fortified and is believed to have exceeded in length the Chinese Wall. Its builders are said to have been auburn-haired white men.

The significance, therefore, is that Atl, Atlas, Atlan, and Atlantic are words directly associated with the civilization founded and ruled over by Poseidon—namely, Atlantis; and they are also associated with the ancient races of the American continent.

It is further significant that, as Montesino tells us, a people invaded America near the time of the Great Flood. We

learn also that one of the four leaders was named Ayar-manco-topa. *Pirhua-manco* means revealer of *Pir*—light. It has been suggested that *"Manco"* is a word associated with the Peruvian colonists, and that *"pir"*, meaning light, becomes Perou, or Peru.

If we are permitted so to argue, then the American invaders mentioned by Montesino, who arrived approximately at the time of the Great Flood, landed in South America and finally became settlers in Peru.

If the Great Flood referred to by Montesino is assumed to be the same as mentioned by Plato, then the Pre-Incas, of what I term the classic period, arrived in Peru approximately between 9,000 and 10,000 B. C., and established there a civilization which they brought with them from Atlantis. The fact that a very ancient city now called Acla (modern form of Atlan)—a so-called Nahuatl word apparently identified with Atlantis—is situated in an almost direct line between Peru and the assumed submerged western area of the Atlantean Islands Empire might suggest that it was first established by those early enforced visitors. Perhaps then, after they had fully recovered from their harrowing experiences occasioned by the sinking of their homeland and hazardous sea flight, they decided that their new location on the coast was unsafe, and learning of the highlands of Peru, they journeyed to that area and established there a culture of which we have evidence today. That a definite urge existed for a guaranteed future safety of their people (as is also evident with all Cro-Magnon invasions of Europe) seems indicated by the fact that the Peruvian settlement is located in almost impregnable mountain fastnesses.

The element of fear is seen, not only in the choice of the location, but in the extraordinary protective measures exhibited in the construction of vast fortifications, building of cyclopean walls, and the full advantage taken of natural barriers. Spence says: "The greatest mystery of all regarding the ruins of Tiahuanaco is the selection of the site. For what reason did the prehistoric Andeans build here? The surroundings are totally unsuited to the raising of such edifices, and the tableland upon which they are placed is at once desolate and difficult of access. The snow-line is contiguous, vegetation will not grow, and breathing at such a height (13,000 feet

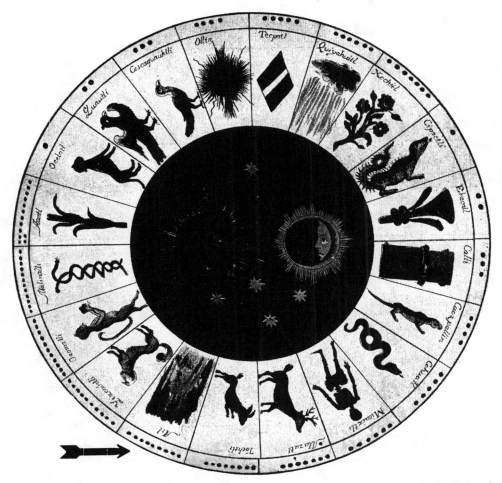

The Aztec Zodiac showing the Atl symbol (see arrow), meaning water. The origin of the word Atlas given to the mountain range in Northwest Africa has no etymon in any language known to Europe or Asia Minor. In the time of Herodotus (born 484 B. C.) there dwelt near this mountain-chain a people called Atlantes. Atlas, in Greek mythology, was the supporter of the world, son of Poseidon who was the Founder God of Atlantis. A city named Atlan in the Panama area existed when Columbus discovered the American continent. Atlan, in the Nahuatl language, means amid the water. With Europe, Africa, America and the waters between all bearing names having the radical Atl (which finds no place in the etymology of the Eastern Hemisphere, but which was known to the ancients of the so-called Old World) which designates the fabled lost continent between the two hemispheres and also is common to the Americas, can it be said the circumstance is without significance? (Ill. from a MS. in the Museo Nacional de Mexico.)

above sea level) is no easy matter. *There is, however, reason to believe that the plateau has risen considerably since it was occupied by the Andeans.*"

We have seen, therefore, that both earth mounds and highly skillful massive stone structures are in evidence among the remains of the Pre-Inca occupants of Peru. This prompts me to offer two hypotheses. One is that perhaps those people arrived in South America from Atlantis at a period when the symmetrically constructed stone-faced pyramid had just evolved from the crude earth-mound form—which period, I suggest, may have been between 12,000 and 10,000 B. C. Or, second, that there were two distinct invasions, one during the era of simple earth-mound construction, or prior to approximately 12,000 B. C., and the other between approximately 9,000 and 10,000 B. C. Personally, I am inclined toward the second hypothesis, as the crude, artificial earth mound era is not to be compared with the period of lavish display of wealth and culture, so directly associated with the "classic" Pre-Incan age, a display which is so similar to that of Atlantis as described by Plato.

Two hypotheses offered

Perhaps, by this time, the reader will have wondered why I have strayed so far from the subject of architecture. My reason is that, in view of the importance of establishing the Atlantean origin of the pyramid, it became necessary to show that although the earliest civilizations in the Americas freely used the pyramid form, those races did not originate it on this continent, neither did any one of them borrow the motif from the other. I wished also to differentiate between the crude sacred mound and the symmetrical stone-faced form, so definitely associated with the architecture of the outstanding American cultures. Until further evidence to the contrary comes to light, I am persuaded that the Mound-Builders of both hemispheres sprang from the same source—Atlantis—and that the prototype was the Sacred Hill of Atlantis.

Reason for digressing

Further, it appears possible that the Atlantean mound-building period was roughly between shortly before 14,000 B. C. and approximately 11,000 B. C.; and that at some time around approximately 14,000 B. C. the first mound-builders appeared in Europe. These people we now know as Magdalenian Cro-Magnons. From this wave, and possibly also from succeeding migrations into Europe from Atlantis shortly after this period, the mound-building culture spread across the northern shores of the Mediterranean and

eventually into Egypt. Either at this time (approximately 14,000 B. C.) or soon afterward, the first mound-builders appeared on the American continent. Possibly succeeding migrations to the Western Hemisphere continued to occur until about 11,000 B. C., or even as late as 10,000 B. C. I believe that these waves of immigrants were composed of people now known to us as the American "Indians", the mound-builders of America. Among other mound-builders who settled in definite centers, I suggest including the earliest Pre-Incas and possibly the earliest Panamanians.

Development of symmetrical pyramid

I suggest that the symmetrical pyramid was developed in Atlantis toward the latter part of the period between 14,000 B. C. and the cataclysm of 9,600 B. C. After the Azilian-Tardenoisian art of Cro-Magnon man entered Europe, pyramid building finally entered the Valley of the Euphrates and eventually Egypt.

I believe that at approximately the same time, and also through later waves, the same pyramid art-form entered America. Its later form was practised by some of the Nahuatl tribes, such as the Toltecs and Aztecs, and the late or "classic" Pre-Incas as well as the late or "classic" Panamanians.

During the period between 9,600 B. C. and approximately 500 to 200 B. C., the pyramid was, I believe, slowly being developed in the remaining portion of the rapidly disappearing Atlantis—the portion nearer the American shore—the last of the once vast archipelagic continent; and further I suggest that some two to five hundred years B. C. the last of that great empire vanished beneath the waves of the Atlantic Ocean. The remnant of her highly cultured people—last of the root Atlanteans—fled hurriedly to Yucatan and Central America, bringing with them—among numerous other expressions of a great civilization—the highly developed art of symmetrical pyramid building. These people we now know as the Mayas.

Last of the root Atlanteans

Facing page 217 is a chart which I have prepared in the hope that it will assist in explaining my hypothesis concerning the various major cataclysms which finally destroyed the continent of Atlantis, and the consequent distribution of her peoples and cultures over both hemispheres.

Chapter Twelve

Columns and City Planning

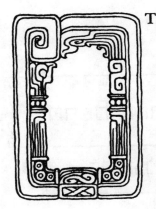

THER important resemblances between the architectural details of the Maya culture and that of Egypt, Greece, and elsewhere are now to be considered.

The column and the arch are the result of necessity. Similar structural requirements were unquestionably encountered by more than one race; but it would be strange indeed to find that widely scattered nations adopted identical methods in overcoming specific as well as general difficulties.

Seeking the origin of the stone column, we learn that its prototype was a wooden member, such as a tree trunk, sapling, or squared timber. It was devised to support a wooden beam, which in turn supported other beams to carry a floor or roof load. The original capital of such a column, however, was an ingenious device to distribute the otherwise crushing effect at the point of contact between the top of the column and the beam. To illustrate this point, I provide the simple sketches on the following page.

The early ingenious architects quickly utilized this structural necessity as a decorative feature. In the generally accepted five classical orders of column architecture—the Doric, Tuscan,

Ionic, Corinthian and Composite—we see the originally crude, yet serviceable, vertical-grain wood block developed into a design unit of beauty. The Greeks are sometimes credited with being the first people to beautify the structurally necessary column-cap or abacus (level tablet on the capital of a column supporting the entablature). But when we turn to the art of the ancient Egyptians, which flourished thousands

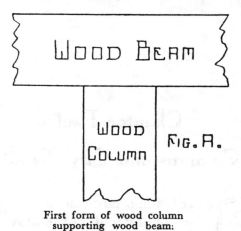

First form of wood column
supporting wood beam:

Column and capital on both continents

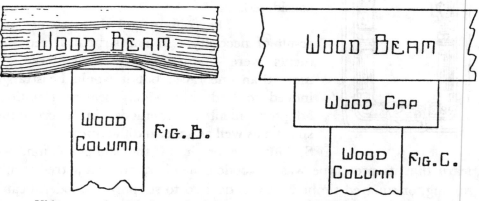

Ultimate result when heavy load is
applied to beam at point directly over
column.

Crushing effect of beam directly
over column overcome by the insertion of
wood cap, or capital.

of years before Greek art was born, we find almost the identical method of treating the column and abacus. Without question, the Greeks borrowed these motifs from the Egyptians, possibly from such examples as the rock-cut tombs of Beni-Hasan, which were executed in the Twelfth Egyptian Dynasty—the period between 2,778 B. C. and 2,565 B. C.

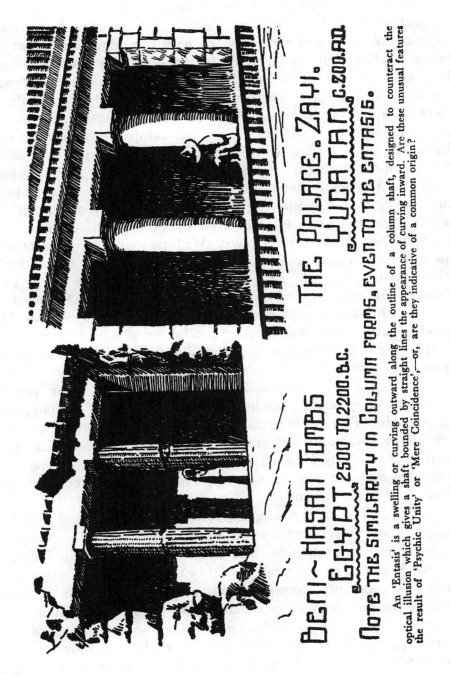

BENI-HASAN TOMBS
EGYPT 2500 TO 2200. B.C.

THE PALACE, ZAYI.
YUCATAN c.200.A.D.

NOTE THE SIMILARITY IN COLUMN FORMS, EVEN TO THE ENTASIS.

An 'Entasis' is a swelling or curving outward along the outline of a column shaft, designed to counteract the optical illusion which gives a shaft bounded by straight lines the appearance of curving inward. Are these unusual features the result of 'Psychic Unity' or 'Mere Coincidence',—or, are they indicative of a common origin?

There is no evidence to show that the Mayas of Central America had any direct or indirect cultural or commercial connections with the Egyptians. Further, it is an exceedingly remote supposition, even assuming contact with the Egyptians, that they borrowed Egyptian art. Yet in the classical Maya architecture we find scores of instances where the so-called Doric column and capital are used. A glance at drawings on the preceding page, of a detail of the second floor of the enormous palace at Zayi in Yucatan, the entrance to the Beni-Hasan Tombs of Egypt, and comparisons with the Greek Doric column, will convince even the lay mind of the striking similarity. The columns forming the entrance to the Beni-Hasan tombs are fluted. This would indicate that a still much earlier design was employed by the Egyptians in treating the column-and-capital combination. The unfluted column was either evolved by the Egyptians prior to the Twelfth Dynasty or was borrowed. With no evidence in Egypt of the use of the plain shaft and abacus prior to that time, I suggest that the style was developed in Atlantis. When we study the Maya art in Central America, we find a plain form of column and abacus of a sturdy utilitarian appearance that appealed to the practical Maya mind. That its design had received careful consideration by their architects is seen in the elimination of clumsiness; its depth and width were reduced to a minimum of structural efficiency.

In addition, they employed their profound knowledge of optical science by creating an entasis, or swelling, on the plain shaft. This counteracts the illusion of column concavity, so irritatingly obvious in perfectly straight shafts. In the columns at the entrance to the Beni-Hasan Tombs, erected well over 2,500 years B. C., this scientific correction is also employed, yet the Greeks are given credit for this refinement.

Again, it is significant to note that in both Egyptian and Maya architecture, the window opening is conspicuous by its almost total absence. The structural style of both civilizations is what is known as trabeated, or flat-beam type. The principle of the arch was apparently known to both peoples, but its use was almost entirely avoided, for reasons which I endeavor to explain later.

Continuing with our consideration of architectural comparisons, we learn that in Plato's narrative a careful description is given of the great buildings of Poseidon in Atlantis, and their surroundings. It appears that the Atlantean system of city

planning followed three important principles: "A citadel upon a lofty eminence, ring upon ring of defending walls, and lastly, alternate zones of land and water."

The Atlanteans apparently were builders of great vision and magnitude of conception. They constructed large temples, palaces, and harbors. Bridges were erected over the *zones* of sea which surrounded the central height. Plato says: "And beginning from the sea they dug a canal three hundred feet in width and one hundred feet in depth and fifty stadia [roughly five miles] in length, which they carried through to the outermost *zone,* making a passage from the sea to this, which became a harbor, and leaving an opening sufficient to enable the largest vessels to find ingress. *Moreover, they divided the zones of land which parted the zones of sea,* constructing bridges of such a width as would leave a passage for a single trireme [a war-galley having three banks or rows of oars] to pass out of one into another, and roofed them over; and there was a way underneath for the ships, for the banks of the zones were raised considerably above the water. Now the largest of the zones into which a passage was cut from the sea was three stadia [approximately 1,800 feet] in breadth; but the next two, as well the zone of water as of land, were two stadia [1,200 feet]; and the one which surrounded the central island was a stadium [600 feet] only in width. The island in which the palace was situated had a diameter of five stadia [3,000 feet]. This, and the zones and the bridge, which was the sixth part of a stadium [100 feet] in width, *they surrounded by a stone wall,* on either side placing towers, and gates on the bridges where the sea passed in . . . One kind of stone was *white,* another *black* and a third *red* . . . The entire circuit *of the wall which went round the outermost one* they covered with a coating of brass, *and the circuit of the next wall* they coated with tin, *and the third, which encompassed the citadel,* flashed with the red light of orichalcum. [Orichalcum is the Latin form of the Greek term for copper ore, and for a mixed metal, either brass or something similar.] . . . In the center was a holy temple *dedicated to Cleito and Poseidon* . . . All the outside of the temple, with the exception of the pinnacles, they covered with silver, and the pinnacles with gold. In the interior of the temple the roof was of ivory, adorned everywhere with gold and silver and orichalcum; all the other parts of the walls and pillars and floors they lined with orichalcum. In the temple they placed *statues of gold;* there was the god himself standing in a chariot—the

City planning

Zones of land and water

Plato describes Atlantis

charioteer of six winged horses—and of such a size that he touched the roof of the building with his head. . . And around the temple on the outside were *placed statues of gold of all the ten Kings and of their wives* . . . "

A careful study of the laws of architecture and town planning discloses the fact that colonizing peoples consistently take with them the fundamentals of their mother culture. As Spence observes: "The plan and outline of the great cities of antiquity were very frequently carried out in their colonial settlements, and the tendency was to model them as closely as possible upon the mother city."

Culture following migrants

Rome is said to have been modeled upon Troy. Corcyra followed the general plan of Corinth, and the cities of southern Egypt are said to have resembled very closely those of the Delta. The Spaniards founded their American cities, both architecturally and politically, on the old-country plan.

When we review the archeological restoration of Carthage, made by Paul Aucler, we observe a striking resemblance to the city-planning system of Atlantis as described by Plato. In Spence's description of Aucler's work we learn that: "The low, walled hill of Byrsa or citadel on which stood the splendid temple of Aesculapius at Carthage was strengthened on the mainland side by three great ramparts which stretched across the breadth of the peninsula, and which were fortified at intervals by towers. Below the market place and the senate house, a vast causeway 1,066 feet wide had been constructed around a circular island on which stood the admiral's headquarters . . . Both Atlantis and Carthage had thus a citadel hill encircled by zones of land and water, a canal to the sea, penetrating to the inmost zone, the zones were bridged over, and the connecting bridges were fortified by towers . . . both were guarded by a great sea wall, masking the entrance to their harbors."

Carthage restored

If we turn to the American continent we learn of ancient cities constructed on almost precisely the same lines. Tenochtitlan, site of the present City of Mexico, was built in the midst of a lake. The general plan included zones of land and water. There were causeways which crossed and recrossed, and numerous canals which surrounded the central pyramid of Uitzilopochtli. This pyramid has its prototype in the Sacred Hill and the Temple of Poseidon.

An examination of the cyclopean works of the Pre-Incas reveals their extraordinary resemblances to the architectural,

Plato's narrative of the Lost Atlantis describes the land surrounding the capital city as being divided into alternate zones of land and water. The above illustration from Waddell's *Buddhism of Tibet* depicts such zoning. Similar planning prevailed among the ancient races of the Americas.

city-planning, and engineering ability of the reputed Atlanteans. In the legend of Titicaca, reference is made to the shrine *which was built upon an island in the middle of a lake*. Another Peruvian legend states that the people of Yamquisapa, in the Province of Alla-susu, worshiped an idol in the form of a woman *on the top of a high hill named Cachapucara*.

The Temple Supreme

Further comparisons are seen in the works of the Pre-Incas who built enormous structures, using stones of cyclopean dimensions, fitted so accurately that, were the faces dressed, the joints

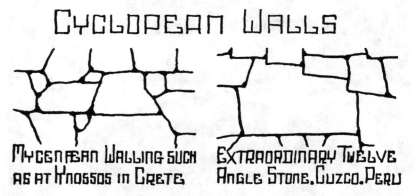

CYCLOPEAN WALLS

MYCENÆAN WALLING SUCH AS AT KNOSSOS IN CRETE.

EXTRAORDINARY TWELVE ANGLE STONE. CUZCO. PERU

could barely be distinguished. The doorways were built narrower at the top than at the bottom, precisely as those seen in Egyptian and Maya architecture.

Gold water pipes and silver garden tools

The Pre-Incan art, leaning toward gorgeousness in architectural decoration, is reminiscent of Atlantis as described by Plato. Descriptions of the Temple of the Sun, for instance, as recorded by Squires and others, resemble the accounts of the great palace of Atlantis. This vast religious structure was situated *on a hill* 80 feet above the river Huatenay. A series of magnificent garden terraces led to the temple proper. Exquisite designs, wrought in solid gold and silver, embellished the landscape; even the garden tools, spades, and hoes were of solid silver. The inner and outer walls of the temple were reputed to have been covered with sheets of gold. The interior of the temple was lavishly decorated with plates of gold, and a host of precious stones enriched a solid gold plaque of the deity to whom the temple was dedicated. Around this dazzling example of the art of goldsmith and lapidary were grouped magnificently garbed mummies. All the temple utensils were made of the most precious metals. Gold and silver were so lavishly used that the latter metal was actually employed

for underground water pipes. Even the landscaped grounds were embellished by the addition of figures of animals and insects modeled in gold and silver.

Gold and silver were so plentiful, we read, that, in the course of twenty-five years after the conquest "the Spaniards sent from Peru to Spain *more than eight hundred millions of dollars of gold.*" In 1534 A. D., Pizarro sent to Spain a quantity of gold objects. They consisted of "four llamas, ten statues of women *full size,* and a cistern of gold, so curious that it excited the wonder of all." In a description of a garden in one of the palace grounds, we read that "they had an *artificial* garden, the soil of which was *made of small pieces of fine gold,* and this was artificially planted with different kinds of maize, *which were of gold, their stems, leaves and ears.*" It is said that at one time the inhabitants of Peru possessed a collection of precious metals which exceeded anything previously known in the history of the world.

Spaniards take from Peru over eight hundred million dollars in gold

In fairness to Plato, therefore, can it be said of him that he attempted the creation of a fabulous country, a country of improbable people and impossible cities? If so, his imagination fell short of the Spanish descriptions of what had actually existed in the New World prior to his time. We must remember, too, that Plato is not the only source of information concerning Atlantis and its advanced civilization.

Continuing, we learn that the general system of planning among the Pre-Incas resembled that of the Maya structures. They employed a plan which consisted of a series of apartments grouped in regular squared-form around an open court, upon which the apartments opened.

Earliest structures of the Americas compared with Plato's description of Atlantean buildings

A description of the Pre-Inca fortresses greatly resembles that of the Atlantean structures. Such stupendous fortresses as Ollantay and Sacsahuaman, erected with immense blocks of stone and perched high upon almost inaccessible and practically vertical crags, have their counterpart in Plato's narrative, as do the circular or semicircular walls, the central citadel, and the holy place in its midst. The mighty fortress of Sacsahuaman, erected on an immense rock "which cleaves the meeting rivers of Huatenay and Rodadero", is described as absolutely impregnable to an attacking force without artillery. It is surrounded by *three distinct rings of walls.* This is

another important reminder of the Atlantean citadels and their triple protecting zones.

So far, in architectural comparison, we see that various similarities exist between the Atlanteans, Egyptians, Pre-Incas, Mayas, and others: similarities of city planning and building plans, based evidently on definite stipulations; similarities in the lavish use of gold and silver in decorative work and sculpture; in the inclined jamb of openings, multiple zones surrounding citadels, irrigation zones, and pyramid building.

At this time, to avoid confusion, I am not including other striking similarities. My immediate endeavor is to indicate the high probability that the great Pre-Inca culture was taken to the Peruvian highlands by colonists who were forced to depart hurriedly from Atlantis.

In weighing the evidence, it must be remembered that Plato was a Greek scholar and philosopher who lived in the middle of the most glorious period of Greek architecture, approximately 480-323 B. C. His great genius was hence influenced by strictly classical concepts acquired in an unparalleled intellectual environment, far removed from the romantic concepts of a much later age. It thus seems almost inconceivable that he could have invented so vivid a detailed description of a mythical city utterly unlike anything in existence in the Hellenic period. It is true that the structures of Nineveh and Persepolis bear a slight resemblance to those of Atlantis as described by Plato, especially in the extravagant use of gold, silver and bronze for decorative treatment; but, were they his models, his story—if simply fiction—would have failed to create even a mild impression at the time. There is no hint of such an hypothesis in contemporaneous Greek writings, and it seems quite out of character for so profound a sage as Plato, in such an age, to have indulged in romantic fiction, which he asserts to be fact.

It is far more probable that he wrote, as he asserted, of fact. The vast accumulation of evidence supplied by architectural remains in the Old and the New World corroborates Plato. The similarity between the Atlantean cities as he described them and those erected by ancient races seems to point unquestionably to a mother source from which the latter sprang. No evidence whatever has appeared, nor has any logical theory been advanced, to indicate any other center than Atlantis as the mother source. Certainly the

Plato declares his narrative on Atlantis fact not fiction

CHART SHOWING DISTRIBUTION of CULTURES
SUGGESTED BY ~ ROBT. B. STACY~JUDD · A.I.A.

MAYAS IN YUCATAN AND CENTRAL AMERICA
Symmetrical Pyramid-Building. Phallus-worship. Stone Sarcophagi. Mark of the Hand. Elephant Art-Motifs. Inclined Openings. Vast structures and cities. Triumphal Arches. Monolithic stones. Temples on Pyramids. Human bones in decoration. Incised Columns. Witchcraft. Incense Burning. Believed in One God and the Immortality of the Soul. Story of Flood. Head-Flattening. Column & Capital. Astrology. "They came from the East."

EGYPT
Symmetrical Pyramid-Building. Incised Walls and Columns. Temples on Pyramids. Monolithic stones. Vast structures and cities. Inclined openings. Triumphal Arches. Stone Sarcophagi. Column and Capital. "They came from the West." Practised Osiris-worship. Bull-worship. Ancestor-worship. Sun-worship. Advanced Mummification. Incense Burning. Astrology. Head-Flattening. Phallus-rites. They believed in one God, the Immortality of the soul. Possessed a Book of the Dead. Story of the Flood. Canopic Jars. Women carried children similarly to Pre-Incas. "Valley of the Dead"

CHINA

INDIA

PERSIA

200 TO 500 B.C.

Possibly numerous American Invasions from sinking Western Atlantis during this Period

TOLTECS AND AZTECS
Symmetrical Pyramid Building. Temples on Pyramids. Vast City-Building. Tower of Babel Legend. Astrology. Book of Dead. Witchcraft. Incense Burning. Story of Flood. Street of Dead. A Cult similar to Cabiri. Serpent-Gods. Twin-Cult.

CLASSIC PANAMANIANS
Cyclopean Wall-Construction. Elephant-Motifs. Monolithic Stones. Phallus-Worship. Sun-Worship. Vast Temple Building. Burning of Incense. Custom of carrying child similar to that of Egyptians and Pre-Incas.

CLASSIC PRE-INCAS
Symmetrical Pyramid Building. Temples on Pyramids. Vast Cities. Cyclopean Wall-Construction. Triumphal Arches. Incised Columns. Stone Sarcophagi. Advanced Mummification. Custom of carrying child similar to that of Egyptians and Classic Panamanians. Sun-worship. Phallus-worship. Inclined Openings. Twin-Cult.

5000 B.C.

6000 B.C.

7000 B.C.

8000 B.C.

Approximate beginning and progress in symmetrical Pyramid Building during this period

VALLEY OF THE EUPHRATES
The AKKADS - Stone Pyramid Building. Vast City-planning and structures. Temples on Pyramids. Tower of Babel. Osiris-Cult. Story of the Flood. Cabiri-Cult. Astrology.

EUROPE

MEDITERRANEAN SHORES

PROBABLE INVASIONS OF AMERICA BEGINNING WITH THIS PERIOD

CIRCA 9600 B.C.
MAJOR SUBMERGENCE OF EASTERN ATLANTIS
ATLANTIS, suggested Mother of Empires, Seat of Culture, from which sprang those on both Eastern and Western Continents

Suggested vast City-building and an advanced Culture in Atlantis during this period

CRO-MAGNON CULTURE KNOWN AS AZILIAN-TARDENOISIAN
Through this immigration wave into France and Spain the Bow and Arrow, Principles of Osiris-Worship, Symmetrical Pyramid-Construction. Sun-worship, Cabiri-cult, Phallus-worship, Serpent-cult, Astrology, Writing, Art and advanced Agriculture etc. were introduced into Europe & Asia Minor

10.000 B.C.

Suggested symmetrical Pyramid-Building toward end of this period

Possibly as late as 10.000 B.C.

11.000 B.C.

Possibly numerous Atlantean Invasions of Europe and Asia Minor during this period

EGYPT
Mound Building

VALLEY OF THE EUPHRATES
Mound-Building among the Akkads

MEDITERRANEAN SHORES

12.000 B.C.

SUGGESTED PROBABLE ARRIVAL IN THE AMERICAS AT THIS TIME, OF THE:
EARLIEST PANAMANIANS (assumed, owing to discoveries indicating Mound-Building and Sun-Worship)
EARLIEST PRE-INCAS, whose Culture included Mound-Building and Sun-Worship
AMERICAN "INDIAN" who also practised Sun-Worship, Head-Flattening, Mound-Building, Mummification, Ancestor-Worship, Twin-Cult, Osiris-Worship, used the Bow and Arrow, possessed a story of the Flood and state, that their Ancestors "came from the East". Suggest the probability, that they migrated to the Americas in numerous waves during a period extending between sometime prior to 23000 B.C. and approximately 11000 B.C.

Probably a Western Atlantean Submergence took place during this period and ANTILLIA was formed

Suggested Mound-Building Period

13.000 B.C.

CIRCA 14.000 B.C.
MAJOR SUBMERGENCE OF EASTERN ATLANTIS

CRO-MAGNON MAN IN FRANCE & SPAIN MAGDALENIAN CULTURE, WHICH IS ALSO SEEN IN CANARY ISLANDS ETC.
(Mounds discovered on Canary Islands, possibly erected at this period) Advanced Animal-Paintings. Extensive system of trade. Advanced Sculpture

CIRCA 23.000 B.C.
MAJOR SUBMERGENCE OF EASTERN ATLANTIS

CRO-MAGNON MAN. FRANCE & SPAIN KNOWN AS AURIGNACIAN CULTURE
Painted human bones. Hand Stencilling. Bison Drawings. Mammoth-Drawings. Witchcraft. Mutilation of fingers. Manufacturing of Wampum. Embalming similar to the custom in Peru. Tectiform device on Bison Flanks.

Possibly earliest arrival in America of the Pre-Mound-Building "Indians" during this period. These people practised painting of human bones. Hand-Stencilling, Bison-Drawing, Witchcraft, Mutilation of fingers, Manufacture of Wampum, Tectiform device on Bison Flanks, all of which customs are attributed to the Cro-Magnon Aurignacians.

Suggested Pre-Mound-Building Period

Suggested Pre-Mound-Building Period

WESTERN HEMISPHERE
All ancient peoples of the Americas claim, that their earliest Ancestors "came from the East"

EASTERN HEMISPHERE
All ancient peoples of Europe and Asia Minor claim that their earliest Ancestors "came from the West."

1939

BEGINNING OF ATLANTEAN CIVILIZATION DATE UNKNOWN

ANTILLIA

CANARIES

ATLANTIS

great cultures of pre-historic Egypt and of the ancient civilizations on the American continents did not originate in their respective lands; nor was either one borrowed from the other. All of them were already highly developed when established where their remains now exist: Nineveh, Babylon, Asia Minor, Egypt, Peru, Panama, Guatemala, Mexico.

THE CHART EXPLAINED

At the bottom of the chart on the opposite page is seen a contour suggesting Antillia to the left, and the Canaries to the right. The submerged continent of Atlantis is presumed to be situated between those two points. Up the center of the chart rises a column representing the extent of the Atlantean culture, the beginning of which is unknown. From this presumed Atlantean genealogical column, branch cultures and their suggested successors are indicated. The approximate eras in which the principal events are believed to have occurred are indicated on the column, commencing with 23,000 B. C. and ending shortly before the Christian era.

The evidence shows, and most authorities agree in general, that the information contained in the *captioned* tabluations to the right of the column (commencing with Aurignacian man in Europe, 23,000 B. C.) is highly probable, and that the approximate dates are conservative. Within each right-hand *captioned* tablet is a brief outline of the principal cultural attainment and customs believed to have had their beginning in the respective periods assigned to them. The smaller tablets immediately to the right of the column (without captions) contain opinions by the author, based upon the accumulated data as set forth in this volume.

The extraordinary list of identical comparisons between the cultures of Europe and Asia Minor and the Americas, some of which are indicated on this chart (an abundance of additional comparisons submitted elsewhere herein), formed the foundation for the author's series of hypotheses, as indicated briefly on the left-hand side of the column.

For example, the fact that painted human bones, hand-stencilling, bison-drawing, witchcraft, mutilation of fingers, manufacture of wampum, etc., are customs definitely associated with the Aurignacian culture of Cro-Magnon man in Europe, suggests that, as exactly the same customs prevailed among the earliest civilizations of the Americas, their cultures must have sprung from the same source, and at the same time as the culture of Aurignacian man in Europe. As there is no evidence to prove that any of the cultural activities, indicated on the right-hand side of the column, originated in Europe, Asia Minor, the Americas, or any known land area, the assumption of Atlantis as the center from which they sprang is well worthy of consideration.

After segregating and listing items of culture belonging to the earliest peoples of Europe and Asia Minor and tabulating them according to the period to which it is generally agreed they belong, the author sought the parallel customs and rites among the cultures of the earliest inhabitants of the Americas. The results are seen tabulated under their respective headings on the left-hand side of the column. As will be seen, the various early races of the Americas are assigned cultural beginnings in periods much earlier than is currently given them and considerably at variance with prevailing opinion; criticism, however, should be reserved until the reader has carefully perused all the evidence herewith submitted.

Chapter Thirteen

Comparisons with Maya Art

E have learned that the Mayas in Yucatan and other ancient races in the Americas offer numerous similarities to the art of Egypt and other Old World countries. We have seen how similar the Maya, Toltec, and Aztec pyramids are to the conventionalized, rectangular form of the Egyptian. We have learned that the crude earth mound, associated with the prehistoric Egyptian, Guanches, Antilleans, Pre-Incas, and American Indians, is not in evidence among the works of the Mayas in Yucatan or Central America. And when we turn to the decorative details of the Maya art we discover apparently inexplicable similarities with European and Asiatic cultures.

But also, we find a great dissimilarity of opinion. Channing Arnold and F. J. Frost, in their book *The American Egypt,* conclude that the Maya art originated in Cambodia, Indo-China. T. A. Joyce believes that the Maya culture originated in Northern Guatemala, Central America, although he admits that no evidence exists in that region to indicate its beginning or even its progression. The Mayas sprang, he says, "full-blown from the earth." Sylvanus Morley, likewise, is at a loss to account for their origin, but he believes

that they must have come from Asia via the Behring Straits. Sapper, as quoted by George Oakley Totten in *Maya Architecture,* believes that the original seat of the Maya family was the Chiapas and Guatemala area in Central America. Totten says *"there can be but little doubt* of the American origin of the Maya style."

Among the items listed by Arnold and Frost as evidence of the origin of Maya art in Cambodia are the following:

The "snouted mask" or elephant trunk; the cross-legged figures; the cross; the faces on some of the statues, which they say resemble the features of the people of Cambodia, Siam and

Items which suggest Cambodian origin of Maya art

Fig. A. Winged symbol of protection over doorway at Ocosingo, Central America. (Restored) Fig. B. Winged symbol of Protection over Egyptian door openings (reversed for comparison). An interesting fact is that the American example is upside down when compared with the Egyptian design.

the Malay Peninsula; the turban-headed figures; and the crouching figures acting as footstools for the chief personages.

Regarding the elephant motif

First as to the elephant figures. According to Plato, the elephant was abundantly in evidence in Atlantis. Its use as a motif in design is therefore logical, and the migrating colonists from Atlantis to both hemispheres would naturally have taken that art detail with them. The outstanding bulk of such an animal, and its physical characteristics, were no doubt just as fascinating to the people of Atlantis as they are at present to all the peoples of the earth. What is more natural, then, than that so conspicuous an animal should

offer numerous detail motifs to the artistic Atlanteans? All root art motifs sprang from the natural form, and many have survived throughout the period of historic man.

When we turn to the cross-legged figures sometimes observed in the architectural decorative work of the Mayas, we find little or nothing to warrant a belief that Cambodia or any other Asiatic center was the seat of origin of Maya art, in which such figures in no sense form the basic motif of the design. Asiatic motifs in no way have influenced Maya art generally or even partially. That the details in question bear a similarity with Cambodian and other Asiatic cultures is admitted; but their dissociation with the rest of Mayan ornamental work indicates that they played no definite part in Maya design. It is possible, of course, that the introduction occurred through visiting Asiatics, but even that conjecture appears highly improbable. In all probability the association may be traced back through religious practice to a common source other than the civilizations involved. Buddhism is an outgrowth of Brahmanical (or Hindu) philosophy, which was introduced into India in very remote times. Brahmanism is accredited to the early Aryans who apparently received most of their higher knowledge from a vastly superior race of people. That the Brahmanical philosophy began among peoples who were not highly intellectual and who therefore probably borrowed the fundamentals of their faith, is gathered from the following information.

Adolphe Pictet says: "The Aryans appear to have had no definite idea of a universe of being or of the creation of a universe." J. Talboys Wheeler says that the Aryans borrowed their notions of the creation of the universe from "the materialistic religion of the non-Vedic population." Le Plongeon tells us that the Brahmins gave names to the geometric figures of their borrowed cosmic diagram and "made use of vocables not belonging to their own vernacular." The Aryans were a very domestic people. They were great farmers and earned fame as ploughmen par excellence—in fact some authorities believe the race-name means the "plough."

In consideration of this and following testimony, it is conceivable that the elephant-trunk motif, the elephant form, and the cross-legged figures occasionally discovered amid Maya decorative work, and the more prolific use of these details in Asiatic art, owe their inception to a common source, which source I suggest was the culture of the Atlanteans.

Asiatic similarities admitted

Believe race name of Aryan means "Plough"

Art motifs from a common source

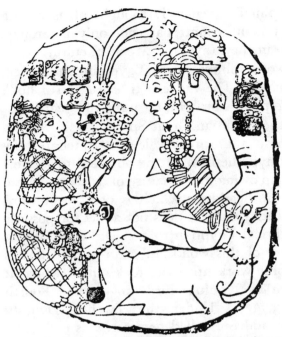

Fig. 1—Compare this double-headed jaguar seat on which sits the cross-legged figure (from Palenque, Yucatan) with the seat in Fig. 2.

Fig. 2—The Hindu god Siva characterized as Ardha Nari, or half woman, half man, standing before a double-headed seat representing the bull and tiger respectively. (From Moor's *Hindu Pantheon*).

Fig. 3—The Hindu goddess Devi, showing leg posture identical with that of Fig. 4. (From Moor's *Hindu Pantheon*).

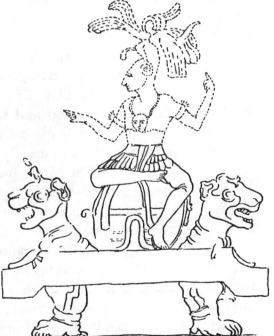

Fig. 4—Compare the leg postures of this bas-relief figure from Casa de Piedra, Palenque, Yucatan, with that of Fig. 3.

The Sphinx is generally thought of as having originated in Egypt, yet we find its counterpart not only in archaic Greek and Indian art but also in the Maya and Mexican cultures.

The Sphinx

The word sphinx is not Egyptian but Greek, the original name being unknown. The modern title is "abu 'l hol", said to be derived from the Egyptian word Hu, meaning the guardian.

That the Egyptian Great Sphinx is exceedingly old there is no question. Some authorities believe it antedates the Great Pyramid, although this hypothesis might be objected to in view of the present impaired condition owing to the nature of its construction. Another objection might be the headdress which is of a form worn only by a Pharaoh, although this argument does not allow for possible changes inspired by early historical Egyptian rulers. Dr. E. A. Wallis Budge says: "The early history of this wonderful man-headed lion is unknown, but it seems that some work upon the rock out of which it was fashioned was undertaken by Khufu (third king in the Fourth Dynasty, beginning B. C. 3,733). Under the Twelfth Dynasty (beginning B. C. 2,466) the headdress, called nemmes, was cut . . ." Here we see that "some work upon the rock" was undertaken, but no evidence exists to show that this was the date of its origin. Available data, however, suggest its existence at least as early as the dawn of historical Egypt.

No data suggesting date of origin

To the Egyptians, the sphinx, which was always a wingless male figure, was androgynous and signified the dual positive and negative, or male and female productive powers. It also symbolized the incarnate God and represented omnipotence. On the other hand, the Greek sphinx, which may be a degenerate form, is a winged woman and a demon, usually connected with death.

The Maya and Egyptian Sphinxes

The Maya and Mexican sphinxes, though much smaller, resemble more the Egyptian type. One, discovered in Yucatan, the head of which is supposedly carved in the likeness of Kukulcan, bears a remarkable similarity to the Great Egyptian Sphinx.

The "Cause of Existence"

Later (Chapter XVI, Quetzalcoatl), we shall learn from Central American mythology that the "Cause of Existence" was the Father and Mother of all Things, frequently symbolized as a dual personality such as Citinatonali, the "Old Ones"; Gucumatz, the male and female. Similarly, we learn from Plato's narrative that the Atlantean god Poseidon was credited with almost identical attributes.

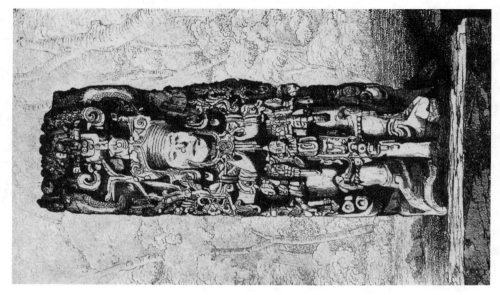

The elaborately carved Maya stele (phallic origin) from Copan, Central America. Drawn by Catherwood.

The Sphinx of Chichen-Itza, Yucatan, symbolizes the Creator. Compare this with its Egyptian counterpart.

Therefore, the so-called Kukulcan sphinx in Maya art may prove to be not of Kukulcan but a symbolic figure of the mythical dual parents of Kukulcan, or Quetzalcoatl as he was known to the Toltecs, namely Citinatonali.

If this and later evidence is tenable, then I offer the opinion that the Great Egyptian Sphinx also symbolizes the dual first parents, the "Old Ones", the "Creators of the Heavens, the Earth and all Living Things." As the origin of the sphinx form is lost in antiquity, and as its presence is seen among the ancient cultures of Egypt, India, Greece, and those of Central America, it points to a mother source foreign to any of these centers. I suggest, therefore, that such source was Atlantis.

Suggest Sphinx from Atlantis

One of the most interesting indications of a very definite link between the Mayas of Yucatan and Central America and the earliest cultures of both hemispheres is the stele. Steles are erect stones, upon

Origin of Phallic and Yonic Symbols

The Sphinx of Egypt symbolized the dual male and female productive powers, the Incarnate God. Scientists state that its age and source are unknown. The symbology of the sphinx is identical in both hemispheres (see American example page opposite). Does evidence exist suggesting Atlantean origin?

many of which elaborately carved hieroglyphs were inscribed. Strictly speaking, the stele does not contribute to architectural designs, but its great prevalence in close juxtaposition to all important structures as well as its actual incorporation in the architectural surroundings, entitles it to be included with other architectural comparisons now presented for discussion.

Merely to offer examples of design and select motifs as evidence of fair comparison with European or Asiatic styles is, in my opinion, not sufficient. In numerous instances, admittedly, no alternative is possible, but when indications of a common origin appear probable, I have endeavored to trace back the testimony in steps reasonably understandable to the average reader.

In my opinion the stelae (steles) of the Mayas, in addition to the strictly architectural comparison value, offer another strong link in the chain of fact and circumstantial evidence which we are weaving to support the theory that Atlantis was the seat not only of Maya learning and of all the earliest cultures of the Americas, but also of the ancient races of Europe and Asia Minor.

Mayas practised Phallus worship

There is apparently no serious objection among scientists to the belief that the stelae of the Maya culture are intimately connected with phallus worship. Further, it is generally agreed that the Maya stele, undoubtedly, is the phallic symbol. There is also no doubt that the Mayas practiced phallus worship. I can personally testify to the fact that there is abundant unquestionable evidence of the phallus cult in Yucatan. A very significant point to remember is that this symbol—either the erect single inscribed stele or the plain stone or menhir—is found in practically every center presumably colonized by emigrants from Atlantis.

Phallic columns in Panama Area

The latest explorations in the Panama area by A. Hyatt Verrill have disclosed similar erect stelae. Verrill reports that: "Many of the phallic columns were from fifteen to twenty feet in length, and from eighteen to thirty inches square. In nearly every case these monoliths had been hand-cut and tooled. Some were square, some rectangular, some octagonal or pentagonal; *some oval and some cylindrical in section* . . . Many too, were elaborately carved in bas-relief." The explorer further reports that after a careful survey he discovered the quarries from which the monoliths were procured *several miles distant* from the site on which they were erected.

The description of the columns found in Panama and the distant location of the quarries from the building site agrees precisely with that of the Maya cult. To construct a column, oval in section, is a particularly difficult operation and requires great skill, so that to find such an unusual architectural motif, irrespective of any other decorative or structural similarity in detail, identical among

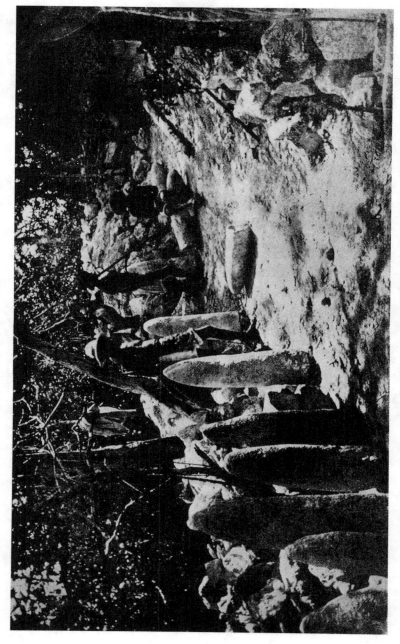

Amid the ruins of Yucatan are scores of both natural form and conventionalized phallus stones. (From a photograph by Le Plongeon.)

the works of both peoples, even to the carving and coloring, surely cannot be classed as mere coincidence or "psychic unity."

When we turn from the Maya and Panamanians and consider the stelae of the Pre-Incas, we again find a great number of identical comparisons of erect monolithic stones, both carved and plain.

In the Eastern Hemisphere there is abundant evidence to show that among all the early races the erect monolithic

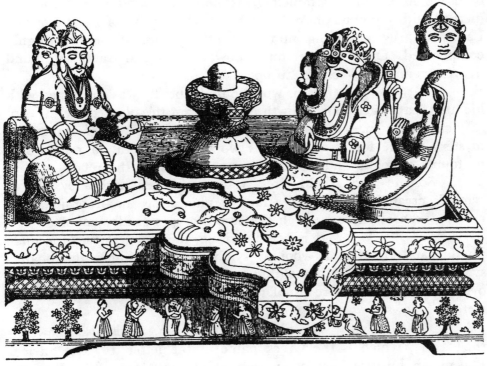

A Hindu portable temple. The figures left to right are Siva, the lingam symbolizing Siva the generative power of Nature, Genesha, and Parvati, wife of Siva. (From Richard Payne Knight's *Worship of Priapus*).

stone also served as a symbol of the productive powers of nature in phallus cult. Priapus rites were practised in Asia, Egypt, and along the European shore of the Mediterranean; precisely where we would expect to find them, if it is true that the practice originated in submerged Atlantis.

Osiris cult

The cult of Osiris bears on this subject. Generally believed to be an importation from Libya to Egypt, in all probability it originated in Atlantis. We have followed in a previous

chapter its apparent progress through one or two of the rites directly associated with it, from the center of the earliest recorded civilizations in Europe—namely the Cro-Magnon man of the Aurignacian Period—across the northern shore of the Mediterranean and into Egypt. We have reviewed the exactly similar rites, practices and customs of Osiris worship on the American continent.

This exceedingly ancient cult was obviously connected in part with the phenomena of growth. In its early period of usage in Egypt it attained great popularity and in consequence merged with the cults of Amen and Ra, which were of Asiatic origin. Later still, by absorbing numerous other cults, it became highly complicated. Of its simpler form, however, decided traces are found in every country in Western Europe.

Phallus and Yoni Symbols

Osiris worship undoubtedly was concerned with life and death rites. The growth of corn from the planted seed was of magical importance. Fecundity in all forms of life was an impressive mystery to the founders of Osiris worship. As with all religions, a profound principle and great reverence supported the tenets of that faith. Solemn and sacred rites were established and a system of symbols created. True to the law of pioneering in all branches of culture, natural forms were chosen as prototypes of all symbols.

It is not surprising, therefore, to find the male phallus and the female yoni as symbols of fecundity: the phallus symbolized by an erect monolithic stone, and the yoni by a circular or oval opening. The more usual forms adopted by the earliest cultists were as follows:

Forms prevalent on both hemispheres

The phallic symbol (Fig. A) is also known as the "Tau", which is the Greek name of the letter T. The ancient Phoenician form is identical with that of the Maya. Fig. B is the erect shaft, column, stele, or menhir. This form is very prevalent in all the areas in both hemispheres where an accumulation of evidence indicates Atlantean colonial centers. Fig. C is the upward pointed triangle or pyramid form, and is also common on both the eastern and western continents.

Figs. D and E represent the yoni or female symbol, both of which are discerned on both sides of the Atlantic Ocean.

The union symbols F, G, H, and J are practically universal throughout Asia, Europe and America, in one form or another. (Incidentally, Fig. K represents what is declared to

be the symbol of Abraham, the Jew. The phallus or Tau sign forms the main structure of the symbol). Religion in its various forms is the foundation of all cultural structures, yet scientists in general have in the past ignored its historical importance. Likewise they have ignored esoteric lore, cults, creeds, mythology, and symbolism as unworthy of consideration. But in the process of tracing back, step by step, the course of any motif, invariably we are led into one or more of these abstract sciences. Sometimes only through their aid is it possible to arrive at the source, there to find historic fact. The earnest investigator will always

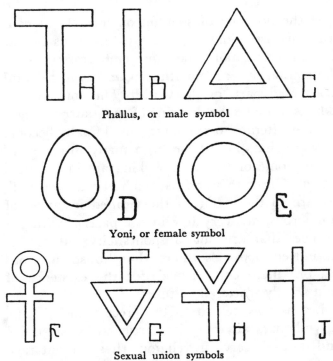

Phallus, or male symbol

Yoni, or female symbol

Sexual union symbols

find many difficulties in his path, but sometimes in fields apparently extraneous to the subject he can hope for and often finds invaluable data which will assist him in his fascinating journey back into the dim past, where so much of what seemed baseless finds ample foundation.

It is natural, therefore, that the abstract sciences and philosophies are subjects of continual speculation which results in wild theories and much heated contention. The phallus cult is an excellent example. Let us, for instance, take a writer's remarks in an article under phallus in the *Encyclopedia Americana*. He says: "It is *impossible* to trace its origin, which probably had a spontaneous origin among different races, *although its source was undoubtedly eastern.*"

Here we have a savant who, first, informs us of the *impossibility* of finding the origin of the phallus cult; second, says

Contradictory statements

227

that the untraceable origin probably had an origin; third, that the latter was spontaneous among different races; and fourth, that this origin or source was *undoubtedly* eastern. What contradictory statements!

If the doctrine of spontaneous origin (as contrasted with the doctrine of dissemination) were to guide us in our present inquiry, we should become more and more embarrassed as we continue, because of the constantly accumulating examples of cultural similarities in widely separated parts of the world. The coincidences would multiply so thickly as to make the doctrine of spontaneous origin less and less tenable until our attempt to uphold it would finally become ridiculous. I am well aware that there have been many instances of independent development. Some of the most striking are in the field of discovery and invention. Grant this and as much else as you will, but you must always return to the fact that the verified instances of spontaneity, however numerous, are very few in comparison with the great multitude of instances that are not of spontaneity but of dissemination. We must, indeed, look elsewhere than to spontaneous origin, "psychic unity", or "mere coincidence" for the existence of identical fundamentals in widely scattered cultures.

Let us now return to the erect monolith, the stele or menhir. If it symbolizes anything in particular, what is it? What function did—and does—it serve in religious rites? What race revered and made use of its common form? What routes, if any, did it follow in the course of its dissemination?

If the worship of Osiris was practised first on the Sacred Hill of Atlantis, then the Sacred Hill was directly associated with the phallus cult, for this cult was included in the worship of Osiris. It is then logical to assume that the phallic symbol—the stele or menhir—followed the trail of the Sacred Hill or Mound, its later form the pyramid, and the other phases of Osiris worship. In seeking for evidence of it we are not disappointed.

But let us first consider the possibility of its introduction into Egypt through Aryan influence, as many authorities suggest.

Some scientists, including Adolphe Pictet, express their belief that the Aryans had no definite idea of a universe of being, or of the creation of a universe. This would indicate that they were by no means an advanced race, and were not qualified to

The doctrine of spontaneous origin as compared with the doctrine of dissemination

The Trail of Phallus Cult

Hindu devotees worshiping Siva in the symbolic form of the lingam.
(From Picart's *Religious Ceremonies*).

introduce such a highly developed conception of the universe as Egypt undoubtedly possessed for thousands of years prior to her historic period. The ancient races of Europe claim Aryan ancestry, but the evidence does not indicate the Aryans were a root race.

Mother tongue conceded

In the *Americana* we learn: "From a multitude of details it has been established that the *original mother tongue* of all these people [the Indo-Iranian group of the Aryan race] was the same." Here is conceded the probability of a mother tongue, obviously earlier than the Aryan. (In view of other data on this point, submitted elsewhere, it is worthy of note that the above statement is followed by another mentioning "the Basques of the Pyrenees" as one of the exceptions. The Basques, it will be remembered, are presumed to be direct descendants of the Cro-Magnon stock that brought from disintegrating Atlantis the cult of Osiris and phallus worship. This, in my opinion, is important as it tends to support the theory that the earliest Basques, or Cro-Magnon stock, and not the Aryans, provided the fundamentals of Egyptian culture).

Following the Aryan trail

In another place, under "Aryan Languages" we read: "It is often said that Sanskrit, spoken by the old Brahmins, is the root of all these classes of tongues. *It is more correct to consider it as a first branch and assume the existence of a root not now accessible to direct investigation.*" Again we see conceded the probability of an earlier, a mother or root tongue.

Also from the same source of information, under the heading "Sanskrit Literature, Development of the Language", we learn that Panini, who lived some time during the fourth century B. C., established a grammar which formed the basis of Sanskrit. We are expressly told that in the second century B. C., the inhabitants of the Âryâvarta, or 'land of the Aryans', that is, the country between the Himalayas and the Vindhya Mountains, were the speakers of the

Others say the word means "the plough"

standard Sanskrit. This does not mean that the area and period above mentioned designate the birthplace and age of the Aryan race. Sanskrit is the language of India which succeeded the Vedic. Where or when the Vedic language began is unknown, although some authorities believe it originated not more than 4,000 B. C.

It must be remembered, however, there is no evidence to show that the word Aryan refers to a race of people. It is stated that *Arya* is a Sanskrit word, the general connotation of which is 'nobility', 'belonging to a good family', and it was used to designate those

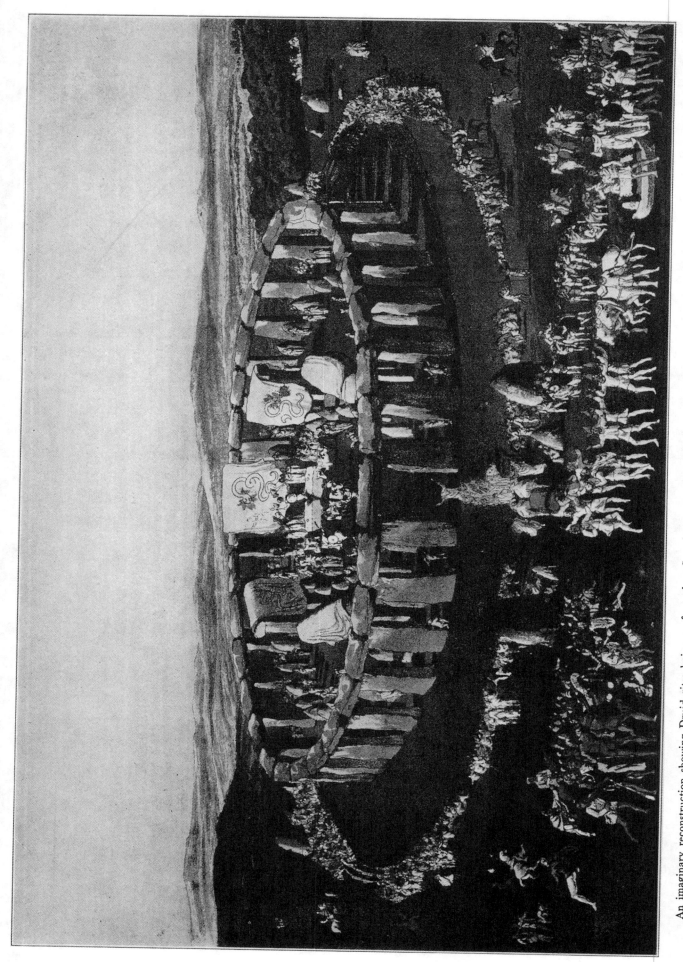

An imaginary reconstruction showing Druid rites being performed at Stonehenge, England. The cult employed both the Tau cross, symbol of the dual generative powers, and the serpent. The serpent was the symbol of Hu, the Druidic Osiris, Creator of all things. The god of the Welsh triad was known as *Hu*, the Mighty. The Central American Quiches' hero-god was *Hu-Nap-Hu*. The Maya supreme god, Creator of all things, was *Hunal-Ku*. Druidism apparently was an outgrowth of Osiris worship, a cult observed in both hemispheres What is the significance?

who invaded India from the northwest. Whence came these people known as Aryans 'from the northwest', has puzzled philologists and anthropologists alike.

As we have seen, Pictet and other authorities believe the Aryans were a people from which sprang the Indo-European, Indo-Iranian group forming the seven nations of the second section of the white or Caucasian race, but infer from their ignorance of a universe of being or creation, that they were a people without much culture. Others believe that Europe and Asia Minor owe their cultures and civilizations to the Aryans.

In view of the evidence it is more logical to presume the Aryans must have had at least well-grounded cultural principles. Otherwise why would their immediate race descendants have possessed cultures obviously borrowed from a common source, and referred to with pride and be conscious of the superiority of a parent race as of the 'nobility', 'belonging to a good family'?

According to Lenormant the Aryans became extinct approximately 3,000 B. C.; there is no evidence, however, to show their culture was not in existence at the reputed period of the last Atlantean cataclysm, or 9,600 B. C. In very early times they invaded India and Persia, but there are no data to indicate they entered Egypt. However, in view of cultural similarities among the ancient races of Europe and Asia Minor, it might be suggested that if Osiris worship and phallus cult, although seen very early among the Egyptians and later common in Europe, did not enter Egypt through the Aryans, it must have been introduced by a culturally advanced race long prior to the Aryan; both, however, possessing the same basic culture, both springing (the former directly, the latter indirectly) from the same root race— the Cro-Magnon. Almost all the ancient races worshipped the yoni and the phallus as appropriate symbols of God's creative powers. Manly Hall in his monumental work *An Encyclopedic Outline of Masonic, Hermetic, Qabbalistic and Rosicrucian Symbolical Philosophy* says: "The Garden of Eden, the Ark, the Gate of the Temple, the

Seeking Phallic Cult origin

The Egyptian Obelisk, a giant monolithic stone shaft, a phallic symbol. (From *Excerpta Hieroglyphica*).

Veil of Mysteries, the *vesica piscis* or oval nimbus, and the Holy Grail are important yonic symbols; the pyramid, the obelisk, the cone, the candle, the tower, the celtic monolith, the spire, the campanile, the May pole, and the Sacred Spear are symbolic of the phallus."

In Harmsworth's *Encyclopedia*, we read that "the commonest representation [of the phallus] appears to have been that of a pillar of wood, such as the *wo-bashira* of Japan, or of stone, as in the Irish instance of St. Olan's stone at Aghabulloge, County Cork . . . Phallic worship is not yet extinct in Japan . . . In India, under the name of *Linga-Puja,* this worship is still practised by the followers of Siva and Vishnu . . . "

Basques of Iberian stock

We have learned that the rite is always associated with the cult of Osiris, and we have followed that religion from the Cro-Magnon colonists on its long trek around the north shore of the Mediterranean and into Egypt.

We now come to the question of Iberian stock and its place in our present discussion.

As with so many ancient civilizations, this one has been the subject of much theorizing. Many historians candidly admit their ignorance, while others have gathered considerable information but have apparently failed to deduce anything from it. However, among the data at the investigator's disposal are a few that serve as important links in the long chain of evidence which the Atlantean-Maya theory is undoubtedly accumulating for itself.

One item, found in the *Encyclopedia Americana* is that "the Iberian language still lives in the Basques."

Iberian ancestors

It is apparently agreed by most historians that the Basques are of Iberian stock, and if we agree that the progenitors of the Iberians were Cro-Magnons who were the first to arrive from Atlantis and settle in Europe, then to the Basques we must turn our attention, in an effort to trace the routes taken by those earliest European colonists to the various countries in which they settled.

Spence (with whom I agree) believes that the Cro-Magnons migrated from disappearing Atlantis in three distinct waves; the first of which was approximately 23,000 B. C., the second approximately 14,000 B. C. and the third approximately 9,600 B. C.

If it is true that the Cro-Magnon invaders brought with them Sacred Mound or pyramid-building, witchcraft, Osiris worship, and the phallus cult, then the stele or menhir will

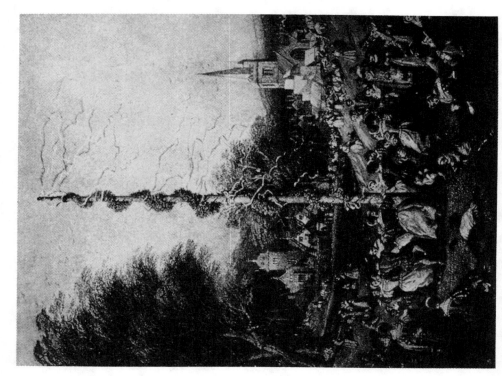

The May-pole Dance, symbolic of phallus worship. This rite suggests the Aurignacian Female cult Witches' Dance. (See ill. p. 108)

The Deluge Totem Pole of Alaska, a form of the phallus symbol. On the breast of the top figure are seen the three human forms which legend says survived the Great Flood.

appear in the majority of centers known to have been colonized by those early wanderers.

That the Atlanteans used the phallic symbol there is no doubt if we are to believe Plato. He tells us that the people of Atlantis engraved their laws upon columns of bronze, or orichalcum; these columns were held to be sacred and were frequently purged of any possible defilement.

To whatever part of Western Europe or North Africa we turn, these indications of Osiris worship are in evidence.

The ancient Druids

There seems to be little doubt that the widespread Druids practised it, only in another form. According to Rhys and other competent authorities, the founders of Druidism were Iberians, and in view of the evidence it seems reasonable to accept the theory that the Iberians were the direct descendants of the Azilian-Tardnoisian Cro-Magnons.

There is some evidence that Druidism is very ancient. In Faber's *Pagan Idolatry* he infers that the Druids believed in books more ancient than the Flood. He says they styled them the "books of Pheryllt" and "the writings of Pridian or Hu." That they were acquainted with the Great Flood is seen in Faber's words: "Ceridwen consults them before she prepares the mysterious cauldron which shadows out the awful catastrophe of the Deluge."

Example of a Roman phallus exvoto, or votive monument, found at Westerwood Fort, Scotland, one of the fortresses on the wall of Antoninus. Figures conspicuously exhibiting the phallus and the yoni, (signifying protection) are found not only among Romans, Greeks, and Egyptians, but among every people who possessed a knowledge of art, from the aborigines of America to the natives of Japan.

The menhirs and dolmens so closely associated with Druidism are apparently the crude parallels of the phallic symbol. It is logical, therefore, to expect such priapic emblems to be connected with the practice of Druidism if, as it appears, that cult was an outgrowth of Osiris worship.

Osiris cult most ancient

Naturally, in the course of widespread migrations covering a long period, and the fusing of other and newer cultures, the different elements of the Osirian cult suffered considerable change. It speaks well for the wisdom and religious principle established by the founders of the ancient faith, that despite the numerous changes made, and the foreign infusions, much of its original ritual and symbolism was

maintained among numerous ancient cultures; more astonishing, however, is the fact that even to this day traces of this archaic cult are to be found in the outstanding religions of the world.

In ancient Egyptian culture, the worship of Osiris was more elaborate than in Europe. Later it merged with the cults of Ra and Amen and became recognized as the outstanding faith of the world.

Chapter Fourteen

The Iberian Link

WE now come to a very important part of our investigations, namely, tracing the movements of the Iberian stock.

The extraordinary mass of corroborative data which lies in this romantic trail of the human race opens an enormous field. It is so voluminous as to be difficult to marshal. In gathering together the material to support the general theory of this work, I originally intended to cover each subject separately and have each complete in itself. Finally I decided to take up separately the items contributing to each subject, because this method enables the reader to follow the items to a conclusion and avoids confusion.

Reason for repetition

By applying this method to the erect monoliths and their origin, the reader has been led through devious yet necessary channels. Repetition occurs not only here but throughout the work, for it is my belief that in an undertaking of this nature repetition is often helpful.

Going back now to the problem of the provenance of the Iberian stock in Europe, we have learned that there is the high probability that their forefathers were the Cro-Magnons of

the Azilian-Tardenoisian invasion, who arrived in the Biscayan area from Atlantis approximately 9,600 B. C.

Throughout this work I have accepted the approximate dates of the first two Cro-Magnon European invasions as suggested by Lewis Spence, namely 23,000 B. C. and 14,000 B. C., respectively. The third, the Azilian-Tardenoisian, I suggest as approximately 9,600 B. C., which date agrees with the period mentioned by Plato. But if the data are worthy of acceptance, dates will not materially change the structure of the general theory. If, on the other hand, later investigation tends to establish a slightly earlier migration from Atlantis to Europe than the Azilian-Tardenoisian, it will merely serve to strengthen my opinion that in addition to the three apparently definite eastern colonizing Cro-Magnon waves, others of a minor nature occurred at frequent intervals in between.

It is also possible that some of the minor European invading waves were voluntary, made after each of the three major Atlantean cataclysms. This conjecture is offered in view of the fact that Plato describes the Atlanteans as an advanced maritime race. It is logical, therefore, to assume that in addition to visiting and trading among the numerous island groups forming the Atlantean Empire, the more daring of those experienced navigators reached the western shores of Europe, and possible America.

Perhaps, too, these early Iberians visited the shore settlements of the Mediterranean and even Egypt. It is to be remembered that at that time, numerous extended colonies had long since been established, directly and indirectly, from the previous major migrations from Atlantis. Those early comers were also of Iberian stock, though of a much earlier period—the Magdalenian Cro-Magnons of the Biscayan area.

To support my belief in additional though minor Atlantean invasions of Europe, I begin by first quoting Donnelly, who says: "The Irish annals tell us that their island was settled *prior to the Flood.*" He continues: "In their oldest legends an account is given of three Spanish fishermen who were driven by contrary winds on the coast of Ireland *before the Deluge.* After these came the Formorians *who were led into the country prior to the Deluge* by the lady Banbha, or Kesair; her maiden name was h'Erni, or Berba; she was accompanied by fifty maidens and three men—Bith, Ladhra and Fintain. Ladhra was their conductor, who was the first buried in

Probably numerous minor migrations occurred

Early invasions of Ireland

Hibernia. The ancient book, the *Cin of Drom-Snechta,* is quoted in the *Book of Ballymote* as authority for this legend."

The Formorians are said to have been a civilized race who possessed "a fleet of sixty ships and a strong army." The Irish *Annals of Clonmacnois* say that the Formorians "were a sept [subdivision of a tribe] descended from the Cham, the son of Noeh, and lived by pyracie and spoile of other nations, and were in those days *very troublesome to the whole world.*"

The Formorians

It will be noted that "Cham, the son of Noeh" sounds very like Shem, son of Noah. In the fifth chapter of the Book of Genesis, three sons of Noah are named, Shem, Ham and Japheth. It is significant that the ancient Irish annals state that the Formorians, who it is claimed invaded Ireland *before the Flood,* were descended from "Cham, the son of Noeh." Further, the Spanish fishermen who settled in Ireland prior to the Deluge imply an Egyptian connection, for as we have learned, the evidence points to the probability that the earliest prehistoric Egyptians were of the Cro-Magnon Magdalenian stock, whose Biscayan ancestors were from Atlantis.

If the above data are of any value, may we surmise that Noah and his family were actually Atlanteans whose frightful Deluge experiences, as chronicled in the Book of Genesis, took place—not in Europe, Asia Minor, or Egypt—but in Atlantis?

Was Noah an Atlantean?

If, as the ancient Irish Annals say, the Formorians, the second invaders of Ireland, were descendants of "Cham", or Shem, son of Noeh, or Noah, and that they arrived on those northern shores "prior to the Deluge", may we assume that the Deluge of Noah's time occurred on the then continent of Atlantis and occasioned the migration to the Biscayan shores of Europe, which migration we know as the Magdalenian Cro-Magnon of approximately 14,000 B. C.?

That the Formorians who so early visited Ireland were not driven there by dire necessity and with little warning, is seen in the statement that they had "a fleet of sixty ships and a strong army." This would seem to indicate that they came from a land not far distant. Authentic deep-sea soundings undertaken by the United States, Great Britain, and Germany reveal a great elevation reaching from a "point on the coast of the British Islands, southwardly to the coast of South America." This elevation rises about 9,000 feet abruptly from the surrounding ocean floor and thence slowly rises until it reaches the surface of the ocean at the Azores, St. Paul's Rocks, Ascension and

The great Atlantic Ocean Plateau

Tristan da Cunha. In other words, if Atlantis once existed, its north-eastern shores were not many nautical miles from the Coast of Ireland and the people we now know as Formorians—who apparently were Iberians, otherwise Atlanteans—who possessed ships, according to Plato's narrative—could easily have navigated the short distance between the northeast part of their country and the coast of Ireland.

Perhaps the above data will serve to strengthen the assumption of numerous minor European invasions—presumably voluntary—by colonists from Atlantis.

The word Africa

The Formorians, according to ancient Irish annals, claimed to have come from Africa. Major Wilford in *Asiatic Researches* says that the word "Africa" comes from *Apar, Aphar, Apara,* or *Aparica,* signifying "the west." The Formorian claim, therefore, would indicate "western" origin. Undoubtedly it did not refer to the American continent, yet was to the *west* of Europe. Does this not again strengthen the theory of a submerged continent in the Atlantic Ocean?

Let us now continue in our endeavor to trace the principal migrations of the Iberians, with the ultimate objective of accounting for the stele, or erect monolith, among the outstanding ancient cultures in the Americas.

A later but still very early invasion of Ireland was led by a chief named Partholan, whose followers are mentioned in Irish annals as "Partholan's people." These settlers in Ireland were from Spain, and arrived in "a fleet of thirty ships, filled with men and women."

Partholan's people

In those days the people of Spain were the Basques, descendants of Europe's earliest settlers the Cro-Magnons, who we assume came from Atlantis. Arguing thus, then, the Basques of Spain are of the original Iberian stock whose ancestors came directly from Atlantis. The *Americana* says: "The Iberian language still lives in the Basque."

We have learned that the Atlanteans, Cro-Magnons, Egyptians, and Basques all were sun worshipers. We have learned also that all these early peoples practised the Osiris cult in one form or another, and further, we have seen that phallus worship was an important part of Osiris worship. There appears, therefore, sufficient evidence to indicate that all these practices originated in submerged Atlantis. With such premise, then, the Iberian trail throughout Europe

and Asia Minor should expose evidence of the phallic symbol—the stele of the Americas and the erect stones of the Eastern Hemisphere.

As Druidism is undoubtedly an outgrowth of Osiris worship, we look for and find the phallic symbol—the erect monolith—wherever those ancient cultists practised their rites. Further, it appears highly probable that the Druids were of Iberian stock.

Druidism an outgrowth of Osiris cult

THE FAMOUS DOLMEN AT BAGNEAUX. BRITTANY. COMPARE THIS WITH THE MEGALITHIC TOMB AT ACORA. PERU.

We have seen that the Iberians, or descendants of Atlantis, in all probability first settled in Ireland when they began to spread north from Spain. From Ireland, they went to England and France. This hypothesis is based on the testimony which indicates that the Druids of Gaul and Britain offered human sacrifice, while those of Ireland did not. This point is interesting as it shows how the cult was originally of an esoteric nature, exalting the Supreme Consciousness and the phenomena of life generation through the medium of the generic symbols. The Atlanteans and all direct colonial migrations from that continent, including the Mayas, believed in the One God, and the immortality of the soul, and *did not* practise human sacrifice, but placed flowers and fruit on their altars. These high religious principles are,

Did not practise human sacrifice

obviously, the result of long cultural progress, and in no civilization were they in greater evidence than among the Mayas.

Frank Stevens, referring to the mysterious monoliths, says: "For the purpose of our inquiry, we must look to all the Mediterranean coast, whence came one branch of the Neolithic (later stone-age) race . . . Secondly, we must note the Alpine race of Central Europe . . . "

Druidism, sun worship and erect monoliths are therefore invariable associated with the Iberian race, which sprang from the Cro-Magnon stock, and still earlier, the Atlanteans. In Egypt, Phoenicia, Ireland, England, France, Peru, Panama, Central America, and wherever evidence exists of those whom I believe to be colonists direct from Atlantis, or descendants of the original immigrants, we find the erect stone, or wood, menhir, the stele, or some variation of the symbol which personifies the male generative power, Priapus.

That the symbol was always of paramount importance, no matter what degenerate form the rites had taken, is seen in the great care the builders took in selecting suitable stones for it. In most cases, considerable mystery surrounds the location of their natural bed. In numerous instances the stones are classed as "foreign", the local geological structure offering no evidence of their source.

That almost inconceivable engineering skill was exerted in quarrying, portaging, and erecting these sacred emblems is very evident. That such knowledge and skill were the work of barbarians and savages is an ignorant statement, made in utter disregard of the preponderance of evidence to the contrary.

Discussing the probable centers from which most of the so-called "foreign stones" were quarried, most theorists admit the impossibility of local origin. Some believe that they were procured from lands far remote from the site of erection. In almost all instances, however, the quarries were undoubtedly far from the building location. The monoliths forming Stonehenge near Salisbury, England, for instance, are presumed to have been quarried at least 180 miles away. As an instance of the immensity of some of the monoliths, one (now fallen) is still to be seen at Locmariaquer, near Carnac, a village overlooking the sheltered waters of the Bay of Quiberon in Brittany. This gigantic single stone, now broken into four pieces, originally measured sixty-seven feet in height, and weighed in the neighborhood of 342 tons. What a stupendous undertaking, first to

Gigantic monoliths

quarry, then to transport and erect such a monster stone! To hoist and lower onto the tops of those immense upright menhirs, the monolithic horizontal stone, also of great size, thus forming the dolmen, is a task beyond comprehension, unless we concede to those builders a knowledge of engineering acquired from a mother source representing a very high civilization. To assume that the vast cromlechs, or carefully planned groups of erect stones and lintels, are the only examples of building construction known to the people who built them, is un-

MEGALITHIC TOMB AT ACORA, PERU.
REFERRING TO THE ABOVE TYPE OF PREHISTORIC SOUTH AMERICAN TOMBS THE MARQUIS DE NADAILLAC SAYS: "—THE BODIES WERE PLACED UNDER MEGALITHIC STONES REMINDING US OF THE DOLMENS AND CROMLECHS OF EUROPE."

reasonable. Other expressions of advanced engineering and the building arts among those obviously intelligent races undoubtedly once existed, but time and destructive conquerors have taken their toll and little or nothing remains to substantiate the belief, except the obvious advanced skill displayed in erecting the structures now existing. Frequently, however, we find examples of structures erected by conquering races from the stones which comprised the buildings of the vanquished, and undoubtedly much remains to be discovered. Possibly the reason why so many of the stones forming the cromlechs remain is that the succeeding peoples were incapable of moving them.

Another factor in support of my belief that the stelae of the Mayas, and of other ancient races in the Americas, are

Unreasonable to assume cromlechs only works

of Atlantean origin, is the prevalence of the cross symbol among all the principal races which we have grouped as either direct colonists from Atlantis, or their descendants.

The cross symbol, which in my belief, is undeniably directly connected with Osiris worship and its associated rites, has taken many forms. If we study some of these we can trace apparent steps in its progression. Among these is the so-called Tau sign ⊤ *The Cross* supposedly of Phoenician origin; the Egyptian Tau ☥ ; the Celtic cross ✛ ; the Greek cross ✚ ; the Christian cross ✝ ; and the swastika 卍 .

All these symbols, and their many diversified forms, according to the accumulated evidence, related to phallus worship. A careful study and comparison of ancient symbols indicates quite conclusively that the Tau sign ⊤ is the lingam symbol. The lingam symbol has also other forms, such as ⫦ | △ ⊥

⇧ to note the more prevalent. Briefly, it represents the male or generative power of nature. The roundlet or oval placed above this sign is the yoni, or symbol of female nature productivity. The combined symbols, according to Egyptian mythology, represented *ankh,*

Symbols of generative organs the emblem of *ka,* the spiritual double of man, ☥ . The Latin cross ✚ is but another form of the Egyptian Tau.

The Greek cross ✚ and the Maltese ✠

are definitely associated with the swastika. We learn that these and many other symbol forms of the generative organs are directly connected with the Osiris cult, and therefore I offer the suggestion that they originated in Atlantis.

When we turn to the Americas for a confirmation, we have little difficulty. Among the Mayas of Yucatan and

Central America we find not only the Tau symbol in sculpture

but often forming openings in the face of the buildings. In Palenque, in the Temple of the Sun there was until recently an exquisitely carved foliated cross. The American Indian, and all branches of the human race which I have included in the various migrations from Atlantis, employed the symbols of generative power in one or more of the recognized forms.

Symbols universal

Numerous works have been compiled on the subject of the swastika and its various cross forms, and many theories as to its origin have been offered, but so far nothing logical.

In an exhaustive work on the subject, written by Thomas Wilson and issued by the Smithsonian Institution, the author in speaking of the swastika says: "No conclusion is attempted as to the time or place of origin, or the primitive meaning of the swastika, because these are considered to be lost in antiquity."

Dr. Daniel G. Brinton, however, believed that the swastika was related to the cross. It is interesting to note that Brinton is one of the few writers of authority who attributes this strange symbol to the Neolithic period and Iberian remains in Europe.

We have seen, therefore, that the stelae of the Americas, the erect monoliths of Europe and elsewhere, the cross, and the swastika are apparently directly associated with the various forms of the symbol of generative powers; and that these, in turn, are connected with the Osiris cult. Unquestionably, they are of a common origin, and in consideration of all the evidence, such as is supplied by the "sacred hills", earth-mounds, and pyramids, combined with the corroborative testimony from numerous other sources, it appears logical to adjudicate Atlantis as the mother country from which they sprang.

Origin of the swastika

The next detail to be considered under the general heading of comparisons between Maya architecture and the art of the ancient races of the Eastern Hemisphere is the arch.

It is frequently stated by archeologists that the Mayas did not understand the principles of the arch, hence their

trabeated, or flat-beam, type of architecture. It is likewise asserted that those people did not understand the uses of the wheel. I disagree with both of these opinions for I have seen considerable evidence to the contrary. On one occasion, while in Uxmal, Yucatan, I discovered a cylinder of granite (opposite page). Whence it came I cannot say. This unusually cut stone is squared toward one end, evidently prepared for insertion into a wall; the other end is perfectly circular. In the center of the circular end is a conical hub; radiating from this to a felloeless rim are numerous flutings. The flutings in section are not a perfect segment of a circle, but egg-shaped. The complete design bears the identical form of a wheel.

The Arch and the Wheel

That an advanced race of people, skilled in mechanics, such as the Mayas, were ignorant of the wheel appears very illogical. As the mechanics of the wheel define the principle of the arch, the fundamentals are analogous. As we shall see, it is logical to assume that the Mayas were not ignorant of the principles of the arch.

Many natural laws are at man's disposal, and may be utilized to his benefit if he but use them judiciously. Fire and water, two of nature's most powerful elements, make good servants but poor masters. Electrical energy, likewise, is an excellent servant. Man has made wise use of all these forces, but the potential energy of the wheel is not to be so easily gauged. Since the birth of our present mechanical age, the wheel has soared into a position which makes it indispensable among the affairs of man. This is the age of the roaring, grinding, screaming rotor. From a single, silent, spinning unit, its use has so developed that now thousands, millions, of wheels in raucous whirling are necessary to satisfy the demands of so-called progress. The wheel has increased man's pleasures and added to his woes. From the silent-running watch to the monster battleship, from the complicated printing presses to the ditch-diggers, the mighty cranes, the intricate linotype, the thunderous locomotive, the swift automobile and the speedy aeroplane—all are ambiguously termed time and labor-saving devices. But is there a safe and sane limit as to the amount of service the wheel shall render man? Is there a margin, beyond which the wheel assumes mastership?

Potential energy of wheel unknown

Who invented the wheel?

This wheel! Emblem of mutability—veritable wheel of life—who invented it? Who in a thinking—or thoughtless—moment started this mighty *rota* on its thundering course? Are we,

This cylindrically ended stone was discovered by the author at Uxmal, Yucatan. It is of granite, cut perfectly true and circular, and having a domical-shaped hub from which radiate numerous flutings. If the Mayas were ignorant of the principles of the wheel, as most scientists assert (although the evidence points to the contrary), would not the above form alone suggest its possibilities? (Photograph by the author)

Arch. Casa de las Monjas, Uxmal, Yucatan.

Doorway. Inca Fort, Cuzco, Peru.

the Frankensteins, being slowly consumed by the monsters we have created? Are we to be likened to the man in Tibetan mythology who was bound to the wheel of life—slaves to the wheel—or its victims? Must cultural progress depend upon the wheel? Who knows?

Strangely enough, all those races which used the wheel experienced the gamut of human emotions and at the same time sought fruitlessly to establish peace. By contrast, we learn of one nation which refrained from its use, and that one is credited with having maintained centuries of peace. I refer to the ancient Mayas. Is there any particular significance to be attached to this fact?

The Mayas and the wheel

I offer the hypothesis that the ancient Mayas, long prior to leaving their empire-home of Atlantis, learned through painful experience the potential mastership of the wheel, and decided against it; that, upon their escape from sinking Atlantis and their hurried arrival in Central America, their wise leaders forbade its use in any form. Its prohibition, if such it were, probably created an important condition; namely, a continuous labor program, thereby preventing unrest among the working class, and in fact all classes; this in turn maintained a status in which was possible an unexcelled period of peace.

Bearing out this is an interesting superstition among the present-day Mayas, which I ran across while in Yucatan. The superstition is founded upon a very ancient myth and is well worth repeating.

The occasion for the recital was not lacking in a certain amount of humor. A Maya was chaining the wheels of his antiquated bicycle to the floor of a hut in the ancient ruined city of Palenque. My friend, who owns thousands of acres surrounding that historic spot, inquired the reason. The answer, interpreted, amounted to this: the wheel, if left free, was liable to roll and cause none could say how much damage. This unusual response led to a request for further explanation. The reciting of the ancient myth was the result. Summed up, it is as follows:

A Maya myth

God, the All-Seeing, All-Knowing Creator of All Things, was one day seated on a raised dais, idly looking into the vast expanse of void that surrounded Him. He reached out and grasped a handful of earth and clay. Unthinkingly, He made pellets of the mixture and listlessly cast them from Him into space. Soon there were untold numbers of these pellets, twisting and whirling before

the eyes of God. They spun around each other in endless revolving motion, in all directions. And, as God casually watched the strange convolutions of these pellets, He became conscious that they were rapidly becoming greater in size, and their speed was increasing at an alarming rate.

Seeing this, God in His infinite wisdom decided that if He was to retain control of those irresponsible rotating bodies, He must establish laws to regulate them. These laws were instantly put into operation, and the star constellations, including this earth, conforming to the laws came into order and harmony. And God decided that, henceforth, no circular form should be created unless it obeyed those laws.

None should create circular form

Later, God made man and gave him the earth. He likewise gave man certain laws which must be obeyed. Among them was one that none should create the circular form, for fear that man, lacking God's wisdom, would not be able to control its inevitable motion, which meant unlimited and possibly uncontrollable power.

This legend came into my possession almost two years after the publication of my article *The Ancient Mayas and the Wheel,* and also my book *The Ancient Mayas,* in both of which I offered the suggestion that those cultured people were well acquainted with the wheel.

Incidentally, I might remind the reader that the Maya symbol for God, the Creator of All Things, is the circle. It is the symbol for power, force, and energy without limit.

Therefore we may well ask ourselves whether we are as wise in this matter as were the Maya. Would the present chaotic condition throughout the world have been lessened by a timely restriction in the use of the wheel and its collaborating parts?

Origin of the Maya Arch

Bearing in mind the above comments on the wheel, we will now seek to learn whether the Mayas understood the principle of the true arch.

In the northern portion of the Maya area we see numerous examples of the inclined jambs. In some instances the jambs are perfectly straight; in others they are curved convexly (with reference to the opening) toward the top; a third type is curved concavely and gives the appearance of an arch on the point of taking true form.

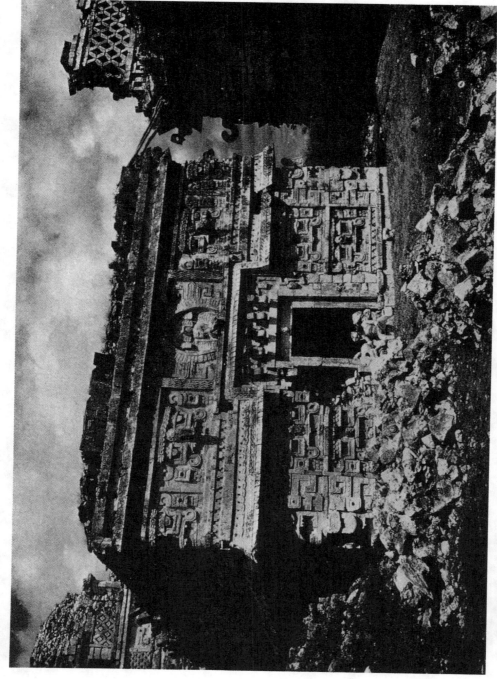

The Annex, Casa de las Monjas, Chichen-Itza, Yucatan. Undoubtedly Maya wall decoration is symbolic. The over-door panel seen above might well symbolize the Orphic Egg of the Supreme Being surrounded by the First Waters. The over-door panel seen above might well symbolize the Orphic Egg of the Supreme Being surrounded by the First Waters. In the Brahmin *Manava-Dharma-Sastra*, compiled about 1300 B. C., we read: "The Supreme Spirit having resolved to cause to come forth from its own corporeal substance the divers creations, first produced the waters, and in them deposited a productive seed. This germ became an egg . . . and in this egg was reproduced the Supreme Being." Does the zigzag pattern (water symbol) bordering the panel and terminating above in serpent heads symbolize Can, the universal protector of saviors, emerging from the First Waters? Is the comparison significant? (Photograph by the author)

Figures A, B, and C illustrate the usual forms of the tapered jamb opening, A and B have a straight taper, and C a slightly convex one. Fig. D, although strongly curved, in no way indicates true arch principles. The method of constructing all the above types is similar, and consists of a series of overhanging layers of

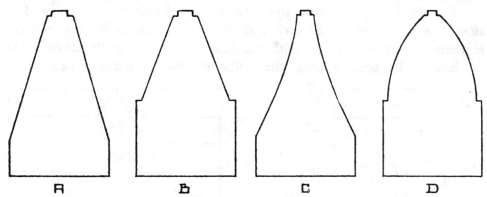

Method of construction

cut stones extending upward until a single stone can bridge the two inclining walls. Not only was this system employed in the bridging of openings, but rooms were ceiled in like manner. The overlapping stones, or corbels, were held in place by a concrete matrix and the superimposed load. That the method of construction is based on sound

Maya and Greek construction similarities

engineering principles is shown by the fact of its long unchanged existence, despite the numerous earthquake disturbances during the life of the structure. (In my travelogue-adventure book, *The Ancient Mayas,* I submit reasons for tapering walls and use of small stones).

Two methods employed in constructing the apexes are seen above in Figs. E and F.

A variance of this procedure, however, is seen in Fig. G, where no ceiling is provided, the inclined walls meeting at

an acute angle. In this example we see precisely the same method employed as is found in the arch at the Treasure House of Atreus at Mycenae, one of the oldest buildings in Greece (see Fig. H).

Among other similar examples in Mycenae is the Gate of the Lions.

In support of my belief that the Mayas understood the principles of the arch I shall offer first the following indirect evidence. Almost identical with the Maya method of arch construction is that to be seen among the ruins of the Etruscan culture. In

The Etruscans

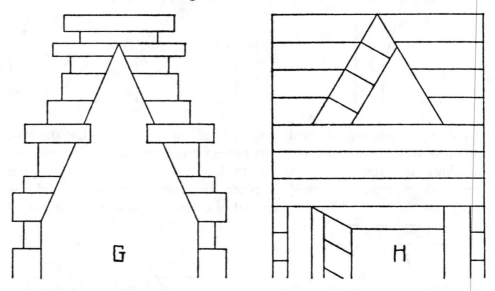

Rawlinson's *Origin of Nations* we read: "Etruscan vaults are of two kinds. The more curious and *probably the most ancient* are false arches, *formed of horizontal courses of stone, each a little overlapping the other and carried on until the aperture at the top could be closed by a single superincumbent slab.* Such is the construction of the Regulini-Galassi vault, at Cervetere, the ancient Caere."

The Etruscans occupied territory that approximately corresponds with modern Tuscany. Etrusci was the name used by the Romans "as the appellation of the people from an early period . . . *To what race the Etruscans belonged is unknown and our ignorance is equally great with regard to their language.*" (*Encyclopedia Americana*). Professor Ridgeway believes that they were of the same stock as the primitive inhabitants of Greece, the Aegean Islands, and in fact most of the Mediterranean coasts, all of whom he calls

Pelasgians. Although a number of Etruscan inscriptions have been discovered they have never been deciphered.

Here then we learn of a highly artistic people whose origin is lost in the mist of antiquity. But the most interesting part of the information is Ridgeway's belief that the Etruscans were of the same stock at the Pelasgians. If we apply knowledge from numerous sources here submitted, I believe we shall cast a little light on the origin of the Etruscans.

Herodotus says that the Pelasgians dwelt first in the isle of Samothrace, in the Aegean Sea. This island is about forty miles northwest of the entrance to the Dardanelles. In the northern part of the island, in the years 1873-5, were discovered very ancient ruins consisting of *cyclopean walls* and a *circular temple.*

Of Samothracian culture little is known, but the island was renowned among the ancients as the seat of worship of the Cabiri. Some authorities do not state definitely that the Samothracians were Pelasgians, but they do not hesitate to assign to the Pelasgians the source from which the Samothracians derived the rites and mysteries of Cabiri worship.

Sanchuniathon, or Sanconiathon, the alleged author of a history of Phoenicia and Egypt entitled *Phoinikika,* is described by Philo, of the second century B. C., as a fellow countryman of his, a Phoenician. The *Phoinikika* was probably made public by Philo, but considerable controversy has arisen among critics as to the author. Nevertheless a fragment of the work is preserved and according to Renan, whether or not it was the work of Sanchuniathon, it was in fact compiled, and a free Greek translation was made by Plato. I feel safe, therefore, in quoting from it.

From the surviving fragment we learn that Cabiri worship was of Carthaginian origin and was associated with the cult of Osiris. Osiris worship, as we have seen, was supreme in Egypt, and was ultimately derived from the Sacred-Mound rites of Atlantis. The fragment further informs us that the Cabiri were the inventors of ships and of all the arts including building and writing.

Now, the Etruscans were known as great agriculturists, great builders—builders of cyclopean walls. They were known by the earliest writers of history as a race of antiquity, highly civilized and cultured, possessing a language having no affiliation with any then known tongue, a people who erected arches with overlapping

Cabiri Worship

Cabiri worship associated with Osiris cult

249

courses, crowned with a single stone. Authorities have decided that they were undoubtedly members of the Pelasgian stock, and that they worshiped according to the rites of Cabiri cult, a definitely associated branch of Osiris worship, which is presumably of Atlantean origin.

Is it not possible, then, that the Etruscans were either directly or not very remotely connected with the last great Cro-Magnon emigrant wave from submerged Atlantis, known as the Azilian-Tardenoisians of the Biscayan area?

Question!

Evidence has tended to substantiate the conjecture that the Azilian-Tardenoisians were the inventors of ships and writing; that they, too, were great builders and agriculturists; that they formed the third major wave of Cro-Magnons to enter Europe—aparently from Atlantis—bringing with them the cult of Osiris, from which Cabiri worship sprang; and further, that they were the progenitors of the Iberian stock which spread over the northern Mediterranean shores, into Egypt and northern Africa.

In view of the fact that the authorities have candidly admitted their total ignorance as to the age and origin of Etruscan culture, although all concede its great antiquity, may we not logically assign to the Etruscans a place on the Atlantean family tree?

If so, we can see very definite reasons for assuming Atlantis as the common source of the peculiarly constructed pointed arches of the Mayas, the Etruscans, and the prehistoric Greeks or Mycenæans.

I have great faith in the science of architecture as a valuable aid in any attempt to solve the great Maya-culture riddle and I have wandered somewhat extensively into the bypaths of architectural detail-comparison. I believe this particular field of research has not yet been fully investigated, therefore my observations may prove helpful to my hypothesis and argument.

Atlantis source of pointed arch

For the time being, then, we shall assume that the Etruscan evidence is sufficient, first, to form another link in our chain connecting Maya culture and others on both hemispheres, with Atlantis; and second, to suggest the seat of the arch origin. Let us now return to our study of the Maya so-called arches, in an effort to add still another link.

It must be remembered that the Grecian types of pointed arch construction were executed in the Mycenæan period, a period which, according to some historians, extends from 2,000 B. C. to

at least 800 B. C. The findings of more recent explorations in early Greek areas may show that a similar type of arch construction was prevalent during the Minoan period, which dates back to 3,000 B. C.

The Mycenæan civilization extended over the islands of the Ægean Sea, the Troad in Asia Minor, Crete, and as many assert, even penetrated parts of Sicily and Italy. Herein we see what is possibly another link with Atlantis.

The early history of Crete is apparently lost in obscurity but its culture is roughly estimated to have been in evidence approximately 3,500 B. C. That the culture sprang either directly or indirectly from Atlantis, appears highly probable. Elsewhere, I have submitted evidence concerning the Osiris cult and bull worship and their suggested origin in Atlantis. In Crete we find the identical cult-practices. Among other similarities, we learn that the palace of Knossos was erected upon a level plain surrounded by mountains, as was the city of Atlantis in Plato's description.

Mycenaean Culture

We have seen that the early Cretans were probably of Iberian stock (or Atlanteans). The Cretans worshiped a goddess who was associated with the serpent. This goddess, even to dress-details, is almost identical with the Toltec goddess Coatlicue. The bull-headed god, the Minotaur, figures prominently as the deity of Cretan legends; bull-wrestling and sacrifice likewise were customs among those people. As no evidence exists to indicate that Cretan culture originated in Crete, it is obvious that it must have begun elsewhere. It is possible that it came directly from some remaining fragment of Atlantis, approximately 3,500 B. C., or arrived from some Atlantean colony in the Mediterranean. In either case, migration in those days was not a difficult feat, as ships had been traversing the Mediterranean for 1,500 years prior to the assumed period of civilization's advent into Crete, but the downfall of the Cretan civilization saw the rise of Greek culture.

Probable origin of Cretans

Of Mycenæan architecture we have many examples which again add to the claim of Atlantean origin. It is noteworthy that the method of building construction was of cyclopean walling, that is, walls composed of huge blocks of stone accurately fitted without the use of mortar. This method of construction is similar to that of the Pre-Incas in South America. In the Harmsworth *Encyclopedia* we read: "The Mycenæan race (if the term may be used) was as truly Greek as the Arcadians and Athenians. Their

civilization reached its height, not in Attica, but in Argolis, Crete, and the Troad. Hence it may be argued that the later civilization of Greece was only a development or a renaissance of the Mycenæan. The language was Greek in an earlier form."

Greek culture based on Mycenaean

If, then, we accept the above evidence, we can reason that Greek culture was based upon the Mycenæan, and by virtue of the similarities of culture point to an Atlantean origin. Therefore, the principles of the architecture of the Greeks and the Mayas, among the more important ancient races, sprang from the great culture established by the civilization which formed the Atlantean Empire.

Is it unreasonable, then, to assert that the so-called pointed arch of Maya art was not borrowed from Europe or Asia, that it in no way indicates a Maya migration from the Eastern Hemisphere, but that it is a part of the art culture originated by the Mother Empire of Atlantis and

The Maya trefoil Arch

was carried by the various migrating waves in their hurried exodus to Europe, Asia, and the Americas?

Returning to the Western Hemisphere we find a very unusual arch form at Palenque in the Chiapas, Central America, known as the trefoil arch (Fig. J). Here we see a marked resemblance to the Arabian trefoil arch but the unique method of construction has its counterpart in the inclined-jamb opening which we have already traced to Mycenæan art, and thence back to a suggested Atlantean origin. It is of very early origin, as is apparent from a study of the method of construction. That the Mayas borrowed the trefoil motif from Arabian art appears reasonable; but when we analyze Arabian art motifs perhaps we are able to follow a more logical line of reasoning.

A line of art descent

Arabian art was fundamentally of Persian origin. The Persian culture obviously perpetuated the art motifs of its predecessors, the Akkads. As we have seen, the Akkads were in all probability of Atlantean descent. In Plato's narrative we learn that the Atlanteans were apparently well acquainted with the principles of the arch as well as with the wheel. Plato speaks of numerous vast spans

in bridge construction under which passed ships of considerable size, (which, in my opinion, might suggest the use of the arch). He also makes reference to chariots, obviously possessing wheels. But apparently the Atlantean type of architecture was prevalently that which we know as trabeated or flat beam construction.

An Akkadian Bakery at least 4,500 years old "Identical with those used now".

Sketch of a Maya hut in Yucatan, from a stone wall, built almost 2,000 years ago "identical with those used now". Showing how persistently the principles of architectural planning and design maintain over long periods of time, and how the immutable form was perpetuated by proceeding on the 'course of tradition' in spite of novel conditions.

We see, therefore, that cyclopean wall construction was common to the Cretans, Pre-Incas, and others whom we are considering as colonists from Atlantis. The archless type of architecture prevailed among the Egyptians, Cretans, Grecians, early Panamanians, Pre-Incas and the Mayas. If we select the Egyptian architecture as an example, we find that despite the introduction of planning and decorative detail improvement, the same fundamental type of construction prevailed throughout their historical period. As Bannister F. Fletcher says: "Egyptian art

Course of tradition A psychological aspect

proceeded on an uninterrupted line *or course of tradition* and when necessity dictated a change in the methods of construction, or in the materials, *the immutable form was not thereby affected but was perpetuated in spite of novel conditions.*"

As with the Egyptians, so it was with all other civilizations which I am including in the Atlantean family of art. The arch, after it was introduced into the mass architectural form, never occupied a permanent place; had it done so, it is obvious that the trabeated architectural styles would have undergone a complete metamorphosis. The exclusion of the arch, though well known to them, assumes a psychological aspect in that its acceptance would have disturbed their well established "course of tradition."

The Circle Symbol

The later races of the Mediterranean shores could easily have taken and developed the isolated examples of the arch in trefoil form from the art of their ancient neighbors, as they were without a culture of their own and therefore lacked the ties of tradition.

The trefoil arch has, so far, appeared in the Western Hemisphere only among the early works of the Mayas in Central America. It is possible that its unique circle-component form is of symbolic significance, and therefore its use was restricted to buildings designed for specific religious purposes.

The circle in Maya symbolism, as previously stated, signified the Eternal One Being, the Boundless, Infinite, Un-Knowable. The circle, a perfect form, is sacred. In Maya belief, only God-the-Creator of all things could make a circle—that is, if He so wished. But as nothing in nature is perfectly circular it was therefore disrespectful for man to attempt what God had decided not to do. The circle, as it applies to the wheel is, according to the Mayan legend, of such sacred significance that its use was forbidden. The trefoil arch is formed out of the overlapping circumferences of three perfect circles. Probably among the ancient races, this form symbolized the Trinity of Forces in the Deity.

Probably symbolic

The trefoil arch of the Mayas, therefore, may possibly be a religious symbol, as is the tau ⊤ opening; it certainly could not have been borrowed from the Arabian or Romanesque art, as the structure in Palenque was erected far antedating those cultures. There is no record of any art culture among the ancient races of Europe and Asia Minor prior to the early Maya period in Central America, in which the trefoil arch motif existed. If not brought by the Mayas from the erstwhile Empire of Atlantis, then whence did it come?

CHART·SHOWING·A·FEW·IMPORTANT·PARALLELS·BETWEEN·THE·CULTURES·OF·ANCIENT·PEOPLES

CORRELATION AND COMMENTS ~ BY ~ ROBERT·B·STACY-JUDD·A·I·A·

SUBJECT	ATLANTIS according to Plato	CRO-MAGNON MAN — AURIGNA-CIAN	MAGDA-LENIAN	AZILIAN-TARDEN-OISIAN	AKKADS First in Valley of the Euphrates	AKKADS Second Invasion	EARLIEST CANARY ISLAND-ERS	EARLIEST EGYPTIAN (Not Negroes)	HISTORICAL EGYPT	EARLIEST OR PRE-MOUND-BUILDING AMER-INDIAN	MOUND-BUILDING AMERICAN INDIAN	MOUND-BUILDING PRE-INCAS	CLASSIC PRE-INCAS	CLASSIC PANAMAN-IANS	ANTIL-LEANS	TOLTECS	AZTECS	MAYAS
SUGGESTED APPROX. BEGINNING OF THE VARIOUS CULTURES	Prior to 23000 B.C. ended Hellas	At least 23000 B.C.	14000 B.C.	9600 B.C.	14000 B.C.	9600 B.C.	14000 B.C.	14000 B.C.	4500 B.C.	23000 B.C.	14000 B.C.	14000 B.C.	9600 B.C.	9600 B.C.	14000 B.C.	9600 B.C.	9600 B.C.	200 B.C. to 500 B.C.
CONTINENTS		←——— EUROPE AND ASIA-MINOR ———→								←——— THE AMERICAS ———→								
1 SACRED HILL	X O				X					X	X		X	X	X	X		X
2 OSIRIS CULT	O		X		X	X	X	X	X	□	X	□	□	□	□	X	X	X
3 ONE GOD	O			X		X	□	X	X		X		X			X	X	X
4 IMMORTALITY OF THE SOUL	O						X	X	X		X	□		X	X	□	X	X
5 SUN WORSHIP	X O		□	□	□	X	□	X	X	X	□	X	X	X	□	X	X	X
6 WITCHCRAFT	O	X	□	Spread throughout Europe & Asia-Minor. Sport of Bullfighting is outgrowth					X	X	X	Outgrowth of Bull-worship is seen in present-day bull fights & Rodeos						
7 BULL WORSHIP	X O	X	Observed in Europe & Asia-Minor						X		X		X	X		□	X	□
8 TWIN CULT	O								X		X						X	
9 PHALLUS WORSHIP	O	Almost all ancient races worshipped the Yoni & Phallus as symbols of God's creative powers							X		X						X	
10 ANCESTOR WORSHIP		Possibly originated after the second major cataclysm, 14000 B.C.						X	X		X				X		X	X
11 CABIRA CULT	O		X	□	X	X	X	X		□	X	X						
12 SIMPLE MUMMIFICATION	O	X	□	□	□	X	X	X	X	X	X		X		X			
13 ADVANCED MUMMIFICATION	O	Mummification among the Aztecs & the Egyptians was similar					X	□	X	X	X						X	X
14 PAINTING OF BONES	O	X					X			X	X	X		X			X	X
15 SARCOPHAGI									X								X	
16 CANOPIC JARS									X								X	
17 BOOK OF THE DEAD									X								X	
18 STREET OF THE DEAD									X								X	
19 MONOLITHIC STONES	O	Erect monolithic stones were symbols of nature's productive powers in Asia, Egypt, Europe & the Americas.							X		X	X	X			□	X	X
20 SERPENT GODS		The serpent was symbolic among all the ancient peoples of both hemispheres.							X		X		X				X	X
21 GODDESS OF FERTILITY	O	Evidence exists in Europe showing Mother Goddess rites persisted from remote age.							X		X		X				X	X
22 INCENSE BURNING		This custom prevailed among most of the early races of Europe & Asia Minor, and persists today.							X		X		X				X	X
23 MARK OF THE HAND	O	X	Custom prevalent among present-day Arabs. Was also common in India.							X	X	X					X	X
24 MUTILATION OF FINGERS		X	An extraordinary custom which I believe must be assigned to the first people of both hemispheres. (This custom also prevailed among the Scythians, Turks, French, Huns under Attila, etc.)				X				X				X		X	
25 HEAD FLATTENING	O		X	□							X		X		X			
26 CARRYING CHILDREN		Custom of the mother carrying the child on her back					X				X							
27 HEAD BORING			X		X						X							
28 MANUFACTURE OF WAMPUM	O	X								X	X					X	X	X
29 BOW & ARROW	X O	X	□	□	X		□	X	X		X		X	□		X	X	X
30 ASTROLOGY		known to all ancient races on both hemispheres		□	X	X		X	X		X		X			X	X	X
31 STORY OF THE FLOOD					X	X	X	X	X		X		X			X	X	X
32 TOWER OF BABEL LEGEND						X					X		X				X	X
33 ANCESTORS FROM THE EAST		All ancient races of the Americas claim that their earliest ancestors came from the EAST									X							
34 ANCESTORS FROM THE WEST		All ancient races of Europe & Asia-Minor claim that their earliest ancestors came from the WEST									X	X		X				
35 MOUND BUILDERS					X	X	X				X	X					X	X
36 VAST CITY BUILDERS	X O					X					X						X	X
37 ZONES OF LAND & WATER	X O	Observed in Carthage and elsewhere in Europe and Africa									X						X	X
38 SYMMETRICAL PYRAMIDS	O								X		X						X	X
39 INCISED WALLS & COLUMNS	O					□					X						X	X
40 INCLINED OPENINGS	O					□					X	X		X			X	X
41 CYCLOPEAN WALLS	X O					□					X					X	X	X
42 TEMPLES ON PYRAMIDS	O					X			X		X						X	X
43 ELEPHANT ART MOTIF	X O	This motif is prevalent throughout both hemispheres, yet the Elephant was extinct in America long prior to my assumed first arrival of the "Indian." Plato says Elephants were plentiful in Atlantis.									X						X	X

NOTES: "O" in "Atlantis" column indicates author's belief that the item originated in Atlantis. Where insufficient evidence exists the square ☐ takes the place of the cross X in the above columns.

COMMENTS: 1. The Sacred Hill was evidently the prototype of the artificial Mound, out of which evolved the Pyramid. 2. It will be observed that Bull-worship, Sun-worship, Cabira-cult, Witchcraft, and Mummification, all closely concerned with Osiris-cult, were practised by Cro-Magnon man. The evidence, however, discloses that Cro-Magnon man did not evolve in Europe or Asia-Minor, but in a land westward of those areas. It is certain he did not come from the Americas; neither did Osiris cult originate in the Western Hemisphere, yet we learn that Cro-Magnon customs and religious rites were practised there. 3. Witchcraft was practised by the Aurignacian Cro-Magnons in Europe, the earliest recorded people. It was similarly practised by the Canary Island Guanches, the so-called American Indian, and probably the Antilleans. This evidence, together with much corroborative data, tends to confirm my belief that all these people were contemporaries of the Aurignacians. 4. The American "Indian," in the author's opinion, is an inhabitant of the Americas from exceedingly remote times. He practised painting of bones, mutilation of fingers, Head flattening, hand stencilling, manufacture of wampum, witchcraft, bison drawing, etc.; all of which customs prevailed among the Cro-Magnons. Is it not reasonable, therefore, to assume that he received this knowledge from the same source as did Cro-Magnon man, namely Atlantis; and that at each successive invasion into the Americas from sinking Atlantis, beginning, at least, as far back as Aurignacian times, he brought with him the various customs and rites prevailing in Atlantis at the time of each enforced migration?

Another fact which apparently substantiates my belief in the Maya knowledge of the fundamental principles of the arch is the evidence afforded by a still further type of so-called Maya arch, such as Fig. K, seen in Uxmal and Labna, Yucatan.

As will be noticed, the form of the arch differs from the preceding examples, A and B, (see page 247), in that the jambs are geometrically formed from a segment of a circle. The

<div align="right">The Voussoir
Arch</div>

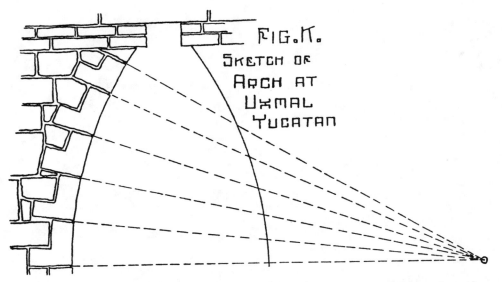

FIG. K.
SKETCH OF
ARCH AT
UXMAL
YUCATAN

important point, however, is the fact that all the stones forming the arc are cut as "voussoirs", whose bed-faces are exact radial lines from the center from which the arc was struck.

To say, as many students do, that the reason the Mayas did not use the arch is that they failed to discover the keystone, lacks, to my mind, logical reasoning. The system employed in forming the voussoir is the key principle, each stone becomes a key.

I have offered a suggestion in defense of the statement that the Mayas were ignorant of the principles of the true arch, my argument being that Maya architectural designs were basically of flat-beam construction; hence the introduction of the arch would necessarily have led to drastic changes in general form, a condition psychologically foreign to an uninterrupted "course of tradition." Again, the type of opening adopted though sparingly employed by the Maya architects—obviously originating elsewhere than

<div align="right">Mayas not
ignorant of
arch</div>

in Yucatan or Central America—is not only structurally efficient, but provides a unique and happy design-unit in keeping with their distinctive type of architecture. Their undoubtedly highly developed knowledge of engineering and construction principles, and the fact that they accurately cut voussoirs on an arc segment, appear evidence enough that had they decided on the true arch form the keystone would automatically have suggested itself.

Chapter Fifteen
The Maya Tongue

*Tolerance
required*

HEN we approach the subject of the Maya language we most decidedly tread on vigorously contested ground. Some scientists have released veritable barrages of invective and denunciation upon the heads of Maya philologists. In my humble opinion, if ever tolerance is required in one branch of study more than any other, it is in that of archeology. Never does it seem to occur to the belligerent gentlemen that there is really nothing to cause them to become offensive in their criticisms. None of them, either pros or cons, had anything to do with the making of past history. Man alone is capable of leaving to posterity a concise and readable record of his works. If he fails to so do, or is prevented by natural causes from so doing, succeeding enlightened peoples have not only the prerogative but the incentive to aid in retrieving the loss—for such it must be accounted. The ramifications of archeology make is impossible for any one student to become an authority on all the sciences involved. It is regrettable that some few, obviously learned men, such as Augustus Le Plongeon, M. D., have encouraged unrestrained denunciation of themselves by their dogmatism, intolerance, and belligerence. Unquestionably, Le Plongeon was a well-educated scholar and

did yeoman service in the Maya research field, but considerable of the almost universal scientific condemnation leveled at him is the result of his personal attitude.

In approaching the subject of the Maya language and its origin, I do so with no intention of discrediting the work of others in the field, but primarily to submit to the reader constructive data and the opinions of recognized authorities to substantiate my personal and humbly expressed theories.

What constitutes an archeologist?

What constitutes an archeologist? Some critics are of the opinion that there are two species, the professional and the amateur or "closet archeologists", as Le Plongeon contemptuously terms them; and that the theories of the former are to be credited and those of the latter discredited. Yet the history of achievement shows that not only does a recognized authority make mistakes (and at times is big enough to admit it), but the amateur frequently has made valuable contributions. Archeological field research offers numerous advantages over the library, no matter how complete. Nevertheless the disadvantages of the latter must not arbitrarily be construed as disqualifying.

Dr. Daniel G. Brinton, one time president of the American Association for the Advancement of Science, and Professor of American Archeology and Linguistics of the University of Pennsylvania, according to Dr. Augustus Le Plongeon "never visited the ruined cities of Yucatan", yet Brinton is quoted as an authority on the Maya culture. On the other hand, Le Plongeon, who says that he claims "no title of professor in any university, nor even that of member of any scientific society", spent many years among the natives in Yucatan.

Brinton eulogizes Le Plongeon

Despite this, Brinton, prior to their unfriendly relationship, wrote of Le Plongeon in 1885 in the November number of the *American Antiquarian*, page 378, as follows:

" I recently passed an evening with Dr. and Mrs. Le Plongeon, who after twelve years spent in exploring the ruined cities of Yucatan, etc . . . no one . . . can doubt the magnitude of his discoveries and the new and valuable light they throw upon ancient Maya civilization. *They correct, in various instances, the hasty deductions of Charnay,* and they prove that buried under the tropical growth of the Yucatan forests still remain monuments

of art that would surprise the world were they exhumed and rendered accessible to students . . . "

Here we see a generous expression of praise coming from a professional scientist for the undoubtedly valuable contributions to science made by a self-admitted amateur.

As in the field of radio, for example, we find that so-called amateur students in ancient Maya research work have contributed much toward what little knowledge is at present available.

This defense of the amateur is not to be construed as at the expense of those who occupy professional positions in the Maya archeological field. To the indefatigable efforts of Dr. Sylvanus G. Morley, Dr. A. M. Tozzer, Dr. Herbert J. Spinden, Dr. W. H. Holmes, Frans Blom, Dr. William Gates, and others, must go the majority of credit in the field of general investigation.

The amateur's contribution to science

My personal acquaintance with both Dr. Morley and Frans Blom has added to my esteem for their contribution to the Maya subject, especially in the case of the latter, whose guest I became on one occasion for a week or two at his base camp in Uxmal, Yucatan. Camp life in off-the-trail places affords excellent means of becoming acquainted. The best and the worst in a man seldom lie long hidden from his companions under such conditions. My conclusions, therefore, are that the earnest students of archeology, professional or otherwise, although at times expressing themselves in an outwardly intolerant manner, are usually open to conviction.

Valuable as are the untiring efforts of Le Plongeon, still it must be admitted that he frequently made mistakes— and who has not? On the other hand, some of the data gathered by him on the Maya subject have proved invaluable to those who followed. Such of that information as, in my opinion, bears reasonable soundness, I have no hesitation in offering for consideration, neither do I hesitate to quote the opinions of other so-called amateur "Maya enthusiasts", if similarly worthy of respect.

Who has not made mistakes?

In this class of non-professionals I include T. A. Willard, for whose deductions and sound advice I have much regard. For the past ten years I have had the pleasure of close association with him. For the past thirty years he has made the study of the Maya civilization his hobby, and has visited the Maya ruins area almost annually during that period. For the past ten years investigation and study of that subject have been his sole occupations and he has published

many books dealing with the Maya culture. What may be termed his forte is the study of Maya glyphs. It cannot be said at this time, however, that anyone has succeeded in finding a key to a solution, a Rosetta Stone, although considerable progress has been made. The Maya numerals, on the other hand, have proved more vulnerable, and their solution is now almost generally admitted.

Willard's contribution

The inclusion of the subject of the Maya language in this work, and the use made of various assumed glyph solutions offered by certain scientists, is in no sense to be considered a criticism of the Maya philologists whose opinions are not quoted herein, neither do I presume to offer a new theory in this particular branch of study. As has repeatedly been stated, we are concerned, primarily, with tracing the Maya civilization back to its origin. What simple deductions I offer are submitted to support by belief in the general theory. We are anxiously awaiting a solution of the Maya glyphs, and it is my opinion that when that time arrives, an amazing story of that ancient civilization will begin to unfold. For the time being we must do what we can with what little knowledge is available.

Strangely enough, although the present-day Maya speaks the language of his forefathers, he can neither read nor write it. This is due to the fanatical act of the over-zealous second Bishop of Yucatan, Father Diego de Landa. After the so-called Spanish conquest of Yucatan in 1542, the conquerors imposed numerous in-dignities upon the vanquished. Upon Landa's arrival in Yucatan he subjected the remnant of the erstwhile great race of Mayas to such further unwarrantable indignities as prohibition of all writing in their language on pain of death, and compelling destruction of all their books and manuscripts. The result was an irretrievable loss to man's intellectual advancement, and to progress in general.

Modern Maya and his language

Apparently Landa soon saw the folly of his act and in the year 1565 endeavored to correct it by appealing to the few remaining Maya leaders to compile a work on their language and its key. Ostensibly they complied, but it is now known that, exasperated by his destruction of their invaluable writings, they deliberately deceived him. Whether they later became soft-hearted and conceded a point is not certain, but it is believed that they gave him some information of value.

Perhaps, however, the more reliable data obtained by Landa concern the symbols of the days and months.

Concerning Maya history and language, he secured little of value and even that little has sometimes proved misleading.

Apparently, the root of the Maya language is derived from no known tongue, although, as the evidence may prove, its vocables are discerned among various ancient languages of Europe and Asia Minor.

Maya writing was in the form of glyphs, usually arrayed in a succession of double columns. The method of reading is two columns at a time, beginning with the left uppermost glyph and crossing to the uppermost right of the second column. The same procedure follows all succeeding double columns. Sometimes the glyphs are arranged in a horizontal band, in which case the order of reading is from left to right in pairs.

Maya language root said to be unknown

In attempting to classify the Maya form of writing many opinions have been advanced. Some authorities incline toward the phonetic. Others regard them as ideographic, still others believe they are pictographic. Phonetic symbols represent a fixed sound and do not express either a thought or an idea. Ideographic symbols represent a complete idea, or a conception; and pictographic symbols are simply complete or abbreviated pictures, or a conventionalized form to represent the objects themselves, such for instance as a man, horse, mountain, and so forth.

The term pictographic writing more nearly describes the Aztec system, but the Maya method differs considerably. Perhaps it might be said that the Maya glyph system is a combination of ideographic and phonetic, although this is not yet generally accepted.

Dr. William Gates, who for more than thirty years has devoted his time almost exclusively to the Maya glyph solution, recently published an exhaustive volume on the subject, which I highly recommend to those who wish to delve more deeply into this particular branch of the Maya subject. An interesting point in connection with Dr. Gates' efforts is that scores of solutions made by him coincided almost identically with those made by Willard. This general agreement between two independent thinkers gives promise of a fairly comprehensive solution of the Maya writings in the not too distant future.

Gates' glyph solutions of great value

To assist the reader in a better understanding of the process involved in attempting to solve the Maya glyphs, I herewith submit a few examples as deciphered by T. A. Willard.

Fig. A

In Fig. A we see first, the jar, or container, out of which is seen protruding a deer's head, *ceh.* In the neck of the vessel is the mouth sign *uah* or *uil,* meaning food. The *ha,* or liquid sign, is seen in the middle of the container, and on either side is a comb-like sign *ca,* meaning "plurality." Beneath the container are three black dots, known as *ek,* meaning black, dark, obscure, charcoal (the result of fire). Literally translated, this sign means that there was plenty of hot deer-meat or stew to eat, and plenty to drink; in other words, a feast; food in abundance.

Maya ideographic symbols

Fig. B

The sign Fig. B means fruit of the *yaxche* or sacred tree—*yax* meaning first, new, fresh, green, *che* meaning tree, wood, stick.

Fig. C

Fig. C means *uinic,* the sign for man.

Fig. D

Fig. D is *tun,* meaning stone. With the *yax* sign preceding the *tun sign* it means a green stone, jade.

Fig. E

Fig. E is *zac,* the knotted cotton sign, meaning white. This sign preceded by the *tun* glyph (stone) means white stone, or cement, plaster.

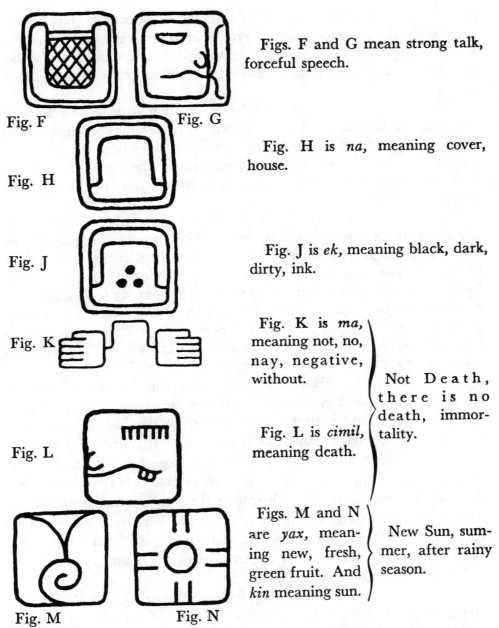

Figs. F and G mean strong talk, forceful speech.

Fig. H is *na,* meaning cover, house.

Fig. J is *ek,* meaning black, dark, dirty, ink.

Fig. K is *ma,* meaning not, no, nay, negative, without.

Fig. L is *cimil,* meaning death.

Not Death, there is no death, immortality.

Figs. M and N are *yax,* meaning new, fresh, green fruit. And *kin* meaning sun.

New Sun, summer, after rainy season.

As with all other branches of Maya culture, there is not the slightest trace in the Americas of the origin of Maya writing and its progressive stages in evolution up to maturity; therefore we must look elsewhere for the source. If we turn to Egypt, the seat of one of—what we are presuming to designate—the colonies from

Maya philological parallels in Asia Minor

Atlantis, we see numerous Maya philological parallels, far beyond mere coincidence. Not alone Egypt, but other centers following a course along the Mediterranean shores and into Persia, even further east, exhibit apparently definite linguistic affiliations with the Maya tongue.

The Egyptian civilization with its vast age and historical background naturally affords considerable evidence of its influence upon lesser cultures. In seeking its beginning, however, we are told that, as with all the ancient races of Europe and Asia Minor, it is of unknown origin. As its history is, so is the origin of the Egyptian language lost in antiquity.

Egyptian and Semitic

Dr. E. A. Wallis Budge, writing in one of the British Museum official journals, says: "The Egyptian language is not Semitic, although it possesses many characteristics which resemble those of the Semitic languages, but in a less developed form . . . The Egyptian and Semitic languages *appear to have sprung from a common stock,* from which they separated before their grammars and vocabularies were consolidated . . . To the period when Egyptian separated itself from the parent stock *no date can be assigned,* but it must have taken place some thousands of years before Christ."

Here we have the opinion of an undisputed authority, that the Egyptian and Semitic languages sprang from a common source, and that the separation from the parent stock must have taken place many thousands of years ago. It is my belief that the general evidence which we have considered, together with that which follows, offers a logically sound argument in favor of Atlantis as being the seat of learning from which sprang the fundamental principles of most of the prehistoric and historic cultures. Perhaps, also, we shall agree that the Maya language, and that of the Egyptians and other early occupants of the Mediterranean borders, are definitely associated, and likewise sprang from Atlantis.

Thoth invents Egyptian art

Continuing with the writings of Dr. Wallis Budge, we learn that: "The invention of the art of writing was assigned to the god Thoth."

This is a very interesting and, in my opinion, a very important point, when we remember that the god Thoth, or Tehuti, was a member of the god family connected with the cult of Osiris. The worship of Osiris, according to the evidence which we have

reviewed, originated with the rites connected with the Sacred Mound in Atlantis.

If we turn to the works of Le Plongeon, however, and glance at his opinions and deductions concerning the Maya tongue, we are at first disturbed in our hypothesis. Later, after careful scrutiny, we realize the inaccuracy of many of his remarks; but as the questions he raises are important, the following comments may prove of assistance in our consideration of the Maya language.

In view of the otherwise excellent contributions made to the Maya subject by Le Plongeon, it is to be regretted that he resorted to pure invention in the majority of his so-called glyph solutions. There is no question that many of his self-acclaimed solutions are very ingeniously deduced and deserve considerable credence in parts, but his frequent resort to rash assertions, devoid of even a vestige of logic, has, in the eyes of his critics, belittled and almost nullified his good work.

Le Plongeon says Mayach mother center

As an instance, Le Plongeon assigns the name Mu to the submerged continent which Plato designated Atlantis, but he states that for thousands of years before the earliest settlers in Egypt, the Mayas occupied the Yucatan peninsula. From this center he says "the Mayas sent colonists all over the earth." He believes that the area of Yucatan and parts of Central America were the mother countries from which all the present known cultures sprang; that "Mayach" was its name, and that the name means "the land that first arose from the bottom of the deep." But in this theory, as with so many others which he offers, there is not a vestige of fact offered in corroboration.

As we have seen, all the evidence herein submitted indicates the almost impossibility of Maya culture either having begun or maturing in the Yucatan and Central American area. On the contrary, the architectural evidence alone plainly tells the story of a hurried arrival, not of a people at the height of its cultural period, but, as I believe, actually on the decline. There has been absolutely no evidence yet brought to light which would indicate evolution from a lower architectural level to maturity in that area. In fact there is no evidence whatever to show that any existing portion of the land surface of the earth can lay claim to being the center in which Maya art was born, or flourished to maturity.

Condition of Maya art tells of hurried arrival

With all the evidence pointing to the probability that the Mayas were not in the Central American area earlier than

500 B. C., it is obvious that the inventors of their language, which is admitted to be exceedingly old, could not possibly have adopted the general outline of the Yucatan peninsula, ⌐ as the symbol of their letter M; and further, employ that sign to represent the Maya negative ma, ▰◠ ◠▰, as Le Plongeon insists.

The words Maya and Yucatan

That philological comparisons exist between the Egyptian and Maya languages is to be seen in many instances. Mention of the negative symbol of the Mayas, for instance, reminds me of the almost identical Egyptian negative sign: ⌒⌒⌒

I am unable to find proof that the word *Maya,* pronounced *ma* (broad A) *—yah,* was used by the occupants of the Yucatan peninsula earlier than approximately the year 1000 A. D. As Willard says: "At the time of the arrival of the Spaniards, the country was designated by various names. The natives told them the people were called Maya-Uinic, or Maya men, and the language they spoke was Mayathan, or Maya speech . . . Various early writers have given it as Maya, Mayab, and Mayob."

The word is composed of two syllables, *ma,* meaning no, not, or the negative vocable, and *ya,* meaning grief, emotion. The broad translation is therefore "no grief", without emotion, in other words, "Peace." By this reasoning it would seem that the word "Maya" does not stand strictly for the name of a people, but more for a state or condition of mind.

Various reasons offered as to derivation of word Yucatan

On the other hand, if we consider Le Plongeon's claim that *Mayach* was the name of the Maya country, we find that there is as much reason to believe as to doubt it. We have likewise no reason or proof that the word "Yucatan" is any nearer correct. It appears that none of the ancient chroniclers use the word "Yucatan." Some authors state that it is a corruption of the words *Yucal-Peten,* which means a long narrow district. Other historians believe the country derived its name from the yucca, hence Yucatan, or the land of the yucca. One version, well worthy of remark, is that of an early writer who says: "When the Spaniards landed, the natives were struck by their strange language and exclaimed 'Ouyouchatan' meaning 'Hear them speak.' To the Castilians, the word sounded so much like 'Yucatan'

that they called the country by that name." Gaspar Antonio Xiu (pronounced Shoo) says: "Yucatan is a corruption of the word Lugitan."

In all these versions, however, we see that Spanish and not Maya words have been juggled with. There is therefore no sound reason why the name of the Maya country should not be Mayach, that is if the people actually called themselves Mayas. My belief, however, is that the words Maya and Yucatan did not originate with the Mayas to denote themselves and their country.

Evidence of language

Following other courses of culture back toward their origin we have learned how a multiplicity of comparisons is easily traceable on both hemispheres, including the Azores, Canaries and West Indies. Employing the language branch of culture as a further test, it is interesting to learn how it too assists in establishing a belief in Atlantis as the Mother of many ancient civilizations. Let us consider a few comparisons offered by Le Plongeon.

The latter lived among the natives of Yucatan for more than twelve years, and was one of the very few white men to speak the Maya language, so that his authority on that point is somewhat difficult to question. But when he takes liberties with words and glyphs by changing them beyond all semblance of their original forms so they will fit a particular place in any one of his so-called solutions, one is forced to regard him with doubt. In submitting the following few Akkadian-Maya word comparisons as compiled by him, however, I believe them tó be of value and well worthy of consideration. Francois Lenormant prepared the Akkadian translations. Le Plongeon provided the Maya comparisons.

Akkadian and Maya word comparisons

AKKADIAN	MAYA	ENGLISH EQUIVALENTS in Both Languages
A	HA	Water
ABBA	BA	Father
BALA	PAL	Companion, also Pal
KUN	KIN	Daybreak, Day, Sun
NANA	NAA	Mother
SAR	ZAC	White
TAB	TAB	To place, to add, to be, to join, to write.

The Akkadi, it will be remembered, were a people who in pre-historic times lived in the Valley of the Euphrates. These people were presumably colonists, or descendents of colonists, from the continent of Atlantis. From this race sprang the Chaldeans. As I believe that the Mayas of Central America are from the same Atlantean stock I shall add strength to the general theory by a few word-comparisons taken from words known to have existed in these two widely divided centers. A further item of interest is added to the above short list of comparisons, through data furnished by Senor Melger in his *North Americans of Antiquity*. He tells us that in the Chiapenec language (a branch of the Maya tongue) the word for father is *abagh*. It will be noted that the Akkadian word for father is *abba*. The Hebrew word for father is also *abba*. The Egyptian letter "A", as in the Akkadian tongue, also stands for water.

Similarity of words on both continents

Numerous words found among the races of Asia Minor and Egypt appear almost conclusively to be from precisely the same root as Maya. *Kabul*, for instance is the name of a city, also the name of a river in the Province of Afghanistan, situated between Persia and India. Le Plongeon says that the word is Maya, of two syllables, *Kab*, meaning hand, and *ul*, meaning fowl—large bird. I, however, am inclined to agree with the more generally accepted definition—i. e., "skillful hand." *Kabul* is also the name of a temple mound in Izamal, Yucatan.

Zahi (Zayil or Sayil), is the name of an ancient city in Yucatan. This is a Maya word meaning "full of menace", "to be feared." We read that the Egyptians called Phoenicia, "*Zahi*." The term was applied after the Phoenicians became a mighty power, and naturally one to be feared.

Both hemispheres have a "River Nile"

Dr. Wallis Budge says: "The Egyptians called both their river (the Nile) and the river god 'Hap' or 'Hapi', a name of which the meaning is unknown." The word is apparently Maya. *ha*, meaning water, and *pi*, to place little by little. Its meaning and Maya connection become more apparent when it is remembered that an Egyptian tradition informs us that King Menes, or Mena, who was the first dynastic King of Egypt, "altered the course of the Nile and so redeemed from the river a large tract upon which he built the first city of Memphis." Of added interest is the word Nile, the name given by the Quiches of Central America (a branch of the Mayas) to a river flowing into the Pacific Ocean.

We are informed by M. Birch that the sacred name for Memphis was Hakapta. Again we have a Maya word. *Ha,* meaning water, *kapta,* to place in a hole, in other words, built in a hole made by water,—a very apt title for the city of Memphis.

Men, amen, both Egyptian and Maya words, mean "the architect", "builder of all things", "wise man", in both languages.

Philologists and Egyptologists have frankly admitted their inability to establish a root or origin for scores of Egyptian words. *Babel,* for instance, is decidedly Maya, Le Plongeon suggests the vocables *ba,* meaning father, ancestor, and *bel,* meaning custom, way, could easily mean: "Built to the custom of our ancestors."

Root of some Egyptian words unknown

The word Canaan, denoting the lowlands in Palestine in early history, is also a Maya word meaning "something that is scarce", "good fortune", "happiness." The Greek equivalent for Canaanite is Phoenix, from which is derived the word Phoenician.

As can readily be seen, the subject of the Maya language and glyphs is one of the essential elements to be mastered in attempting a solution of this, the most fascinating enigma in all history. Much information will undoubtedly be forthcoming through other sources in the near future, but a knowledge of Maya philology will prove to be one of the greatest factors in deciding definitely for or against a Maya cultural affinity with ancient races in Europe, Asia Minor and, in all probability, Atlantis.

It always has been considered bad form to introduce either religion or politics into an argument. The reason why the former subject was barred is due primarily, to ignorance and narrow-mindedness; perhaps the same cause debars the latter. In religion, however, we find that all beliefs are founded upon certain similar fundamentals obviously emanating from a common source, but it is not the fundamentals that cause the disputes, it is the manner of their interpretation. As Max Muller remarks: "There was an original language"; so also was there an original religion. Our earliest cultured ancestors fully realized the immeasurableness of the omnipotence of the Creator, and humbly referred to Him solely as The Nameless, deeming themselves unworthy even to suggest a name. This tribute was further enhanced by representing God, the Creator of all things, by numerous symbols representing the various qualifications ascribed to the Universal Deity. Together with these symbols, laws considered

Christ and the Mayas

commensurate with the desires of the Creator were established to govern man's conduct.

During the course of long centuries, many of the original meanings of these symbols have become confused or lost, and the laws of God have been grossly misapplied.

Through succeeding generations, man's effort to interpret correctly the beauty, symbolism and true application of the first established laws, is reason enough for much confusion of opinion and diversification of religious practice among the peoples of the earth.

In eras of great stress world leaders appear

There seems to be a law for eras of great stress, which provides that at such times men of great courage and inspiration have appeared as teachers for the betterment of mankind. Such teachers have expounded the true principles of religious thought and practice and have renewed enlightenment in a world of ignorance. There can be no doubt that such men were exceptionally inspired and that their intuitive sense of metaphysical and theological law drew them toward the learned masters of their times, who lived in seclusion to meditate and carry on to posterity the fundamental principles of religious thought established by their earliest progenitors.

These master-philosophers were, however, unfitted to expound their wisdom to the great public, but among their scholars were men who were adapted to become inspired teachers, men such as Zara-thustra (Zoroaster), Confucius, Mohammed, the numerous Buddhas, and Jesus Christ.

It is generally supposed that Christ spent years with the sages of His time. It is my endeavor to corroborate that supposition with evidence which will at the same time strengthen the theory of a common origin for the earliest races of both hemispheres.

Inspired teachers

We have reviewed an abundance of evidence which seems to point to the conclusion that the ancient civilizations of both Asia Minor and the Americas sprang from a common center which, I believe, was Atlantis. We have also considered evidence showing that much of the so-called Maya or a cognate language is to be found in the cultures of the earliest peoples of southern Europe and Asia Minor. Is it then preposterous to state that Christ understood and spoke Maya or a language that was closely related to that tongue? Before condemning this assertion, or passing hasty judgment, let us first consider the evidence.

By a strange coincidence, just as I was penning the last words of my translation of a phrase which appears to answer this question, I received a copy of a magazine article by Dr. George M. Lamsa, entitled: "The Strange Words of the Savior on the Cross Explained." It is peculiar that these very words on the cross are the identical subject of my translation referred to above. In view of earlier remarks, it might be asked whether this coincidence is to be ascribed to "psychic unity" or assigned to the category of mere chance. However, it must be admitted that the occurrence of two almost simultaneous attempts to solve this unusual problem is, to say the least, interesting.

Christ's last words

My personal studies in search of a solution of Christ's last words have covered a long period. Many years ago, I arrived at certain conclusions which appeared to me entirely satisfactory and which I have decided to include in this present volume. It is an arresting coincidence, therefore, that just as I had finished writing my theory into this manuscript, Dr. Lamsa's article should come to my hand. His theory is so interesting that I take the liberty of quoting this Kurdistan scholar and comparing his opinions with Le Plongeon's and my own. The general resemblance among all three is remarkable.

The coincidence of our joint interest in the last words of Christ is the more remarkable, in view of the great lapse of time during which the translations of St. Matthew and St. Mark have remained unchallenged. With the exception of Le Plongeon's interpretation made approximately forty years ago, I do not recall any other attempts worthy of mention to interpret the last words of Christ.

Interpretation remained unchallenged for 1900 years

In the Gospel of St. Matthew, King James version, Chapter 27, 46th verse, Christ's disciple states that the Savior's last words were: *"Eli, Eli, lama sabachthani."* St. Mark's Gospel, Chapter 15, verse 34, records these words as *"Eloi, Eloi, lama sabachthani."* The interpretation given in both gospels is "My God, my God, why hast thou forsaken me?"

To me, the translation has always seemed out of character. Christ, the great metaphysician, consistently taught love, fortitude, and faith. He emphasized hope in the ultimate, and belief in divine guidance; but the long-accepted translation places Christ in the light of lacking faith in God in His hour of great trial.

Eli, Eli, Lama Sabachthani

Matthew's version is a pure Maya sentence. From all accounts Matthew was the best educated among the disciples. The fact that Matthew recorded the words as he did implies that he

was acquainted with the Maya tongue. It is highly probable that Mark, if he wrote the gospel bearing his name, did not personally record Christ's last words. On the other hand there is no actual proof that either Matthew or Mark wrote the gospels ascribed to them. The earliest texts appeared approximately one hundred and seventy years after the death of Christ, and were written in Greek. This fact alone would easily account for the discrepancy of spelling the first two words in Mark's version, viz: *"Eloi, Eloi"*, instead of *"Eli, Eli"*, as recorded by Matthew.

Le Plongeon's Definition

If for the purpose of argument it be assumed that Christ spoke the Maya tongue (which in all probability was preserved by the High Priests and the Masters as the classic language), we see that whoever actually made a record of Christ's last words was also acquainted with the language and experienced no difficulty in recognizing the words. But, whoever wrote the texts, the fact is that the sentence was included in the gospels of Matthew and Mark within two hundred years after the death of Christ.

Before discussing Dr. Lamsa's version, let us consider **Le Plongeon's** interpretation.

The first thing we find is that Le Plongeon makes a radical change in the sentence. Instead of "Eli", as Matthew has it, he substitutes the word "Hele", a Maya word meaning "Now," The third word in the sentence is "lama", but Le Plongeon adds to this the letter "h" so that the word reads "lamah." This word he interprets as "fainting." The Maya word "lamah" has various definitions such as something sunken, submerged, cast down, put under, fainted. Lama, which is also a Maya word, is an uncommon variant of lamah. The fourth word "sabachthani" Le Plongeon changes considerably, his definition being "zabac-ta-ni", which he says means "a darkness covers my face." Le Plongeon's final rearrangement of the original sentence is "Hele, Hele, lamah zabac ta ni." His free translation being: "Now, now I am fainting; darkness covers my face." The changing of the first letter in "sabachthani" from "s" to "z" is of no consequence as in Maya they are the same, but the alteration in the last part of the word completely changes its meaning. Le Plongeon apparently forced the words to fit the meaning, a meaning entirely inconsequential and devoid of profundity or importance.

Inexcusable liberties

It is of great importance when deciphering a text that words be not distorted to suit the interpreter's definition of a

sentence. By taking liberties, entirely new meanings can be constructed at will. A certain elasticity may be permitted, however, when reasonably supported by facts or sound reasoning. Therefore, we grant that it is perfectly permissible for Le Plongeon to have added a letter here and there, or even to separate words to prove his contentions. But the sweeping changes he makes in the original sentence are inexcusable. Such excessive liberties have occasioned the quite understandable distrust of Le Plongeon that many have expressed. On the other hand, his knowledge of the Maya language entitles him to considerable respect, even though we do not always agree with his deductions.

Dr. Lamsa's definition

Let us now consider the version submitted by Dr. Lamsa, who has based his translation on Aramaic, an ancient language now spoken by no more than approximately 28,000 persons, and one which I believe is an outgrowth of the mother tongue of Maya. Dr. Lamsa admits that Aramaic and Hebrew are related languages, but offers no suggestion as to the root tongue from which they sprang.

As he does not comment on the first two words, *Eli, Eli,* presumably he accepts the translation in King James's version as "My God, My God." Dr. Lamsa states that lama is misquoted, that the Aramaic Bible version is not "lama", but "Imana", the meaning of which, in Aramaic, is "for this" yet he admits that "lama exists in Aramaic and means "why."

The next word, *sabachthani,* he says does not mean "forsaken, is a form of the verb 'to keep', and only in the sense of the word as it is used in the phrase 'keep away from me' could it have even a vague similarity to the English word 'forsaken'." (I have copied this as in the article quoting Dr. Lamsa as its authority). His translation of the complete sentence is: "For this I was kept," meaning: "This is my destiny."

Interpretation without mutilation

Dr. Lamsa points out that the Hebrew word *Azavtani* means "forsaken." That is, it resembles and has the same meaning as *sabachthani.*

I suggest that the probable reason why Dr. Lamsa thought he recognized in the Aramaic language the meaning of Christ's last words is that Aramaic is apparently, in my belief, an outgrowth of Maya, and very like it. But, being in possession of an imperfect key, the translator was forced to make changes to provide a convincing Aramaic sentence.

Evidently the original expression was intended as one of great importance, else why the care with which it has been preserved? Yet all three versions, the Biblical, Le Plongeon's and Lamsa's are of little significance. All are forms of complaint.

Before continuing further I should like to remark it is not my intention to usurp credit due to Le Plongeon as the first to suggest Maya origin of Christ's last words. I merely claim a new interpretation based on the Maya tongue, without mutilation of the original sentence. Naturally, considerable knowledge on the Maya subject has accumulated since Le Plongeon's time. I have simply taken advantage of that fact.

Author's definition

Likewise, I do not wish to discredit the painstaking efforts of Dr. Lamsa. Relying entirely upon Aramaic as the source of information, his definition is undoubtedly good and of value, and in one sense he is supporting the theory of Maya origin.

It is my belief that Christ studied with finished masters who thoroughly understood Maya, in its root sense, or a language very closely related to it.

The Maya root, I suggest, originated with the people we know as Mayas when they occupied Atlantis. Presumably, this root language was carried by the early colonists, the Azilian-Tardenoisian and possibly earlier waves of Cro-Magnons who spread through Europe and Asia Minor and who later settled in the Euphrates Valley, where they were known as Akkads. The origin and disappearance of these people, together with all ancient races of Europe, Asia Minor, and the Americas, has remained unexplained by scientists. I suggest it is highly probable that all of them sprang from the mother empire of Atlantis, and that they spoke one or another form of the Maya tongue (the language of Atlantis), or a branch very closely related to it. Time, naturally, brought numerous changes, but the fundamentals remained.

Frequently two forms of writing developed

Frequently two forms of writing developed in great cultures, such as those recognized in Egypt, one for the priesthood, the other for the people. As is the custom among all highly advanced peoples, there is much information that cannot be made common knowledge; some indeed must be reserved only for the few. I submit the probability, therefore, that this custom was followed by the Maya masters when they became established in the various colonial centers, that it became their solemn duty to preserve for their successors and for

posterity not only the ancient secrets of their occult, esoteric, and metaphysical lore, their religious rites, arts and sciences—but their mother or classic tongue also.

We learn that thus throughout the ages master minds have perpetuated their more profound or abstract knowledge. It is these masters whom we have to thank for what little ancient culture of that nature has come down to us. That we have not more, is through no fault of theirs. Other minds of little vision but with equal ardor have become obsessed by the urge to destroy all that which passed their comprehension. These learned savants of the past, then, proved to be one of the strongest and most reliable channels of information. The knowledge they have handed down to us was always painstakingly preserved, and usually at considerable personal risk.

It was such men as these who, in my belief, taught Christ (and other great world leaders at various periods in history) the hidden sciences, the fundamentals in religion, philosophy, and all the higher branches of culture. Only in this classic manner could the knowledge of their higher culture be preserved.

Men who taught Christ

Therefore it is my belief that, when Christ uttered His last words, He spoke not in a branch language, such as Aramaic, but in the classic root tongue of the Atlantean masters, of which He was one; and that classic root language was what is now known as Maya, or a cognate tongue.

When the Assyrian refugees fled into the mountains of Kurdistan, many centuries ago, they took with them the Aramaic tongue. The present remnants of that race still preserve the language. The Aramaic Bible, which the Nestorian Christians compiled, and which Dr. Lamsa uses as his authority, was not in evidence until approximately two hundred years after Christ.

Author explains his interpretation

Aramaic and Hebrew being comparatively young in Christ's time, provided just a sufficient number of Maya words to mislead a translator two thousand years later into believing he had found the key to Christ's last words.

With these comments I shall now proceed to give a detailed explanation of my interpretation of the words as they stand in Matthew.

According to the few available Maya authorities, the word *Eli* means burned, scorched, heated; the extension of which includes "consumed by fire", "parched with heat", etc.,

which terms are still further interpreted as "wounded", "feverish." The fact that the word is repeated indicates in my belief the plural— more than one, many, or twice heated, twice burned, much or badly wounded, etc.

This deduction I arrive at in view of a parallel practice of repetition observed in certain ancient languages which, in my opinion, point to a common root or mother tongue from which the so-called Mayan language also sprang. One of these very ancient tongues is known as Akkadi, Accadian, or Chaldean.

A special magic language

Lenormant, the great French authority, says that: "Chaldea possessed, then, a special magic language which preserved this character for the Assyrian people also, *and that language is the Accadian* . . . It seems that the idea of supernatural virtue inherent in the words of this language increased in proportion as it ceased to be used as a spoken idiom, *becoming for the priests a dead language exclusively applied to religious uses, while to the people it was an unintelligible gibberish.*" Incidentally, this verifies my remarks concerning the popular Egyptian tongue, and the outgrowth from a common source of such branch languages as Aramaic, Hebrew, and so forth.

Further, Lenormant says: "There is positive proof that the Assyrians themselves entitled the ante-Semitic idiom of Chaldea *'the Accadian language'* and we have no real reason for differing from them." In another place we learn that the Accadian language "has ceased to be spoken for some three thousand years, at least."

Repeated words indicate plural

Having already reviewed a few Maya words with equivalent meaning in the Accadian, or Akkadi tongue, the following remarks by Lenormant may serve to substantiate my belief that certain words repeated in the Maya tongue indicate the plural. We read: "The Accadian (Akkadi) like Mantchoo and Japanese, contains some rare specimens of the most ancient mode of forming the plural in the Turanian languages by doubling the root; for instance, 'ana ana', the gods, 'kur-kur', the countries, as in Mantchoo, *jalan jalan'*, the countries."

Therefore, in view of the physical condition of Christ at the time, I interpret the words "*Eli, Eli*", as wounds, many wounds, or much wounded. The words "burned" or "heated" may be construed as the pain and consequent fever resulting from the wounds.

276

The next word, *"lama"*, is definitely Maya. Some students believe that the words *"lama"* and *"lamal"* are identical. These words must not be confused with the presumed Maya word, *lamat*. Dr. Sylvanus G. Morley, for whose personal acquaintance and distinguished work in the Maya field I have the utmost respect, will, I trust, pardon my reference to an evident mistake made by him in the spelling of the word in question. Writing in Bulletin 57, Bureau of American Ethnology, he gives a list of Maya Day Signs. The eighth one on the list is spelled *"lamat."* This is now considered to be a mistake, and was evidently taken from Father Landa's account which contains the original error. According to Willard there is no such word in the Maya language. The Maya Day Sign is *"lamal."*

It has been my endeavor throughout the undertaking of this delicate translation to adhere as strictly as possible to the original words of our subject sentence. Therefore, I accept the word *"lama"* as in the Scriptures. *"Lama"*, in Maya, means, scarcely, hardly, barely; in the sense of "hardly had I spoken to him when he departed", or, "scarcely had he completed a sentence when he continued with another." This may be extended to mean "almost without pause", "at almost the same time", "one event to follow another almost without a break", "kept going", "almost before a certain event ended it was repeated."

Concerning the words lama and lamal

The last word, *"sabachthani"*, is a Maya compound word. There is no letter *"s"* in the Maya language, the *"z"* takes its place, so the Maya spelling would be *"zabachthani."* The first part of the word is *"Zabach"* the second half *"thani."* I can discover no word *"zabach"* so that evidently the *"h"* at the end of the first syllable is either a conjunction or a mistake, or its insertion was due to local idiom. *"Zabac"*, however, is a Maya word meaning black, dark, black hue or color. These definitions may be extended, according to the meaning of the sentence, to false, spurious, defamatory, and so forth. *"Than"* in Maya means talk, speech, conversation, etc. The *"i"* at the end of the word is a verbal complement.

The Biblical sentence, then, is literally: "Burned, Burned, (or wounded, or wounds); scarcely (or hardly, barely, almost before, kept going); and Black (or false, defamatory), Talk.

The meaning as I understand it is: Scarcely have they completed my torture, when (that my wounds may remain open) they speak falsely of me.

My free translation, therefore, is:

My wounds will be kept open by those who defame me.

Author's free translation

For those sufficiently interested I tabulate the three versions and the hitherto generally accepted meaning.

CHRIST'S LAST WORDS INTERPRETED

ELI	ELI	LAMA	SABACHTHANI	St. Matthew's Gospel Chap. 27, Verse 46.
My God	My God	Why hast	Thou forsaken me	Previously accepted meaning.
ELI	ELI	LAMAH	SABACHTHANI	Dr. Le Plongeon's misquotation of the Bible sentence. He has added the letter "H" to the word "LAMA".
HELE	HELE	LAMAH	ZABAC TA NI	Dr. Le Plongeon's reconstruction of the Bible sentence.
Now	Now	I am fainting	darkness covers my face	Dr. Le Plongeon's interpretation.
ELI	ELI	IMANA	SABACHTHANI	Dr. Geo. L. Lamsa's version of the original sentence.
My God	My God	for this	I was kept	Dr. Lamsa's interpretation of the literal translation.
My God	My God	this is my destiny		Dr. Lamsa's free translation.
ELI	ELI	LAMA	ZABAC(H)THANI	Author's version of original sentence. "S" and "Z" are synonymous in the Maya tongue. The first "H" in the last word is either a mistake or was used as a conjunction.
Burned (Twice burned, or much Wounds.)	Burned wounded.	Scarcely, hardly almost before, kept going.	Black Talk False testimony defamatory remarks.	Author's literal translation.
Scarcely have they completed my torture when, (that my wounds may remain open) they speak falsely of me.				Author's interpretation.
MY WOUNDS WILL BE KEPT OPEN BY THOSE WHO DEFAME ME.				Author's free translation.

It will be noted in my suggested translation, based on the Maya language, that with the exception of deleting the first "*h*" in the last word, and changing the "*s*" to a "*z*" in the last word I have not altered or substituted even a single letter.

Very humbly I offer the criticism, first, that the long accepted version translated from the Bible is weak and unworthy. It is unthinkable that Jesus doubted God's presence. He knew, beyond all question, that God never would forsake Him. Second, I feel that Le Plongeon's translation is inconsequential, of no esoteric or historical importance; and third, that Dr. Lamsa's version is in the nature of a complaint rather than a statement pregnant with meaning. None of the above three explanations sounds other than a declaration of despair.

*Criticism
humbly
offered*

Justification for the presumption—if such it may be considered—in submitting my own version of the last words of Christ, is found in their spiritual import; for those words, as I interpret them, contain a very definite message as well as a warning.

Christ, according to the Scriptures, burdened His heart with the spiritual welfare of mankind. His every word and deed evidenced a profound conviction that He had a mission on earth, direct from God, to point mankind the way to the Kingdom. To that mission He dedicated Himself without reserve, and in its ultimate fulfillment He went unfalteringly to the cross and to His death. Throughout Christ's entire ministry, His teachings and acts reveal that *faith in God* was the fundamental and dominating element in His character. Is it reasonable to conclude that in the final and supreme test in His life He lost that faith? That He surrendered to doubt and despair and exclaimed: "My God, My God, why hast Thou forsaken me?"—words that have puzzled the Christian world for nearly two thousand years?

*Well might
He exclaim*

In full consciousness that one of His disciples had betrayed Him with a kiss, another had denied Him thrice, and others seemingly had deserted Him; that in times of stress and danger other followers would deny and betray Him; that hostile religious leaders, such as those who had brought about His crucifixion, would malign His motives and His character; that false prophets would feign to perform miracles in His name—conscious of all this and more —His compassionate heart overwhelmed with inexpressible sorrow—

well might He exclaim: "My wounds shall be kept open by those who defame me."

That interpretation carries a double message—a warning and an appeal: a warning that those who should defame Him and betray His cause would perpetuate the agony of the cross; and that those unwavering in their faith and loyalty to Him would become a healing balm to His wounds.

Obvious importance of sentence

It is obvious that the sentence is of importance, else why the reason for preserving a record in the first instance? Being of importance, the words, in my opinion, were uttered, not in the colloquial idiom of the times, but in the classic speech of very ancient lineage, as preserved by the priesthood and masters. Whether or not the reader cares to believe that the words were actually uttered by Christ, the fact remains that they are in the Scriptures and were intended as a message of importance, not an expression of doubt. And, further, as the accumulated evidence apparently proves, the sentence was spoken in a language the root of which is the same as that from which sprang the Maya tongue.

Chapter Sixteen

Quetzalcoatl

THE evidence already submitted should prove sufficient, at least to warrant a belief that the various cultures of the two continents divided by the Atlantic Ocean sprang from a source foreign to all known centers of the earth. Only a cultural foundation laid by a stupendous civilization could have furnished the permanent links which are slowly being gathered to form a fairly complete chain of testimony running back to the dim past. How great was that mother race, we have at the present time no means of knowing; but its advanced condition can be roughly gauged by the fact that all the succeeding races—its own progeny in truth—have preserved all the original principles of its culture.

An unparalleled story

As time progresses, further various scraps of evidence will without a doubt be uncovered. It is my belief that within the not-too-far-distant future, sufficient knowledge will have been gathered to piece together an unparalleled story, closely linking together Biblical history with the cultures of most of the prehistoric races of both hemispheres. I believe, further, that mythology, legends, and the so-called hidden sciences will play an increasingly valuable part in

clarifying the present somewhat narrow-minded conception of religion, its origin, principles, and value to mankind.

A comprehensive survey of all important subjects concerning man's activities, both historic and prehistoric, points, in my belief, to Atlantis as the center from which all the known cultures sprang. In terming that race the "Mother of Empires" I do not dispute the theory of preceding cultural cycles, or even grand cycles; in fact I believe in the high probability that such existed. Whatever culture was developed by any earlier people, no evidence of it has yet appeared. It is, in my opinion, illogical to consider the hypothesis of man's beginning in Atlantis or Mu, or Lemuria, or any other center of the earth, visible or otherwise; although scientists are generally agreed that life, as we understand it, was spontaneous, and man merely the result of evolution. In my opinion, life always was and always will be. Death, as we understand it, is merely disintegration of organized form. Organized form is a community of individual life units congregated into a variety of shapes and sizes which evolved for the purpose of the most efficient functioning under prevailing physical conditions and the demands of environment. Life, however, in the sense of energy or force, is indestructible. If form or the organized functioning being constitutes life, then it may be said to have had a definite beginning on this earth, perhaps spontaneous but of no definable center. Similarly, the birth of all culture is equally of no definable center. In both instances, the problem of beginnings, where and when they took place, is open and always will be open, to the wildest speculation.

As with life and culture, so with religion, the beginning of culture, its place and time of origin are unknown, although, if we are permitted to consider the delicate subject of religion from an analytical point of view, we are forced to recognize a much greater background than our preceptors have taught us.

The evidence appears to point to the high probability that much of Biblical history concerns an area of the earth other than Asia Minor. Scores of identical data are included in the mythology and legends of the so-called New World. Decidedly, there was a common center, but there is not a vestige of evidence to indicate any existing land area as such center, or that the culture of one continent was borrowed from any culture on the opposite continent. As we have learned, the Flood story of the Bible is common knowledge among

Previous cycles of cultures not disputed

Vast background of religion and culture

practically all the races on the American continent, both ancient and modern. Also scores of descriptions and historical data concerning important personages and events, as described through Aztec, Toltec and other American race sources, are identical with those of the Biblical records.

Religion has served a dual purpose as a philosophy of right living and as an incentive to emulate the highest attributes ascribed to a deity. Man's veneration for beneficence is expressed by elevating the benefactor above the common status, even to deification. In such manner have men been honored throughout the period of history; undoubtedly the custom prevailed in prehistoric times. Among the earliest records we learn that hero worship was prevalent in remote times. Mythology teems with heroic characters, obviously having foundation in fact. Often, too, both history and myth refer, apparently, to exactly the same illustrious personage; an example of which is the important individual known as Quetzalcoatl.

The deifica-tion of men

The Toltec hero-god, Quetzalcoatl, has provided a subject of considerable discussion among the few interested historians. It is conceded, however, that both mythology and documentary evidence, though widely varying at times, supply valuable biographical information concerning this dramatic personage. The accumulated data have suggested to my mind an additional hypothesis which I now offer for discussion. Before submitting the evidence and my conclusions, however, I propose first to present certain testimony concerning Itzamna, a character almost identical with that of Quetzalcoatl, and one who, though of considerable importance in Maya history, also plays a part in the present discussion. To enable the reader to follow my method of deduction and reasons for my opinion, it is necessary that certain facts first be submitted concerning early Maya history in Central America.

Yucatan's silent empire

To begin with, it must be remembered that at the present time a vast, silent empire of unpeopled cities lies buried beneath an almost impenetrable carpet of jungle growth. The so-called Maya area extends from Yucatan to Guatemala, and includes together with those two states Campeche, British Honduras, Tabasco and Chiapas. So far, Yucatan has provided most of the sensational discoveries, but the remaining territory suffers merely delayed recognition.

Regarding the history of the Mayas little is at present known. There are but three Maya books, or codices, extant. One writer refers to them as *The Books of the Chilan-Balam*, but this is a mistake.

The three known Maya codices are books written in Maya hieroglyphs on a smooth-surfaced, pressed maguey pulp, coated with fine lime. The contents mostly consist of the calendar and religious ceremonies. The drawings are made in black and various colors and the whole is folded like a Japanese screen. Early accounts state that the Mayas possessed large libraries of works on numerous subjects, such as medicine, civil and religious history, rites and magic. The only known remaining examples, unfortunately, are not to be seen in America. One, known as *The Dresden Codex,* reposes in the museum of that city in Germany; *The Peresianus Codex* is in Paris, France; and *The Tro-Cortesianus Codex* is in Madrid, Spain.

As before stated, Father Diego de Landa, second Bishop of Yucatan, caused an irretrievable loss when he ordered the destruction of all the Maya books and manuscripts. He created further enmity against himself when he forbade the Mayas to write in their language under penalty of death. In consequence little evidence remains. Of that little, a certain amount of value is to be found in the answers to the questionnaire of fifty items which King Charles V of Spain caused to be sent to all his principal representatives in Yucatan. This was done in an effort to recover some of the Maya history, although the effort was not entirely satisfactory, as Landa's drastic mandates had been executed only too well. The more valuable information, however, came to light through the efforts of a small group of Maya priests who defied Landa's orders, although working in the strictest secrecy. We are greatly indebted to these brave men, sixteen in all, each of whom wrote a history of his people from memory. These histories are known as *The Sixteen Books of the Chilan-Balam* (Willard says approximately a dozen), and all have been preserved. In general they all agree, although often differing widely on details. It is recorded that several other accounts were written by the learned Mayas at that time, but their works, discovered by the Spanish taskmasters, were destroyed.

In addition, we can rely to a certain extent upon the early Spanish chroniclers of Maya history, for the reason that they obtained their information at first hand from the very small remnant of intellectual Mayas. Another though somewhat meager fund is what

has come to us by word of mouth during the last hundred years through the unlettered natives. Normally, such a source of information is not reliable, but it is a well known fact to those who have had to do with the present descendants that they are not given to prevarication. They are essentially a truthful people.

Among the most important answers to the questionnaire which agree in general, we learn that the ancient Mayas "had come *from the east*", that they were *"the first people* who came to Yucatan after the Flood." (*Documentos Inéditos, from the History of Tiquinbalam*, by Juan Gutierrez Picon). In these histories it is definitely

The Chanes

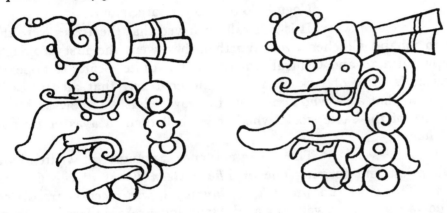

Two Deified Portraits of Itzamna

stated that they were not idolaters, and "did not make human sacrifice"; that "they had knowledge of only one God, Hunal (or Hunab)-Ku, who created heaven and earth and all things"; and that they placed flowers and fruit and "presents and alms" on their altars.

In answer to question number 14, we find that practically all replies refer to "the immigration *from the east*", that these people "came *from the east*", that they came "from (Likin) where the *sun rises*", from *"toward the east"*, and so forth.

The Chumayel

In the work of Father Diego de Landa, we read "that certain people populated that land (Yucatan) *who entered by the east.*"

Another writer says: "The Chanes (people of the serpent) were the first inhabitants of Yucatan. *They came from the east* with their leader, Zamna, sometimes known as Itzamna." Molino Solis, historian of Yucatan, says: "The Chanes were Itzaes. They

285

entered Yucatan by the *South East* of the peninsula. They travelled from *East to West.* The word Itzaes is the name given to the followers of Itzamna, their leader, who no doubt, brought them through very troublous and even dangerous times. Later, he was elevated to the status of a divinity."

Brinton says: "Zamna, or Itzamna, reserved the name of Lakin-Chan, *the Serpent of the East,* under which name he was generally known." In another passage as we have already seen, we read: "He (Itzamna) was said to have come in his boat *from the east* across the water."

Cogulludo tells us the same story.

It is generally believed that the Itzaes were the first to inhabit Chichen-Itza. Whether they were the first people to occupy Yucatan and Central America is not quite clear. It appears, however, in view of lack of data to the contrary, that all the early arrivals in that area who contributed toward what we know as Maya art, were of the same stock, whether we call them Mayas or by any other name.

There is in existence a manuscript written by a Maya priest and forming one of *The Sixteen Books of the Chilan-Balam.* This work, known as *The Chumayel,* was recently translated in Yucatan by a very well-educated Maya for T. A. Willard, to whom I am indebted for excerpts here quoted.

In this *Manuscrito de Chumayel* we learn of a story concerning the coming of the "First People" into Yucatan which bears evidence of considerable authenticity. It states that *"The First People"* came across the water *"from the east"* in boats. They were known as "Ah-Canule", meaning "People of the Serpent." Their mothers were "Ix-zac-u-luum", meaning "White Female Turkey", and "Ix-cu-lumil-na", meaning, "Female in the house on elevated land." They were the *First People* and located on an island off the east coast of Yucatan, which they named Cuzmil, later known as Cozumel. In time, their small population had grown to such an extent that they were forced to visit the mainland of Yucatan and build a city. At the end of each generation they sought new city sites. Their long and slow trek took the form of a figure eight, with the first or lower circle much larger than the upper. They built, in all, about 150 cities, and named each one according to the most important incident which occurred upon their arrival; such, for instance, as the manner in which Chichen-Itza

The
Ah-Canule

Built 150
cities

was named, the meaning of which is "The mouth of the wells of the Itzaes."

The above story is well substantiated by the fact that of the names mentioned as having been given by the "First People", fifty per cent remain to this day, and, what is more, have the same meaning as mentioned in *The Chumayel*.

So far, we have reviewed ample data, all from apparently reliable authorities, to the effect that the Mayas, or "First People" in Yucatan *arrived in boats from the east.* Concerning the

The arrival of Itzamna

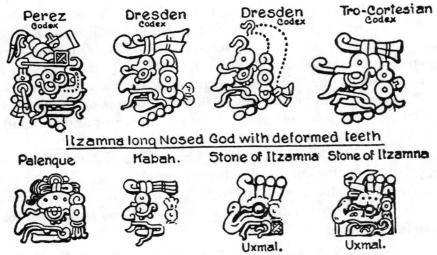

Perez Codex Dresden Codex Dresden Codex Tro-Cortesian Codex

Itzamna long Nosed God with deformed teeth

Palenque Kabah. Stone of Itzamna Stone of Itzamna

Uxmal. Uxmal.

Faces of Itzamna with deformed teeth as identification, from Pictures made by the Mayas in their hieroglyphic Books and elswhere — T.A.WILLARD.

"First People", whom we refer to as the ancient Mayas, no authentic evidence whatever exists which claims that these people came from the west. Churchward, who makes this claim, offers no items of convincing evidence; and both Churchward and Le Plongeon ignore the chronicles of the early Spanish writers, who are worthy of consideration, in reference at least to points on which they agree, for they came into actual contact with the last of the learned Mayas, and are at present the only direct link with the Maya historical past.

Itzamna

Further information of considerable interest in the Chumayel manuscript is the reference to the arrival of Itzamna in Yucatan *at a later date than that of the Ah-Canule people.* Upon his

arrival there was bloodshed, but later he became a leader and taught his people many things.

According to the most authentic early Spanish chroniclers of Maya history, Itzamna came "in his boat *from the east across the water*" in the fourth Ahau of the Maya calendar. This date is approximately 219 A. D. As the earliest dated Maya stone yet discovered bears the date 96 B. C., the coming of Itzamna in the fourth Ahau did not inaugurate the arrival of the Maya civilization in Yucatan and Central America.

He of the skillful hand

Itzamna was the personification of the *East*. He represented all that made up the foundation of the so-called Maya culture. His was a monotheistic faith. He is credited with having named "all beings, things and places of the peninsula, instituting the religion of the first epoch, unstained with blood. He was considered the father of wisdom, the legislator and prophet, benefactor of his people . . . " It is said that he claimed "a line of ancestors *of divine origin*." He is reported to have observed: "I am the celestial substance, and on me is the dew of the clouds and tears of the heavens."

The historian Lizana says of him: "He was a king, priest, legislator and ruler of benevolent character. He was called *Kabul*, the skillful hand, with which *he performed* miracles such as the *curing of the sick by the laying on of hands. He possessed the power of reviving the dead.*"

R. F. Gabriel Buenaventura, a Maya grammar authority, says: "The first one who found the letters of the Maya language and who made the computation of the years, months and centuries, and who taught it to the Indians of this province, was an Indian whose name was Kinich-Ahau, and who was called Itzamna."

Itzamna, said to be founder of Maya

Brinton says: "Chief among the beneficent gods was Itzamna. *He was the personification of the East* . . . He was said to have come in his magic skiff from across the waters . . . he received the name of Lakin-Chan, serpent of the east . . . *He was the founder of the culture and was the first priest of their religion. He invented writing and books* . . . he was famous . . . possessing the power of *healing by touch* . . . He himself is never connected with symbols of death, nor misfortune, but *always with those of life and light* . . . it is he who is connected with the *Maya tree of life,* the celebrated *symbol of the cross.*"

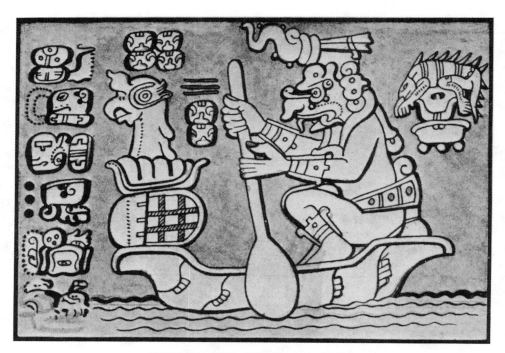

ITZAMNA AND HIS MAGIC SKIFF

From the Dresden Codex, ancient Maya hieroglyphic book, showing the deified leader prepared for a long journey. In the front of his boat is a big supply of food, and behind him is an additional bundle of provisions with an iguana on top. In the upper left-hand corner is the hieroglyph of the east. Itzamna personified the east. It is said he claimed divine origin, raised the dead, founded the Maya culture, and returned to Tlapallan, *a land beyond the waters to the east,* whence he came.

Here we learn of a personage with godlike characteristics, a much greater individual than a mere leader of a handful of hastily escaping emigrants, great though his powers would appear to such a group of followers. Here we are concerned with a man claiming "divine origin", who "performed miracles", cured the sick "by the laying on of hands", "possessed the power of reviving the dead", "was the personification of the east", "the founder of the (Maya) culture", "the first priest of their religion", and who "invented writing and books."

Landa says: "It is the opinion among the Indians [Mayas] that with the Itzaes, who populated Chichen-Itza, reigned a great man called Kukulcan. And they say he entered *by the*

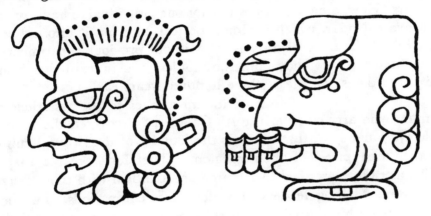

Arrival of Kukulcan

Two Deified Portraits of Kukulcan

part of the west and that he entered *before or after the Itzaes or with them.*" Later, the account states that Kukulcan *returned to Mexico* and in that country *he was known as Quetzalcoatl.*

Further to establish the attributes of Itzamna and prepare for my conclusions concerning Quetzalcoatl, it is again necessary that I deviate somewhat from the direct line of correlating the evidence.

First it must be admitted that the data have shown the undoubted spread throughout two hemispheres of what I believe to be Atlantean culture in all its branches. Even if the reader is not yet convinced that Atlantis was the center from which sprang the various civilizations of Europe, Asia Minor and the Americas, the evidence surely has established the fact of a common source. We

Facing facts

have learned, architecturally and otherwise, that the buildings in Yucatan and Central America most certainly did not result from an art begun in that area, but expressed an art that had matured elsewhere and was, when brought to Yucatan, already decadent. How, then, is it possible for an individual, no matter how great, to have "founded" the Maya culture—the architecture, letters, language, writing, and religion—in the early part of the third century A. D., when we have positive evidence of that culture's existence in the same territory at least as early as 96 B. C.?

It takes thousands of years to establish even a reasonably correct calendar. We, ourselves have taken almost two thousand years to discover and correct the errors of our previous calendars. How, then, was it possible for one individual to have invented the Maya calendar, which is almost perfect, and put it into use at the beginning of the third century A. D. without previous experiment, not to mention the fact that numerous tablets are in existence bearing undisputed dates of at least three hundred years earlier?

Identical attributes ascribed to many supermen

Similar criticism applies to the assertions that Itzamna, who arrived after the Ah-Canules, "discovered the letters of the Maya language", that "he was the founder of the [Maya] culture" and the "first priest of their religion." Therefore, we see that the godlike attributes ascribed to Itzamna are identical with those assigned to other outstanding leaders of widely different periods. The honor bestowed upon him, as with other supermen, apparently was accompanied by all the virtues associated with the Son of the Creator—he was of divine origin, able to raise the dead, heal the sick, perform miracles, was the founder of their culture, and so forth. As we shall see, Quetzalcoatl and other deified personages under discussion bear similar qualifications.

Poseidon and family

From Plato's story we learn of Poseidon as the founder of Atlantis. He was the god of the sea, and he married Cleito who was the goddess of waters. They dwelt in the Sacred Hill of Atlantis. This couple begat five pairs of twin boys. The most important of these sons was Atlas, the eldest. Each of the twins ruled over one of the ten states into which the kingdom was divided. *Atlas is shown as bearded,* and is popularly portrayed as *carrying the world on his shoulders.* This legend refers to a civilization that disintegrated with the last major sinking of Atlantis in approximately 9,600 B. C.

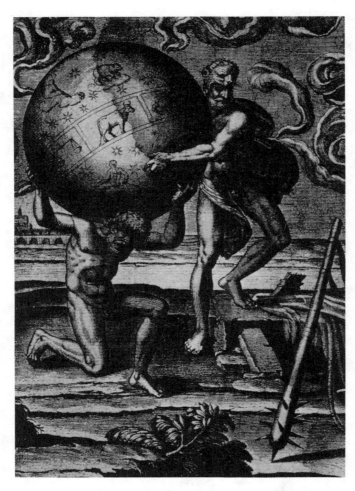

In Greek mythology Atlas, a twin son of Poseidon, founder of Atlantis, is portrayed carrying the world on his shoulders. (From *Les Philostrates*)

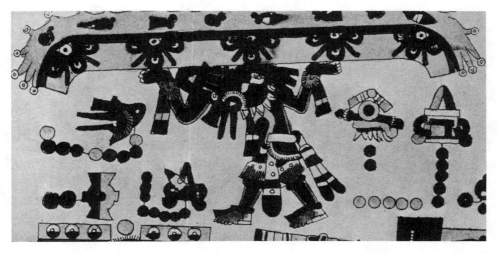

The Mexican Toltec Hero-god Quetzalcoatl, a twin son of Citinatonali, creator of all things, is likewise portrayed carrying the world on his shoulders. Is this a significance or mere coincidence? (From Kingsborough)

An almost identical myth is connected with ancient civilizations in the Americas. First comes the god Citallatonali, or Citinatonali, the creator of the heavens, the earth, and all living things. In Mexican mythology he is known as "the Very Old One." He is represented by the sign Cipactli, meaning "the dragon or whale from which the earth was made, and which rose out of the sea." Among the Mayas he represents the god of the sea, just as did Poseidon.

The Mayas refer to him as "the Old Serpent who is covered with green feathers and who lies in the ocean." He was also known to them as Gucumatz, meaning "Old Ones", alluded to in the *Popul Vuh* as a pair, male and female: "The old serpents covered with green and blue feathers (or scales) who live in the depths of the ocean."

The Mayas knew Quetzalcoatl as Itzamna, Kukulcan, and Gucumatz. As Kukulcan, he apeared in Yucatan in the beginning of the eleventh century A. D. As Itzamna, he appeared in Central America in the early part of the third century A. D. In the *Popul Vuh,* or *Cellection of Written Leaves*—a remarkable work written in the language of the Quiches, a branch of the Maya race—we learn that the "Cause of Existence" was the Father and Mother of all things. They were known as Xpiyacoc and Xmucane, the male and female progenitors respectively. They were also known as "The Old Ones", the Gucumatz, who are the serpents covered with green and blue feathers, and who dwelt in the deep. They are the same as Quetzalcoatl, Votan, Kukulcan, and Itzamna.

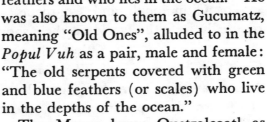

Quetzalcoatl

Oannes, the Chaldean Savior who came out of the sea, brought to the Chaldeans their culture, and returned to the sea. Similar attributes are observed among American myths.

The Mexican dual gods Citinatonali, or "The Old Ones", where the parents of Quetzalcoatl, one of twins. In fact it

is recorded that "The Old Ones" begat five pairs of twins. Quetzalcoatl is described as *bearded,* father of the arts, and *one of the supporters of the world.* Coatlicue is described as the wife of Citinatonali, mother of Quetzalcoatl, goddess of the waters.

*Supporters of
the world*

In brief, then, we see that Poseidon, mythical god of Atlantis, is credited with attributes identical with those of Citinatonali, of Central America. Cleito, wife of Poseidon, is a goddess, the double of Coatlicue, wife of Citinatonali. Each of these couples begat five pairs of twins.

The outstanding offspring of Poseidon and Cleito was Atlas, who is an almost exact counterpart of Quetzalcoatl, son of Citinatonali and Coatlicue. Both were bearded, and both reputedly bore the world on their shoulders.

Other evidence bearing on the subject we gather from the interpreter of *The Codex Vaticanus A.* The writer says: "They say that it was he [Quetzalcoatl] who effected the reformation of the world by penance, since, according to his account, *his father had created the world* and men had given themselves up to vice, on which account it had frequently been destroyed. Citinatonali (The Father, The Old Ones, the Old Serpent covered with green and blue feathers, Creator af All Things) *sent his son into the world to reform it.*" Here we learn of remarkable parallels to be observed in the Christian faith.

*Sent his son
into the
world to
reform it*

Quetzalcoatl was also known as the *Son of the Virgin,* Coatlicue. Here we have another parallel with the Christian belief. Still further identical attributes between Christ and Quetzalcoatl are seen in the following:

*Christ and
Quetzalcoatl
have identical
attributes*

Dr. Wallis Budge tells us that: "The cult of Osiris is as old as Dynastic Egyptian Civilization, and from the earliest to the latest times he was regarded as the God Man *who suffered, died and rose again,* and reigned eternally in heaven. He was the 'King of Eternity', 'lord of the everlastingness', 'the prince of gods and men', 'the god of gods', 'the governor of the world whose existence is everlasting.' " The Aztec legend description of Quetzalcoatl is almost identical.

We have learned, therefore, that, as with Christ in the Christian faith, Quetzalcoatl, under whatever name, was revered not only as a god, but as a man. He was known as the Son of

God "who was sent into the world to reform it", he was the "Son of the Virgin", and, as was the case of Christ and the Egyptian god Osiris, he suffered, died and rose again.

Further, we have learned from the legend of Poseidon, the mythical founder of Atlantis, that the zones of land and water, the Sacred Hill, the twins, Atlas the son, and the wickedness of the people which caused the gods to flood the lands by submergence, as related by Plato, find their almost identical counterpart in the legends of the Peruvians, the Aztecs, the Creek "Indian", and the Miztecs. In a lesser degree the legends exist among other ancient races in the Americas, while the so-called Flood Myth is known among practically all races and tribes on the Western Hemisphere.

Additional parallels

From the Peruvian legends we learn that Paria-caca, the Peruvian god, arrived in a hilly country, as did Poseidon. Because the people reviled him he sent a great flood upon them. The beautiful maiden Choque Suso, whom he wooed and won, he eventually turned into

Viracocha also a Culture hero

J. S. M. Ward, B. A., F. R. Econ. S., in *Freemasonry and the Ancient Gods,* suggests that the above illustration (from Kingsborough) depicts Quetzalcoatl descending the ladder of 33 steps from heaven, corresponding to his age. This brings to mind the biblical heavenly ladder, Christ's age at death, and Mohammed's ladder to heaven of 33 steps. Do these parallels point to a common origin?

a statue of stone. There is another version of the Peruvian myth which states that the god Thonapa became angered at the people of Yamquisapa because of their lust for pleasure and debauchery, and destroyed their city by drowning it in a great lake. In this region was a

sacred hill upon which stood the statue of a woman whom the people had worshiped. The god destroyed both the hill and the statue and disappeared into the sea.

The Aymara-Quichua race of Peru worshiped Viracocha as a culture hero. He was the Maker of All Things. He taught his people their culture. He sent storms and cataclysms upon

Significant comparisons

THE CRUCIFIXION OF QUETZALCOATL
(From the *Codex Borgianus.* Kingsborough.)

The attributes of the mythical gods of the Greeks, Egyptians, Phoenicians, Hindus, Scandinavians, and the ancient races of the Americas correspond with the gods of Atlantis as described by Plato and others. The Cross is phallic, symbolizing the generative powers of nature, and was prevalent among the peoples of both hemispheres. Among the many historical and allegorical world saviors who were crucified are the Hindu Buddha, the East Indian Christna, the Egyptian gods Osiris and Horus, Jupiter, Christ, and the Mexican Quetzalcoatl.

A Seminole Legend

his people. He was the Ruler of the Sea, as were Poseidon and Quetzalcoatl. He was the Rain God, as was Kukulcan. In the end he disappeared into the ocean. He was thought of as coming from the Region of the Dawn (the east), as were Quetzalcoatl, Kukulcan, and Itzamna.

A legend has been preserved by the Seminoles, the Creeks, and the Choctaws which says that a *great hill* appeared

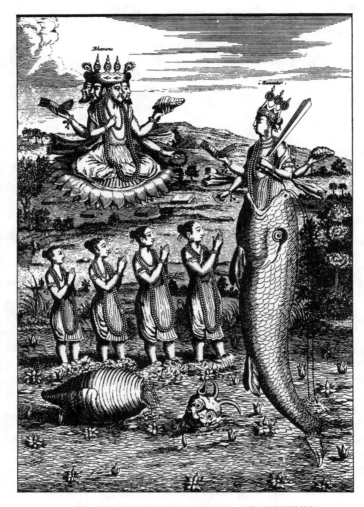

THE FIRST INCARNATION OF VISHNU

The fish has frequently been associated with World Saviors. Vishnu was expelled from the mouth of a fish. The Egyptian Isis is often shown with a fish on her headdress. Oannes, the Chaldean Savior, is depicted with the head and body of a fish from which his own form protrudes at various points. Christ was symbolized by a fish. The mysterious Greek name of Jesus means a fish. The first monogram of the Christians was a fish. Oannes came out of the sea, was amphibious. He brought to the Chaldeans their culture, showed them how to build cities, and retired again to the sea. Quetzalcoatl, the Mexican Toltec hero-god, is represented by a whale which rose out of the sea— the old serpent covered with feathers who lies in the ocean. He, too, was amphibious and was known as "the Heart of the Sea." He, too, reputedly brought to his people their culture.

when the earth rose out of the waste of waters. This hill was called Nunne Chaha, in the center of which stood a great castle in which lived Esaugetuh Emissee, meaning "The Master of Breath." This god built men of clay and protected them by building *an encircling wall.*

The serpent motif in Maya and Aztec art is undoubtedly symbolic in all its forms. The serpent cult, we learn, was

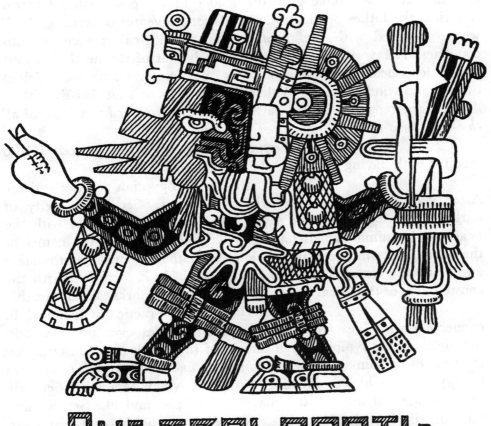

QUETZALCOATL

FROM THE MEXICAN CODEX BORGIA ~ BY ~ R.B.S.J.

venerated by Druids, Egyptians, Aztecs and Mayas. We find also that the symbol of the serpent and the bird is common to both Egyptians and Aztecs. Herodotus says that the Egyptians believed that the sacred ibis destroyed the serpent. One of the outstanding legends of Mexico is of the founding of the City of Mexico. According to the legend, the eagle, instead of the ibis of the Egyptian myth, destroys the serpent.

The serpent was the symbol of protection of both Itzamna and Quetzalcoatl.

When we turn to Egyptian mythology, we discover a host of characteristics easily discerned among the cultures of the Americas. Thoth, the Egyptian god, is credited with having invented "the art of writing." He is known as the scribe of the gods. Quetzalcoatl, the Toltec god, the leader of his people into Central America, the father of the arts, was also the inventor of writing. Both were connected with the moon in the astrological science of both countries. A favorite headdress for both is that of the head of a bird with a long beak. Both were masters of magic and both were deities of rain and wind. Charles Walcott Brooks tells us that Tai-Ko-Fokee, "the great stranger", ruler of earliest China, *introduced writing and all the arts to his people.*

Tai-Ko-Fokee introduced culture into China

The Egyptian Osiris, father of the gods, is also credited with having invented "the three letters."

The attributes of the Egyptian god Set and the Aztec god Tezcatlipoca are strikingly similar. Set is the deity of darkness and night. Spence says: "He [Set] is represented with the head of an animal which has been likened to that of the camel or the okapi, but which seems to belong to neither. Storms, earthquakes and eclipses were attributed to his agency. He is identified with the constellation of the Great Bear, the region of cold, darkness, and death."

These associations are practically identical in connection with Tezcatlipoca. "He, too, presides over darkness and the night, and is symbolized in certain of the Mexican manuscripts by the head of an animal *unknown in Mexico, and seemingly also unknown in Egypt,* but which is identical with that which represents Set. He was the deity of storm, earthquake and eclipse, and like Set, we find him identified in the *Historia de los Mexicanos* with the Great Bear, from whence no good thing might come. He typifies coldness, sereneness, and sin."

Quetzalcoatl of foreign origin

Votan (Quetzalcoatl) made frequent visits to the land whence he came, Tollan-Tlapallan, as the Toltecs called the country, which they claimed was *in the eastern ocean.*

Ixtlilxochitl described Tlapallan as a region near the sea, and the Aztec myths concerning Quetzalcoatl are agreed as to his alien origin. As the traditions of the Aztecs frequently refer to their original homeland as "on a great water" perhaps we may

assume, as fact, that Tollan-Tlapallan, the land from which Quetzalcoatl came, was situated in ancient Antillia, of which the present Greater and Lesser Antilles are now all that remain.

Upon one of Quetzalcoatl's numerous visits to his homeland Tlapallan, it is said, he came to a great tower which reached into the heavens. Its builders intended to save themselves in the event of another cataclysm, but, *due to the confusion of tongues,* the Creator destroyed it.

Another American Tower of Babel

Another American version of the Biblical Tower of Babel is that given by Father Duran in his manuscript *Historia Antigua de la Nueva Espana,* A. D. 1585. He says that he secured the legend from the lips of a native of Cholula, Mexico, whose age was over one hundred years. The recital, in part, reads as follows: "In the beginning, before the light of the sun had been created, this land [Cholula] was in obscurity and darkness, and void of any created thing: all was a plain, without hill or elevation, encircled in every part by water . . . and immediately after the light and the sun arose in the east there appeared gigantic men of deformed stature and possessed the land; and desiring to see the nativity of the sun, as well as his occident, proposed to go and seek them. Dividing themselves into two parties, some journeyed to the west and others toward the east; these travelled until the sea cut off their road, whereupon they determined to return to the place from which they started, and arriving at the place [Cholula], not finding the means of reaching the sun, enamored of his light and beauty, *they determined to build a tower that its summit should reach the sky* . . . and having reared it to the greatest possible altitude, so that they say it reached to the sky, the Lord of the Heavens, enraged, said to the inhabitants of the sky 'have you observed how they of the earth have built a high and haughty tower to mount hither?' . . . Immediately the inhabitants of the sky . . . destroyed the edifice *and divided and scattered its builders* to all parts of the earth."

Bible and the Aztecs

The Bible says that: "They found a plain in the land of Shinar, and they dwelt there." This agrees with the Aztec legend above, which reads: "All was a plain without hill or elevation." Both accounts agree as to the builders being "determined to build a tower so high that its summit should reach the sky." Both state that the Lord of the Heavens became angry and decided to descend to earth "and confound" the presumptuous builders. In the Bible story

there was a confusion of tongues *and the people scattered;* the Mexican Tower of Babel was destroyed by the gods and the people were scattered.

The Pyramid of Cholula

The great pyramid of Cholula is a stupendous piece of construction. It occupies almost four times the area of the Great Pyramid of Cheops in Egypt. The latter covers an area of between twelve and thirteen acres, while the former covers forty-five acres.

In a Toltec legend we are told that the Cholula pyramid was built "as a means of escape from a second flood, should another occur." The evidence in all cases agrees that the structure was erected by 'aliens', but in Torquemada's *Monarquia Indiana* we learn that Quetzalcoatl, after visiting Tollan and finding that part of the country too thickly populated, led his people, the Toltecs, to Cholula, where they were well received.

Atlantis, seemingly, is the logical center around which these stories originated; especially when we remember that all the legends of both hemispheres concerning outstanding cataclysms indicate an erstwhile land surrounded by water. It is obvious that, with the total absence of any mention of a devastating flood having occurred in the centers preserving the flood legends, the construction of a so-called Tower of Babel would be superfluous. It is further obvious that the great pyramid of Cholula was built in fear of a fate similar to that which occurred in a land whence the builders came, as it must be remembered they were aliens. If such a structure was built by the Chaldeans, as is described in the Bible story, it was for similar reasons. In all probability, both legends were derived from accounts of an Atlantean cataclysm.

No flood occurred in centers preserving legend

In his *Historia del Cielo,* Ordonex de Aguilar says that Votan, a local name for Quetzalcoatl, "proceeded to America by divine command, his mission being to lay the foundations of civilization in that land."

Who, then, is Quetzalcoatl?

If this personage, Votan, is Quetzalcoatl, then it is obvious he could not be the Quetzalcoatl who finding "the country there [Tollan and its immediate neighborhood] *too thickly peopled,* passed on to Cholula, where they were well received."

Also, it must be remembered, we have learned that the Mayas spoke of Quetzalcoatl as Gucumatz, the founder of their civilization in the Americas. Of further significance, in view of

the hypothesis I offer later, are certain analogies observed between Buddha and Votan. For instance, Humboldt says: "We have fixed the special attention of our readers upon this Votan, or Wodan, an American who appears of the same family with the Wods or Odins of the Goths and of the people of Celtic origin. Since, according to the learned researches of Sir William Jones, *Odin and Buddha are probably the same person,* it is curious to see the names of Bondvar, Wodansdag, and Votan designating in India, Scandinavia, and in Mexico the day of a brief period."

All came "from the east"

Concerning the various principal American invasions by the Aztecs, Toltecs and Mayas, which occurred at widely spaced intervals together with the legendary reference to the arrival of "the first peoples" on the American continent, we see that the leader in each case was, apparently, the same personage, whether known as Votan, Gucumatz, Quetzalcoatl, Viracocha, Kukulcan, or Itzamna. One and all are known as "The Feathered Serpent", "The Old One", "The Founder of Civilization", "The Civilizer", "The Creator of All Things", etc. In any case there appears to be no evidence contrary to the claim that, no matter by what name he be known, Quetzalcoatl came in his boat across the waters, *from the east.*

Again turning to the *Documentos Inéditos* we learn that in the *History of Teav-y-Tec and Tiscolum* the author, Juan Bote, says: ". . . The first lord of Uxmal was called Hunuitzilchac—it is said of him that he was very wise in native things, and in his time taught them how to work the land, *divide the months of the year and taught the letters."* Here we see further reference to Kukulcan, otherwise Quetzalcoatl, Itzamna, Votan, and so forth.

It is obvious that the Maya natives in Landa's time were greatly confused; they were not sure whether Kukulcan arrived before, after, or with the Itzaes. The Spaniards had ruthlessly slaughtered what few intelligent Mayas were living at the time of their arrival, and Landa had destroyed their libraries. It is, therefore, not to be expected that the remaining simple natives would be acquainted with much of their early history.

A conferred title

As we have seen, the Itzaes, under the leadership of Itzamna, or Zamna—another name for Quetzalcoatl, Kukulcan, etc.—entered Yucatan approximately in the year 219 A. D., after the Ah-Canule, or First People. Additional evidence, given later, will tend to show that Kukulcan or Quetzalcoatl arrived in Yucatan approxi-

mately in the year 1000 A. D., or shortly afterward. This shows a discrepancy of almost 800 years. My belief is that the title, in all cases being a conferred one, caused the confusion. In my opinion, those who champion the theory that the Mayas came from the west have been misled by Landa's statements and other similar references to Kukulcan arriving in Yucatan from the west. It appears evident that the students referred to failed to associate Kukulcan (which name does not appear in Yucatan prior to the beginning of the eleventh century A. D.) with

Many deluges

Quetzalcoatl, who in Mexican mythology and legends is described as their leader who came in a boat from a land situated *"in the east."* Kukulcan's visit to Yucatan was a purely temporary one. During his stay he is credited with having built the city of Mayapan (which statement I doubt) in addition to numerous pyramids in Chichen-Itza, Uxmal and elsewhere. It is further claimed that he built the "Adivino" in Uxmal, one of the most interesting of all the pyramids, but in this also I disagree, as unquestionably that structure was erected many hundred years earlier. However, it is recorded that he left Yucatan as he entered it, via Chanputan, where he erected a large building in the sea to commemorate his visit. According to Herrera, this structure was plainly visible in the year 1618 A. D.

In Plato's narrative, it will be remembered, he quotes the old priest of Sais as saying: "For, in the first place, you remember one deluge only, whereas there were many of them." This remark is assumed to have been made approximately 600 B. C. It is perfectly obvious that the slow disintegration and submergence of the erstwhile vast continent of Atlantis would occasion numerous migrations east and west to safer lands. Naturally, the leader who successfully piloted an escaping horde across the storm-tossed sea to safety would be hailed as a great deliverer. The safe arrival on a friendly shore

Excusable errors

raised the status of their leader to the dignity of a god. The attributes of Itzamna are similar to those of other gods in the mythology of both hemispheres, long prior to the arrival of Itzamna in Yucatan (219 A. D.). Therefore Itzamna, like Quetzalcoatl, Votan, Kukulcan, and Gucumatz, was, in my belief, a deity-title bestowed only upon those who were saviors or who had rendered service of supreme national importance. It is further logical, in view of the corroborative evidence, to assume that the Maya priests who wrote the sixteen books of the Chilan-Balam made a mistake in acclaiming Itzamna as the leader of the Yucatan invasion in the early part of the third century A. D.; a

leader who also gave them their culture. But that he was the leader of a people calling themselves Itzaes is perfectly logical, for he was a very great leader, according to all accounts; on the other hand it is just as evident that he could not be the "inventor of books and writing", the "father of the arts."

As we have seen, many great floods were recorded in Europe and Asia, according to the Egyptian priest of Sais; many occurred, in my opinion, in which the peoples of the western world were concerned. The Aztecs, for instance, believed "that the earth had been destroyed on several occasions, by the agency of fire, tempest and water." They also believed that the earth was not destined to receive its present inhabitants, although occupied by man-like beings, until it had undergone a series of cataclysms or partial destructions. I suggest therefore, that the ancient records concerning Itzamna, of which we now are in possession, were written by men ignorant of the general culture of their forefathers. Nevertheless, the ignorance of the writers of the Chilan-Balam should not be stressed too heavily, when it is remembered that these men wrote their recollections of their country's past entirely from memory. I wonder how many college or university professors, if suddenly deprived of all recourse to reference books, could write an accurate history of the United States of America. Certainly no two out of sixteen would agree.

*Histories
written from
memory*

In view of the evidence, therefore, I offer the suggestion that exalted titles, such as Quetzalcoatl, Votan, and the rest, were conferred upon the great leaders, not for distinguished execution of the country's business but for piloting a panic-stricken people from a sinking land to a place of safety, and then establishing well-conducted colonies with at least a semblance of the former culture. The greatest title which they could confer would be little enough.

To my mind, the evidence is sufficiently corroborative, and there is no justifiable reason for not accepting the various legendary references to numerous invasions of the Americas at different periods, from a land which sank "in waters toward the rising sun"; all of which invasions were led by men who apparently were awarded the same apotheosis under different names with the same meaning.

*Heirs to title
descended
from Atlantis*

It seems evident, therefore, that the personage known as Kukulcan by the Mayas and Quetzalcoatl by the Toltecs who flourished during the tenth and eleventh centuries A. D. is not

the Quetzalcoatl to whom the Toltecan and Mexican legends refer to as the "Creator of All Things", the founder of their culture, he who gave them their letters, and so forth, but that he fell heir to the titles which had been bestowed upon earlier leaders of their own and of other peoples, in times of extraordinary national adversity.

Sculptured head of a distinguished personage discovered at Kabah, Yucatan. The strange cicatrized design on the left side of the face is a painful form of tatooing, charcoal dust being inserted into the wounds to give prominence to the scars. Tattooing was practised on both continents.

Adam and Eve by Durer. Winchell says that Adam means of the red earth. ADaM, meaning a man, red, ruddy. Hargrave Jennings says Adam is symbolic of the lingam of Siva. The Hebrew word Elohim means God the androgynous, male and female creative powers. The Bible says God created Adam first (prior to the separation of the sexes) as a plural, of the dual sexes, in His own (dual) image. (See Genesis, Chapter 1.)

Chapter Seventeen

Summing up the Evidence

Proponents of Atlantean theory grow- ing rapidly

THERE are two leading theories of the origin of cultures, each with numerous variations. One theory regards the successive existences of a culture in widely separated parts of the earth as either mere coincidence or the result of the psychic unity of mankind; the other regards such a succession as the result of dissemination.

Coincidence may explain, psychic unity may explain certain broad likenesses. But similarities in multitudinous profusion of detail they cannot explain. The disseminationist, on the other hand, finds his chief asset in such a multitude of similarities—provided his premise is sound.

Among the adherents to the dissemination theory is a group that proposes Egypt as the mother of civilizations; other groups propose Northwest Africa, Mesopotamia, Central Asia, and divers other centers. Apart from these is the group that supports the Atlantean hypothesis, who, since the middle of the last century, have collected a body of data that keeps outdistancing the rest in volume and coherence. The proponents of a vanished Atlantis as the earliest discernible center from which certain great cultures have spread differ from those who propose still accessible parts of the earth in having to

depend on circumstantial evidence alone. But the circumstantiality is of a pattern much clearer than any evidence in behalf of other proposed sources of dissemination; and it is no less than a conclusive refutation of the psychic-unitarians.

But intolerance still prevails over inquiry in many fields, for we are not living in a truly scientific age. It is with this in mind that I have written in support of the Atlantean hypothesis, trying not to forget that the Lord "taketh the wise in their own *Flood legends* craftiness." My interest in Atlantis as the source of certain ancient peoples and cultures of the Old and the New World began with my study of the Mayas. And the more I learned about them the more analogies I found with Old World races, peoples, and cultures. I have set them forth in the foregoing chapters. If the argument has been hard to follow in some passages, it may be owing not entirely to my limitations but also partly to the wealth of detail. It is advisable, therefore, to summarize here the whole case for Atlantis.

As the Flood story is preeminently concerned with the basis for my general argument, I shall briefly note some of its more important corroborative data.

We have seen that the *Genesis* account of the Flood is almost identical with the Chaldean story set down at least as early as 1,700 B. C.; thousands of years earlier is the Akkadian version; there is a Hindu story in the *Rig-Veda* similar to that of *Genesis,* with Manu as Noah; similar also is the Iranian (Persian) account, whose Noah is Yima; and there are the Greek legends. In brief, all the legends from Europe and Asia resemble each other and the Noah story. When we come to the Americas we find Flood legends from Alaska to South America, almost parallel with those of Europe and Asia.

Bible Flood Story concerns only the white race The Bible story of the Flood cannot be construed as referring to one of universal proportions, because the Bible's list of peoples sprung from Noah definitely excludes the black, yellow, and red races. As Lenormant says: "The descendants of Shem, Ham, and Japhet . . . include only one of the races of humanity —the white race."

We find that Egypt does not contribute a single reference to such a world-wide legend as that of a Flood. Is not that remarkable? Donnelly says: "To my mind the explanation of this singular omission is very plain. The Egyptians had preserved

in their annals *the precise history* of the destruction of Atlantis, out of which the Flood legends grew."

Another point: whether in the Old or the New World, we find no reference to a destruction of *land*. So we assume that extant accounts of the cataclysm cannot refer to any land now visible.

In seeking through the seven seas for the possible location of such an erstwhile land area, we are confronted by three principal legends of major-continent submergences: Gondwana-land, a reputedly vast continent which stretched from India to South America and included Africa and Australia; Lemuria, or Mu, generally assumed to have occupied a portion of the Pacific Ocean; and Atlantis, the probable one-time land bridge connecting Europe with America. The probability of the first two legends is conceded; but there is not a vestige of corroborative data to support a theory that either one was the mother country from which sprang the numerous ancient cultures. Nevertheless, there apparently is no reason to doubt that a major area of land once existed in which flourished such a mother empire.

Three lost continents

The evidence has shown beyond conjecture, first, that the Mayas of Yucatan and Central America, and other ancient peoples of the Western Hemisphere, arrived hurriedly from a land amid water situated toward the rising sun—the east—bringing advanced cultures with them; second, that the Cro-Magnons, the Akkads, the Egyptians, and other early peoples of Europe and Asia Minor migrated hurriedly from a land amid water situated toward the setting sun—the west—bringing advanced cultures with them; third, that all those cultures, of both hemispheres, bear basic similarities pointing definitely to a mother source; fourth, that no evidence exists to show that those cultures were disseminated from any land now visible; and fifth, that to the west of Europe and to the east of the Americas, which is the Atlantic Ocean, a land once existed known as Atlantis.

Hurried arrivals

The legend of Atlantis is attributed primarily to Plato, but it is now known that his narrative is not the only reference to Atlantis, for the story has been found, in part, in ancient Hindu books. In addition, we have seen in the legends of other races a direct or an inferred reference to a lost land.

Regarding the possibility of large bodies of land rising or falling, the geological evidence shows, for instance, that " . . . the whole coast of South America lifted up bodily ten or fifteen feet and let down again in an hour"; that the Andes sank two hundred and twenty feet in seventy years; that the shores of the Scandinavian Islands have risen from two hundred to six hundred feet within the last five thousand years; that Great Britain at one time " . . . was submerged to the depth of at least seventeen hundred feet"; that the Desert of Sahara was once under water; and that geologists agree that all existing continents once were under water. We considered the evidence of recorded volcanic disturbances which caused the submergence of minor land areas. We have learned of air-cooled lava taken from the bottom of the Atlantic Ocean. And we have the evidence of the combined report of the United States, German, and British governments showing that a great bank exists 9,000 feet above the Atlantic Ocean bed, beginning not far from the coast of Ireland, extending southeasterly almost to the coast of Africa, and from that point westerly almost reaching the coast of Central and South America.

The evidence of Geology

We have the biological improbability of certain faunal and floral migrations from one hemisphere to the other except via a land bridge. And we have seen the illogic of an Asiatic invasion of the Americas.

On both sides of the Atlantic we find among the ancient races—and even among their present descendants—precisely the same religious beliefs, customs, habits, traditions, legends, sciences, arts, and linguistic affiliations, all suggesting a common root.

The evidence of Religious Customs

The early races of both hemispheres worshiped one god, believed in the resurrection of the body, and the immortality of the soul. They worshiped similarly, practised phallic rites and circumcision, and made images of Pan. The cult of Osiris is definitely traced through all the early and late civilizations on both hemispheres. The witchcraft lore, mythology, and legends of all these people contain identical fundamentals.

Sun worship prevailed among the Cro-Magnons, Akkads, Egyptians, Basques, Peruvians, Panamanians, the American Indians, Toltecs, Aztecs, and Mayas.

Sarcophagi were employed by the Canary Islanders, Egyptians, Pre-Incas, Aztecs, Mayas, and others.

The preservation of human bones and painting them red was a custom among Cro-Magnons, American Indians, Pre-Incas, and the Antillians.

Embalming and mummification were common practices among the Cro-Magnons, Canary Islanders, Egyptians, American Indians, Pre-Incas, Antillians, Aztecs, and Mayas.

The evidence of Mythology

Burnt offerings and incense burning were customs among the peoples of both hemispheres.

Other religious links apparently connecting the cultures of both hemispheres with that of Atlantis are the references to Maya affiliations in the Mormon records, and the parallels between Jewish and Maya religious rites and customs.

We have seen that the god Poseidon of Plato's Atlantis, Osiris of Egypt, Christ of the Christian faith, Quetzalcoatl of the Toltecs, Votan of the Quiches, Kukulcan of the Aztecs, Zamna or Itzamna of the Mayas, and Pariacaca of the Peruvians, all bear strikingly similar attributes. And it is interesting to learn that the god of the Welsh triads is known as *"Hu,* the mighty", the Quiches' hero-god as *H*u-Nap-Hu, and the Maya god as *H*unab-Ku, or *H*unal-Ku.

The evidence of Symbology

In connection with the serpent and its symbolic meaning, we have, among scores of similar references, evidence linking the early peoples of both hemispheres.

In a Hindu book *Manava Dharma Sastra,* the serpent is referred to as the Creator. The sacred book of the Quiches, the *Popol-Vuh,* says: "The Creator, the Maker, the Dominant, the Serpent covered with feathers." Kan means serpent in the Maya tongue, and is associated with God, the Creator. Eusebius says that the Egyptians called the Creator Kneph, who was symbolized by a serpent. Khan was the title adopted by the Asiatic rulers, and the serpent became their emblem of rule, as was the custom among the Egyptian kings.

The evidence of Ancestor Worship

In ancestor worship we see another link. In the Egyptian reference books of the British Museum, by E. A. Wallis Budge, we learn that " . . . the worship of ancestors . . . appears to have been general" in Egypt up to the time of King Semti, or Ten, formerly known as Hesepti. This king reigned in the first Egyptian Dynasty, approximately 4,400 B. C.

Among the early American races, ancestor worship was, and still is, a religious custom. R. G. Halliburton in

Festival of Ancestors, speaking of ancestor worship says: "It is now, as it was formerly, held at or near the beginning of November, by the Peruvians, the Hindus, the Pacific Islanders, the people of the Tonga Islands, the Australians, the ancient Persians, the ancient Egyptians, and the northern nations of Europe, and continues for three days among the Japanese, the Hindus, the Australians, the ancient Romans and the ancient Egyptians."

The evidence of Legends and the Bible

Further links of a religious nature are seen in comparisons between the Bible records and American legends. For instance, the story of the Creation. The Bible says: "And the earth was without form and void." In the Quiche (branch of the Mayas) legend, it says: "At first all was sea—no man, bird, or green herb— there was nothing to be seen but the sea and the heavens." The Bible and the Quiche legend agree as to the separation of the land and the waters. They also agree as to the origin of man. "And the Lord God formed man of the dust of the ground," says the Bible. "The first man was made of clay," says the American legend.

According to the Quiche legend, the Creator saw that there were four men (from whom descended the four races of mankind—probably suggesting the red, black, yellow and white races) who were without wives. The Creator made wives for them "while they slept." The Biblical version is: "And the Lord God caused a deep sleep" to befall Adam—"and He took one of his ribs and— made He a woman, and brought her unto the man."

In the *Documentos Inéditos*—a work considered by many to be of equal importance with the manuscripts by Father Diego de Landa—we learn that the Mayas "had knowledge of only one God, Hunal-Ku (or Hunab-Ku) . . . They *had knowledge of the creation of the first man and that God made him of the earth,* who was called Ahom, the Tree of our Existence. After he was made, a woman appeared before him, whom he married. From that proceeded all of the human race."

Toltecs and the Garden of Eden

In the monumental works of Lord Kingsborough we read: "The Toltecs had paintings of a garden, with a single tree standing in the midst; round the root of the tree is entwined a serpent, whose head, appearing above the foliage, displays the face of a woman." Is this not reminiscent of the Biblical version of the Garden of Eden?

Turning now to architecture and engineering, we have learned that city planning, as described by Plato in his story

of Atlantis, was followed almost identically by the Peruvians, Aztecs, and Mayas of the western world as well as by the early Greeks and other peoples of the eastern world.

It is recorded that the early Peruvians built roads up to two thousand miles in length. Humboldt says "they were among the most stupendous works of man." They built aqueducts up to five hundred miles long. They constructed magnificent bridges in

The evidence of Architecture

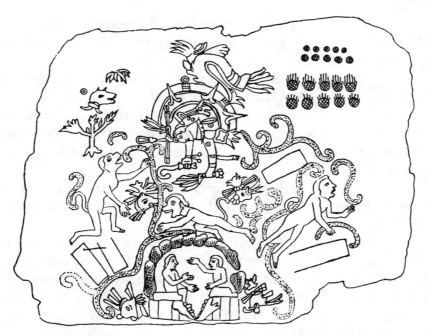

The Mexican Story of Creation depicting Adam and Eve.
(*Anales del Museo Nacional*)

stone, and "invented suspension bridges thousands of years before they were introduced in Europe." The ancient Mayas also were great builders of roads and waterways. And Plato tells us that the Atlanteans constructed enormous watercourses, roads and bridges.

The evidence of Customs

Mound building, also, was a custom among practically all of the ancient races on both hemispheres.

The pyramid was associated with burial and with embalmed bodies, in Egypt, the Antilles, Mexico, Yucatan, Peru, and elsewhere. Pyramids with pointed apexes exist in Egypt, Central America, and Mexico. Pyramids faced with stone were built by the Egyptians, Toltecs, Mayas, and others. We have considered the

probability that the prototype of the pyramid is to be found in Plato's Sacred Hill of Atlantis.

We found that the Egyptians and the Pre-Incas erected monumental structures in stone without the use of mortar.

We have traced the obvious similarities in motifs through the architecture of the ancient cultures of both hemispheres, notably the serpent motif, and the almost identical sameness in other symbolism.

Tattooing

The custom of head flattening prevailed among the Magdalenian Cro-Magnons, earliest Egyptians, Antillians, American Indians, Pre-Incas, Aztecs, and Mayas.

Both Egyptians and Mexicans possessed a *Book of the Dead*; both had a *Street of the Dead*.

Boring circular holes in the skulls of the dead to release the soul was a common practice among Azilian-Tardenoisian Cro-Magnon man, early Canary Islanders, Mound-building American Indians, and the Pre-Incas.

Filing or serrating the teeth was a practice common to Toltecs and Mayas, and is found in Africa and elsewhere in the Old World.

Tattooing was a custom among the early races in both hemispheres. The women of some of the African tribes still tatoo their faces, arms, and ankles. Dorman says: "Every Indian [American] had the image of an animal tattooed on his breast or arm to charm away evil spirits." It is still a custom preserved from antiquity for sailors to tattoo their arms and chests.

The evidence of odd practices

The mark of the hand by impressing it on the walls and elsewhere is a custom prevailing to this day from remote times. It was prevalent at least twenty-five thousand years ago among the Aurignacian Cro-Magnons, and among the Egyptians, American Indians, Mayas, and it is a very common practice among the present-day Arabs.

Both in Egypt and Peru the rulers were accustomed to put their hand to the plough at the annual festivals, "thus dignifying and consecrating the occupation of husbandry." The custom prevails in America to this day.

In Asia, Africa, and America the bark canoe was used. On the Euphrates and the waterways of Peru, rafts supported by inflated skins were employed.

The Chaldeans, Egyptians, and Peruvians divided the year into twelve months. Five days were added to complete the 365-day year. Both the Egyptians and the Mayas regarded these additional days as ominous ones.

Astrology was an advanced science among the very early Akkads in the Euphrates Valley, the earliest Egyptians, Pre-Incas, Toltecs, Aztecs, Mayas, and other races.

Paper was manufactured almost identically by the Egyptians, the Mexicans, the Pre-Incas, and the Mayas.

There is no record for at least the past seven thousand years which indicates the further domestication of wild animals, or of foodstuffs from the wild plant. The culture of cotton and manufacture of its product were known to the ancients of both hemispheres, yet cotton never has been discovered growing in its wild state in any part of the known world except in America.

Evidence of domestication

We have learned also of the remarkably sumptuous display of precious metals in building adornment among the Pre-Incas, the Akkads and, according to Plato, the Atlanteans.

We have traced the courses of the Cro-Magnons, the Basques, Aryans, Iberians, Akkads, Egyptians and other early peoples of Europe and Asia Minor, and we have noted the cultural parallels between all those peoples and the early peoples of the Americas. We have traced back to their apparent origin such subjects as religion, symbolism, the arch, the column and its capital, and the serpent and other art motifs. We have learned the remarkable fact that Christ's last words were apparently recorded in the Maya tongue. And we have discussed the hypothesis that all the early inhabitants of the Eastern Hemisphere and all the early inhabitants of the Americas apparently belong to one great family tree; the root of which, in my belief, was in Atlantis.

The evidence of the American Mound-Builders

In conclusion, I again call the reader's attention to the American Indian, the evidence I submit to suggest his origin, and my belief in his very early arrival on the American continent. As we have seen, many savants believe the American Indian is a comparatively new comer to the Americas. It will be remembered that Lewis Spence remarks: "I believe the Mound Builders of North America to have been the *cultured descendants* of those Maya-Toltecs who found their way from Guatemala to Mexico, and who, quite conceivably, may

have pushed farther north. *Indeed this view is accepted by many authorities of weight.*"

From Plato we learned of the Sacred Hill or natural mountain of Atlantis. If we decide to believe him, then we may presume that the Sacred Hill of Atlantis was the center whence sprang Osiris worship; that all the peoples who it is presumed were migrants from Atlantis practised Osiris rites in one form or another. Many of them erected artificial mounds apparently to represent and commemorate the Sacred Hill of their homeland. The artificial mound is the prototype of the pyramid. The pyramid was prevalent in both hemispheres at least ten thousand years before Christ. Mound building came, then, prior to pyramid building. Its prevalence among so many widely scattered early peoples of both hemispheres suggests that it was popular for many thousands of years prior to its later form, the pyramid.

From the Sacred Hill of Atlantis to the Maya Pyramid

The Mayas were the latest of the dominant peoples to arrive in the Americas. They brought with them the regular-sided, advanced type of pyramid. Further evidence shows that the American Indian spread to the far north as well as to the far south of the American continent, thousands of years before the advent of the Mayas or the Toltecs. And, lastly, there is no evidence to indicate that he, at any time, was directly associated with the highly cultured Mayas, or in any way came in contact with them, socially, commercially, or otherwise. How, then, is it possible for the American Indians to have borrowed the custom of mound-building, including the Osiris rites so closely associated with it, from the Mayas who had definitely advanced in culture and religious practices far beyond the primitive cult connected with the Sacred Hill or the mound, long prior to their arrival in Yucatan and Central America?

Is it not more logical to assume that the mound-building American Indian arrived in the Americas during the mound-building period, which the evidence suggests was prior to 11,000 B. C.? The fact that the custom prevailed among certain tribes until comparatively recent times is due, I suggest, to his nomadic proclivities induced by the vast area of rich soil, variety of climate, and abundant wild game; such conditions would have prevented cultural progress and tended to ensure a long period without change.

I could submit scores of further corroborative data, and as the subjects have had no place in the preceding text, the introduction of a few of them at this time, such as the very early use of

so-called recent inventions and discoveries, might prove of interest and of value.

The mariner's compass or magnetic needle is supposed to have been invented by Amalfi, an Italian, in 1302 A. D. *The Landnamabok* says: "In A. D. 868 it [the compass] was employed by the Northmen." The Italians are supposed to have used it as early as 1190 A. D. Herodotus says that "a guiding arrow" was carried by the hyperborean magician "in order that it may prove useful to him in all difficulties in his long journey." Donnelly suggests that the compass was used by the Atlanteans. Plato in his narrative of Atlantis says: "All these and their descendants were the inhabitants and rulers of *divers islands in the open sea;* and also, as has already been said, they held sway in the other direction *over the country within the Pillars* [Strait of Gibraltar] *as far as Egypt and Tyrrhenia.* . . . and the largest of the harbors were full of vessels and merchants coming from all parts." This does not indicate haphazard wanderings over wide expanses of water, but definitely planned routes through the use of a guiding device. One writer says: "Tradition affirms that the magnet originally was not on a pivot, but set to float on water in a cup."

In ancient Sanskrit, a language dead for more than two thousand years, the magnet was called "the precious stone beloved of iron." *The Talmud* speaks of it as "the stone of attraction." The ancient Egyptians referred to the lodestone as "the bone of Haroeri, and iron the bone of Typhon." It is said that the early Britons, as the Welsh today, called a pilot Llywydd (lode). Lodemanage, in Skinner's *Etymology,* is the word for the price paid to a pilot.

Lucian tells us that "a sea-shell often took the place of the cup, as a vessel in which to hold the water where the needle floated, and hence upon the ancient coins of Tyre we find a sea-shell represented."

The carrying of a magnetic cup, or sea-shell, therefore, was symbolic of divine guidance. As one writer says: "So 'oracular' an object as this self-moving needle, always pointing to the north, would doubtless affect vividly the minds of the people, and appear in their works of art."

As no logical reason has yet been offered for the presence of such a bowl or cup resting upon the breast of the so-called Chac Mool—the strange, half-reclining Maya sculptured figure

discovered in Yucatan—may we presume it, too, symbolizes divine guidance?

Whether or not we believe that the very early races, including the Atlanteans, possessed a knowledge of and utilized the magnetic cup or prototype of the mariner's compass, it is significant that the Akkads, the Egyptians, the Mayas and others, set their pyramids squarely with the four cardinal points.

The evidence of the use of gunpowder

The prehistoric races undertook vast sea journeys. Thousands of years before Christ, ships were plying in all directions throughout the Mediterranean. And according to Schliemann, Pharaoh sent out an expedition *to the west* in search of traces of "Land of Atlantis", whence 3,350 *years before the ancestors of the Egyptians arrived.* It might be asked, therefore, how was all this possible without the use of the magnetic compass?

Another interesting item is gunpowder. It is said that in the year 80 A. D. "the Chinese *obtained from India* a knowledge of gunpowder." Yet it is possible that the Carthaginian general Hannibal (247-183 B. C.) was well acquainted with gunpowder and used it effectively against the Romans. At the battle of Lake Trasymene "the earth reeled under the feet of the soldiers, a tremendous crash was heard, a fog or smoke covered the scene, the earth broke open and rocks fell upon the heads of the Romans." Still earlier, in the time of Alexander the Great (356-323 B. C.), there was, it is said, a city in India which defended itself by the use of gunpowder: "And lightning came from its walls to resist the attack of its assailants."

Bacon's belief

Roger Bacon, who is said to have rediscovered gunpowder in the 13th century, believed that Gideon, when he captured the camp of the Midianites (Judges, VII) used gunpowder. Gideon is said to have "divided the three hundred men into three companies, and he put a trumpet in every man's hand, with empty pitchers, and lamps within the pitchers." Later we read that they "blew the trumpets, and brake the pitchers, and held the lamps in their left hands . . . and all the host ran, and cried, and fled."

In Murray's *Manual of Mythology* we learn of the Atlantean "War of the Titans", in which were used *thunderbolts,* fashioned by Kyklopes. "Old Chaos thought his hour had come as from a *continuous blaze of thunderbolts the earth took fire,* and the waters seethed in the sea. The rebels were partly slain or consumed and partly hurled into deep chasms, *with rocks and hills reeling after them.*"

Zeus, the mythical King of Atlantis, was known as "the thunderer", and was represented as armed with thunderbolts.

If we agree as to the possibility of an erstwhile Atlantis, and thereby admit the probable truth of Plato's story of an advanced race living thereon, then his description of enormous buildings and advanced engineering skill displayed in constructing vast waterways is not unreasonable. It is, therefore, not illogical to conjecture that the Atlanteans used some form of explosive, possibly gunpowder.

When we consider the popular belief that knowledge of a spherical earth and other heavenly bodies is of recent acquisition, it is interesting to learn that Plato knew the earth "is a body held in the center of the heavens", that it is a "round body" . . . "a globe", and that it revolves on its own axis, producing day and night. Whence came his knowledge?

Evidence of Astronomical Knowledge

Plutarch mentions optical instruments used by Archimedes (287-212 B. C.). The Greeks associated the origin of astronomy with Atlas and Hercules, the two Kings or hero-gods of Atlantis. Astronomy was a highly developed science among the Akkads, Egyptians, Pre-Incas, Mayas, and other early races. Is it logical to assume that these races, who undoubtedly possessed considerable knowledge of astronomy and astrology, obtained accuracy without the aid of magnifying lenses? Let us consider some of the evidence.

Layard says that a lens of considerable power was discovered among the ruins of Babylon. It was an inch and a half in diameter and nine-tenths of an inch thick. Still earlier, in the immense library of tablets preserved by the Akkads, magnifying glasses were discovered which were used by the student to assist in reading the minute letters inscribed on the tablets. There is also indication that they used a form of telescope.

The evidence of Akkad Culture

While on the subject of the Akkads, it is interesting to know that they also possessed the clepsydra or water clock, the lever and pulley, and the sundial. All their children were taught to read and write. They used land-leases, drawn up by conveyancers; had judges in courts like our own; and taxes were levied for religious purposes. They were a simple and peaceful people, honoring their women and motherhood. Music was an important branch of their study. They had songs and hymns, and many musical instruments. They were excellent artisans—weavers, dyers, potters,

smiths, carpenters, sculptors, and stone masons—to which trades their young people were apprenticed.

The evidence of weapons

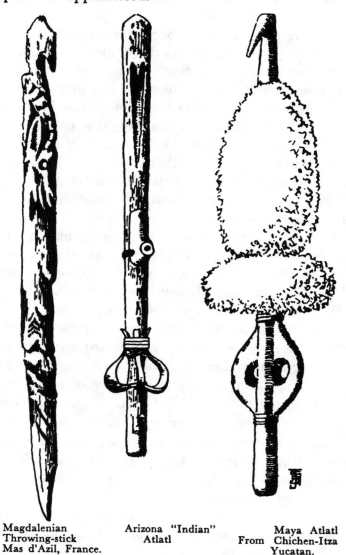

Magdalenian
Throwing-stick
Mas d'Azil, France.

Arizona "Indian"
Atlatl

Maya Atlatl
From Chichen-Itza
Yucatan.

The exact similarity between all the above devices, from widely scattered areas, points to a common origin.

Weapons originally were intended for the chase, and probably the earliest inventions devised for that purpose are the ingeniously conceived bow and arrow, and the throwing stick, both of which, if invented today, would be patentable. The bow and arrow were extensively used by the Azilian-Tardenoisian Cro-Magnons, the

Egyptians, and practically all of the ancient races in Europe and Asia Minor. Likewise, the Pre-Incas, Mexicans, Mayas and all the American Indian tribes, from the farthermost north to the farthermost south of the Western Hemisphere, employed the bow and arrow.

The throwing-stick is a simple device for the better propulsion of an arrow or a spear. It consists of a short stick with finger holds in the handle, and a beak-like head. By inserting arrows having a depression in the head, into the beak tip, the thrower could propel the arrow approximately three times as far as is possible

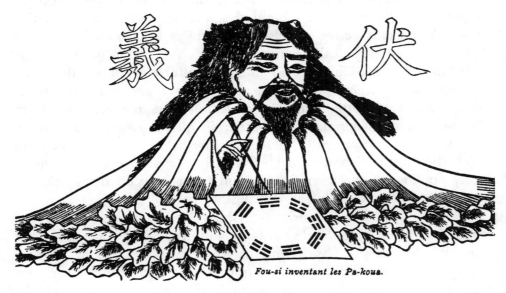

Fou-si inventant les Pa-kous.

(From *Peking* by Alph. Favier)
Fou-si (Fou-hi, or Fo-hi), presumed to have founded the Chinese Empire 2,852 B. C. Numerous parallels exist between the cultures of China and the ancient peoples of the Americas. What is the significance?

The evidence of Chinese Culture

without the aid of this device. Having experimented with the throwing-stick I can testify as to the arrow's swiftness, accuracy, and effectiveness. This method of arrow propulsion was used by the Magdalenian Cro-Magnons at least 14,000 years ago; by the American Indians, in my belief from approximately the same period; and by the ancient Mayas. In all cases the form of the device is exactly the same. Examples of this weapon have been found among the Mexican remains of the archaic period; among American Indian remains in Arizona, presumed to be from 10,000 to 15,000 years old; in Central America and elsewhere. In the Americas the device is known as the *atlatl*.

I have but lightly referred to the possible Chinese inclusion among those whom I believe to be racially and culturally children of a common parent. I think consideration should be given to a few items from this source before bringing this summary to a close. Researchers in the Chinese field are rapidly becoming convinced that the numerous parallels and similarities observed between Chinese and Maya cultures are of particular significance. The knowledge gained has been used in an effort to support an otherwise unfounded theory of an Asiatic cultural invasion of the Americas via the Behring Straits, especially in reference to the Mayas. In the foregoing chapters, I believe I have submitted sufficient data to disprove this claim. As unconstructive criticism is worthless I have endeavored to show, and have graphically outlined on the chart facing page 217, the probability that the Chinese and affiliated cultures are descended from the same family tree to which belong the Maya and numerous other early cultures of both hemispheres. Admittedly, the evidence from Chinese sources is not sufficient, either in quantity or corroboration, to build a sound argument in defense of my belief as to the root from which their culture sprang; but what little is available adds strength, in my opinion, to the theory of an American invasion from Atlantis, rather than from Asia via the Behring Straits.

Evidence refutes Behring Straits Theory

Historically, China is not extremely old, but much of its history is shrouded in fable and myth. Yet if we apply our general belief in the basic truth of legends and myths to Chinese examples, we discover certain interesting data concerning their prehistoric past. The cautious historian is not inclined to extend the Chinese historical period beyond the Chow dynasty, founded by Wu Wang about 1,100 B. C., and lasting until 255 B. C. Others, believing the first date over-conservative, are inclined to agree with Chinese legends, which claim a much earlier origin.

China's prehistoric past

In the *Encyclopedia Americana* the statement is made that "Fuh-hi, who is regarded as a demigod, founded the Chinese Empire 2,852 B. C. He introduced cattle, taught the people how to raise them, and taught the art of writing." In this we see a further parallel with Quetzalcoatl, Kukulcan, Itzamna, Osiris, and others. It might be asked where Fuh-hi gained his knowledge.

Short, in *North Americans of Antiquity,* says: "There is no doubt that strong analogies exist between the Otomi and the Chinese." The Otomi are among the Aztec group which Professor

Deniker designates as Mexicans proper. In earlier times these people occupied the Mexican tablelands; now, however, they inhabit the upper portion of the Moctezuma basin between the cities of Mexico and San de Potosi. Senor Najera in *Dissertacion Sobre la lingua Othomi, Mexico,* lists a number of words taken from both the language of the Otomis and the Chinese which indicate strong analogies between those people. M. Terrien de la Couperie demonstrated his belief that "the Chinese language is clearly related to the Chaldean and that both the Chinese characters and the cuneiform alphabet are degenerate descendants of an original hieroglyphical alphabet."

The Otomis and the Chinese

Lydekker, in *Living Races of Minkind,* referring to the Otomis says: "More remarkable still is the *monosyllabic* character of their language." Edward Clodd, in *The Story of the Alphabet,* speaking of the Chinese language says: "The language has never got beyond the monosyllabic stage."

Before continuing, and so that the reader may follow the argument clearly, a brief explanation of the early development of the various alphabets may prove helpful.

The alphabets of the various languages are composed of abbreviations descended from primitive forms devised for recording events which transpired, or messages which were exchanged, during man's long cultural formative period. The development shows four well-marked stages, although the actual lines of demarcation are not definite. The four divisions are named the mnemonic, the pictorial, the ideographic, and the phonetic.

The first or mnemonic stage is represented by the *quipus* or knotted cords, and by the wampum or shell-ornament belts. Knotted cords were used by the Ionians, as recorded by Herodotus; the Aztecs; the Pre-Incas, whence came the name, *quipu;* certain American Indian tribes, such as the Palonis of California and the Mexican Zuni; the ancient Egyptians; and the Chinese.

The development of alphabets

Clodd says of the *quipu* that it "has a long history, and is with us both in the rosary on which the Roman Catholic counts his prayers, in the knot which we tie in our handkerchief to help a weak memory, and in the sailor's log-line."

The Chinese custom of sending messages in their mnemonic period, then, was identical with one which prevailed among many other races of the world. To substantiate this we see that in the sacred historical book of the Chinese, the *Shû-King,* is recorded

the use of the knotted cords prior to the invention of writing. From another Chinese legendary source we learn that "the most ancient forms were five hundred and forty characters, formed by a combination of knotted strings."

Chinese origin

In Baldwin's *Prehistoric Nations* we learn that "an Arabian sovereign, Schamar-Iarasch (Abou Karib), is described by Hamza, Nuwayri, and others as a powerful ruler and conqueror, who carried his arms successfully far into Central Asia; *he occupied*

Example of Quipu, or Knotted-Cord, from Peru. Also employed by the American Indians, Egyptians, Ionians, and Chinese.

Samarkand and invaded China." This indicates at least one direct journey from Africa to China in ancient times, and is significant in reference to the following two interesting points in connection with Chinese origin. One is that they possess legends of a great flood which destroyed their early ancestors. Two, that it is believed by many that the Aryan Atlantean colonies were founded at a very early period, not far from the Caspian Sea.

Professor Winchell says that the Chinese arrived from Lake Balkat or Balkash, or Balkhash, a location not far distant from the Caspian Sea. "The Chinese themselves claim to have invaded China in the early days *from the northwest.*"

In the religious rites and customs of the early Chinese culture, such as sun worship, we discern an outgrowth from Osiris cult.

When we turn to the subject of Chinese art we again find numerous comparisons with the works of other ancient races. The unusual archaic Chinese designs in jade to be seen in recent discoveries made in Lo-yang tombs and the open plaque work from Hsin-Cheng, are strikingly similar to Maya art detail forms. Both the Chinese and the Mayas were great lovers of jade, and both carved prolifically in this beautiful substance. The twined serpent and animal motifs, and the method employed in conventionalizing the natural form toward the abstract, are almost identical in both cultures.

Chinese art

From these few items it will be seen that certain cultural characteristics are analogous among the Chinese, Mayas, and others. But the theory which assigns the ancient peoples of the Americas to Asiatic origin is denied by the evidence already submitted. Admittedly, Asiatic motifs are discerned in the Maya art, but I suggest the parallels are more in the nature of sister motifs derived from a common parent—the Atlantean civilization, Mother of Empires.

Many branches of thought now have been studied in our effort to establish, primarily, the origin of the Mayas. Whether or not my hypotheses and opinions (humbly submitted) are accepted, is of little consequence. Hopefully, however, I quote the encouraging words of Spence who says: "Troy vanished, and men in after ages thought it never had been, until the vision and enthusiasm of a Schliemann brought it to light once again." And the same writer remarks that "the man who justified his dreams of Troy to the confusion of a thousand scoffers, entertained as firm a belief in the existence of a submerged Atlantis."

Wide range of thought studied

But now, the Troy myth no longer exists, and the wonders of Atlantis are minimized by still stranger events. The miracle of yesterday is the commonplace of today. The impossible has become possible. An impossible world war took place. Impossible, but aerial transportation now spans the globe; radio, television, telephotography, and scores of other recent impossibilities now are accomplished facts.

The miracle of yesterday is commonplace today

If in the vast heavenly expanse solar systems are born, flourish, and die; if our earth does revolve around the sun on a regular schedule; if the polar centers of the earth have shifted their position; if existing land surfaces of the earth once were under water, then where lies the impossibility of a comparatively small portion of this earth's crust, such as Atlantis, sinking beneath the ocean surface?

Chapter Eighteen
The Mayas in Yucatan

THE primary object of this work is to show that the ancient Mayas of Yucatan and Central America were not indigenous to the Americas, and to suggest that in all probability they were colonists from a now submerged Atlantis. To write a complete and connected history of that people after their arrival on American shores is not to that purpose, nor is it yet possible, owing to the very limited data available. And even that limited knowledge does not include the Mayas of Central America and Yucatan as a whole, but of Yucatan only. The history of the early Mayas of Central America remains in obscurity. But a very brief review of what is known is here set down for those who are interested.

Confusing Spanish Chronicles

Some writers have attempted to tell a reasonably coherent story based on one or more of the early Spanish chronicles, but they have been handicapped by confused and conflicting information. I, too, have found the same confusion and conflict. The clearest evidence that I have gleaned from the Spanish narratives is circumstantial, and this is not discouraging; for circumstantial evidence is frequently decisive. The regrettable feature of the inquiry is not circumstantiality but conflict of testimony. It is this that makes a more

coherent story impossible at this time. But out of the maze of legend and fact enough can be put together, I think, to discern the main features of Maya civilization, at least during their occupancy of Yucatan. (See map on page 14 for present known ancient Maya city sites).

This begins, so far as we can learn, with the arrival in the present Maya area of the Ah-Canules. Such reports of them as are extant call them the "First People" and declare that they came "from the east across the water in boats."

The Ah-Canules

After them came a wave of colonists known as Chanes, or People of the Serpent. They were captained by Itzamna, and for this reason are also called Itzaes. And they, too, are reported to have come "from the east across the water in boats."

Next is the arrival of the Tutul-Xius (shoos). But they, instead of coming from the east and across the water, came from the southwest through the deserts. Another account of them in the *Documentos Inéditos* states that in the year 179 A. D. a strange people left Nonualco, their homeland in the southwest, and in the course of a long and mysterious wandering *came upon a number of flourishing cities,* the first being Chacnovitan, but which they are not supposed to have discovered until the year 258 A. D., some seventy-nine years after they left Nonualco. Later they discovered Bakalar, and in 455 A. D. discovered Chichen-Itza. These discoveries, beginning as early as 258 A. D., apparently confirm the belief in a much earlier Maya occupancy of Yucatan than is maintained by most authorities.

The Chanes

A fourth Yucatan invasion concerns the much discussed Toltecs, although their very existence has been disputed. Brinton and others, for instance, believed them a people of fable. Others, again, admit they once existed, but see in them little of cultural importance. But the word Toltec means the cultured, the builders; and if we are to believe the evidence of archeology and architecture, there is little doubt that they were a dominant and cultured people who flourished in Mexico.

The Tutul-Xius

As to when their culture first appeared on this continent we have little evidence of a definite nature. Spinden gives a summary of Toltecan history, beginning with 726 A. D., and ending 1070 A. D. Fernando de Alva Ixtilxochitl, who lived shortly after Cortés' conquest of Mexico, says that the Toltecs founded the city of Tollan in A. D. 566, which city site is now occupied by the modern

town of Tula, situated northwest of the mountains which bound the Mexican Valley.

But, as we have seen in Chapter XVI, the Toltecs were aliens whose hero-god Quetzalcoatl led them from Tollan-Tlappan, presumably in the Antillian region, across water to the eastern shores of America. Conceivably, the Mexican city of Tollan was named after their eastern home. It appears certain that the sites of Tollan, Cholula, and Teotihuacan are of Toltec origin. Certain also, it is that Toltec influence is seen in the late Maya structures of Yucatan, such as at Chichen-Itza. But regarding the date when they invaded the territory of the Mayas the evidence is not sufficiently clear. Presumably, and lacking data to the contrary, I suggest a period approximating the eleventh and twelfth centuries A. D.

The Toltecs

How to separate, one from another, the three early major movements into the present Maya area is still obscure, but we must approximate the date of each movement if we are to extract any clear picture of the Mayas, and, particularly, the place of their origin.

When the First People or Ah-Canules came "from the east across the water in boats" is unsettled, but that they had a very long career thereafter is suggested by the *Manuscrito de Chumayel,* which says that they built more than an hundred and fifty cities throughout Yucatan.

The People of the Serpent, or Chanes, later to be called the Itzaes, were also city builders. The same *Manuscrito* speaks of "Chichen-Itza, the city of the divine Itzaes, the great Ix-Caan-Zi-Ho, the great Izamal, the great Ake, the great Uxmal, the great Mayapan." All these, it says, were erected by the Itzaes. Chichen-Itza was evidently their capital, but no information is yet available of its people between the city's foundation and its first abandonment, which occurred in 642 A. D. and lasted more than three hundred years.

Approximating the arrival dates

The cause of the abandonment seems to have been an invasion of forces from the cities of Izamal and Motul in alliance with the Tutul-Xius from the city of Uxmal and vicinity. The Itzaes, overcome and driven out, wandered for forty years, with severe hardships, until in 682 they came to the city of Chan-Putan, where they spent twenty years attempting to gain control; they succeeded in 702. The Itzaes governed Chan-Putan from 702 to 982 A. D.

During that period they had not forgotten "their ancient country of Chichen-Itza" and in 982 the entire population departed from Chan-Putan under command of two valiant captains, Kak-U-Pacat and Bilu, or Biil-Huh, and marched toward their ancestral home. They had a terrible journey because "instead of taking the road along the coast leading to Campeche", as Solis says, "they penetrated the forests and deserts of the south, and there were lost under the trees, under the boughs, under the branches, to their sorrow, as the Maya chronicles say." Finally they "appeared through the mountains of Yucatan" [low hills of the Cordillera range to the west of the province] after great suffering from hunger, thirst, and predatory animals. Nevertheless they mustered sufficient courage and strength to attack the seat of their ancient enemies, the people of Izamal and Motul, who, we have seen, allied with the Tutul-Xius, had driven them out of Chichen-Itza in 642. The Itzaes now took both Izamal and Motul, and the people submitted to the Itzae rule. They extended their conquests, and after all their enemies had been defeated the entire country recognized "the dominion of the intrepid Itzae captains." In 987 the Itzaes returned in triumph to Chichen-Itza, the capital so ignominiously abandoned by their forefathers. The Itzae captain Kak-U-Pacat came to be adored by them and also by the Xius, and later was elevated to divinity.

The overthrow of the Itzaes

Approximately in the year 1007 there arrived from Mexico a leader called Kukulcan, commanding forces representing the Aztec power. He is described as just but firm, a brilliant statesman, a forceful character who impressed his will upon the Mayas. Apparently his will also had a sinister aspect, at least in one respect, for he is accused of imposing upon the gentle Maya people the Aztec abomination of human sacrifice. Whether or not he did so, the introduction of this and other atrocious Aztec practices apparently began in his time.

The Itzaes regain control

Kukulcan did other and better things, however. In a masterful and masterly way he organized the Maya Federation. At least he is credited with this. The Federation consisted of the four principal cities—Chichen-Itza, Izamal, Uxmal, and Mayapan. Mayapan was made the capital. In the Federation the Itzaes and the Tutul-Xius were leagued together, and the appointment of a chief lord over all the other lords of both peoples presented a difficulty. Kukulcan solved it by nominating Cocome, an Itzae noble. The Tutul-

Xius objected, but when a vote was taken and Cocome won, they submitted with apparently good grace.

But Kukulcan, according to all accounts, still remained the guiding genius of the Federation. He revived the arts, built scores of structures throughout the country, including some pyramids, and by his mediations maintained a measure of peace. About the year 1087 he returned to Mexico.

Kukulcan is described as blue-eyed, white-skinned, and bearded—all characteristics absent from the Mayas and Aztecs. The beard is shown in the sculptured figures of this hero-god, for in the course of time he, like the Itzae captain Kak-U-Pacat, was elevated to divinity.

During the next two hundred years, approximately, after the departure of Kukulcan, numerous petty misunderstandings threatened to disrupt the Federation, and about 1204 the rupture occurred. The ruler of Chichen-Itza, named Chac-Xib-Chac, seeking revenge for some unrecorded grievance, marched on the capital city of Mayapan. The lord of Mayapan, Cocome—not to be confused with the Cocome of Kukulcan's time—was in the midst of his wedding festival. Whether by some traitorous prearrangement or not, Chac-Xib-Chac raided the palace and abducted the bride.

Thereafter, and until the coming of the Spaniards, as Landa records, a succession of wars and pestilences largely depopulated the once prosperous cities of the Federation. The capital city of Mayapan was destroyed and the Maya Federation broke up. Cocome and his entire family, with the exception of one son, were killed. From its ruins three principal powers emerged—the Cocomes, the Xius, and the Cheles—each the enemy of the others. The Cocomes held the Xius to be foreign traitors, and the accusation was largely true, for the Xius were originally from Mexico, and they were traitors because chiefly responsible for the murder, after the raid and abduction, of the family of the Cocomes, whose great ancestor had befriended the Xius. The role of the Cheles in the three-cornered fight is not clear, but it is related by Landa that all three factions remained at enmity, each with the others, until the coming of the Spaniards.

The series of internecine wars which followed the ending of the Federation slowly caused the decay of the entire social and political structure. Subsequent famine and pestilence left the

The arrival of Kukulcan

Kukulcan not Maya

The Beginning of the End

people weak and unprepared for the coming of the Spaniards. The death-knell of the great race of Mayas was sounded.

Resembling the repeated blows of a battering ram, the murderous attacks of the Spaniards finally forced the tottering Maya Empire to collapse. The magnificent temples and palaces that testified (and though now partially in ruins, to this day testify) to a vanished greatness, suffered ruthless destruction at the hands of the invading bigots and vandals. Countless works of marvelous art, priceless books and manuscripts were deliberately destroyed, some few to become stowed in garrets by ignorant collectors, as occasional recoveries have shown. May a kindly fortune bring these hoards to light ere long; for I firmly believe that not all the treasures of the Mayas have been lost forever.

Sic Transit
Gloria Mundi

Questions are frequently put to me such as: "What is the reason for the sudden disappearance of the Maya civilization?" "How were the millions of ancient Mayas able to live in the midst of a dense jungle, raise crops, and maintain such large and magnificent cities?" "Did they die of starvation owing to impoverished soil?" "Was lack of water the cause?" "Did they perish through incurable diseases?"

In the first place, and strictly speaking, the Maya civilization has not entirely disappeared. Although no official census is taken of the present-day Mayas, it is estimated by some authorities that possibly one million of them still live in the ancient Maya area; but it is more than probable that this is excessive. At the height of their prosperity it is possible that the Mayas throughout Central America and Yucatan numbered from fifteen to twenty millions.

Reasons why
the Maya
race vanished

Perhaps even the minimum figure is excessive, although there is reason to believe that the population at one time might not have been far short of it. To destroy such a vast number as fifteen million people, however, raises the question of the time element. Of course, it must be remembered that the process of destruction occupied centuries. Then again, the population of Central America did not consist wholly of Mayas. Various invading forces, principally from Mexico, accounted probably for fifty per centum of the total, but, at subsequent stages of Maya history, these foreign hordes mostly returned whence they came. So that the actual number of Mayas destroyed during their

cultural decline may not have exceeded one-half the minimum estimate of the peak total.

Their destruction was caused, in my opinion, principally through the numerous wars, first provoked by invaders (for it must be remembered the Mayas fundamentally were a peaceful people and possessed no weapons of warfare), and secondly through internecine causes, and resultant famine and disease. The Spaniards were responsible for the final carnage, which apparently was on a stupendous scale. Landa speaks of one battle alone during which "150,000 men died."

As to the next question, it is almost certain that every available acre was utilized. One report states that the entire Maya country was an endless garden of great beauty, consisting of grain fields, orchards, and flowers, studded with magnificent cities. The Maya occupancy of the Central American and Yucatan area for many centuries proves an advanced knowledge of soil conservation. On the other hand, a highly cultured people does not die from soil exhaustion or water shortage when migration is possible, and there is no evidence that the Mayas attempted to migrate. They lived in peace and contentment until their despoilers arrived.

Did not die from soil exhaustion

I believe that as their numbers diminished, through causes explained above, portions of their highly cultivated land areas were abandoned. The semitropical climatic conditions would rapidly turn the cultured tree growth into a dense jungle. Once in control, the jungle defies even the most determined manual onslaught. Relentlessly, it has spread until now a major part of the country lies beneath its green mantle.

Lack of water is hardly a tenable explanation of the disaster of the Mayas. There are no rivers in Yucatan but there is an abundance of water beneath the surface. And the fact that they have demonstrated extensive engineering ability in their carefully planned structures, and actually built reservoirs and water courses, dispels such a thought.

Another element, which apparently in no small manner contributed to the reduction of Maya life, was the annual series of violent hurricanes (*huracan,* a Maya word) which created widespread destruction of life and property. Landa recounts many such happenings. It must be remembered that the hurricanes which

devastate the northern shores of the Gulf of Mexico start in the Maya area. They were just as frequent during early Maya historical times as they are now, probably more so, but, lacking present day warning facilities, the Maya death rate from this cause was undoubtedly terrific. Undoubtedly too, frequent and violent earthquakes added to the toll.

Summarizing, then, we have the evidence, first, that the Mayas, a cultured and industrious people, lived apparently in peace for many hundreds of years. They were wisely and firmly ruled, but possessed no means of defense or weapons of war. During this time they multiplied to the extent of possibly 20,000,000 people; they prospered and were content. Then came the first warlike invaders who took a heavy toll of Maya life. This sanguinary invasion was followed by many others, each at the cost of a heavy loss of life to the Mayas, each followed by famine and pestilence, thereby adding to the toll. Later, internecine wars still further reduced their numbers. The coming of the Spaniards saw bloodshed on an unprece- dented scale, and the slaughter continued until but a handful of the original number of Mayas was left, these con- sisting mainly of the artisan and lower classes.

This, then is my explanation (based on the evidence) for the disappearance of the highly cultured Mayas, whom I believe to be a direct race-child of the Mother of Empires, a root race of Atlantis.

Jungle the final victor

THE END

Index

HAARP
The Ultimate Weapon of the Conspiracy
by Jerry Smith

The HAARP project in Alaska is one of the most controversial projects ever undertaken by the U.S. Government. Jerry Smith gives us the history of the HAARP project and explains how it can be used as an awesome weapon of destruction. Smith exposes a covert military project and the web of conspiracies behind it. HAARP has many possible scientific and military applications, from raising a planetary defense shield to peering deep into the earth. Smith leads the reader down a trail of solid evidence into ever deeper and scarier conspiracy theories in an attempt to discover the "whos" and "whys" behind HAARP, and uncovers a possible plan to rule the world. At best, HAARP is science out-of-control; at worst, HAARP could be the most dangerous device ever created, a futuristic technology that is everything from super-beam weapon to world-wide mind control device. The Star Wars future is now. Topics include Over-the-Horizon Radar and HAARP, Mind Control, ELF and HAARP, The Telsa Connection, The Russian Woodpecker, GWEN & HAARP, Earth Penetrating Tomography, Weather Modification, Secret Science of the Conspiracy, more. Includes the complete 1987 Bernard Eastlund patent for his pulsed super-weapon that he claims was stolen by the HAARP Project.
256 PAGES. 6X9 PAPERBACK. ILLUSTRATED. BIBLIOGRAPHY & INDEX. $14.95. CODE: HARP

LOST CONTINENTS & THE HOLLOW EARTH
I Remember Lemuria and the Shaver Mystery
by David Hatcher Childress & Richard Shaver

Lost Continents & the Hollow Earth is Childress' thorough examination of the early hollow earth books of Richard Shaver and the fascination that fringe fantasy subjects such as lost continents and the hollow earth have had for the American public. Shaver's rare 1948 book *I Remember Lemuria* is reprinted in its entirety, and the book is packed with illustrations from Ray Palmer's *Amazing Stories* issues of the 1940s. Palmer and Shaver told of tunnels running through the earth—tunnels inhabited by the Deros and Teros, humanoids from an ancient spacefaring race that had inhabited the earth, eventually going underground, hundreds of thousands of years ago. Childress discusses the famous hollow earth books and delves deep into whatever reality may be behind the stories of tunnels in the earth, Operation High Jump to Antarctica in 1947 and Admiral Byrd's bizarre statements, tunnel systems in South America and Tibet, the underground world of Agartha, the belief of UFOs coming from the South Pole, more.
412 PAGES. 6X9 PAPERBACK. ILLUSTRATED. $16.95. CODE: LCHE

LIQUID CONSPIRACY
JFK, LSD, the CIA, Area 51 & UFOs
by Jim Keith

Mind Control, World Control author Keith on the politics of LSD, mind control, Area 51 and UFOs. With JFK's LSD experiences with Mary Pinchot-Meyer the plot thickens the ever expanding web of CIA involvement, underground bases with UFOs seen by JFK and Marilyn Monroe among others to a vaster conspiracy that affects every government agency from NASA to the Justice Department. Focusing on the bizarre side of history, *Liquid Conspiracy* takes the reader on a psychedelic tour-de-force.
256 PAGES. 6X9 PAPERBACK. ILLUSTRATED. $14.95. CODE: LCON

KUNDALINI TALES
by Richard Sauder, Ph.D.

Underground Bases and Tunnels author Richard Sauder's second book on his personal experiences and provocative research into spontaneous spiritual awakening, out-of-body journeys, encounters with secretive governmental powers, daylight sightings of UFOs, and more. Sauder continues his studies of underground bases with new information on the occult underpinnings of the U.S. space program. The book also contains a breakthrough section that examines actual U.S. patents for devices that manipulate mind and thought from a remote distance. Included are chapters on the secret space program and a 130-page appendix of patents and schematic diagrams of secret technology and mind control devices.
296 PAGES. 7X10 PAPERBACK. ILLUSTRATED. BIBLIOGRAPHY. $14.95. CODE: KTAL

COSMIC MATRIX
Piece for a Jig-Saw, Part Two
by Leonard G. Cramp

Leonard G. Cramp, a British aerospace engineer, wrote his first book *Space Gravity and the Flying Saucer* in 1954. *Cosmic Matrix* is the long awaited, sequel to his 1966 book *UFOs & Anti-Gravity:Piece For A Jig-Saw*. Cramp has had a long history of examining UFO phenomena and has concluded that UFOs use the highest possible aeronautic science to move in the way they do. Cramp examines anti-gravity effects and theorizes that this super-science used by the craft—described in detail in the book—can lift mankind into a new level of technology, transportation and understanding of the universe. The book takes a close look at gravity control, time travel, and the interlocking web of energy between all planets in our solar system with Leonard's unique technical diagrams. *A fantastic voyage into the present and future!*
364 PAGES. 6X9 PAPERBACK. ILLUSTRATED. BIBLIOGRAPHY. $16.00. CODE: CMX

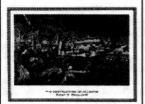

ROBERT B. STACY-JUDD

ATLANTIS: MOTHER OF EMPIRES
Atlantis Reprint Series
by Robert Stacy-Judd

Robert Stacy-Judd's classic 1939 book on Atlantis is back in print in this large format paperback edition. Stacy-Judd was a California architect and an expert on the Mayas and their relationship to Atlantis. Stacy-Judd was an excellant artist and his book is lavishly illustrated. The eighteen comprehensive chapters in the book are: The Mayas and the Lost Atlantis; Conjectures and Opinions; The Atlantean Theory; Cro-Magnon Man; East Is West; And West Is East; The Mormons and the Mayas; Astrology in Two Hemispheres; The Language of Architecture; The American Indian; Pre-Panamanians and Pre-Incas; Columns and City Planning; Comparisons and Mayan Art; The Iberian Link; The Maya Tongue; Quetzalcoatl; Summing Up the Evidence; The Mayas in Yucatan.
340 PAGES. 8x11 PAPERBACK. ILLUSTRATED. INDEX. $19.95. CODE: AMOE

JESUS CHRIST: THE NUMBER OF HIS NAME
The Amazine Number Code Found in the Bible
by Bonnie Gaunt

Mathematician and theologist Bonnie Gaunt's latest book on the amazing number code found in the Bible. In this book Gaunt says that the numerological code tells of the new Millennium and of a "Grand Octave of Time" for man. She demonstrates that the Bible's number code reveals amazing realities for today's world, and gives evidence of the year of the "second coming" of Jesus Christ. Gaunt says that the code was known to the ancients and has only been rediscovered in recent years. The book reveals amazing evidence that the code number for Jesus Christ has been planted in the geometry of the earth, ancient megalithic buildings in Egypt, Britain and elsewhere, and in the Bible itself. Gaunt examines the mathematics of the Great Pyramid, Stonehenge, and the city of Bethlehem, which she says bears the number of Jesus by its latitude and longitude. Discover the hidden meaning to such number codes in the Bible as 666, 888, 864, 3168, and more.
197 PAGES. 6x9 PAPERBACK. ILLUSTRATED. BIBLIOGRAPHY. $12.95. CODE: JCNN

THOTH
Architect of the Universe
by R. Ellis

Imported from Britain, this deluxe hardback is on sacred geometry, megalithic architecture and the worship of the mathematical constant pi. Ellis contemplates Stonehenge, the ancient Egyptian god Thoth and his Emerald Tablets, Atlantis, Thoth's Ratios, Henge of the World, the Ma'at of the Egyptians, ancient technological civilizations, more. Well illustrated with color photo sections.
236 PAGES. 6x9 HARDBACK. ILLUSTRATED. BIBLIOGRAPHY. $24.95. CODE: TOTH

ATLANTIS: THE ANDES SOLUTION
The Theory and the Evidence
by J.M. Allen

Imported from Britain, this deluxe hardback is J.M. Allen's fascinating research into the lost world that exists on the Bolivian Plateau and his theory that it is Atlantis. Allen looks into Lake Titicaca, the ruins of Tiahuanaco and the mysterious Lake PooPoo. Lots of fascinating stuff here with Allen discovering the remains of huge ancient canals that once crisscrossed the vast plain southwest of Tiahuanaco. A must-read for all researchers into South America, Atlantis and mysteries of the past. Forward by John Blashford-Snell.
173 PAGES. 6x9 HARDBACK. ILLUSTRATED. BIBLIOGRAPHY. $24.95. CODE: ATAS

COEVOLUTION
The True Story of 10 Days to an Extraterrestrial Civilization
by Alec Newald

One Monday in mid-February 1989, Alec Newald set off on what should have been a 3-hour drive from Rotorua to Auckland, but instead became 10 days of missing time! Newald claims he began to remember his missing 10 days, during which time he had been taken by friendly aliens to their home planet, described in detail in this book. The second part of the book is about the strange visitations that he recieved from "government scientists" and others who wanted to know what he knew about this extraterrestrial race and the profound implications for planet earth: coevolution with another world.
204 PAGES. 5x8 PAPERBACK. ILLUSTRATED WITH APPENDIX. $16.95. CODE:

INSIDE THE GEMSTONE FILE
Howard Hughes, Onassis & JFK
by Kenn Thomas & David Hatcher Childress

Steamshovel Press editor Kenn Thomas takes on the Gemstone File with David Hatcher Childress in this run-up and run-down of the most famous underground document ever circulated. Photocopied and distributed for over 20 years, the Gemstone File is the story of Bruce Roberts, the inventor of the synthetic ruby widely used in laser technology today, and his relationship with the Howard Hughes Company and ultimately with Aristotle Onassis, the Mafia, and the CIA. Hughes kidnapped and held a drugged-up prisoner for 10 years: Onassis and his role in the Kennedy Assassination; how the Mafia ran corporate America in the 1960s; more.
320 PAGES. 6x9 PAPERBACK. ILLUSTRATED. $16.00. CODE: IGF

24 HOUR CREDIT CARD ORDERS—CALL: 815-253-6390 FAX: 815-253-6300
email: auphq@frontiernet.net http://www.azstarnet.com/~aup

ANCIENT MICRONESIA
& the Lost City of Nan Madol
by David Hatcher Childress

Micronesia, a vast archipelago of islands west of Hawaii and south of Japan, contains some of the most amazing megalithic ruins in the world. Part of our *Lost Cities of the Pacific* series, this volume explores the incredible conformations on various Micronesian islands, especially the fantastic and little-known ruins of Nan Madol on Pohnpei Island. The huge canal city of Nan Madol contains over 250 million tons of basalt columns over an 11 square-mile area of artificial islands. Much of the huge city is submerged, and underwater structures can be found to an estimated 80 feet. Islanders' legends claim that the basalt rocks, weighing up to 50 tons, were magically levitated into place by the powerful forefathers. Other ruins in Micronesia that are profiled include the Latte Stones of the Marianas, the menhirs of Palau, the megalithic canal city on Kosrae Island, megaliths on Guam, and more.
256 PAGES. 6x9 PAPERBACK. HEAVILY ILLUSTRATED. INCLUDES A COLOR PHOTO SECTION. BIBLIOGRAPHY & INDEX. $16.95. CODE: AMIC

FAR-OUT ADVENTURES
The Best of World Explorer Magazine

This is a thick compilation of the first nine issues of *WORLD EXPLORER* in a large-format paperback. Included are all the articles, cartoons, satire and such features as the Crypto-Corner, the News Round-Up, Letters to the Editor, the Odd-Ball Gallery and the many far-out advertisements. World Explorer has been published periodically by THE WORLD EXPLORERS CLUB for almost eight years now. It is on sale at Barnes & Noble Bookstores and has become a cult magazine among New Agers and Fortean Researchers. Authors include David Hatcher Childress, Joseph Jochmans, John Major Jenkins, Deanna Emerson, Katherine Routledge, Alexander Horvat, John Tierney, Greg Deyermenjian, Dr. Marc Miller, and others. Articles in this book include Smithsonian Gate, Dinosaur Hunting In the Congo, Secret Writings of the Incas, On the Track of the Yeti, Secrets of the Sphinx, Living Pterodactyls, Quest For Atlantis, What Happened To the Great Library of Alexandria?, In Search of Seamonsters, Egyptians In the Pacific, Lost Megaliths of Guatemala, The Mystery of Easter Island, Comacalco: Mayan City of Mystery, and plenty more.
520 PAGES, 8x11 PAPERBACK. ILLUSTRATED. $19.95. CODE: FOA

SECRET CITIES OF OLD SOUTH AMERICA
Atlantis Reprint Series
by Harold T. Wilkins

The reprint of Wilkin's classic book, first published in 1952, claiming that South America was Atlantis. Chapters include Mysteries of a Lost World; Atlantis Unveiled; Red Riddles on the Rocks; South America's Amazons Existed!; The Mystery of El Dorado and Gran Payatiti—the Final Refuge of the Incas; Monstrous Beasts of the Unexplored Swamps & Wilds; Weird Denizens of Antediluvian Forests; New Light on Atlantis from the World's Oldest Book; The Mystery of Old Man Noah and the Arks; and more.
438 PAGES. 6x9 PAPERBACK. HEAVILY ILLUSTRATED. BIBLIOGRAPHY & INDEX. $16.95. CODE: SCOS

ATLANTIS IN AMERICA
Navigators of the Ancient World
by Ivar Zapp and George Erikson

This book is an intensive examination of the archeological sites of the Americas, an examination that reveals civilization has existed here for tens of thousands of years. Zapp is an expert on the enigmatic giant stone spheres of Costa Rica, and maintains that they were sighting stones found throughout the Pacific as well as in Egypt and the Middle East. They were used to teach star-paths and sea to the world-wide navigators of the ancient world. While the Mediterranean and European regions "forgot" world-wide navigation and fought wars the Mesoamericans of diverse races were building vast interconnected cities without walls. This Golden Age of ancient America was merely a myth of suppressed history—until now. Profusely illustrated, chapters are on Navigators of the Ancient World; Pyramids & Megaliths: Older Than You Think; Ancient Ports and Colonies; Cataclysms of the Past; Atlantis: From Myth To Reality; The Serpent and the Cross: The Loss of the City States; Calendars and Star Temples; and more.
360 PAGES. 6x9 PAPERBACK. ILLUSTRATED. BIBLIOGRAPHY & INDEX. $17.95. CODE: AIA

MAPS OF THE ANCIENT SEA KINGS
Evidence of Advanced Civilization in the Ice Age
by Charles H. Hapgood

Charles Hapgood's classic 1966 book on ancient maps produces concrete evidence of an advanced world-wide civilization existing many thousands of years before ancient Egypt. He has found the evidence in the Piri Reis Map that shows Antarctica, the Hadji Ahmed map, the Oronteus Finaeus and other amazing maps. Hapgood concluded that these maps were made from more ancient maps from the various ancient archives around the world, now lost. Not only were these unknown people more advanced in mapmaking than any people prior to the 18th century, it appears they mapped all the continents. The Americas were mapped thousands of years before Columbus. Antarctica was mapped when its coasts were free of ice.
316 PAGES. 7x10 PAPERBACK. ILLUSTRATED. BIBLIOGRAPHY & INDEX. $19.95. CODE: MASK

24 HOUR CREDIT CARD ORDERS—CALL: 815-253-6390 FAX: 815-253-6300
email: auphq@frontiernet.net http://www.azstarnet.com/~aup

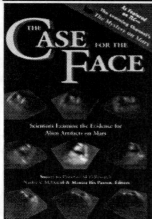

NEW BOOKS from ADVENTURES UNLIMITED PRESS

FAR-OUT ADVENTURES
The Best of the World Explorer Magazine

This is a complete compilation of the first nine issues of World Explorer in paperback. Included are all the incredible articles, cartoons, satires and features and many unique ads. World Explorer magazine is published by Adventures Unlimited Press and the articles reflect a desire to get behind the politics of science on a variety of subjects. Articles include: Smithsonian Gate, Dinosaur Hunting in the Congo, Secret Writings of the Incas, Secrets of the Sphinx, Quest for Atlantis, the Mystery of Easter Island and more. Authors include: David Hatcher Childress, Joseph Jochmans, John Major Jenkins, Deanna Emerson, Alexander Horvat, John Tierney, Dr. Marc Miller and Richard Noone to name a few. A must for the collector of the esoteric. 520 pgs. 8X11 $19.95

CODE: FOA

MIND CONTROL, OSWALD & JFK
Were We Controlled?
Introduction by
Kenn Thomas

Steamshovel Press editor Kenn Thomas examines the 1969 book, Were We Controlled. The author of the book was supposedly an ex-FBI agent using the name Lincoln Lawrence. The book maintained that Lee H. Oswald was a special agent who was a ind control subject, having received an implant in a Russian hospital in 1960. Thomas looks at the mind control aspects of the RFK assassination and details the history of implant technology. The implications of this advanced mind-controlling technology in assassinations and general control of a population are enormous. A growing number of people are interested in these CIA experiments and its purposes. Freedom of the mind is no longer to be taken for granted, the space between your ears is now the next battleground, be prepared. See Thomas's other books, NASA, Nazis & JFK, The Octopus or Popular Alienation. 256 pgs. 6X9 $16.00

CODE: MCOJ

MAPS OF THE ANCIENT SEA KINGS
Evidence of Advanced Civilization in the Ice Age
by Charles H. Hapgood

Charles Hapgood's classic 1966 book on ancient maps is back in print after 20 years. Hapgood produces concrete evidence of an advanced world-wide civilization existing many thousands of years before ancient Egypt. He has found the evidence in many beautiful maps long known to scholars, the Piri Reis Map that shows Antarctica, the Hadji Ahmed map, the Oronteus Finaeus and other amazing maps. Hapgood concluded that these maps were made from more ancient maps from the various ancient archives around the world, now lost. Hapgood also concluded that the ancient mapmakers were in some ways much more advanced scientifically than Europe in the 16th century, or than the ancient civilizations of Greece, Egypt, and Babylonian. Not only were these unknown people more advanced in mapmaking than any people prior to the 18th century, it appears they mapped all the continents.
316 pgs, 7x10 $19.95

CODE: MASK

ANCIENT TONGA
& the Lost City of Mu'a
by David Hatcher Childress

In this new paperback series, with color photo inserts, Childress takes into the fascinating world of the ancient seafarers that Pacific. Chapters in this book are on the Lost City of Mu'A and its many megalithic pyramids, the Ha'amonga Trilithon and ancient Polynesian astronomy, Samoa and the search for the lost land of Havaiiki, Fiji and its wars with Tonga, Rarotonga's megalithic road, Polynesian cosmology, and a chapter on the predicted re-emergence of the ancient land of Mu. May publication.
218 pgs, 6x9 $15.95

CODE: TONG

NASA, NAZIS & JFK
The Torbitt Document & the JFK Assassination
Introduction by Kenn Thomas

This first published edition of the Torbitt Document emphasizes what the manuscript says about the link between Operation Paper Clip Nazi scientists working for NASA, the assassination of JFK, and the secret Nevada air base Area 51. The Torbitt Document also talks about the roles in the assassination played by Division Five of the FBI, Defense Industrial Security Command (DISC), the Las Vegas mob, and the shadow corporate entities Permindex and Centro-Mondiale Commerciale. The Torbitt Document makes a number of sensational claims such as that the same people planned the 1962 failed assassination of Charles de Gaul, who ultimately pulled out of NATO because he traced the "Assassination Cabal" to Permindex in Switzerland and to NATO headquarters in Brussels. The Torbitt document paints a dark picture of NASA, the Military Industrial Complex, and the connections to Mercury, Nevada and the Area 51 complex which headquarters the "secret space program."
242 pages, 5x8 . $16.00.

CODE: NNJ

UFOs and ANTI-GRAVITY
Piece For A Jig-Saw
by Leonard G. Cramp

Cramp's 1966 classic book on flying saucer propulsion and suppressed technology is available again. A highly technical look at the UFO phenomena by a trained scientist. Cramp first introduces the idea of 'anti-gravity' and introduces us to the various theories of gravitation. Chapters include Crossroads of Aerodymanics, Aerodynamic Saucers, Limitations of Rocketry, Gravitation and the Ether, Gravitational Spaceships, G. Field Lift Effects, The Bi-Field Theory, more.
388 pgs, 6x9 $16.95. **CODE: UAG**

Adventures Unlimited Press
One Adventure Place
Kempton, Illinois
60946
24 Hour Telephone
Order Line
815 253 6390
24 Hour Fax Order Line
815 253 6300
EMail orders
adventures_unlimited
@mcimail.com

THE FANTASTIC INVENTIONS OF NIKOLA TESLA
by Nikola Tesla
with additional material by David Hatcher Childress

This book is a virtual compendium of patents, diagrams, photos, and explanations of the many incredible inventions of the originator of the modern era of electrification. The book is a readable and affordable collection of his patents, inventions, and thoughts on free energy, anti-gravity, and other futuristic inventions. Covered in depth, often in Tesla's own words, are such topics as:
• His Plan to Transmit Free Electricity into the Atmosphere;
• How Anti-Gravity Airships could Draw Power from the Towers he was Building;
• Tesla's Death Rays, Ozone Generators, and more…

342 pp. ♦ *6x9 paperback* ♦ *Highly illustrated* ♦ *Bibliography & appendix* ♦ *$16.95*
code: FINT

LOST CITIES OF ANCIENT LEMURIA & THE PACIFIC
by David Hatcher Childress

Was there once a continent in the Pacific? Called Lemuria or Pacifica by geologists, and Mu or Pan by the mystics, there is now ample mythological, geological and archaeological evidence to "prove" that an advanced and ancient civilization once lived in the central Pacific. Maverick archaeologist and explorer David Hatcher Childress combs the Indian Ocean, Australia, and the Pacific in search of the astonishing truth about mankind's past. Contains photos of the underwater city on Pohnpei, explanations on how the statues were levitated around Easter Island in a clockwise vortex movement, disappearing islands, Egyptians in Australia, and more.

379 pp. ♦ *6x9 paperback* ♦ *Photos, maps, & illustrations* ♦ *Footnotes & bibliography* ♦ *$14.95* ♦ **code: LEM**

THE FREE-ENERGY DEVICE HANDBOOK
A Compilation of Patents & Reports by David Hatcher Childress

Large format compilation of various patents, papers, descriptions, and diagrams concerning free-energy devices and systems. The Free-Energy Device Handbook is a visual tool for experimenters and researchers into magnetic motors and other "over-unity" devices with chapters on the Adams Motor, the Hans Coler Generator, cold fusion, superconductors, "N" machines, space-energy generators, Nikola Tesla, T. Townsend Brown, the Bedini motor, and the latest in free-energy devices. Packed with photos, technical diagrams, patents, and fascinating information, this book belongs on every science shelf. With energy and profit a major political reason for fighting various wars, free-energy devices, if ever allowed to be mass-distributed to consumers, could change the world. Get your copy now before the Department of Energy bans this book!

306 pp. ♦ *7x10 paperback* ♦ *Profusely illustrated* ♦ *Bibliography & appendix* ♦ *$16.95* ♦
code: FEH

EXTRATERRESTRIAL ARCHAEOLOGY
by David Hatcher Childress

With hundreds of photos and illustrations, Extraterrestrial Archaeology takes the reader to the strange and fascinating worlds of Mars, the Moon, Mercury, Venus, Saturn, and other planets for a look at the alien structures that appear there. This book is non-fiction! Whether skeptic or believer, this book allows you to view for yourself the amazing pyramids, domes, spaceports, obelisks, and other anomalies that are profiled in photograph after photograph. Using official NASA and Soviet photos, as well as other photos taken via telescope, this book seeks to prove that many of the planets (and moons) of our solar system are in some way inhabited by intelligent life. The book includes many blowups of NASA photos and detailed diagrams of structures—particularly on the Moon. Extraterrestrial Archaeology will change the way you think.

224 pp. ♦ *8¹/2x11 paperback* ♦ *Hiighly illustrated with photos, diagrams & maps!* ♦ *Bibliography, index, appendix* ♦ *$18.95*
code: ETA

MAN-MADE UFOS: 1944-1994
50 Years of Suppression by Renato Vesco & David Hatcher Childress

A comprehensive and in-depth look at the early "flying saucer technology" of Nazi Germany and the genesis of early man-made UFOs. From captured German scientists, escaped battalions of German soldiers, secret communities in South America and Antarctica to today's state-of-the-art "Dreamland" flying machines, this astonishing book blows the lid off the "Government UFO Conspiracy." Examined in detail are secret underground airfields and factories; German secret weapons; "suction" aircraft; the origin of NASA; gyroscopic stabilizers and engines; the secret Marconi aircraft factory in South America, and other secret societies, both ancient and modern, that have kept this craft a secret, and much more. Not to be missed by students of technology suppression, UFOs, anti-gravity, free-energy conspiracy, and World War II. Introduction by W.A. Harbinson, author of the Dell novels Genesis and Revelation.

440 pp. ♦ *6x9 paperback* ♦ *Packed with photos & diagrams Index & footnotes*
$18.95 ♦ **code: MMU**

Renato Vesco
David Hatcher Childress

THE HISTORY OF ATLANTIS
by Lewis Spence

Lewis Spence's classic book on Atlantis is now back in print. Lewis Spence was a Scottish historian (1874-1955) who is best known for his volumes on world mythology and his five Atlantis books. The History of Atlantis (1926) is considered his best. Spence does his scholarly best in such chapters as The Sources of Atlantean History, The Geography of Atlantis, The Races of Atlantis, The Kings of Atlantis, The Religion of Atlantis, The Colonies of Atlantis, more. Sixteen chapters in all.
240 pp. ♦ *6x9 paperback* ♦ *Illustrated with maps, photos & diagrams* ♦ *$16.95*
code: HOA

by Lewis Spence

Atlantis Reprint Series

ATLANTIS REPRINT SERIES

SECRET CITIES OF OLD SOUTH AMERICA
Atlantis Reprint Series
by Harold T. Wilkins

The reprint of Wilkins' classic book, first published in 1952, claiming that South America was Atlantis. Chapters include Mysteries of a Lost World; Atlantis Unveiled; Red Riddles on the Rocks; South America's Amazons Existed!; The Mystery of El Dorado and Gran Payatiti—the Final Refuge of the Incas; Monstrous Beasts of the Unexplored Swamps & Wilds; Weird Denizens of Antediluvian Forests; New Light on Atlantis from the World's Oldest Book; The Mystery of Old Man Noah and the Arks; and more.

438 PAGES. 6X9 PAPERBACK. HEAVILY ILLUSTRATED. BIBLIOGRAPHY & INDEX. $16.95. CODE: SCOS

THE SHADOW OF ATLANTIS
The Echoes of Atlantean Civilization Tracked through Space & Time
by Colonel Alexander Braghine

First published in 1940, *The Shadow of Atlantis* is one of the great classics of Atlantis research. The book amasses a great deal of archaeological, anthropological, historical and scientific evidence in support of a lost continent in the Atlantic Ocean. Braghine covers such diverse topics as Egyptians in Central America, the myth of Quetzalcoatl, the Basque language and its connection with Atlantis, the connections with the ancient pyramids of Mexico, Egypt and Atlantis, the sudden demise of mammoths, legends of giants and much more. Braghine was a linguist and spends part of the book tracing ancient languages to Atlantis and studying little-known inscriptions in Brazil, deluge myths and the connections between ancient languages. Braghine takes us on a fascinating journey through space and time in search of the lost continent.

288 PAGES. 6X9 PAPERBACK. ILLUSTRATED. $16.95. CODE: SOA

RIDDLE OF THE PACIFIC
by John Macmillan Brown

Oxford scholar Brown's classic work on lost civilizations of the Pacific is now back in print! John Macmillan Brown was an historian and New Zealand's premier scientist when he wrote about the origins of the Maoris. After many years of travel thoughout the Pacific studying the people and customs of the south seas islands, wrote *Riddle of the Pacific* in 1924. The book is packed with rare turn-of-the-century illustrations. Don't miss Brown's classic study of Easter Island, ancient scripts, megalithic roads and cities, more. Brown was an early believer in a lost continent in the Pacific.

460 PAGES. 6X9 PAPERBACK. ILLUSTRATED. $16.95. CODE: ROP

THE HISTORY OF ATLANTIS
by Lewis Spence

Lewis Spence's classic book on Atlantis is now back in print! Spence was a Scottish historian (1874-1955) who is best known for his volumes on world mythology and his five Atlantis books. *The History of Atlantis* (1926) is considered his finest. Spence does his scholarly best in chapters on the Sources of Atlantean History, the Geography of Atlantis, the Races of Atlantis, the Kings of Atlantis, the Religion of Atlantis, the Colonies of Atlantis, more. Sixteen chapters in all.

240 PAGES. 6X9 PAPERBACK. ILLUSTRATED WITH MAPS, PHOTOS AND DIAGRAMS. $16.95. CODE: HOA

ATLANTIS IN SPAIN
A Study of the Ancient Sun Kingdoms of Spain
by E.M. Whishaw

First published by Rider & Co. of London in 1928, this classic book is a study of the megaliths of Spain, ancient writing, cyclopean walls, sun worshipping empires, hydraulic engineering, and sunken cities. An extremely rare book, it was out of print for 60 years. Learn about the Biblical Tartessus; an Atlantean city at Niebla; the Temple of Hercules and the Sun Temple of Seville; Libyans and the Copper Age; more. Profusely illustrated with photos, maps and drawings.

284 PAGES. 6X9 PAPERBACK. ILLUSTRATED. EPILOG WITH TABLES OF ANCIENT SCRIPTS. $15.95. CODE: AIS

THE LOST TEACHINGS OF ATLANTIS
and the Children of the Law of One
by Jon Peniel

Are the Lost Teachings of Atlantis kept in a secret monastery in Tibet? According to this fascinating book, in a remote mountain valley in Tibet are the ruins of a mysterious monastery built before the Great Pyramid. It was built by a strange people thought to be gods. Their archives contained amazing revelations from our ancient ancestors — Angelic Beings who became human to light our way home. They were the first spiritual masters, and the forefathers of countless religions. This book is their history, prophecy and knowledge including Energy Techniques, Meditations, Science-Magic, Universal Law, the Nature of Life & God and the Secrets of Inner Peace, Freedom & Enlightenment.

256 PAGES. 6X9 PAPERBACK. $18.95. ILLUSTRATED. CODE: LTA

ATLANTIS STUDIES

ATLANTIS IN AMERICA
Navigators of the Ancient World
by Ivar Zapp and George Erikson

This book is an intensive examination of the archeological sites of the Americas, an examination that reveals civilization has existed here for tens of thousands of years. Zapp is an expert on the enigmatic giant stone spheres of Costa Rica, and maintains that they were sighting stones similar to those found throughout the Pacific as well as in Egypt and the Middle East. They were used to teach star-paths and sea navigation to the world-wide navigators of the ancient world. While the Mediterranean and European regions "forgot" world-wide navigation and fought wars, the Mesoamericans of diverse races were building vast interconnected cities without walls. This Golden Age of ancient America was merely a myth of suppressed history—until now. Profusely illustrated, chapters are on Navigators of the Ancient World; Pyramids & Megaliths: Older Than You Think; Ancient Ports and Colonies; Cataclysms of the Past; Atlantis: From Myth To Reality; The Serpent and the Cross: The Loss of the City States; Calendars and Star Temples; and more.
360 PAGES. 6x9 PAPERBACK. ILLUSTRATED. BIBLIOGRAPHY & INDEX. $17.95. CODE: AIA

THE SECRET TRADITION IN ARTHURIAN LEGEND
by Gareth Knight

Knight shows how the Arthurian legend may be structured into a mystery system, comprised of three primary grades of attainment. The first is the grade of the Powers of Arthur—of loyalty, dedication and service, enshrined in concepts of chivalry. Second is the grade of the Powers of Merlin, bringing knowledge of the true roots of causation within the material world. The final grade is of the Powers of Guenevere: those who work with the power can form magnetic links between individuals and groups—power that is based upon the forces of polarity within the aura. Includes an index to Arthurian characters, locations and objects.
304 PAGES. 6x9 PAPERBACK. ILLUSTRATED. INDEX. $16.00. CODE: STAL

KING ARTHUR'S CRYSTAL CAVE
by Donald L. Cyr

King Arthur's crystal cave: a cave in which he was said to lie in state. This magical crystal cave could be in Glastonbury, or in Aberdeenshire, or somewhere else. Avalon could be located in England, in Wales or elsewhere while King Arthur may have been an early Sun King, a king who strangled two dragons and tossed his sword to Vivian, the Lady of the Lake. Chapters on crystal veil patterns, the myth of the warm land at the North Pole, hollow earth beliefs, Avalon, more.
160 PAGES. 6x9 PAPERBACK. ILLUSTRATED. $12.95. CODE: KACC

GLASTONBURY TREASURES
Stonehenge Viewpoint Series
edited by Donald L. Cyr

A Stonehenge Viewpoint oversize compilation on the many wonders of Glastonbury, an important crossroads town of the Druids and other early cultures. Chapters on the Glastonbury Zodiac, Joseph of Arimathea, Geomancy, the Hollow Earth and Glastonbury, the Chalice Well, the Mary Church Mystery, more.
92 PAGES. 9x11. PAPERBACK. ILLUSTRATED. $9.95. CODE: GLT

THE SEARCH FOR LOST ORIGINS
A Long-Forgotten Fountainhead of Civilization
by the editors of Atlantis Rising Magazine

An anthology of material on early civilizations, Atlantis, and ancient technology. Articles and interviews from John Anthony West, Graham Hancock, Robert Bauval, Zecharia Sitchin, Michael Cremo, Joseph Jochmans, David Hatcher Childress, Rand Flem-Ath, Laura Lee and others. Articles on the amazing antiquity of the Sphinx, high-tech artifacts from the past, Antarctica as a possible location for Atlantis, the 12th planet and the Annunaki of Sumeria, secret chambers in the Great Pyramid, decoding the past, more.
224 PAGES. 6x9 PAPERBACK. HIGHLY ILLUSTRATED. $14.95. CODE: SLO

ARCHITECTS OF THE UNDERWORLD
Unriddling Atlantis, Anomalies of Mars, and the Mystery of the Sphinx
by Bruce Rux

Wide-ranging discussion of such enigmas as the Egyptian pyramid, the Sphinx, the Face and other monuments on Mars, crop circles, UFOs, cattle mutilations, alien abductions, the myth of Atlantis, and theories of cosmic conspiracy involving extraterrestial governments. This work draws on more than 13 years' research, including contact with important figures in these areas of inquiry, such as Zechariah Sitchin, Jacques Vallee, Linda Moulton Howe and David Jacobs.
575 PAGES. 6x9 PAPERBACK. ILLUSTRATED. $18.95. CODE: AOU

ATLANTIS IN WISCONSIN
by Frank Joseph

A group of sunken pyramids in a northern lake leads the author to conclude that the legendary continent of Atlantis was actually Wisconsin. The strange tales of pyramids, sunken cities, ancient mining colonies and terrible wars makes the prehistory of Wisconsin, Illinois and Michigan a fascinating place indeed. Is it Atlantis? Chapters include Outposts of Aztalan, Atlantis and the Copper Question, Paranormal Occurances, Psychic Overview of Rock Lake and Aztalan, more.
204 PAGES. 6x9 PAPERBACK. ILLUSTRATED. FOOTNOTES & BIBLIOGRAPHY. $14.95. CODE: AIW

THE MYSTERY OF EASTER ISLAND
by Katherine Routledge

The reprint of Katherine Routledge's classic archaeology book which was first published in London in 1919. Portions of the book later appeared in *National Geographic* (1924). Heavily illustrated with a wealth of old photos, this book is a treasure of information on that most mysterious of islands: Rapa Nui or Easter Island. The book details Katherine Routledge's journey by yacht from England to South America, around Patagonia to Chile and on to Easter Island. Routledge explored the amazing island and produced one of the first-ever accounts of the life, history and legends of this strange and remote place. Routledge discusses the statues, pyramid-platforms, Rongo Rongo script, the Bird Cult, the war between the Short Ears and the Long Ears, the secret caves, ancient roads on the island, and more. This rare book serves as a sourcebook on the early discoveries and theories on Easter Island. Original copies, when found, sell for hundreds of dollars so get this valuable reprint now at an affordable price.

432 PAGES. 6x9 PAPERBACK. ILLUSTRATED. $16.95. CODE: MEI

MYSTERY CITIES OF THE MAYA
Exploration and Adventure in Lubaantun & Belize
by Thomas Gann

First published in 1925, *Mystery Cities of the Maya* is a classic in Central American archaeology-adventure. Gann was close friends with Mike Mitchell-Hedges, the British adventurer who discovered the famous crystal skull with his adopted daughter Sammy and Lady Richmond Brown, their benefactress. Gann battles pirates along Belize's coast and goes upriver with Mitchell-Hedges to the site of Lubaantun where they excavate a strange lost city where the crystal skull was discovered. Lubaantun is a unique city in the Mayan world as it is built out of precisely carved blocks of stone without the usual plaster-cement facing. Lubaantun contained several large pyramids partially destroyed by earthquakes and a large amount of artifacts. Gann was a keen archaeologist, a member of the Mayan Society, and shared Michell-Hedges belief in Atlantis and lost civilizations (pre-Mayan), in Central America and the Caribbean. Lots of good photos, maps and diagrams.

252 PAGES. 6x9 PAPERBACK. ILLUSTRATED. $16.95. CODE: MCOM

IN SECRET TIBET
by Theodore Illion

Reprint of a rare 30's travel book. Illion was a German traveller who not only spoke fluent Tibetan, but travelled in disguise through forbidden Tibet when it was off-limits to all outsiders. His incredible adventures make this one of the most exciting travel books ever published. Includes illustrations of Tibetan monks levitating stones by acoustics.

210 PAGES. 6x9 PAPERBACK. ILLUSTRATED. $15.95. CODE: IST

DARKNESS OVER TIBET
by Theodore Illion

In this second reprint of Illion's rare books, the German traveller continues his journey through Tibet and is given directions to a strange underground city. As the original publisher's remarks said, this is a rare account of an underground city in Tibet by the only Westerner ever to enter it and escape alive!

210 PAGES. 6x9 PAPERBACK. ILLUSTRATED. $15.95. CODE: DOT

IN SECRET MONGOLIA
by Henning Haslund

Danish-Swedish explorer Haslund's first book on his exciting explorations in Mongolia and Central Asia. Haslund takes us via camel caravan to the medieval world of Mongolia, a country still barely known today. First published by Kegan Paul of London in 1934, this rare travel adventure is back in print after 50 years. Haslund and his camel caravan journey across the Gobi Desert. He meets with renegade generals and warlords, god-kings and shamans. Haslund is captured, held for ransom, thrown into prison, battles black magic and portrays in vivid detail the birth of new nation. Haslund's second book *Men & Gods In Mongolia* is also available from Adventures Unlimited Press.

374 PAGES. 6x9 PAPERBACK. ILLUSTRATED. BIBLIOGRAPHY & INDEX. $16.95. CODE: ISM

MEN & GODS IN MONGOLIA
by Henning Haslund

First published in 1935 by Kegan Paul of London, Haslund takes us to the lost city of Karakota in the Gobi desert. We meet the Bodgo Gegen, a god-king in Mongolia similar to the Dalai Lama of Tibet. We meet Dambin Jansang, the dreaded warlord of the "Black Gobi." There is even material in this incredible book on the Hi-mori, an "airhorse" that flies through the air (similar to a Vimana) and carries with it the sacred stone of Chintamani. Aside from the esoteric and mystical material, there is plenty of just plain adventure: Haslund and companions journey across the Gobi desert by camel caravan; are kidnapped and held for ransom; initiation into Shamanic societies; reincarnated warlords, and the violent birth of "modern" Mongolia.

358 PAGES. 6x9 PAPERBACK. 57 PHOTOS, ILLUSTRATIONS AND MAPS. $15.95. CODE: MGM

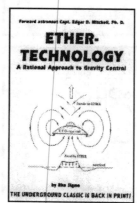

THE FREE-ENERGY DEVICE HANDBOOK

A Compilation of Patents and Reports

by David Hatcher Childress

A large-format compilation of various patents, papers, descriptions and diagrams concerning free-energy devices and systems. *The Free-Energy Device Handbook* is a visual tool for experimenters and researchers into magnetic motors and other "over-unity" devices. With chapters on the Adams Motor, the Hans Coler Generator, cold fusion, superconductors, "N" machines, space-energy generators, Nikola Tesla, T. Townsend Brown, and the latest in free-energy devices. Packed with photos, technical diagrams, patents and fascinating information, this book belongs on every science shelf. With energy and profit being a major political reason for fighting various wars, free-energy devices, if ever allowed to be massdistributed to consumers, could change the world! Get your copy now before the Department of Energy bans this book!
292 PAGES. 8x10 TRADEPAPER. ILLUSTRATED. BIBLIOGRAPHY. $16.95. CODE: FEH

UNDERGROUND BASES & TUNNELS

What is the Government Trying to Hide?

by Richard Sauder, Ph.D.

Working from government documents and corporate records, Sauder has compiled an impressive book that digs below the surface of the military's super-secret underground! Go behind the scenes into little-known corners of the public record and discover how corporate America has worked hand-in-glove with the Pentagon for decades, dreaming about, planning, and actually constructing, secret underground bases. This book includes chapters on the locations of the bases, the tunneling technology, various military designs for underground bases, nuclear testing & underground bases, abductions, needles & implants, military involvement in "alien" cattle mutilations, more. 50 page photo & map insert.
201 PAGES. 6x9 PAPERBACK. WELL ILLUSTRATED. $15.95. CODE: UGB

UFOS AND ANTI-GRAVITY

Piece For A Jig-Saw

by Leonard G. Cramp

Leonard G. Cramp's 1966 classic book on flying saucer propulsion and suppressed technology is available again. *UFOS & Anti-Gravity: Piece For A Jig-Saw* is a highly technical look at the UFO phenomena by a trained scientist. Cramp first introduces the idea of 'anti-gravity' and introduces us to the various theories of gravitation. He then examines the technology necessary to build a flying saucer and examines in great detail the technical aspects of such a craft. Cramp's book is a wealth of material and diagrams on flying saucers, anti-gravity, suppressed technology, G-fields and UFOs. Chapters include Crossroads of Aerodymanics, Aerodynamic Saucers, Limitations of Rocketry, Gravitation and the Ether, Gravitational Spaceships, G-Field Lift Effects, The Bi-Field Theory, VTOL and Hovercraft, Analysis of UFO photos, more. "I feel the Air Force has not been giving out all available information on these unidentified flying objects. You cannot disregard so many unimpeachable sources."
— John McCormack, Speaker of the U.S. House of Representatives.
388 PAGES. 6x9 PAPERBACK. HEAVILY ILLUSTRATED. $16.95. CODE: UAG

MAN-MADE UFOS 1944—1994

Fifty Years of Suppression

by Renato Vesco & David Hatcher Childress

A comprehensive look at the early "flying saucer" technology of Nazi Germany and the genesis of man-made UFOs. This book takes us from the work of captured German scientists, to escaped battalions of Germans, secret communities in South America and Antarctica to todays state-of-the-art "Dreamland" flying machines. Heavily illustrated, this astonishing book blows the lid off the "government UFO conspiracy" and explains with technical diagrams the technology involved. Examined in detail are secret underground airfields and factories; German secret weapons; "suction" aircraft; the origin of NASA; gyroscopic stabilizers and engines; the secret Marconi aircraft factory in South America; and more. Not to be missed by students of technology suppression, secret societies, anti-gravity, free energy conspiracy and World War II! Introduction by W.A. Harbinson, author of the Dell novels *GENESIS* and *REVELATION*.
318 PAGES. 6x9 TRADEPAPER. ILLUSTRATED. INDEX & FOOTNOTES. $18.95. CODE: MMU

THE COMING ENERGY REVOLUTION

The Search For Free Energy

by Jeane Manning

Free energy researcher and journalist Jeane Manning takes us for a great look at the break-through technologies, inventions and inventors that will change the way we live. Chapters on Nikola Tesla; Solid-State Energy Devices and their Inventors; Floyd Sweet—Solid State Magnet Pioneer; Rotating-Magnet Energy Innovators; Cold Fusion; Hydrogen Power; Low-Impact Water Power—A New Twist on an Old Technology; Harassing the Energy Innovators. 15 chapters in all.
230 PAGES. 6x9 PAPERBACK. ILLUSTRATED. GLOSSARY, BIBLIOGRAPHY, INDEX. $12.95. CODE: CER

One Adventure Place
P.O. Box 74
Kempton, Illinois 60946
United States of America
Tel.: 815-253-6390 • Fax: 815-253-6300
Email: auphq@frontiernet.net
http://www.azstarnet.com/~aup

ORDERING INSTRUCTIONS

✓ Remit by USD$ Check, Money Order or Credit Card

✓ Visa, Master Card, Discover & AmEx Accepted

✓ Prices May Change Without Notice

✓ 10% Discount For 3 or more items

SHIPPING CHARGES

United States

✓ Postal Book Rate { $2.50 First Item / 50¢ Each Additional Item

✓ Priority Mail { $3.50 First Item / $2.00 Each Additional Item

✓ UPS { $3.50 First Item / $1.00 Each Additional Item

NOTE: UPS Delivery Available to Mainland USA Only

Canada

✓ Postal Book Rate { $3.00 First Item / $1.00 Each Additional Item

✓ Postal Air Mail { $5.00 First Item / $2.00 Each Additional Item

✓ Personal Checks or Bank Drafts MUST BE USD$ and Drawn on a US Bank

✓ Canadian Postal Money Orders OK

✓ Payment MUST BE USD$

All Other Countries

✓ Surface Delivery { $6.00 First Item / $2.00 Each Additional Item

✓ Postal Air Mail { $12.00 First Item / $8.00 Each Additional Item

✓ Payment MUST BE USD$

✓ Checks and Money Orders MUST BE USD$ and Drawn on a US Bank or branch.

✓ Add $5.00 for Air Mail Subscription to Future *Adventures Unlimited* Catalogs

SPECIAL NOTES

✓ RETAILERS: Standard Discounts Available

✓ BACKORDERS: We Backorder all Out-of-Stock Items Unless Otherwise Requested

✓ PRO FORMA INVOICES: Available on Request

✓ VIDEOS: NTSC Mode Only

✓ For PAL mode videos contact our other offices:

European Office:
Adventures Unlimited, PO Box 372,
Dronten, 8250 AJ, The Netherlands
South Pacific Office
Adventures Unlimited NZ
221 Symonds Sreet Box 8199
Auckland, New Zealnd

Please check: ☑

☐ This is my first order ☐ I have ordered before ☐ This is a new address

Name	
Address	
City	
State/Province	**Postal Code**
Country	
Phone day	**Evening**
Fax	

Item Code	Item Description	Price	Qty	Total

Please check: ☑

☐ Postal-Surface

☐ Postal-Air Mail (Priority in USA)

☐ UPS (Mainland USA only)

Subtotal →	
Less Discount-10% for 3 or more items →	
Balance →	
Illinois Residents 6.25% Sales Tax →	
Previous Credit →	
Shipping →	
Total (check/MO in USD$ only)→	

☐ Visa/MasterCard/Discover/Amex

Card Number

Expiration Date

10% Discount When You Order 3 or More Items!

Comments & Suggestions

Share Our Catalog with a Friend